RUSSIAN SYMBOLISM

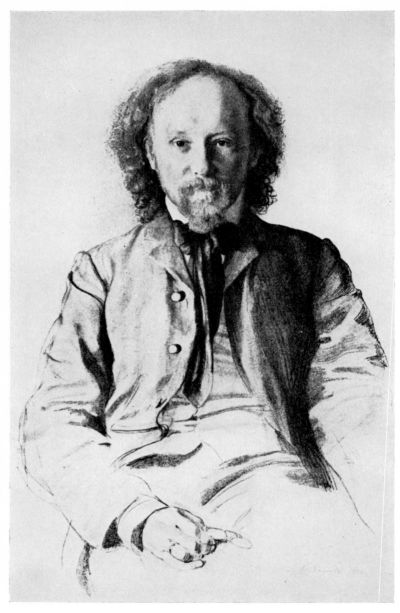

Portrait of Vyacheslav Ivanov by K. A. Somov (1869–1939)

RUSSIAN SYMBOLISM

A study of Vyacheslav Ivanov and the Russian
symbolist aesthetic

James West

METHUEN & CO LTD
11 New Fetter Lane London EC4

First published 1970
Methuen & Co Ltd
11 New Fetter Lane, London E.C4
© *1970 by James West*
Printed in Great Britain by
William Clowes and Sons, Limited
London and Beccles
SBN 416 19350 1

Distributed in the U.S.A.
by Barnes & Noble Inc.

Contents

v

15914

THREE The Symbolist Debate

CONCLUSION Poetry and The Absolute

Acknowledgements

This book would never have been embarked upon without the encouragement and help of Professor Elizabeth Hill.

A British Council bursary enabled me to spend four months in Leningrad, working under the supervision of Professor D. E. Maksimov, to whom I am greatly indebted for his kindness and his willingness to share his immense knowledge of the period in question.

I am grateful for valuable advice from Dr J. P. Stern and Mr E. R. Sands, and from Dr P. Boyde, who also suggested the translation of Michelangelo's lines quoted on page 91. Dr J. D. Elsworth generously lent me a number of works by Ivanov and Bely which would otherwise have been difficult to come by, and Edward Braun corrected some of my misconceptions about the symbolist theatre.

I am grateful to the Clarendon Press for permission to reproduce Ivanov's poem 'Golubyatnya' from the collection *Svet Vecherniy*, and to the Harvill Press for permission to cite three important passages from his *Freedom and the Tragic Life*. My thanks are also due to Bowes and Bowes for leave to quote from Erich Heller's *The Disinherited Mind*; to Yale University Press for allowing me to refer extensively to Ernst Cassirer's *An Essay on Man*; and to Editions Gallimard, for permission to reproduce a part of Saint-John Perse's *Poésie*.

K. A. Somov's portrait of Ivanov appeared in *Zolotoye runo* in 1907 and is reproduced by courtesy of the Taylor Institution, University of Oxford, from the copy in their holding.

Introduction

This book is about the theory of art of the symbolist movement in Russia in its mature phase, and concerns itself in the first place with the question, central to any aesthetic, of the representation of reality in art.

It may seem at first surprising that it should be necessary to devote a book entirely to the theoretical ideas of a group of writers who are chiefly remembered for their enrichment of Russia's poetic heritage in the early years of this century. My reason for writing such a book is the extraordinary preoccupation of the Russian symbolist poets – Bryusov, Bal'mont, Bely, Ivanov, Blok, and a great many figures of lesser stature – with the justification of their poetry in terms of a comprehensive 'philosophy of culture'. Even their contemporaries were struck by the symbolists' predilection for theorizing about the function of their creative writing, an activity for which the pages of Russian literary periodicals, several of which were founded during this period by the symbolists, provided an incomparable platform. A critic who was by no means wholly unsympathetic, A. Gornfel'd, wrote in the newspaper *Tovarishch* on 23rd August 1907 that 'among the leaders of Russian symbolism there are more theorists than practitioners of literary innovations. Where there is a need for a poet to speak, they are hopelessly given to ratiocination – and their awareness that something new must be said far exceeds their ability to say it.' Whilst Gornfel'd's criticism is in many ways unfair, it pinpoints a characteristic of the movement of which some at least of the symbolists were themselves aware, to judge by Zinaida Gippius' sad, and equally exaggerated, reflection that 'we have artists, thinkers, writers – but no art'.†

The theorists of Russian symbolism used the word 'art' in its widest meaning, intending their theories to apply to all branches of creativity, even though, for the most part men of letters, they based their detailed arguments mainly on poetry and drama. Indeed, they looked upon symbolism not simply as a philosophy of art, but as the guiding principle of an entire way of life, with art holding pride of place as the activity in which man realizes his whole being most fully.

† Зинаида Гиппиус: *Литературный дневник*, СПб., 1908, стр. 397.

1

It must on no account be supposed from this that their attitude was that of the aesthete, for the majority of them sought in art, besides aesthetic gratification, the key to the realization of serious social and even political ideals. Theirs was essentially a Romantic world-view, in which, as for Friedrich Schlegel, the whole world is a constantly self-perfecting work of art, and human art but a reflection of this universal process. It is scarcely surprising that the Russian symbolists were dismissed as 'neo-Romantics' by certain of their contemporaries, albeit by virtue of a brutal oversimplification.

The question of the exact nature of artistic 'representation' became the central issue of the symbolists' confrontation with the heirs to the view of art which predominated in Russia towards the close of the nineteenth century. However, the issue was complicated, as much in the case of the symbolists as in that of the nineteenth-century realists, by arguments going beyond the narrow province of aesthetics, based on the assumption that art has a purpose and a power that are not suggested by the word 'representation'. For although the Russian symbolists, inspired by the example of symbolism and modernism in Europe, championed the independence of the artistic imagination, they did not advocate 'art for art's sake', except in the case of a few individuals, as a passing phase, early in the history of the movement. In asserting the independence of the artist's imagination, they emphasized its equal validity, alongside the reasoning mind, not only as a means of extending and communicating man's highest awareness of life, but as a weapon in the struggle for the betterment of the human condition. A great part of the conflict between the symbolists and their opponents took place, therefore, on ideological rather than aesthetic ground; the confrontation was between rival philosophies of life, rather than simply of art. But since it is through their creative writing, rather than their 'philosophical' ideas, that the Russian symbolists are usually approached, I have tried to identify those elements of the conflict which have most significance from the point of view of aesthetics, and to describe the essential characteristics of the Russian symbolist theory of art.

It is customary to divide the Russian symbolists into an earlier, 'decadent' group, headed by Bryusov and Bal'mont, in which the influence of French and Belgian symbolism is paramount, and a 'second generation', whose leading representatives were Ivanov, Bely, and Blok, characterized by a more religious and philosophical bent, less derivative, betraying in any case the influence of German

rather than French sources, and not infrequently claiming to have roots in a native Russian tradition. The turning point between the two is generally set at around 1904. This is from many points of view a valid and useful division, and it is with the aesthetic theory most characteristic of the second phase that this study is primarily concerned. The second generation entered eagerly into discussions of the question of 'art and reality'; they showed themselves more than willing to argue the issue with representatives of the established realist tradition, and often answered criticism from this quarter by presenting their ideal as a more valid form of 'realism'. Indeed, Aleksandr Blok observed in 1907 that Russian symbolism was distinct from its Western counterpart by virtue of its tendency to realism.† However, the division is very blurred, and cannot be followed too rigidly; some of the ideas developed by the later generation of symbolists can be discerned in one form or another in the earlier 'decadents', and in this study they will be traced wherever they may be found. Most of the writing discussed dates from between 1900 and 1917, but I have included some material both earlier and later than this period which is plainly relevant to the discussion.

I feel bound to emphasize that what is offered here is not a critique on philosophical grounds of the theories of the Russian symbolists, but an attempt to clarify a confusing and considerably less than coherent body of theory, and to describe the Russian symbolist aesthetic by reference to more precisely formulated ideas that are reasonably familiar to the Western reader. My intention has been to provide the clear characterization which must precede any valid critique, be it of the soundness of the symbolists' aesthetic ideas, or of their acceptability as a basis for the practice of the arts, and the aim has dictated the method adopted: exposition and analysis have been combined in equal proportions, and, in particular, I have wherever possible summarized the ideas discussed by drawing analogies – or pointing to contrasts – with comparable aesthetic theories outside the bounds of either Russia or the symbolist movement. A good deal of space is given to the heritage of nineteenth-century Russian realism, since other studies of Russian symbolism have given the impression of a cleaner break with the specifically Russian past than proves, when perspective is restored, to have been the case. By the same token, the objections of the leading contemporary opponents of symbolism have been taken into account,

† Александр Блок: *Собр. соч.*, т. 5, М/Л., 1962, стр. 206–7.

for the effect of a climate of controversy on the Russian symbolists' formulation of their views has hitherto been largely ignored.

My reason for placing Vyacheslav Ivanov at the centre of this study is that, among the Russian symbolists, his theory of art is the most fully elaborated, making it possible to identify clearly what might only be conjectured from the less systematic theoretical writings of the majority of his fellow-symbolists.

Chapter One consists of a brief and very selective survey of the aesthetic theories that were the common heritage of the Russian symbolists and their detractors at the close of the nineteenth century, and it is slanted towards the questions which most preoccupied both these warring factions. It makes no claim to present a balanced picture of nineteenth-century Russian treatment of the problem of realism in art; indeed, it is an act of trespass committed with some hesitation on ground that others are better qualified to tread, and I hope it may be accepted as a suggestive, and in no sense authoritative, account.

In an effort to prevent the analysis of Ivanov's ideas from being hopelessly abstract at the very outset, Chapter Two begins with a paraphrase of one of his most characteristic pieces of theoretical writing, from which are drawn the most promising headings under which to examine the main body of his work. With one or two exceptions, no account has been taken of Ivanov's writings from the period of his self-imposed exile in Italy after the Revolution.

In Chapter Three, the pattern of Chapter Two is followed as far as possible, in order to provide a framework for the analysis of less coherent material drawn from a wide variety of sources. This approach inevitably gives little scope to dwell upon the many minor differences between the theories of individual symbolists, but it is hoped that the resulting sharper characterization of the Russian symbolist aesthetic as a whole will at least partly compensate for this obvious drawback.

Russian prose material is cited in translation. Poetry, isolated words of Russian which do not bear translation, and references are given in Cyrillic script. Proper names and the titles of some literary periodicals have been transliterated, following the system recommended by *The Slavonic and East European Review*. The index may be used as a 'Who's Who' in Chapter Three.

One

THE NINETEENTH-CENTURY HERITAGE

POLIXENES. *You see, sweet maid, we marry*
A gentler scion to the wildest stock,
And make conceive a bark of baser kind
By bud of nobler race: this is an art
Which does mend nature, change it rather, but
The art itself is nature.
PERDITA. *So it is.*
POLIXENES. *Then make your garden rich in gillyvors,*
And do not call them bastards.

The Winter's Tale

1. Introduction

At the outset of this chapter, it will be necessary to explain its aims exactly, for it runs the risk of being taken for a balanced, if brief, survey of nineteenth-century Russian aesthetics since Belinsky, and this it certainly is not.

The present study is primarily concerned with a lively and explicit debate, which took place in the early 1900s, about the proper relationship of art to reality, between the 'modernists' or 'decadents' or 'symbolists' on the one hand,[1] and, on the other, those who considered themselves heirs to a tradition of Russian realism stretching back at least to the 1840s. This debate can be meaningfully examined only if we have a clear idea of the solutions to the problem in question which its participants had to fall back upon or to react against. There follows, then, not a balanced but a highly partial conspectus of certain of the more important pronouncements on the relation of art to reality made by the principal representatives of the nineteenth-century tradition. These mid- and late-nineteenth-century contributions to the theory of art in Russia will be presented from the point

5

of view of the reactions they reflect to the particular problems which were most to the fore in the early twentieth century. This approach is very much open to the objection that it will give rise to misleading distortions; however, the material in question is so familiar, or at least accessible, that it should not be difficult to correct by reference to the overall picture the incompleteness and tendentiousness inherent in such an account. The primary concern of this chapter is to focus attention on certain problems that are found to be significant when considering the background against which the symbolist aesthetic developed. From among the major contributors to Russian aesthetics in the nineteenth century (and they are all too few), six writers will be examined. The choice is less arbitrary than it appears; those figures have been chosen who were most frequently invoked by one side or the other in the debate we are to consider, and (in the cases where the nineteenth-century tradition and the first flowering of 'decadence' coincide chronologically), those who had the most interesting or revealing comment to make on the principles underlying the new movement. The general picture of nineteenth-century discussions of art is, after all, well enough known. The aim of this chapter is to re-invoke it with a bias, emphasizing those notions which have some relevance to symbolist formulations, and laying particular stress on attempts to deal explicitly with the psychological problems raised by artistic creativity.

2. Vissarion Grigor'evich Belinsky

Belinsky affords the most convenient starting-point, since later Russian critics of a variety of hues acknowledged him as the 'father of Russian criticism', and also because he provides the earliest example of a wide-spread characteristic which will be discussed at length later in this study – an uneasy balance between the claims of 'realism' and 'idealism'.

In his surveys of Russian literature for the years 1846 and 1847 (which contain, in one form or another, most of his characteristic views on art and reality, and will be extensively drawn upon for illustration), Belinsky frequently appeals to Russian writers to develop a national self-awareness, and in the same breath extols the new realism that he discerns in Russian letters – the 'natural school', as he

6

calls it. For example, talking of the steady progress of Russian litera-
ture towards freedom from European models, he bids the reader re-
view its course from Lomonosov to Gogol. 'Then you will see', he
says, 'that up to Pushkin the whole course of Russian literature was
determined by the striving, albeit unconscious, to shake off the in-
fluence of Lomonosov and to draw nearer to life, to reality, conse-
quently to become original, national, Russian.'[2] The use of the
word 'consequently' here indicates how closely the ideas of Realism
and Russianness were linked in Belinsky's mind, and when the ques-
tion arises of continuity in Russian views of art and reality, it is use-
ful to be able to point to a writer who formulated his concept of
realism in terms of faithfulness to specifically Russian social realities,
and to Russian ways of thinking – who, in a word, appealed to what
he discerned as a Russian tradition, and sought to further it.

Belinsky invariably viewed art in a social context, and whenever,
in his discussions of literature, he talks of 'reality', he is referring to
people, not to things; his criticism abounds in statements like the
following –

> [The striving to become natural] could be accomplished only by
> directing art exclusively towards reality, passing by all ideals. For
> this it was necessary to direct the attention towards the crowd, the
> masses, to represent ordinary people. . . .[3]

– where 'reality' appears to be equated with 'the people'. It is only
to be expected therefore that Belinsky's concept of the proper rela-
tion of art to reality should be in the last resort inextricable from his
ideas of social progress and service to the community. The crucial
difference, as he saw it, between the writers of the Romantic tradi-
tion and those of the new 'natural school', is that the former ideal-
ized nature, and represented only fictional entities, whereas the lat-
ter reproduce life and reality in its true form. This, he claims, has
given literature a new social significance, which lies in its power to
express 'the striving of Russian society towards self-awareness, and
consequently the awakening in it of moral interests and intellectual
life'.[4] In this by no means untypical pronouncement Belinsky ap-
pears to assume that there is no conflict, not even a certain polarity,
between artistic method and the social function of literature. He
would have us believe that the truthful representation of reality is a
process involving no greater psychological complexity than a refusal

7

to invent; the only version of 'truth to reality' that he admits here is one which will accord instantly with the aspirations of a society struggling towards political self-awareness. In fact, Belinsky is not consistent in his disregard of the peculiarly psychological problems raised by the question of 'truth to life', and he does, in developing this idea, draw a distinction between the social and the psychological implications of the attempt to represent nature faithfully in art. However, he seldom goes further than a bare acknowledgement of the existence of the psychological difficulties, which for him are scarcely important beside the task of voicing and realizing the aspirations of society. Literature, says Belinsky, which is always the voice of society, becomes very much more in the context of the 'new society', helping to arouse the community, to direct and form it, rather than simply reflecting its movements without lagging too far behind.[5] This publicistic view of the function of literature is not allowed to stand unmodified; Belinsky makes other pronouncements in which the subject is, significantly, not 'literature' but 'the poet', and once he begins to particularize even to this slight extent, he becomes oddly (for an avowed realist) metaphysically-minded. In one important instance he places art on a par with scientific method as a means of knowing reality. The political economist, so he argues, *proves* to his readers by rational means that the lot of a particular social class has improved or worsened, for certain reasons. The poet, armed with a 'clear and living representation of reality', *shows* his readers, 'by acting upon their imagination', precisely the same situation. Here Belinsky is still the publicist, in so far as he is treating literature as a means of communicating knowledge that will be of use to the community in its social development. But he has taken care to point out that the kind of knowledge bestowed by art is of a different order to that imparted by science; that it is instantaneously rather than progressively achieved, an overall picture rather than an argument built up step by step; and that its medium is the imagination, not the intellect. The way in which poetry can become a social force is recognized as lying through an area of the mind governed by psychological processes less easy to account for than the social scientist's reasoning.

However, though he may admit that the poet's realm is that of the imagination, Belinsky can never bring himself to grant it autonomy from the mainland of the national, popular 'self-awareness', to which

he lends his support for reasons which, of course, have little to do with aesthetics. Thus he combats the notion (so dear to the Romantics, against whom, specifically, he was reacting) that the poet is isolated from society at large. The genius, Belinsky claims, is the bodying forth, the realization, of a potential which resides in the national subconscious; he is the plant, the people are the soil, and the relationship between them, he insists, is one of complete unity.[6]

It follows for Belinsky that the poet expresses not his own particular and random thoughts, but the innermost thoughts of the whole of society, 'that which is general and essential and gives colour and meaning to his whole epoch'.[7] This standpoint, applied to the artistic process, gives the concept for which Belinsky is chiefly remembered – the concept of the 'type'. It is by the process of 'typification' that a nation's 'innermost thoughts' (in other words, its ideals) are embodied in a truthful representation of reality. For the writer bent on so representing reality, Belinsky holds, 'the crux of the matter lies in *types*, and here the *ideal* arises not as a decoration (which would be a falsification) but as the relationship which the author establishes between the types he has created, in accordance with the thought which he sets out to develop in his work'.[8] Thus, Belinsky has progressed from the bald claim that literature should reproduce life as it really is, and that this is all that is necessary in order for it to become the instrument of social self-determination, to an awareness that the writer, in selecting those features of life which he will depict (for the creation of types necessarily implies selection), is putting his own construction upon reality, a process which is far from objective, but which Belinsky refuses to call 'idealism' only because the writer is held to stand in a close organic relationship to society and to express its common intent. But society, we have seen, is what Belinsky generally understood by 'reality'. His argument for his own variety of realism in literature is circular, and, for those who inherited it, it stood or fell on socio-political rather than aesthetic grounds.

In the *Survey of Russian Literature for 1846* Belinsky introduces a second concept, which profoundly modifies the concept of the type, but which has received conveniently little attention from Belinsky's commentators (themselves for the most part of the realist confession). This is the idea of the 'individual personality' ('личность').

Belinsky was not content to deal in logical abstractions. Tracing

the course of the 'realist' and 'idealist' streams which he discerns in eighteenth-century Russian literature, he makes the somewhat surprising observation that both tendencies were perfectly legitimate, but that both were inspired not by life but by abstract theory, implying that the 'natural school' of his day has overcome this disability.[9] In introducing the concept of 'личность', Belinsky recognizes that the writer is not an abstract being, but a living individual, whose individuality 'gives reality to his feelings and his mind, his will and his genius', and that without such an element of individuality the work of art is either a fantasy or an abstraction.[10]

Belinsky appears here to derive a principle from the distinctive individual contribution which, in his observation, the writer makes when he 'typifies'; the writer is exercising his 'individual personality' when he establishes relationships between the types he has created, and develops ideas through his representation of reality. In formulating this concept and pursuing it, Belinsky introduces a serious (but surely obvious) reservation into the theory of types. The writer's individuality, he says, presupposes the exclusion of other individualities; it may be what breathes life into art, but it is also the sign of human limitation, of the fact that no man can ever encompass more than a minute part of life.[11] And if the writer can only know factually a fraction of the reality which he is called upon to represent in generalized, typified form, then great must be the power which, even as it limits him, enables him to transcend his individuality. 'It is a secret on a par with the secret of life', says Belinsky, evading the issue: 'everybody can see it, everybody feels its effect, but none can say what it is'.[12]

In the following year he turned again to this mysterious quality which alone makes the artist's 'types' ring true. In the continuation of the passage quoted at note 7, he identifies the quality enabling the poet to discern the general and the essential as 'instinct, that defies common sense and goes straight to the essence of things'. This is a reasonably commonplace definition of 'artistic intuition'; Belinsky plainly recognized the existence of a creative mental process lying outside the pale of reason. He named it 'instinct', but he named it only to marvel a while at it before passing on to the serious business of the social function of literature, to whose elaboration he was pledged.

The purpose of this argument is to introduce a strong reservation into the claim that Belinsky was a 'realist' in the period sense; for if

we accept René Wellek's definition – 'Realism as a period concept ... means "the objective representation of social reality"'[13] – we must exercise care in fastening the label on Belinsky, because, on balance, he did not advocate strictly objective representation in art. The classification of Belinsky under the general category of 'nineteenth-century Russian realists' has meant that historians of Russian literature have paid insufficient attention to the details of his departure from the objectivity which we normally equate with literary realism, even though, at the same time, the 'taint' of idealism in his views is often acknowledged in passing.

It is a commonplace of histories of Russian literature that Belinsky's early beliefs were founded in German Romantic idealism. Soviet critics chart his progress from this unpropitious start towards more acceptable materialist views, and scorn the suggestions of some later nineteenth-century Russian critics – such as the populist Skabichevsky – that he remained an idealist to the end.[14] René Wellek sees Belinsky as completely bound by German idealist theories, and in no sense a realist at all.[15] Certainly the ideas we have just examined show distinct points of resemblance with 'idealist' theories – for example, the assertion that the artist creates, on an analogy with the real world, a world of the imagination which has its own laws. But we should be wary of trying to follow the resemblance too deeply, and it is not easy to digest René Wellek's assertion that Belinsky infected the whole tradition of Russian literary criticism with the ideas of German idealism,[16] since the majority of Belinsky's successors expressed a specific hostility towards such ideas. Belinsky himself emphatically rejected several 'idealist' notions, amongst them that of 'pure art', precisely on the grounds that they were German metaphysics and would not therefore take root in Russian soil.[17] His awareness of Russian social realities always tempered and often mastered his enthusiasm for German philosophy. Much more important from the point of view of later comparisons is the concept of type, which is Belinsky's most original and lasting contribution to literary criticism; its importance in the Russian tradition cannot be overstressed.

There are, besides the above, two features of Belinsky's theories that are particularly worth bringing into relief. Firstly, Belinsky differs sharply from his successors, the men of the 1860s, by virtue of the dualism of his philosophy. We have seen that he recognized

11

the value of irrational, as distinct from rational cognition; moreover, at least in 1846, he believed quite firmly in the primacy of mind over matter and in the separate existence of 'an eternal, intransient, essential being' which was man's 'higher and more noble reality'.[18] Secondly, he expounded quite early in his career,[19] and developed thereafter, the view that subjectivity is *necessary* to realist art; that in displaying his subjective relation to the reality which he portrays, the artist is expressing certain collective inspirations which are the most important quality in realist art. Even some Soviet critics, however strongly they may repudiate the suggestion that Belinsky was an idealist at heart, feel obliged to give due weight to the rôle of the subjective element in his analysis of art.[20]

3. Nikolay Gavrilovich Chernyshevsky

The continuity between Belinsky and the three great radical critics Chernyshevsky, Dobrolyubov and Pisarev ('revolutionary democrats' in Soviet parlance) is largely conditioned by the latters' enthusiastic recognition of the former's immense significance as their socio-political forefather. These three thinkers were, in contrast to Belinsky, 'materialist monists';[21] all three emphatically denied the duality of matter and spirit and their analysis of art in this respect differs fundamentally from that of Belinsky.

Of the three, Chernyshevsky undertook the most explicit treatment of the problem of art and reality, in his *The Aesthetic Relations of Art to Reality* (1855). In this treatise Chernyshevsky sets out expressly to counter what he sees as the 'prevailing aesthetic system', which is an idealist system of German origin.[22] It is a disappointingly abstract work; in spite of Chernyshevsky's declared hostility to abstractions, his arguments are conducted for the most part in terms of abstract value-judgements that ignore the psychology of creativity and do not even seek roots in his more concrete formulations, such as 'natural beauty'.

Chernyshevsky opens his treatise, surprisingly, by conceding two points to the idealists. The idealist formulation – 'Beauty is the full realization of the idea in a particular object' – is, he says, a wrong definition, but at least establishes quite correctly that 'the beautiful' is not an abstraction but a living particular; and the notion that the

Idea is omnipresent and timeless helps to establish the fact that true art appeals to all mankind. However, the idealist theory is vitiated for Chernyshevsky by its preoccupation with 'beauty in art' rather than 'beauty in nature'.[23] For Chernyshevsky, beauty resides primarily in life, and only secondarily in the work of art. He arrives at this concept by the following argument: since the feeling which beauty arouses in us is the same 'bright joyfulness' ('светлая радость') that we feel in the presence of those we love, beauty must be something which is dear to us, but on an all-embracing plane, and the thing which is most generally dear to a man is – life; therefore, an object is beautiful in so far as it expresses or recalls life.[24] This celebrated formula is generally held (at least in the West) to show that Chernyshevsky has abolished aesthetics altogether, meaning presumably that he appears to deny that either the artist's imagination or the beholder's eye plays any part in the feeling that something is beautiful. Chernyshevsky does indeed enlarge on the formula in a way that outlaws what we have come to regard as aesthetics, but his essay contains several unresolved asides which show that he, too, was unable entirely to dismiss 'the beholder's share', the element of perception and interpretation which gives rise to 'aesthetic' considerations in the first place,[25] even though he could not allow it a prominent place in his main argument. The most striking case in point is his elaboration of the formula referred to above which is, significantly, never quoted in full by those who assert that Chernyshevsky 'banished aesthetics'. He in fact concludes his argument thus: 'That being is beautiful in which we see life *as it ought to be according to our conceptions*; that object is beautiful which manifests life or puts us in mind of life.'[26] Even as he declares that beauty resides in life, not art, he admits that it is only discerned there if we feel it ought to be; and yet he refuses to follow the opening he has made into the psychology of perception.

Contemporary aesthetics, Chernyshevsky observes, quite rightly distinguish three embodiments of beauty – in nature, in the imagination, and in art, and he accepts as fundamental the need to establish the relationship between the first of these and the other two. He then quotes at length Vischer's assertion that the beauty which resides in nature is transitory, and of a lower order than the 'ideal' beauty embodied in art, because it is a random occurrence, not a deliberate creation.[27] Chernyshevsky rejects Vischer's view that man strives to

13

perfect and transcend in art the imperfect beauty which he finds in his natural surroundings. He insists that man takes refuge in his imagination[28] only when his surroundings are too unpleasant to be borne; that where reality is at all bearable, the imagination ceases to satisfy.[29]

Our aesthetic needs, according to Chernyshevsky, can be satisfied in practice, because life is rich enough to provide anything man can need.[30] Man can find beauty in nature in a satisfactory form without imposing human modifications upon nature. The very idea of 'perfect' or 'absolute' beauty dismays Chernyshevsky, and he observes that: '. . . the practical life of man convinces us that he seeks only an approximate perfection. . . . Only pure mathematics seeks perfection; even applied mathematics contents itself with approximations.' Characteristically, Chernyshevsky then dilutes his materialist argument with the unresolved question of value-judgements: distilled water, he remarks by way of illustration, does not even *taste* pleasant.[31]

When he comes to deal specifically with poetry, Chernyshevsky observes that, unlike all other arts, which act directly upon the feelings, poetry acts upon the imagination,[32] but that the poetic image stands in the same relationship to the 'real live image' (the phrase is Chernyshevsky's) as a word does to the object it designates: '. . . it is no more than a pale and general, imprecise reference to reality'.[33] Generalization, for Chernyshevsky, involves paleness, not (as for Belinsky) intensification, and he explicitly repudiates the notion that the value of art lies in its generalizing function. For man, he declares, the general is always paler than the particular, and 'particular details do not in fact detract from the general significance of an object, on the contrary, they bring it alive and complement its general significance'.[34] It is interesting to see how, in Chernyshevsky's view, this comes about. He evidently feels the need to replace the banished process of typification by some other value-bestowing process, and, when he comes to discuss the portrayal of human character in literature he names the substitute – '. . . all that is needed – and this is one of the qualities of poetic genius – is to grasp the essence of the character of the real man, to subject him to a penetrating gaze'. 'Typification' has been replaced by 'penetration to the essence'. The phrase 'all that is needed', which introduces the substitute, is significant; it represents an attempt to reduce all that is implied by poetic genius

to a self-evident trick-of-the-trade, in order to avoid the necessity to treat it as one of the more fundamental and problematic ingredients of art. It is the key to all the inconsistent asides with which Chernyshevsky's argument is laced; indeed, as his argument progresses, it becomes fundamentally inconsistent through his failure either to ignore or to take proper account of those imaginative mental processes which have to be explained away before a strictly materialist view of art can be made plausible. He is haunted by the undeniable 'transformation' wrought upon reality in the process of representing it in art:

> Nature and life are higher than art; but art tries to fall in with our inclinations, whereas reality cannot be subjected to our urge to see all things in the form and hue which please us or correspond to our often one-sided conceptions of them.[35]

He feels bound to try to purge art of its tendency to fall in with our inclinations, to establish that 'the primary significance of art, inherent in all works of art without exception, – is the reproduction of nature and life', a reproduction made not with a view to improving reality, but simply because reality is in itself beautiful.[36] And yet, he declares, the seventeenth- and eighteenth-century theories of art as an imitation of nature were wrong, for art must have 'content'[37] and the prevailing definition of this 'content' as simply 'the beautiful' is insufficient, since many a work of art involves features which are intrinsically ugly: the original term *mimesis* should never, in Chernyshevsky's view, have been brought into European currency as 'imitation' – it corresponds more to what he means by 'reproduction' and involves 'the communication of inner content'.[38] Chernyshevsky accounts for the intrusion of ugliness into art by defining 'content' as everything in life which most interests man, but in so doing he is allowing a process of selectivity in representation, which is the 'beholder's share' in another guise. In the last resort, Chernyshevsky admits that in artistic representation reality is distorted by man's need to interpret what he sees, and that the imagination is the faculty through which such interpretations are made:

> In showing an interest in the phenomena of life, man cannot avoid consciously or unconsciously passing judgement on them . . . this is the new meaning of art, according to which art takes its place among man's moral activities.[39]

15

Even in making this admission, Chernyshevsky stands by the absolute primacy of life over art:

> . . . as an education, as a science, life is fuller, more true, even more artistic than all the creations of scientists and poets. But life offers us no explanation of its phenomena. . . . Science and art (poetry) are a handbook for beginners in the study of life: their rôle is to prepare the way for the reading of the sources . . .[40]

This last sentence is frequently quoted on its own, to misleading effect: its context surely shows, by the implication that art exists alongside science to provide the explanation of life's phenomena, that Chernyshevsky's aesthetic was less consistently materialist than it is generally taken to be. And though he begins the essay by taking a resolute stand against the imagination – '. . . the author [Chernyshevsky] ascribes very little significance at all for our age to flights of the imagination even in the sphere of art . . .'[41] – he is forced by the end of it to concede the rôle of the imagination in manipulating the artist's imperfect impressions and memories of real life, in filling them out and enabling him to make a coherent work of art.[42]

4. Apollon Aleksandrovich Grigor'ev

There emerged in the atmosphere which prevailed in the world of Russian letters after 1848 [43] two conflicting strains of literary criticism. Annenkov and Botkin, who had consorted with Belinsky in the early 1840s, turned away in the 1850s from the radical tradition which Belinsky had come to represent, and set out to justify art in its own terms; joined by Druzhinin, they minimized the social and educative significance of art, and strove on the whole not to assimilate, but to contrast art with 'reality', thus bringing themselves into direct conflict with the radical critics, in particular Chernyshevsky. This period also saw an important resurgence of lyric poetry, connected most prominently with the names of Tyutchev, Fet, and Maykov, and generally associated with the assertion of 'art for art's sake'.

The opponents of symbolism frequently referred back to Chernyshevsky, but the symbolists for their part, although they took Tyutchev and Fet for their own, seem to have been largely indifferent to

the critical writings of the 'aesthetic school' (to give it its Soviet label) – they regularly invoked not Annenkov and his associates, but Apollon Grigor'ev, a figure who, whilst owing a certain allegiance to the aesthetic school, stood somewhat apart on the literary scene of the 1850s. Blok in particular showed considerable interest in Grigor'ev, both as poet and as critic, and he was by no means alone in this interest.[44] Volynsky, in his *Russian Critics* (1869) declared Grigor'ev to be of far greater talent than Maykov, and to have formulated several 'correct' critical notions, even though he was prevented by the shortcomings of his aesthetic and philosophical ideas from developing them along the proper lines.[45]

Broadly speaking, Apollon Grigor'ev steered a middle course between the materialists and the aesthetes of his day.[46] His theory of 'organic criticism' opposed the idea of 'art for art's sake', but, in recognizing the irrational nature of artistic creativity, it rejected equally the materialist conception of art. Grigor'ev's view of the part played by art in the life of man is most clearly expressed in his two essays *On Truth and Sincerity in Art* (1856) and *A Critical Review of the Basis, Value and Techniques of Contemporary Criticism of the Arts* (1858), in which he laid the foundations of his 'organic theory'.

The question of truth and sincerity in art, Grigor'ev remarks in concluding the first of these two essays, transposes into that of the relation of art to reality;[47] and indeed, the greater part of the essay has a close bearing on the problem we are considering.

Grigor'ev readily acknowledged the social usefulness of art. A number of objections to the idea that art should be useful are, he maintains, a perfectly legitimate reaction to an over-narrow conception of usefulness.[48] He suggests that it is possible to assert the autonomy of art without denying its utility, and, in the two essays considered here, he establishes the concept of art as an independent form of human activity, which yet has its 'organic' roots in every aspect of the life of man. According to Grigor'ev, works of art '. . . are as alive and as independent as the phenomena of life itself, they are born and not made, in the same way as any living thing'.[49] In this sense, they express life without being either an imitation of, or a substitute for it. Art is in its own right a form of life, and the separation of the element of pure creativity from that of social usefulness is an artificial device of German idealist theorists, unfortunately implanted in Russian criticism in a period of strong German influence. Such a

17

distinction, Grigor'ev observes, applies least of all in Russia, where life still has its organic wholeness and the artist and the man are still one.[50] Thus, when he comes to speak of Russian criticism in his *Review of Contemporary Criticism of the Arts*, Grigor'ev recognizes that the field of discussion of the arts has widened to embrace social and historical interests, and questions of psychology – in fact, every aspect of life.[51] On the other hand, he warns against the danger of a loss of balance within the wide range of reference that art criticism should properly enjoy; he is equally disturbed by those who draw into criticism questions belonging to experimental psychology, which he does not find germane to a valid discussion of the arts, and by those who fall into the trap of judging art by its performance of a *theoretical* function, as did Belinsky.[52] 'Organic' art, however, answers to a human need, and has its own function as an 'ideal expression of life'.[53] The particular achievement of the most recent tendencies in criticism, Grigor'ev declares, is to bridge the gap between theory and practice, to bring art into a closer relationship with life: art may be an ideal reflection of life, but 'we have ceased to believe that the ideal is something distinct from life'.[54] Thus far, it is not clear whether the 'ideal' is a quality added to life in the process of representation by the artist, or whether it is the function of art to discover certain ideals that reside in life itself. Both possibilities are suggested, for the characterization of art as an 'ideal expression' or 'ideal reflection' of life is matched by the assertion that 'art must determine the meaning of life, and the intelligence behind its phenomena. . . .'[55] For a clearer indication of what Grigor'ev means by 'ideal expression', we must turn to his descriptions of the qualities that distinguish the work of art.

Grigor'ev assumes, for the purpose of his account of the artistic process, that art is concerned with the objective representation of life or some quality in life. He discerns three aspects of the objectivity which characterizes artistic representation.

Objectivity, in Grigor'ev's view, is attained neither by the identification of the artist with the phenomena of life, nor by his subordination of himself to them, but by his ability to discern their essential nature. This sensitivity to the innermost nature of phenomena must be matched by a certain degree of 'accuracy' in their representation: the artist must be able to convey particular details without loss of particularity, and at the same time weld individual

18

features into a 'typical' whole. The final degree of objectivity is achieved by the impress of the artist's 'ideal philosophy of life' upon the material of his art. This latter process, Grigor'ev insists, is of crucial importance: the artist always injects something of his inner self into the representation, and the extreme view of objectivity in art, which excludes the artist's 'ideal' contribution, is unhealthy.[56]

Grigor'ev's account of the representational process presents several features of interest.

Most strikingly, full allowance is made for the subjective construction put upon reality by the artist, and yet this feature of the process is said to represent the highest degree of objectivity. This paradox arises from the heavy stress which Grigor'ev lays upon the degree to which the artist's 'individual truth' is rooted in the truth of the people.[57] The artist's world view must, for Grigor'ev, express a form of collective popular wisdom, and it is evidently in this sense that the modifications wrought by the author upon what he represents can be considered to have a value that is more than simply personal – in other words, to be 'objective'.

Secondly, the process by which the artist arrives at a 'type' is declared to fall outside the bounds of common reasoning – to be, in fact, something of a mystery. The ability to spy out the general in the particular is, says Grigor'ev, the artistic ability *par excellence*, but exactly how the artist perceives the typical is not known: it is, however, certain that 'synthetic' rather than 'analytic' thinking is involved and he adds: 'I believe with Schelling that the indefinable profundity of works of art derives from their unconscious nature.'[58] When he comes in the *Review of Contemporary Criticism of the Arts* to consider the characteristics of artistic talent more generally, Grigor'ev dwells again on its mysteriousness, and also on the synthesis of the particularity of the artist with his adherence to a higher, more general scheme of things. We believe, he says, neither in a purely *personal* creativity, nor in 'indifferent', impersonal creativity. The artist is first and foremost a particular, individual human being, but he belongs to a certain age and place, and has a certain ancestry and affiliations; he is one of the fullest expressions of a certain type. He has his own personal life, but he is gifted with – and in some sense *is himself* – a constructive force, governed by a 'higher law'. Grigor'ev accepts that there is such a thing as inspiration, which is active when:

. . . a kind of lighting-flash illuminates for the artist the world of his spirit and his relation to life, and creation begins. It both begins and is accomplished in a state which actually approximates to clairvoyance, but even so, the artist contributes to this state all the means that God has endowed him with: his general type, his locality, his era and his personal life; in a word, even when inspired he does not create in isolation; and his creation is not purely personal, although, on the other hand, it is not impersonal either, and is not achieved without the involvement of his qualities of spirit.[59]

Grigor'ev is anxious to admit the phenomenon of artistic inspiration into his account of the aesthetic process, but insists that the artist prepares himself for the inspiration by his own careful observations; he is equally anxious to demonstrate that the product of inspiration is a work of art having *general* human significance (and therefore we may assume from his earlier discussion of the process of representation, enjoying 'objective' status). He respectfully declines to enter any more deeply into the nature of inspiration: whether because to do so would put further difficulties in the way of his theory of 'objectivity', or because of his unwillingness to admit into the discussion of creativity questions which seemed to belong in the domain of experimental psychology, is never made clear. However, he does in effect establish that the least accountable parts of the artistic process – the 'inspiration', and the 'ideal expression' – represent a 'constructive force' and enable the artist to interpret the phenomenal world in the light of his 'ideals'. His grasp of the ordering power of art is summed up in a strikingly 'modern'[60] phrase which he uses to define 'objectivity': objectivity, he declares, can be regarded as 'an astonishing subtlety of poetic organization'.[61] The resulting work of art he claims to be valid, alongside the phenomena on which it is based, as an independent form of life. The 'life of the age', of which, for Grigor'ev, art is the expression,[62] is an *ideal* life, rescued from subjectivity by virtue of the collective, popular origin of the ideal. The most outstanding characteristic of his aesthetic is a sense of the ambiguity of the 'objective' quality in art. He is aware that the likeness of nature which the artist draws undergoes considerable subjective modification, and he is willing to concede that the modifications are arrived at by an irrational process.

Grigor'ev is equally aware that the picture resulting from this process, and the 'new' knowledge of reality it gives, are characterized by the certainty that they are 'real'. The distinction between 'objective' and 'subjective' works of art is, he admits, difficult to draw, for *all* works of art, even the outwardly objective, have their roots deep in the individual psyche,[63] and the peculiar talent of the inspired artist is to invest his artistic truths with, not a relative, but an absolute certainty:

> The phrase: *relative truth* – is a phrase, no more and no less. The absence of a stable, unconditional ideal, the absence of certain conviction, – this is where the weakness of historical criticism lies, the cause of its decline, and the reaction against it of 'pure art' criticism.[64]

5. Lev Nikolayevich Tolstoy

Tolstoy's *What is Art?* (the fruit, he claimed, of fifteen years of hard thinking about the theoretical basis of art) appeared in 1897–8, by which time 'decadence' was to his mind already far too evident on the Russian literary scene. He devotes a certain amount of attention in its pages to the new tendencies in literature, but without taking account of them in his theoretical considerations. He speaks disparagingly of a history of nineteenth-century art that views pre-Raphaelitism, 'decadence' and symbolism as legitimate reactions to extreme naturalism, and condemns its attempt to extend the sphere of art in order to embrace such movements.[65] Tolstoy's objection to 'modern' art is not aesthetic but moral, and he inveighs against the greater part of contemporary art and letters on the grounds that they are morally and politically corrupting. Such strictly aesthetic assumptions as underlie *What is Art?* have for the most part to be inferred from Tolstoy's account of the task and the methods of the kind of art he hoped to see in a healthier society of the future – that is to say, from statements expressive more of a speculative philosophy of culture than of an aesthetic.

Tolstoy's point of departure is a rejection of the currently accepted theories of beauty, which in his view all culminate in one of two definitions: beauty is found to be either an objective external manifestation of the absolute (whether it be called 'will', 'idea', or

'God'), or a subjective value, a pleasure free from conscious purpose or profit. He does not accept the 'objectivity' of the former, metaphysical definition of beauty, since in practice the manifestation of the absolute is recognized by the pleasure it gives, and both definitions are, he finds, in the final analysis equally founded on the subjective pleasure-principle.[66] All theories which reduce art to a form of pleasure, he maintains, are unsatisfactory, for they fail to recognize art as 'one of the conditions of human life', in particular – 'one of the means whereby people communicate amongst themselves'.[67] He seeks explicitly to define art by its function, and withdraws from the vexatious business of establishing a working definition of beauty:

> In order to define any human activity, its meaning and significance must be understood. And in order to understand the meaning and significance of any human activity, it is necessary first and foremost to examine that activity in its own right, independently of its causes and consequences, and not in relation only to the satisfaction that we derive from it.[68]

What kind of communication should art be, in Tolstoy's view, and what should it communicate?

For Tolstoy, art translates the most vital rational knowledge into feelings,[69] and it is the business of art to communicate feelings, not thoughts, by a process of 'infection' – that is, by arousing in the spectator the feelings experienced by the artist himself.[70] True art is indeed specifically to be recognized by the successful carrying-out of this process: 'There is one certain sign distinguishing real art from its counterfeit – it is the infectiousness of art.'[71] This characteristic of art has for Tolstoy two important implications: it makes art a universally accessible form of communication, and enables man to have more knowledge than his reason alone can bring him to. The first he sees as to some extent attendant upon the second. For 'infection' overrides the barriers of class and race that are inherent in rational forms of communication. Art, says Tolstoy, is distinguished from the activities of the reason by its ability to affect people regardless of their education or state of development, and:

> The business of art consists precisely in making accessible to the understanding that which might not be so in the form of reasoned discourse. It usually seems to the recipient of a genuinely artistic impression that he knew this before, only was unable to express it.[72]

There are two inferences of aesthetic significance to be drawn here, apart from the explicit recognition of art as its own universe of discourse, independent of the reasoning mind. Firstly, there is an implicit suggestion that the unstated object of artistic understanding is of a higher order than the object of knowledge achieved by reasoning. This is borne out by the slightly earlier unfinished essay *About Art* (1889), in which Tolstoy is not preoccupied with his onslaught on the moral corruption that art can bring about, and is able to be more open about the superiority of artistic over everyday knowledge:

> But a real work of art . . . cannot be made to order, because the state of mind and spirit of the artist, in which the work of art has its origins, is a higher manifestation of knowledge, a revelation of the mysteries of life. And if such a state is a higher knowledge, then there cannot be any other kind of knowledge that could guide the artist in the acquisition of this higher knowledge.[73]

There are fairly clear indications in *What is Art?* of what Tolstoy meant by 'the mysteries of life', and we shall examine these shortly; meanwhile, let us return to the suggestion that the aesthetic experience is accompanied by a feeling that the artist has caught something universally known, but beyond the power of the ordinary mortal to express. Such an introspective account of a mental process is very rare in Tolstoy's theoretical writings. In the context, it seems unlikely that he was hinting at a universal repository of human knowledge or a 'collective subconscious', though the idea must have been familiar to him from his preparatory study of European philosophies of art; it was not the kind of idea, we know, with which he had any patience at all. It is far more likely that he was suggesting the *immediacy* of the knowledge which art confers, a characteristic which is discussed almost as a matter of course by theorists who, unlike Tolstoy, are prepared to treat the question of intuition seriously and in detail. To say that 'one knew it before', is, in fact, a common enough way of expressing the feeling of immediacy that is inseparable from an intuition: the mind often rationalizes its ignorance of how the intuition was arrived at, in defiance of all laws of reasoning, into a willingness to believe that the knowledge must have been there already, and has merely been unexpectedly recalled.

The idea that art, in transcending reason, becomes intelligible to

every man, regardless of his background and education, has aesthetic as well as social implications. Indeed, it is tempting to seize on this at once as an example of the intrusion of Tolstoy's social idealism into his characterization of the mental processes of the artist. If he sees the irrational, universally intelligible, 'artistic knowledge' as a higher form, it is because it answers to his social ideal: the art of the future, he suggests in *What is Art?*, will unite people by its accessibility, and its content will be only such ideas as lead men to union.[74] The point becomes clearer if we bear in mind the kind of content which Tolstoy advocated as appropriate to true and morally acceptable art.

Art, he declared, derives its stature from its ability to reveal and express nothing less than the meaning of life, and becomes in consequence a religious and social activity:

> The evaluation of art, that is, of the feelings which it communicates, depends on people's understanding of the meaning of life, on where they discern the good and where the bad in life. But what is good or bad in life is determined by what are called religions.
>
> Mankind moves ceaselessly from lower, more particular and less clear things to a higher, more general and clearer understanding of life.[75]

Artists, for Tolstoy, are those individuals who have the clearest grasp of the meaning of life, and art in an age of little belief entirely forfeits its stature. Even the function of art, as the vehicle whereby the finest feelings of any age are made available to succeeding generations, is perverted by the decay of the religious sense, for the values of feelings are only to be judged by the religious consciousness of a given age.[76] By 'religious consciousness' Tolstoy means something quite distinct from religious cult[77] – rather a feeling of belonging to a universal 'brotherhood in Christ': 'The essence of Christian consciousness', he claims, referring for scriptural authority to St John's Gospel (xvii, 21), 'consists in every man's recognition that God is his father, and of the consequent union of all men with God and one another....' The aim of all art, Tolstoy continues, should be to unite people in the above sense. Non-Christian art only joins people together into small, mutually hostile groups and sects, and so eventually disunites them; Christian art, on the other hand, unites all

men without exception.[78] For Tolstoy, the glory of art is its unifying force, which even extends over the passage of time, allowing man to address himself through the images of art to the whole of his past and future,[79] and this force is lost when art ceases to be religious:

> ... when it ceased to be religious, art ceased to be popular, too, and so further narrowed the range of feelings it expressed ...[80]

Art became the province of the few, of the privileged classes of privileged races; and when the art-bearing classes of Europe lost their religious beliefs, and with them their contact with universal values, art ceased to be even intelligible to the many.[81]

For Tolstoy, then, the acid test by which true art may be distinguished (true, that is, not simply as art, for which it is enough to infect the spectator with feelings, but true in respect of its content) is this: does the work of art communicate feelings deriving from love of God and one's neighbour? Only if it does so is it healthy art.[82] Tolstoy unites his religious and social ideal with the concept of supra-national consciousness, as he declares that the art of the future will be ...

> ... the means of transposing the religious, Christian consciousness from the sphere of reason and intellect into the sphere of feeling, thereby bringing people close in practice, in life itself, to that perfection and union of which their religious consciousness makes them aware.[83]

It is difficult to escape the conclusion that Tolstoy has adopted the widespread concept of a non-rational realm of discourse, proper to the expression of the emotions, and made it subserve his religious and social ideal (which demands that art shall be equally intelligible to all the members of a Christian democracy, regardless of their educational development or even of their age[84]), without, however, taking proper account of the mental processes involved. For if we accept the commonplace view that perception involves, and is largely conditioned by, learning-processes (and it would be pointless obscurantism to reject so common-sense a piece of psychology) then we must conclude that Tolstoy's idea of an art immediately accessible to all men, whatever their particular mental conditioning, is unattainable. It is quite unrealistic to discount the fact that the way we see things is the way we have learnt to see things in the light of

3

our particular environment and needs, and to imagine that a form of communication can be devised which will be valid for people of every background without any adaptation of their habits of mind. To take a specific example: in the course of propounding the wide intelligibility of good art (in this case excluding literature) Tolstoy asserts that a *speech* in Chinese may be good, but unintelligible to him since he knows no Chinese, whereas good *art* should be intelligible to all men, regardless of their language – if a Chinaman acted out, for example, his grief, Tolstoy claims he would be 'infected' by the display as much as by any other man's show of grief.[85] However, it is most unlikely that he would be infected with the same emotion as another Chinaman. Unless he were extraordinarily well acquainted with Chinese manners and the Chinese mind, including the language in which it framed its thoughts, it is unlikely that he would do more than reconstruct a wholly Russian emotion from what seemed to him most familiar in the Chinaman's display; he would certainly not respond in the same way as another Chinaman. Tolstoy seems quite unaware that human behaviour, not to speak of language, involves more or less conventionalized and localized patterns of interpretation of the perceptions, and that ignorance of these patterns in another's behaviour is as much of a barrier to communication with him as ignorance of his language. Nor need Tolstoy have lived in the age in which this kind of psychological formulation is taken for granted in order to be aware of the principle it expresses: many of his predecessors, including Belinsky and Chernyshevsky, were able to recognize the important rôle of the 'eye of the beholder', both when the beholder is the artist and when he is the spectator, in interpreting reality to produce a work of art, and in interpreting the work of art to produce an aesthetic experience. Of all the thinkers we have been considering, none was less 'psychological' than Tolstoy, or more resolute in denying the whole process by which humans learn to see, and express what they see, in response to their individual and social needs. Vyacheslav Ivanov, who was, amongst the symbolist critics, the most charitably disposed towards Tolstoy, described him as an artist in words who struggled to free himself from the power of words; as a writer gifted with insight into the soul of man, who yet wished to emancipate himself from psychology.[86]

The process of interpretation referred to here is, of course, fundamental to the treatment of reality in art that is our principal concern,

and we may wonder in what form a mind attuned to resist both metaphysics and psychology, and at the same time passionately committed to social idealism, conceived of the principle of realism in art. Tolstoy wished to inscribe his philosophy of art on an entirely clean slate,[87] and disposed summarily of all currently accepted theories, including the realist theory. In *About Art* he divided works of art, with unnecessary rigidity, into three categories: those in which content predominates, those whose hallmark is beauty of form, and those distinguished by their sincerity and truth to life. To these categories correspond 'the three principal false theories of art': to the first, the 'tendentious theory', to the second, 'art for art's sake', to the third, the theory of realism. All three are false, because true art gives equal weight to content, form, and sincerity.[88] By this safe formula Tolstoy considered himself to have risen above accepted standards of realism, and defined an art which is empowered to reveal life's mysteries through the discourse of feelings. Realism in the narrow, imitative sense, he even saw as a hindrance to the proper function of art, since an excess of realistic detail could hinder the process of infecting others with the feelings experienced by the artist.[89] Art, in Tolstoy's view, is primarily a moral vehicle (a fact so well known as hardly to need restating), and the representation of reality had for him a secondary value.

6. Aleksandr Mikhaylovich Skabichevsky

A. M. Skabichevsky was one of the foremost literary critics of the populist movement; he was closely associated with the periodical *Notes of the Fatherland* in the 1870s and maintained a steady output of critical and publicistic articles throughout the 1880s and 1890s. Younger than Lavrov and slightly older than Mikhaylovsky, he lived nearly a decade longer than either, and long enough to see the symbolist movement into its prime.

The populists generally regarded literature as a moral force, whose task was not to reflect life faithfully, but to provide a critical commentary on reality in the light of its approximation to their social ideal, and they largely rejected the radical aesthetic, since it presupposed a greater acceptance of the existing order of reality than they could agree to. For the radical realists, art was to reflect what

actually existed, good or bad, independently of the action necessary to improve the material lot of mankind; for the populists, art was a means of rousing the moral energy and will of men and, in order to attain this end, its representation of reality had to contain a sufficient element of bias and exaggeration to bring home forcibly to the reader or spectator the extent to which the existing world falls short of the moral ideal. In his *History of Modern Russian Literature* Skabichevsky found that Chernyshevsky's aesthetic betrayed a 'striking lack of understanding of the aims and the meaning of art'.[90] He held the aesthetic tradition founded by Belinsky responsible for the artistic poverty of Russian belles-lettres in the 1870s, and levelled against this tradition the interesting criticism that, despite its ostensibly scientific approach, it ignored contemporary scientific findings that were relevant to aesthetics, particularly in the fields of physiology, psychology, and logic, emphasized the aims of art at the expense of its underlying causes, and raised the barrier of realism under false pretences.[91] He rejected explicitly the principle of truth to life, maintaining that:

> . . . art must reproduce reality not in the form in which it actually exists, but as it appears to us. But once we make such a change, we immediately emancipate art from its former vain pursuit of truth to reality and re-dedicate it to the principle of truth to our own conceptions.[92]

Truth to reality, be it noted, is here a vain pursuit, and art is assumed to be an expression of our subjective impressions. However, this does not license the artist's unbridled fancy: art has a vital rôle in the education of the people and the elucidation of life's problems,[93] and the only 'real' poet is he who has so identified himself with the interests of the people as to become its mouthpiece. Art, in fact, is strictly a means to an end:

> Thus, the concepts of realism in poetry and of populism coincide exactly: the difference between them is merely that realism in literature is a certain course, whose goal is – populism.[94]

A literature framed in these terms of reference, as both the voice of the people and the instrument of its education, must obviously be generally intelligible, and Skabichevsky insists on this principle as much as Tolstoy.[95] He is equally close to Tolstoy in viewing art as

primarily the vehicle of expression for the nobler feelings, the factual content of a work of art being subordinated to its emotional expressiveness:

> The truth of a genuine work of art – is secondary, a by-product, as incidental to the aim of the process, though also as inescapable and indispensable, as the smoke to the fire in our hearth, as the heat that comes from the lamp that lights us, as the monotonous rumble of a railway train. The artist strives only to embody in images, as vitally, clearly and fully as possible, the feelings that move him, to arouse as strongly as possible in the reader the feelings which move him. . . .[96]

After the failure of the 'going to the people', populist ideology underwent a change, characterized in general by a greater concern with the practical details of social change. In 1882, Skabichevsky wrote a series of 'letters to his readers' under the title *Life in Literature and Literature in Life*, in which this ideological change is consciously applied to the populist theory of art.

Skabichevsky was not content to record the transition to a more practical ideology as a development within the populist movement; he felt obliged to derive it from a wide analysis of the organic changes which have punctuated the history of European culture. It is sometimes tempting to regard as pre-eminently Russian the willingness to see every change of plan that may be forced upon an undertaking as pre-ordained, necessary in the wider scheme of things and in no way a modification of the original aim. This, precisely, was Skabichevsky's manœuvre in *Life in Literature*, and he himself later diagnosed the same tendency in the symbolists, who tried to show that the greater part of past Russian literature contained the seeds of their own philosophy of life.

Skabichevsky begins his 'letters' by observing that Russian life has become too complicated to be reflected in literature – it lacks the firm foundations of, for example, the bourgeois French society on which Zola could base his novels. There is undoubtedly, he says, an underlying principle to be found in Russian life, but it must be sought 'not in that abstract people which exists only in the pages of the journal *Russia*, but in the real people'[97] This is, when compared with the passage quoted on page 28 (at note 92), unquestionably a retreat from the principle of truth to the artist's own ideal

conceptions, and there follows an elaborate historical justification: the major movements of European thought are traced so as to show that each movement passes inevitably through two phases, an abstract and philosophical stage followed by a search for a more practical application of the ideas it has developed. The 1860s, according to Skabichevsky, were Russia's abstract and philosophical period, during which, in the name of realism, a good many illusions were foisted upon the public; these illusions must be shed as Russia enters her period of practical thought.[98] As long as the abstract period lasted, the Russian literary intelligentsia was convinced that it was basing its activities 'on the most real ground possible', and believed that the ideal peasant was in complete solidarity with the intelligentsia who had invented him. Such notions were abruptly dispelled by the first practical confrontation with the people.[99]

This is plainly not simply an attempt to generate a more practical vein of social thought; it represents a significant change in the populist aesthetic, a call to temper the ideal, moral, tendentious content of art with a much greater degree of truth to nature. Tendentiousness in belles-lettres, according to Skabichevsky, was a characteristic of the 1860s, and died when the phase which those years represented came to an end.[100] Thus he came round to the view that art has a duty not to distort reality, a duty which may conflict uncomfortably with the artist's obligation to preach.

However, Skabichevsky remained very much preoccupied with the subjective element in art, and with the implications for his social theories of his acceptance of the subjective nature of human thought. He devoted a good deal of space to a particular feature of the intellectual life of the day which he called 'Hamletism', and diagnosed as a psychological state whose causes were primarily social. He suggested a number of forms of the phenomenon, including one form which has considerable significance in the discussion of his theory of art:

> And here is a third case of Hamletism: a man strives to attain a goal and is conscious that it is perfectly realizable. He is equally aware that he has not the slightest strength to realize it, and feels himself totally bankrupt. But at the same time he is so subjective (again as the result of a weakness in his psychological make-up), that he is incapable of perceiving that his bankruptcy is a purely personal quality, or perhaps a quality of two or three subjects like

himself. It appears to him that his whole milieu . . . if not the whole of humanity shares this bankruptcy with him.[101]

This passage implies strongly the possibility of some kind of objective knowledge of reality, and equates the limitations of subjectivity with failure to communicate on a wide front with other members of society. Skabichevsky appears to be suggesting that objectivity is attendant upon the defeat of isolation and the achievement of a wider communion among men, that subjective feelings lose their subjectivity once they are shared, and that the goal which an isolated individual sees as beyond his powers to attain, might be approached more optimistically in concert by those strong enough to 'externalize' their feelings.

Only when confronted with, and horrified by, the early manifestations of 'decadence' on the Russian literary scene, did Skabichevsky venture into the open on the question of the mysterious creative process. In 1893, the appearance of Merezhkovsky's *On the Causes of Decline and New Currents in Contemporary Russian Literature* prompted a rejoinder from him in his *Reviews of Current Literature*. Merezhkovsky had put forward three principles that distinguished truly 'live' creativity from 'dead' positivism – namely, symbolism, impressionism, and mysticism – and had discerned these three principles at work in all the greatest contributions to Russian literature: as well he might, concludes Skabichevsky, for critics of all colours have recognized these three elements of poetry, though they have used other, less imprecise terms to describe them.[102] Tantalizingly, Skabichevsky is no more specific than this about the alternative terminology, but the form of his attack on the early symbolists is of the greatest significance. He disdains to reject them out of hand, but accuses them instead of claiming a spurious originality, and (more interesting still) of probing where they should not: the three elements identified by Merezhkovsky, he claims, represent the highest achievements of art, which come seldom even to the most genial artists, and when they do, come of their own accord, independently of the artist's will, in an elemental gust of creativity; to pursue them consciously is as pointless as to try to raise a storm in order to admire it. He is left filled with regret that the French decadents have infected their Russian counterparts with a conscious hankering after a quality which they would have achieved *unconsciously* had they

31

been good artists in the first place.[103] In effect, Skabichevsky is accusing the decadents of making an unnecessary cult of a commonplace, albeit indefinable, faculty possessed by every great artist.

In the same year, an article by Prince S. Volkonsky in the *European Herald*[104] provoked Skabichevsky into a statement of his aesthetic, in which he outlawed the idea of the duality of matter and spirit; he saw art not as the pursuit of an aesthetic emotion, involving a separate aesthetic compartment of the mind, but as a process which made it possible to regard the human mind as an indivisible whole, whose functions interact and can never be clearly differentiated. Great works of art therefore constituted in his view a means of knowing reality more completely, providing mankind with 'as rich a scientific equipment as could be derived from any ten of the most expert and learned treatises', but as a final definition of art, Skabichevsky confined himself to the suggestion (strongly reminiscent of Tolstoy) that the artist attempts to arouse in others, as it were by hypnosis, his own feelings, to make others relive his experiences. Under cover of the label 'hypnosis' Skabichevsky retreats from closer investigation of the creative process.[105]

In 1896 Skabichevsky brushed with the 'decadents' again, in response to a critical miscellany entitled *Philosophical Currents of Russian Poetry*,[106] in which Merezhkovsky, S. A. Andreyevsky, P. P. Pertsov, and Vladimir Solov'yov, amongst others, discussed the classics of Russian poetry in the light of their 'decadent' ideology. Skabichevsky was horrified at the facility with which Merezhkovsky in particular could read his own (juvenile and illiterate, as far as Skabichevsky was concerned) philosophy into the poetry of whomsoever he chose, but his principal objection was that life was too complex a phenomenon to be reduced to the two warring principles of Merezhkovsky's philosophy.[107] And yet, in the course of the next five years, he so far altered his standpoint as to half-assimilate the 'decadents' – a modification of his views which was once again accompanied by a demonstration of the inevitable historical process which had conditioned his change of stance. In *New Currents in Contemporary Literature*, published in 1901,[108] he traced the process whereby each new literary 'school' preaches 'freedom of creativity', meaning simply freedom from the canons laid down by its immediate predecessors, which it promptly supplants with its own no less constricting dogma, propounded always

as the last word in theoretical wisdom. The Romantic movement supplanted rationalism in this way, and gave place in its turn to 'naturalism', in which term he includes, it seems, every avowedly realist tendency in nineteenth-century literature:

> The principal error of naturalism lies in the aesthetic theory underlying it. Equating art with science, this theory supposes that artistic, just as scientific, creativity consists in a transition from the particular to the general. The artist studies human life in order to arrive at some generalization or other. The significance of the work of art depends on how important and essential these generalizations are . . .
> . . . such a theory excludes from the field of creativity everything particular, concrete, accidental or individual, however striking in some respect – in a word, however strong an impression it may have made on the artist. Life, meanwhile, does not consist solely in general schemes: it is beautiful by virtue of its infinite variety, and by its rare and sometimes fantastic combinations of colours, characteristics or facts.[109]

Skabichevsky complains that the principle of the 'type', carried to extremes, defeats realism by directing the attention to abstract generalizations which exclude from artistic activity 'the whole vast ocean of concrete phenomena'.[110] Most interesting of all is that his refutation of 'naturalism' corresponds in almost every detail with Belinsky's objection to the 'realism' that his 'natural school' was to supplant (see page 10). The terms have become reversed; but the concepts are identical. Skabichevsky's 'naturalism' and Belinsky's 'realism' are both intended to describe a situation in which the principle of truth to life has become an abstraction, and the quest for the typical has filled realist (or naturalist) literature with lifeless stereotypes; the alternative advocated by both is that the artist should concentrate on what strikes him most forcibly as a live particular, not on what can be shown to be the norm. And in both cases, there is implied a quality in the artist which enables him to sense what is most live in his surroundings, to decide, on the strength of his subjective impressions, what it is most fitting to reproduce in art.

Skabichevsky has now come to recognize 'decadence' as a legitimate force in literature, not simply an undesirable freak, for he declares it to be the successor to 'naturalism' in his historical scheme

of reaction and counter-reaction. He still raises all the standard objections to the new movement in literature – that it is a purely negative movement, incapable of becoming a constructive force in Russian intellectual life, that it represents a swing back to undesirable metaphysical theories, and most particularly, that the literature it has fathered is incomprehensible to any but the narrowest circle of initiates. However, he recognizes that any new movement begins with a swing to an opposite extreme, and he partly excuses the aberrations of the earliest representatives of 'decadence' as a natural over-assertion of the case against too rigid a form of realism. He concedes to Merezhkovsky and his associates a value as pioneers, and suggests that they are already yielding place to others 'no less daring, but more reliably equipped for a successful voyage'.[111] More important still, he sees the chief vanquishers of the old order not in its declared opponents, but in those who quietly introduce the vital innovations under the banner of established realism. Turgenev, Skabichevsky declares, was in his two stories *Ghosts* (1863) and *Enough* (1864) closer to symbolism or decadence than to realism, whilst more recently Korolenko, Chekhov, and Gorky have all to some extent stepped aside from accepted notions of literary realism, and Garshin falls half-way between the two camps.[112] The movement away from the standards of naturalism is becoming more general and inescapable, and reflects a change of heart in the public at large:

> In a word, the public, as once before, in the age of Romanticism, is beginning to distinguish the wearisome 'prose' of everyday life from 'poetry', by which it means those rare moments of spiritual exaltation and extensions of all our capacities, so cherished by all of us, when life is fired with a bright flame, and in an instant there open before man such distant perspectives as he could never dream of in days or even years of the quiet and hardly noticeable flickering of the spark of life.[113]

This passage highlights the curious anomaly in Skabichevsky's aesthetic. It betrays a clear recognition of the state of mind associated with creativity, in terms quite acceptable to modern European aesthetics,[114] but Skabichevsky's curiosity seems to end with recognition; he will applaud, but he will not investigate the moments of inspiration on which poetry depends, even whilst acknow-

ledging with gratification that the poetry of his day is becoming richer in such moments. In his conclusion he is as evasive as it is possible to be: a new art is arising, he declares, which will be neither 'naturalist' nor 'decadent', and that is all that he can say about it for the time being.[115] The implication, however, is that after the swing of the pendulum from one extreme to the other there will at last prevail a realism that takes full account of the qualities peculiar to creative art, without centering upon them an esoteric cult.

When later the symbolists began to claim that their art represented a move towards true 'realism', their enemies attacked Skabichevsky for encouraging such a view. Shulyatikov, contributing three years later to one of the heaviest concerted onslaughts on symbolist thought, singled out Skabichevsky for what seemed to him an attempt to replace realism with a revived form of romanticism, and accused him in particular of trying to show that 'decadence' represented a form of realism.[116]

7. Vladimir Solov'yov

Vladimir Solov'yov, as a religious philosopher opposed to any permanent form of lay socialism,[117] is the 'odd man out' in the company scrutinized in this chapter. He is also alone in having exerted a recognizable positive influence on the Russian symbolists, principally Bryusov, Merezhkovsky, Bely, Ivanov and Blok. His name is most often mentioned in connection with his attacks on positivism and materialism and his philosophy of art has come to be regarded as an exception to the general continuity of nineteenth-century realist thought. And yet there is a link, not tenuous or peripheral but at a fundamental level, between Solov'yov and at least one of his materialist opponents; his conclusions and those of Chernyshevsky were diametrically opposed, but their point of departure was practically identical. This link was openly acknowledged by Solov'yov himself, and enlarged upon by one contemporary historian of Russian aesthetics,[118] but has subsequently received scant attention; indeed, Mochul'sky in his *Life and Teachings of Vladimir Solov'yov* (1951) can speak of Chernyshevsky as the only other serious contributor (besides Solov'yov) to aesthetic theory in nineteenth-century Russia, and yet completely ignore the essay which Solov'yov devoted to a demonstration of the common ground he shared with

35

Chernyshevsky.[119] It is worth investigating the matter in more detail before examining Solov'yov's aesthetic.

First, some remarks to dispel the commonly held notion that Solov'yov was opposed to the scientific spirit of the materialist thinkers, a notion which appears to be responsible for a good deal of misconception about his place in the history of Russian thought, and in particular for the idea that he must automatically have opposed all the views of materialist thinkers. Solov'yov's insistence on the *insufficiency* of the rational mind has obscured the fact that the essential characteristic of his thinking is not hostility to reason, but a desire to extend logical thinking to the sphere of the irrational – to produce, as it were, a 'transcendental logic'. A passionate adherence to both Christian revelation *and* scientific method lies at the very core of his nature. Mochul'sky dwells on this aspect of Solov'yov's intellectual constitution very instructively in his biography; describing Solov'yov's youthful period of extreme materialism, he quotes, for example, L. M. Lopatin's recollection that he had never seen 'a materialist so passionately convinced', who gave the impression that he sought something very much resembling a new revelation from his materialist faith.[120] Solov'yov in later years described his younger materialist self as a 'metaphysical radical',[121] and Mochul'sky discerns in Solov'yov's statements of his aesthetic a 'childishly touching' attempt to base metaphysics on strict scientific method.[122] Lev Shestov found that Solov'yov shared Schelling's inability to reconcile a philosophy of revelation with an insistence that it should be expressed in a strictly logical dialectic;[123] this is a more fundamental recognition still of the same duality in Solov'yov's thought. This duality is nowhere more clearly expressed than in Solov'yov's second *Lecture on God-Manhood*, in which he argues that the life of the spirit is just as susceptible as that of matter to the laws of 'material' reasoning, provided the forces acting in the material world are understood to include 'spiritual' as well as 'physical' forces.[124] It is evidenced in the most obvious way by the abundance in Solov'yov's writing of illustrations drawn from the physical sciences, and of double appeals to reason and 'conscience' for the justification of his arguments in favour of irrational concepts. Here is an example:

> Anyone . . . can arrive at a perfectly clear understanding of this ideal limit towards which history *really* moves, if only he will look

for its proof ... to such factual historical conclusions as are vouched for by reason and borne out by the conscience.[125]

The idea that all history moves towards a single preordained destination is supported by a simultaneous appeal to reason, and to something more than reason.

In 1893 there appeared a third edition of Chernyshevsky's *The Aesthetic Relations of Art to Reality*, of which in 1894 Solov'yov wrote a review entitled *The First Step Towards a Positive Aesthetic*. He begins this by expressing his solidarity with Chernyshevsky's hostility towards the school of 'art for art's sake', whose adherents, he says, would be beyond reproach if they had confined themselves to their assertion of the independence and specificity of art and its media; however, they went too far in setting art quite apart from all other human activities, failing to see that art merely has a somewhat special place in the *total* activity of the human organism. Grasp of the true status of art is a first step in the right direction:

> To reject the fantastic estrangement of beauty and art from the general movement of life on earth, to recognize that artistic activity has in itself no particular higher object, but merely serves *in its own way*, by its own means, the general aim of human life – this is the first step towards a truly positive aesthetic.[126]

Chernyshevsky, he adds, made this step, and his celebrated treatise is not, as many hold it to be, the last word in aesthetics, but only the first. In asserting the primacy of 'beauty in nature' over man-made beauty, Chernyshevsky had been concerned, above all, to establish the *reality* of beauty against the objection that beauty lies in the eye of the beholder:

> If our author subordinates art to reality, then he does so, of course, not in the sense in which some of his literary contemporaries were wont to declare that 'boots are more important than Shakespeare'. He merely asserts that the *beauty* of real life is higher than the beauty of creations of the artistic imagination. At the same time, he is defending the reality of beauty against the Hegelian aesthetic, for which the beautiful 'is no more than a phantom', springing from the lack of penetration of the gaze that is not informed by philosophical thought. . . .[127]

In insisting that beauty has a value outside the human conception

of it and that a rightly-informed human can become objectively aware of beauty, Chernyshevsky earned the whole-hearted agreement of Solov'yov; whatever view the latter may have taken of the 'shortcomings' in Chernyshevsky's elaboration of his thesis, he acknowledged its point of departure to be the only right one. Moreover, he concurred with Chernyshevsky in rating 'beauty in nature' higher than the beauty of art, for he declared the whole situation to be summed up in Fet's lines:

Кому венец: богине ль красоты,
Иль в зеркале ее изображению?
Поет смущен, когда дивишься ты
Богатому его воображению.
Не я, мой друг, а Божий мир богат . . .[128]

Solov'yov and Chernyshevsky, as Anichkov remarks, were alike in their hostility to idealism;[129] it must be made clear at the outset that Solov'yov's incorporation into his system of the Platonic teaching of 'ideas' does not make him an 'idealist' in the sense in which Anichkov is using the expression to make his distinction. For Solov'yov, 'ideas' were the ultimate, the only truly objective reality, and he rejected any explanation of beauty which was 'idealist' in the sense that it relegated beauty to the status of an ideal generated at the level of human aspirations.

Solov'yov's own theory of beauty was expounded five years before his review of Chernyshevsky, in *Beauty in Nature* (1889) and *The General Meaning of Art* (1890) – a statement to which must be added the obvious reservation that his aesthetic is implicit in his whole system, the two articles in question doing little more than highlight the significance of that system for the theory of beauty.[130] In discussing his aesthetic, therefore, it is helpful to have occasional recourse for amplification to his more specifically philosophical writings, in particular the *Lectures on God-Manhood* (1877–81).

Beauty in Nature opens with a polemic: indeed, Solov'yov's aesthetic is largely conditioned by the attempt to overthrow aberrant strains of realism (and not, it must be remembered, realism in general). Beauty, Solov'yov declares, in the present day is imperilled by a vein of criticism which unthinkingly equates the ideal with the beautiful, and reality with ugliness, and asserts the latter over the former. But contemporary realist and utilitarian aestheti-

cians, behind all the logical contradictions that abound in their arguments, are only saying that . . .

> . . . what is beautiful in the aesthetic sense must lead to *a real betterment of reality*. A demand which is perfectly just; and, generally speaking, one which idealist art never refused. . . .[131]

The principal objection of the realists to the idea of pure art, he continues, is that hitherto art has failed to exert such a practical influence on life. In what sense might art transform reality? Solov'yov draws an example from the physical sciences: diamonds and coal are the same substance, and it is therefore hard to maintain that the beauty of a diamond resides in its substance. Its beauty results from the refraction of light in the diamond, light being 'a higher-than-material, ideal agent', so that we must define beauty as '*the transfiguration of material through the embodiment in it of some other, higher-than-material principle*'.[132] The goal of our enquiry then, should be to find a non-material principle which is, to the whole of human life and physical reality, what light is to the diamond in the above illustrative instance.

This is not the place to expound in detail Solov'yov's religious philosophy, but we shall have to turn to it at this juncture for the principle on which his aesthetic rests. To put it as simply as possible, Solov'yov posited as the ultimate reality a single, universal religious entity which is more than God alone and embraces every aspect of life. It is compounded of three elements which are Nature, the Divine Principle, and Human Individuality.[133] Every creature or part of the natural world exists in itself (in its 'subjective idea') and also as a part of a complex chain of relationships to the cosmic whole, whose culminating point is the 'objective idea', which is the absolute principle of divine love.[134] Man is bound always to seek the unifying principle in nature[135] for he is 'real' only to the extent that he partakes of that principle; cut off from his relationship to the divine reality, he is reduced to a disembodied 'act of self-knowledge'.[136] However, man has a specific role to play in the divine scheme: he is the instrument of God's revelation of his unified existence[137] and is blessed therefore with the potential capacity to know the 'ideal' reality as a whole,[138] and endowed for this purpose with a means of knowing 'ideas': this is 'mental contemplation or intuition' and is typified in the activity of the artist. Indeed, art can

legitimately concern itself neither with particular phenomena nor with generalized concepts derived from them by the process of reasoning, but only with 'ideas', revealed by contemplation or intuition.[139] The whole of nature is constantly striving to express the divine principle, or to reflect it more immediately, man's glorious and tragic task being to assist nature in its endeavour.

The *Lectures on God-Manhood* give a clear indication of what constitutes the light that transfigures the diamond: namely, the divine principle at work in nature. In the second of Solov'yov's specifically aesthetic essays he elaborates the relationship between art and the transfiguring process in nature.

In *The General Meaning of Art* Solov'yov sets out to explain why art is necessary at all if beauty is a divine principle inherent in nature, and nature is constantly striving toward a more perfect realization of that principle. Solov'yov's explanation is this:

> [The aesthetic relation of art to nature] consists not in the duplication, but in the continuation of the artistic activity which has been begun by nature. . . .[140]

It is through art that man fulfills his rôle and comes to the aid of a natural world that is bent upon reorganizing itself into an ever better expression of the Absolute whose imperfect reflection it is. Nature is incompletely equipped for the task; only man is privileged to have knowledge of the divine spirit and only he, in the light of this knowledge, can impart to nature's striving the higher-than-material, the 'spiritual' quality that will enable it, eventually, to become completely identified with the divine principle – that will enable matter to become pure spirit. Here is how Solov'yov defines the task of art under these circumstances:

> Hence the triple task of art in general is: 1. The direct objectivation of those profound inner attributes and qualities of the living idea which cannot be expressed by nature; 2. the spiritualization of natural beauty and, through this, 3. the immortalization of its individual phenomena. This is the transformation of physical life into its spiritual counterpart. . . .[141]

'Real' art, for Solov'yov, has a solemn and prophetic religious rôle, to which the inseparability of art from religion in ancient times bears eloquent testimony. Its nature, he concludes, can be finally expressed in the following terms:

*. . . any sensible representation of any object or phenomenon whatso-
ever, from the point of view of its ultimate state, or in the light of the
future world, is a work of art.*[142]

The 'ultimate state' is the state of complete identification with the
divine essence, for which all matter longs.

The place which art occupies in Solov'yov's religious philosophy
accounts for the dominant concern of his aesthetic, which is to
demonstrate beyond all question that beauty is not a subjective illu-
sion of the human imagination, but an absolute, objective value,
which can, moreover, be known and demonstrated with quasi-
scientific plausibility. If human artistic activity is to take its place in
the cosmic process, the realization of the divine, then beauty must
be shown conclusively to reside outside man. We know, he asserted
in *The General Meaning of Art*, that 'beauty has an objective value,
that it acts outside the world of men, that nature itself is not indiffer-
ent to beauty', and that the task of conscious human creativity is to
'realize perfect beauty in the sphere of physical life'.[143] Solov'yov's
theory of knowledge was entirely conditioned by the need to prove
the objectivity of knowledge of non-material values; it was expressed
in its most concise form in a comparatively early article, written in
response to criticisms of his *Crisis of Western Philosophy*. In this
article, *Concerning the Reality of the External World and the Basis of
Metaphysical Knowledge* (1875), Solov'yov completely accepts that the
knowledge derived from our experience of the phenomenal world
'consists purely of elements of our own psyche, of sensations or im-
pressions of our senses', [144] but insists that, quite apart from our
subjective knowledge of phenomena, we are capable of objective
knowledge of 'essences'.

It is necessary to enlarge a little here on the details of Solov'yov's
proof of the possibility of such knowledge, for it was almost cer-
tainly drawn upon by the theorists of symbolism, particularly
Vyacheslav Ivanov, in framing their theory of knowledge.

If subjective knowledge were the only form of human knowledge,
Solov'yov argues, then I would be forced to deny my own existence,
even as a subject, for even though I have only subjective knowledge
of *external* things, I myself cannot be a projection of my own sub-
jective consciousness; if I existed at all, it would have to be as a pro-
jection of some *other* consciousness, existing outside myself, and
such there cannot be if everything outside myself is a figment of my

own consciousness. The only truly logical supposition is that I can have *objective* knowledge of my own existence, though every other phenomenon (to which precisely the same applies) is only experienced by me subjectively. 'It is true that I can know only a series of psychological states, but I know that these states are the immediate expression of *my own* being, and no other, otherwise I would not be conscious of them and would not call them *my* psychological states.'[145] In other words – 'the phenomenal nature of the world does not contradict its independent existence'.[146] Moreover, I am able to apply my knowledge of my own existence so as to give me *objective* knowledge of things outside myself, beginning with beings like myself. I can suppose with certainty that another person with whom I may come into contact has the same objective reality as myself; furthermore, I can extend this supposition indefinitely, to embrace even the inorganic world, for science is fast ceasing to draw a rigid distinction between the organic and inorganic worlds. Thus I am able to have 'positive, though extremely general, knowledge of the metaphysical essence of the cosmos, by analogy with my own essential being'.[147]

We are not concerned here with the obvious antecedents or the validity of this 'logical proof' (for such Solov'yov held it to be) of the reality of metaphysical knowledge. It is cited because it may explain why the theorists of the symbolist movement assumed it to be possible for the isolated individual to have knowledge of the 'essential' world. In Solov'yov's case, such an assertion is a natural accompaniment to his insistence on the objectivity of beauty. It was not enough to postulate a 'real' beauty, existing outside the consciousness of man, without postulating also the ability in man to know it objectively.

8. Summary

The chief difficulty in summarizing the ideas examined in this chapter lies in distinguishing statements of the social utility of art from theories of the relation of art to reality, and in facing up to the impossibility of making this distinction in every case. The basic fact which must be accepted in advance of any attempt to make sense of

nineteenth-century Russian aesthetics is that all the writers concerned were resolved that what they saw must be changed. Any theory confining art to imitation of nature was bound, in the intellectual climate of nineteenth-century Russia, to fall on barren ground. We are dealing in this survey with a variety of statements of what enters into art *other than* the obvious and generally admitted element of imitation – even in the case of Chernyshevsky, whose insistence that art is but a reproduction of reality was tempered by the admission that the process of reproduction involves 'the communication of inner content'. The accounts here reviewed of the non-mimetic element in art are all complicated by a tendency to confuse or combine two issues: that of the changes which must be made to existing realities in order that the world shall be a better place to live in; and that of the extent to which any representation of reality in art is bound to differ from its model. The former is a moral imperative, whether expressed in political or religious terms; the latter is conditioned in part by the conscious moral imperative, as well as by other more or less clearly definable human needs, but is primarily a question of the limitations and peculiarities of human perception and self-expression. The literary critics of nineteenth-century Russia found the second issue impossible to ignore, but equally impossible to admit fully into their theories, unless a way could be found to incorporate it in terms of the social issue – as for example, when Apollon Grigor'ev relates the subjective construction imposed by the artist on the reality he depicts to an ill-defined 'collective wisdom' of the people.

For Belinsky, art had an overt social purpose: to bring the community to social self-awareness. The same applies in the case of Apollon Grigor'ev, for whom art was to provide an 'ideal expression' of the life of the community, and in that of Tolstoy, who saw art as the vehicle for the transmission of social values from generation to generation. Skabichevsky held that art should directly inspire action for the betterment of society. In all these cases, art is linked in the most obvious way with the need to change reality. The social purpose in art is less to the fore, though still present, in Chernyshevsky and Solov'yov. Chernyshevsky conceded to art a more independent place among the means at man's disposal for the interpretation of his surroundings, primarily as a means of deepening his knowledge of the physical world; but he allowed that art is a pur-

poseful moral activity, in so far as no artist can avoid passing judgement on what he represents in his art. Solov'yov conceived of art as a force transforming reality directly, by 'spiritualizing matter', rather than indirectly, by inciting men to action for the improvement of their surroundings; but he saw this process as coming to fruition only in a religiously ordered society, a 'free theocracy', and described the church (of his and Dostoevsky's vision, rather than any existing church) as 'a positive social ideal', to be realized through 'a universal, popular heroic act'.[148]

All the writers considered in this chapter advocated a considerable degree of tendentiousness in art; all, on the other hand, recognized that qualities of insight and imagination account for what is most valuable in the artist's vision of reality, but avoided discussing the nature of these qualities. Solov'yov is to some extent an exception, but he was ultimately more intent upon the *object* of intuitive knowledge than on the process by which it is attained. All were loath to admit that the artist's talent is personal and individual; they dwelt as lightly as they could on the subjective nature of artistic insight, or if they admitted it as whole-heartedly as Skabichevsky, endeavoured to restore the balance by showing it to derive from an awareness of communal, 'objective' needs. The reason is to be sought in the way in which they defined the contribution which the artist makes to the process of transmuting reality into art.

We have seen this contribution defined as discernment of the essential nature of the object represented (Chernyshevsky, Grigor'ev, Solov'yov, Tolstoy), as the creation of a 'typical' form (Belinsky, Grigor'ev), and as the modification of what the artist sees in the light of an 'ideal' (Skabichevsky, Grigor'ev). These definitions differ only in the *stage* of the representational process which each emphasizes, as is made clear by Grigor'ev's use of all three to characterize successive stages in the attainment of 'objectivity'. 'Essence', 'type', and 'ideal' have an important common denominator: they are all held to be objectively knowable values, originating outside the individual artist, even though their discovery depends upon a quality of his individual personality. For Belinsky, Grigor'ev and Skabichevsky, their origin lies in a common social consciousness. Chernyshevsky and Solov'yov, we have seen, shared the assumption that the values with which art is concerned are external to man and supremely real. The more the subjective nature of the

artist's gift was conceded, the more effort was made to demonstrate its origin in his sense of identification with the community. Grigor'ev and Skabichevsky came nearest to a 'modern' characterization of art as a form of 'poetic organization' extending to the whole life of the individual, and purposeful only in the widest sense; and they provide between them the clearest examples of the relation of the individual ideal to communal values in order to establish its 'objectivity'.

The demand of the nineteenth-century theorists that art should represent reality in the light of communal aspirations gave rise to the assumption that artistic representation is a process of generalization, of the discernment of what is most generally valid amidst individual human needs and sufferings. In other words, their assumption as to the purpose and function of literature generated an apparently naturally corresponding assumption about the aesthetic process. Yet there is apparent in all the theories examined here an uncomfortable tension between this assumption and the recognition that successful art creates its effects at the level not of the general, but of the individual, the particular phenomenon. The insistence that art communicates something more than the immediate shape of things, and that excessive attention to detail can impede this process (Skabichevsky, Tolstoy) is accompanied by a strong resistance to abstractions and generalizations (though sometimes this resistance itself takes a decidedly abstract form, as with Chernyshevsky). Thus Belinsky, Grigor'ev and Skabichevsky put forward the almost identical argument that if, in representing the 'type', the artist loses his grasp of live particulars, of the immediate *données* of reality, the result will be a lifeless abstraction. Chernyshevsky repudiated the idea of the 'type' altogether, on the grounds that generalization brought paleness and that 'particular details do not in any case detract from the general significance of an object' Tolstoy, who warned in *What is Art?* against the danger that an excess of detail can hinder the expression of feelings, showed himself able to use realistic detail with compelling effect in his novels. Solov'yov conceived of the perfect art of the future in terms which, on the surface, reflect precisely this tension, a point that will be of the greatest significance when we come to deal with the theorists of symbolism. In discussing the principle underlying contemporary realism, he declared that:

45

... the penetrating gaze will be able to distinguish in [contemporary art] the indistinct features of the future religious art, precisely in its twofold striving – towards the full embodiment of the idea in the minutest material details, to the point of almost complete fusion with the flux of reality, and at the same time in the striving to *act upon* real life, emending and improving it in accordance with certain ideal demands.[149]

This uncertain double allegiance (to the 'type' or 'ideal' and to the unassimilated particular detail) has a diagnostic value. It may be possible at least partially to explain the concern for the particular by reference to a *theoretical* hostility to abstract generalizations that was the hall-mark of an intellectual climate dominated by practical questions. More than this, however, it reflects an awareness on the part of all the writers we are considering, except Solov'yov, of the weakness inherent in the theory of the 'type'. They were all anxious to show that art conveyed something of general import, but were all more or less unhappy about the justification of this process offered by current naturalist theories and supported by contemporary notions of the psychology of perception. Skabichevsky voiced the common objection most clearly when he suggested that art differs from science in moving from the general to the particular, rather than in the reverse direction as the exponents of naturalism would have it (cf. p. 33). His insight into the nature of the aesthetic process guided him more reliably, ultimately, than the nineteenth-century theories of the psychology of perception, with their emphasis on the progressive distortion and generalization of initial particular sense-impressions. For such theories have in modern times been substantially discounted in the light of discoveries in psychology which show that the organism's first response to its surroundings is general and imprecise, and that the process of learning involves not generalization, but the progressive transformation of the response into something more precise and particularized. The significance for the theory of artistic representation of this development in modern psychology has been very cogently suggested by E. H. Gombrich in his *Art and Illusion*.[150] The issue is raised at this point not simply as an invitation to applaud the instinctive certainty of (in particular) Skabichevsky and Grigor'ev that art by its very nature resists the tendentious generalization and gives body to our most indistinct

impressions of the world, but because it highlights the tension inherent in all the realist theories examined here, and enables us to define more clearly the position of Solov'yov in relation to the remainder of the company.

Solov'yov shared with the most radical of the realists a conviction that art seeks its values outside man. He accepted the tenet of secular realism that art should lead to 'a real betterment of reality', but argued that if art is to do more than simply incite men to self-improvement, if it is to act directly upon reality, then mere representation is not enough: art must invoke 'supernatural forces' that will transfigure the existing world.[151] We have seen, in fact, that he believed a supernatural force to be at work throughout nature, constantly relating particular phenomena to the single principle from which they derive their being. When, therefore, he speaks of 'the full embodiment of the idea in the minutest material details', he is in effect *reversing* the progression from general to particular by adding a new dimension, in which each particular, not in the form in which it is represented in art, but in actual fact, is assimilated to the divinely ordered world scheme. Man, himself a unit of the cosmic order, is there with his art to encourage this process of assimilation.

In making art a function of such an interaction between the divine and the material worlds, Solov'yov has cast himself in the role of Polixenes. He is defending art as the instrument of a higher purpose, assisting nature to set the finishing touches to her own handiwork. Chernyshevsky, in his unwillingness to let art tamper with nature's beauty, comes nearest to Perdita's neglect of gillyflowers (on the grounds that it is wrong to vie with 'great creating nature'). Belinsky, Grigor'ev and Skabichevsky admit the disputed hybrid to nature's garden, but are resolutely anthropocentric: if they see a higher power at work behind the *individual* artist, it is that of the community of man. Tolstoy, for whom religion is essentially an ideal of Christian brotherhood, largely shares their reliance on the values of the community; but his religious world view gives him some common ground with Solov'yov. Indeed, he has one foot in Solov'yov's world, for his characterization of art as a religious and social activity whose aim is to discover the meaning of life, is followed by the observation that 'mankind moves ceaselessly from lower, more particular ... things to a higher, more general ... understanding of life'.

Two

VYACHESLAV IVANOV'S
PHILOSOPHY OF ART

Another Sonnet to Black itself

Thou Black, wherein all colours are compos'd,
And unto which they all at last return,
Thou colour of the Sun where it doth burn,
And shadow, where it cools, in thee is clos'd,
Whatever nature can, or hath dispos'd,
In any other Hue: from thee do rise
Those tempers and complexions, which disclos'd,
As parts of thee, do work as mysteries,
Of that thy hidden power; when thou dost reign
The characters of fate shine in the Skies,
And tell us what the Heavens do ordain,
But when Earth's common light shines to our eys,
Thou so retir'st thyself, that thy disdain
All revelation unto Man denys.

EDWARD, LORD HERBERT OF CHERBURY

1. Introduction

There are two reasons why Vyacheslav Ivanov has been singled out
for treatment at length. The first is that among the theoretical writ-
ings of the Russian symbolists his alone form a coherent aesthetic,
developed as such rather than as a running critical commentary on
the *belles-lettres* of his day, and based on extensive scholarship. The
only rival claimant to such stature is Andrey Bely, who will be
treated in Chapter Three in enough detail to suggest that his excur-
sions into the philosophy of art show a good deal of insight, but are
inconsistent and sometimes hardly coherent. A close study of
Ivanov's aesthetic to a great extent places in perspective the issues

48

over which the majority of the symbolists argued amongst themselves, and engaged in battle with their vexed opponents.

The second reason for devoting so much space to Ivanov is that the stature which posterity accords him rests less on the importance and influence of the ideas he contributed to the forum of his day, than on respect for his obscurity. Many of his fellow-symbolists looked up to him as their leader or pontiff, but when remembering him they always stress the stimulus of personal contact with him, the fact that he drew them out of themselves, or was simply a good listener; nobody seems able to acknowledge a specific intellectual debt to him.[1] More recently his literary executor has published two essays devoted to his theories,[2] but makes no attempt either to interpret them in the general context of Russian or European philosophy of art, or to specify their importance for Ivanov's contemporaries. By 'respect for his obscurity' is meant a conviction, rooted more in awe than in reason, that something profound must lurk behind such abstruse propositions; and indeed, the very least that can be said is that Ivanov's aesthetic is couched in unfamiliar terms. Between his readers and his account of the aesthetic experience there stands a highly idiosyncratic language that is sometimes scientific, sometimes metaphorical and poetic, and sometimes rapturous. It may be explicit or it may be figurative, it is often cryptic, and the terms that it takes to itself have a tendency to proliferate incestuously.

It follows that an important part of the task of elucidating Ivanov's ideas must be to divest them of their covering layer of unfamiliar terminology – terminology that was apparently as unfamiliar to the majority of his contemporaries as it is to us today. It is for this reason that Ivanov is here introduced by an extended paraphrase of one essay which contains at least the germ of all that is most characteristic in his aesthetic; this paraphrase will reflect as closely as possible the idiosyncrasies of his vocabulary, and the ensuing analysis will attempt to relate the ideas expressed in this essay to other, kindred ideas that are familiar in a more acceptable guise. The obvious drawback of this method of presentation is that the terminology employed and quoted in the earlier stages may seem puzzlingly strange; the advantage (which in an introductory study surely outweighs the drawback) is that the reader will be made progressively more familiar with Ivanov's own vocabulary, as distinct from the language in which his ideas are discussed.

49

Vyacheslav Ivanov was, to invoke Isaiah Berlin's celebrated definition, a hedgehog. He knew many things, of course, and his erudition might occasionally disguise him as a fox, but at root he knew one big thing, to which he constantly returned from as many points of the compass as his wide learning might take him to. His analyses of religion and myth, of ancient history, and of literature and philosophy (classical, renaissance, or nineteenth-century), all seem to lead him in the last resort to the same generalizations about the mind and soul of man. His essays on aesthetics in particular mirror the centripetal organization of this thought in general; from different points of departure, they work towards the same conclusions. If analysis is not to unnecessarily distort Ivanov's ideas, it must take its cue from this self-evident pattern in his thought; if the issues raised in the essay which serves as introduction are examined in turn, they will be seen to be statements of the different aspects of a single polarity, discerned by Ivanov as lying at the root of human nature.

2. 'Two Elements in Contemporary Symbolism'

The essay singled out is *Two Elements in Contemporary Symbolism*, first published in the periodical *The Golden Fleece* in April and May 1908, and republished in 1909 in the collection *By the Stars*. The 'two elements' in question are 'realism' and 'idealism', viewed as two contrasting patterns in the mental processes involved in artistic self-expression. The essay is, in effect, a short statement of a psychology of creativity.

Ivanov begins the essay with the assertion that symbols do not designate single, particular ideas; they may be hieroglyphs, but they are polyvalent. 'Like a ray of the sun, the symbol penetrates all levels of being and all spheres of consciousness, and represents different entities at each level, performs a different function in every sphere.'[3] The snake, for example, is linked symbolically with the ideas of earth, incarnation, sex, death, sight, and knowledge, temptation and enlightenment, but all these possible meanings of the snake-symbol are drawn together into 'a great cosmogonic myth, in which every aspect of the snake-symbol finds its place in the hierarchy of levels of the divine unity'.[4] The assumption implicit in this

statement, that symbolic representation is organically linked with religious experience, is made clear as the essay proceeds:

Revealing in the objects of everyday reality symbols, that is, signs of another reality, [symbolic art] presents reality as significative. In other words, it enables us to become aware of the interrelationship and the meaning of what exists not only in the sphere of earthly, empirical consciousness, but in other spheres too. Thus true symbolic art approximates to religion, in so far as religion is first and foremost an awareness of the interconnection of everything that exists and the meaning of every kind of life.[5]

Moreover, Ivanov declares, the religious artist of the future will not be content to remain the passive vehicle of the religious idea. As Vladimir Solov'yov has prophesied,[6] he will wield it actively and consciously, a notion which Ivanov illustrates with two lines from his first collection of verse:

Творящей Матери наследник, воззови
Преображение вселенной.[7]

How is the new religious artist to wreak such a transformation upon the universe? He will not do it by filling the universe with his own creations, much less by becoming the artist-tyrant of whom Nietzsche dreamed. The artist is called not to impose his will on the external form of things, but to reveal the will that resides in them:

As a midwife eases the process of birth, so should [the artist] help things to reveal their beauty. . . . The very clay itself will take on in his fingers the form which it had been awaiting, and words will form themselves into harmonies predetermined in the element of language.[8]

This, Ivanov continues, is why realist art is preferable in the religious context to idealist art. He defines 'realism' as 'the principle of faithfulness to things as they are both in appearance and in essence', and 'idealism' as 'faithfulness not to things, but to the postulates of an individual, aesthetic mode of perception'.[9] At the conclusion of the opening section of *Two Elements* Ivanov combines Solov'yov's notion of the 'reincarnation' of heavenly values on earth with a realist standpoint in the philosophical sense:

. . . we hope to demonstrate that a realist viewpoint, as a psychological basis for the creative process and as the prime impulse to

creativity, alone assures the religious value of the work of art: in order to 'consciously direct the earthly embodiments of the religious idea' [these are Solov'yov's words, quoted earlier in the essay] one must first believe in the reality of what is being embodied.[10]

In the next section of the essay, Ivanov takes up more explicitly the psychology of creativity he has already hinted at. Throughout the ages, he says, the form of art has been governed by two inherent tendencies. Man's mimetic urge to reproduce what he observes and experiences has always provided a passive 'material substratum' to his artistic activities, but the active, 'dynamic' side of his psychological make-up has caused this substratum to be overlaid by two equally fundamental forms of conscious striving. On the one hand, man feels the need to 'celebrate' things as he reproduces them,[11] and on the other, to transform them. The two strivings correspond to 'realism' and 'idealism', and also to the eternal antithesis of female and male: realism is the female, receptive type, idealism involves a masculine initiative. The history of art has seen a progression from a naive 'symbolic realism', in which the artist remained receptive to whatever intimations of divine values his surroundings might reveal to him, to an idealism in which the artist endeavours to convey his own ideal, not revealed to him but conceived by him. Such an artist's ideal is of a beauty 'which perhaps really exists neither here nor in a higher world, but is none the less dear to him as a bird that has strayed from fabled lands'[12] The most significant point to emerge from this distinction is that, for Ivanov, the *creative* contribution of the artist to the process of representation belongs only to that tendency which he calls idealist. Realism, by this token, may be interpretative, but is not creative; the artist has been described as a midwife, one who merely helps to bring about an inevitable happening, a revealer, not a maker. Ivanov distinguishes two processes within artistic 'idealism':

> . . . the idealist artist either gives things back in a different state to that in which he received them, having re-wrought them not only negatively, by abstraction, but also positively by linking with them new features prompted by the associations of ideas that have arisen in the process of creation, – or, he produces compositions that are not justified by observation, but are the offspring of his despotic and wayward fantasy.[13]

It is interesting to note that Ivanov has here distinguished, within his one concept of idealism, two tendencies that correspond fairly closely to the distinction drawn by an earlier generation of Russian theorists between 'realism' and 'idealism'. The criterion of closeness to observation, as opposed to the dominance of untempered imagination, was adhered to by the radicals, and indeed, Ivanov's warning of the limitations of idealism would not be out of place on the pages of Chernyshevsky's treatise.[14]

After a brief digression to trace the history of the two principles in art, Ivanov applies his analysis to contemporary symbolist art, in three sections devoted respectively to realistic symbolism, idealistic symbolism and the criteria for distinguishing one from the other.

Baudelaire, says Ivanov, heralded the appearance of modern symbolism with a work of pure 'celebratory' art, that is, art of the first of the two types distinguished. In the first two stanzas of his sonnet *Correspondances*, Baudelaire laid bare the secret of nature – that nothing is random, and that nature is not dumb, rather we are deaf; that 'for those who can hear it, there sounds in nature the myriadvoiced eternal word'.[15] Baudelaire's attempt to express symbolically this objective truth identifies him as a realistic symbolist. Ivanov traces the idea expressed in *Correspondances* back to Balzac's 'mystical-romantic' tales *Louis Lambert* and *Séraphita* – back, that is, to a writer who in his view combined the realist and the romantic casts of mind. He takes care to point out that his 'realistic symbolism' is linked both with the realist movement in literature, and with those features of the romantic movement exemplified by Novalis. He stresses a particular link with Goethe's symbolism, in which he discerns echoes of both Schiller and Dante. The conclusion of the section devoted to realistic symbolism is worth quoting at length:

> To bring about a direct understanding of the life that lies hidden in reality, by means of a portrayal which unshrouds the manifest mystery of this life – such is the task that only the realistic symbolist sets himself, for he sees the profound and true reality of things, *realia in rebus*, and does not deny the relative reality of the phenomenal world, in so far as it contains and stands for the more real reality. 'Alles Vergängliche ist nur ein Gleichnis' ... Goethe approaches idealist art with the only legitimate demand, the demand which is equally acceptable and sacred for realism (remember that Plato's ideas are *res*) – the insistent

demand to discover and assert the general type in the changing and inconsistent variety of phenomena:

> So im weiten Kunstgefilde
> Webt ein Sinn der ewigen Art.[16]

Ivanov's 'realistic symbolism' is clearly a much more complex conception than the form of Russian realism founded by Belinsky, and involves a (psychologically speaking) more far-reaching aesthetic, but it can still find expression in terms of the theory of type, the assumption that the artist conveys the general truth that lies hidden in the bewildering multiplicity of the particular.

The continuation of Baudelaire's sonnet, on the other hand, illustrates the reverse of realistic symbolism. The 'parfums frais comme des chairs d'enfants' seem to Ivanov to betray the idea of a divine unity to which all phenomena are linked; they are 'correspondances' only on the sensual level, an enjoyment of associations between perceptions of the different senses, having nothing to contribute to the deepening of our understanding; they are a lapse into idealism, since they are on the level of 'an individual aesthetic mode of perception'.

Ivanov's next step is to establish a criterion by which to distinguish the contrasting strands that make up contemporary symbolism:

> The criterion by which one may make the distinction is given in the very concept of the symbol. . . . For realistic symbolism – the symbol is the goal of the revelatory process in art: any object, inasmuch as it is a hidden reality, is already a symbol, and the more directly and immediately the object partakes of absolute reality, the profounder it will be, and the harder it will be to fathom its ultimate meaning. For idealistic symbolism, the symbol, being only a means of artistic representation, is no more than a signal, designed to establish a community between the consciousness of disunited individuals. In realistic symbolism, the symbol is also, of course, the principle which links separate conscious beings, but their communion is attained by common mystical contemplation of the one essential, objective reality which is identical for all. In idealistic realism [sic][17] the symbol is a conventional sign by which individualists conspire to deceive one another, a secret sign, expressing a solidarity in their individual self-awareness, their subjective self-determination.[18]

Ivanov has here classed symbols according to the form of communication they represent. Idealistic symbols, by his definition, suffer from the limitations of verbal communication; they are conventional signs, of a relative value only, owing what common meaning they have to a community of interests on a level that Ivanov finds trivial. They scarcely break the bounds of subjectivity. Realistic symbols, on the other hand, put men into communication with each other by enabling all to attain to a sphere of absolute awareness in which eternal values are to be found that do not depend on the self-interest of individuals, and so are objective. He is claiming that true symbols transcend the limitations of their medium – a claim which we may hope he will try to justify in more detail, particularly as regards the nature of, and the means of access to, that common sphere which is the resort of all realistic symbolists and (presumably) their public.

In concluding his essay, Ivanov treats this question more deeply. To state his thesis at its simplest: the common sphere is universal truth, made known through a universally accepted symbolic construction which is myth. Realistic symbolism creates new myths, where idealistic symbolism can only deal in old myths, distorting them as it does so. The function of myth in the process of artistic communication is stated as follows:

> For myth is a representation of realities, and to interpret genuine myth in any other way is to distort it. A new myth is a new revelation of the same realities; and just as any private realization of an unconditional truth must necessarily become general as soon as it is proclaimed even to a few others, so any adequate signification of an objective truth about things, revealed to one person's cognitive faculty, will of necessity be accepted by all as important, true and inescapable, and will become a genuine myth in the sense of a generally accepted form of aesthetic and mystical perception of this new truth.[19]

All symbols which genuinely reflect the eternal truth that resides in the realities for which they stand (Ivanov is saying) are, by virtue of this quality, in some sense inherently public; and when the realistic symbolist refers to a conglomeration of symbols as a myth, he is asserting their unconditional public validity. The force of truth is compelling, and all who once become aware of the vehicles of truth will accept them as such without demur.

55

However, for all that it has been made a term of the aesthetic process, myth has here lost none of its religious connotation. The symbolist artist's attainment, through myth, of eternal truth is described quite explicitly as an act of faith:

Thus the poet believes, thus does he know by intuition. To create myth is to create belief. The myth-maker's task is indeed 'the revelation of things unseen'. And realistic symbolism is the laying bare of what the artist sees, as reality, in the crystal of a lower reality.[20]

We are also constantly reminded that the 'eternal truth' is a religious truth, the truth of the divine unity of the created world. Ivanov preaches a return to religious art, in the sense in which ancient Greek art was religious, and he claims to recognize in, for example, the works of Tyutchev and Vladimir Solov'yov, and in the interest shown by contemporary poets in mythology, signs that the soul of man is rediscovering its roots in myth. 'It is not the folklore themes that are of value', he writes, 'but the return of the soul and its new contact, however timid and haphazard, with the "dark roots of being".'[21]

The final section of *Two Elements in Contemporary Symbolism* is concerned with the implications on a slightly more practical level of the 'mythological' theory of art. The form of expression appropriate to symbolic myth in the age of classical tragedy (the golden age of religious art) was the chorus, which cannot be dissociated from the idea of myth. 'The chorus is a postulate of our aesthetic and religious credo . . .'[22] – a formulation which indicates more plainly than ever how closely his aesthetic and his religious beliefs are knit together. However, he eschews nostalgia, and is swift to add that there is no excuse for an attempt to artificially resurrect the chorus of classical drama on the modern stage, which is enslaved by the illusionism inherent in contemporary concepts of drama, and could only distort myth. For a reappearance of the chorus which is uniquely expressive of myth, we must await some future time 'when science will have to take account of certain truths which are already clear to investigators of myth and symbol'[23] The principal of these truths is that myth has come down through the ages as something at least potentially absolute and 'common to all men' (the word Ivanov uses is 'всенародный'). 'Popular' myth has survived the ever-present

tendency of man to form esoteric groups of one kind or another in order to preserve the mysteries of a particular form of religion. This tendency bears the same relation to popular myth as idealistic symbolism bears to its realistic counterpart. Ivanov's conclusion follows naturally from the rôles he has assigned to myth and symbol in artistic creativity: the preoccupations of contemporary art are linked, through the realistic symbolism he advocates, with the wider issue of religion in an unpropitious age. Here is how the threads are pulled together:

> Religion is the bond uniting all that is real, and is knowledge of realities. Art, drawn into the sphere of religion by the magic of the symbol, inevitably runs the risk of becoming masked in the hieratic forms of non-religious reality, unless it adopts the slogan of realistic symbolism and myth: *a realibus ad realiora*.[24]

The risk indicated here is that of lapsing from popular myth into an esoteric cult, of failure to rise above the 'lower', the 'non-religious' level of reality and attain a true, 'higher', 'more real' reality.

Two Elements in Contemporary Symbolism gives us scope for three generalizations which will be useful at the outset.

Ivanov sees the work of art as a representation of the phenomenal world, and insists that it should have its roots there, and nowhere else; but he envisages a representation which, without distorting the appearance of things, reveals their essential nature and their place in the divine scheme. Furthermore, he views this revelation (through art) of the hidden nature of the world as a force acting on reality, working upon it a 'transformation' or 'transfiguration' in terms of Solov'yov's notions of 'theurgic art'.[25]

Secondly, when considering art under another of its aspects, as communication, Ivanov is never far away from this concept of representation-involving-revelation; the revelation of true reality has itself a value as communication, in that it gives common access to the truth.

Lastly, Ivanov stresses that art is knowledge, not simply a vehicle of knowledge but a mode of knowing, which stands in the same relation to some 'higher', 'more real', religious truth as our normal ways of knowing do to the concrete, visible world. Religion, he has said, is knowledge of reality.

The analysis which follows will proceed from the third of these

generalizations to the first, from Ivanov's theory of knowledge to his preoccupation with communication, and thence to the representation of reality, the question which most narrowly concerns us.

3. Art and the theory of knowledge

(a) Poetry as an independent form of knowledge

That art is a means of knowing is a fundamental assumption of Ivanov's aesthetic, expressed in its most categorical and cryptic form in one of his aphorisms:

> Poetry is perfect knowledge of man, and knowledge of the world through man's cognitive faculty.[26]

In the essay *The Testament of Symbolism* (1910) Ivanov looks back to the age of ancient Greek civilization when – 'The task of poetry was the incantatory magic of rhythmic speech, mediating between man and the world of divine beings'. Symbolism, he then claims, represents a return to this heritage, of which one characteristic is 'the conception of poetry as the source of intuitive knowledge, and of symbols as the means of realizing this knowledge'.[27] Ivanov acknowledges that the 'knowledge' which poetry may impart consists not in rational ideas but in imaginative insight. We read in another aphorism:

> Characteristic of the lyric style are sudden transitions from one mental image to another, lightning leaps of the imagination. The multiplicity of the images evoked is made one by a single mood which can be called the lyric idea.[28]

Implied in this statement are two assumptions which are widely familiar in our own day; that poetry deals in insights which have an immediacy and a fluidity denied to rational thoughts; and that the imagination has the power to synthesize what the reasoning mind cannot. It is on this latter quality of poetic knowledge, its power to bring order and wholeness, that Ivanov lays most stress:

> The task and purpose of lyric poetry is to be an organizing force, to proclaim and command order.[29]

His view of the purpose of poetry goes beyond the simple recogni-

tion of intuitive knowledge; it has the ring of a psychologically-based aesthetic in which art is seen to order experience. It also has an obvious relevance to Solov'yov's conception of art as a 'transfiguration' or transformation of the phenomenal world, for this too is an ordering activity. Moreover, as in the case of Solov'yov, epistemological considerations clearly lie at the centre of Ivanov's aesthetic, and this aspect of his thought must be examined in order for a meaningful analysis of his philosophy of art to be possible at all. For, as will become increasingly clear as we proceed, Ivanov's consideration of the problem of knowledge transposes at every turn into the cognate problem of communication, thus emphasizing its close bearing on questions of aesthetics in the narrower sense.

In an essay on Vladimir Solov'yov, in which he suggests that Solov'yov strove for a form of knowledge in whose light all relative, historical truths will be seen to partake of the one divine principle, Ivanov describes what he regards as the crisis of contemporary theories of knowledge:

> Contemporary philosophy, from a desire to be strict and scientific, tries to confine itself to the sphere of theories of knowledge. ... As a result of the investigations of the Neo-Kantians, the cognitive subject which the individual has become, sees itself trapped in a closed circle. Everything that lies within the magic circle is relative; everything outside it is an indeterminate datum. But woe betide the individual when the vicious circle is arbitrarily broken: a relativistic theory of knowledge, carried over into life, results in non-existence.
>
> ... It is impossible to live in accordance with such a theory of knowledge; the circle of the particular consciousness can only be broken by the action of our collective will.[30]

He is also rebelling against the Kantian tradition of the relativity of human knowledge, on the grounds that the relativistic epistemology constitutes a barrier confining the individual within himself, and that it obstructs communication. The obvious corollary at once suggests itself: that knowledge of the absolute furthers communication and liberates the individual from isolation. Indeed, this was hinted at in the passage quoted earlier from *Two Elements in Contemporary Symbolism* asserting the inherently public nature of unconditional truth (see p. 55, note 19).

(b) Relative knowledge and absolute knowledge

The idea is taken a stage further in another essay, *Lev Tolstoy and Culture*. Ivanov 'places' Tolstoy as the Socrates of the nineteenth century, and draws a parallel between Socrates' Greece and Tolstoy's Europe. Both ages were characterized by 'a general critical reappraisal of spiritual values', and by rootlessness and relativism in philosophy.[31] Once relativism became established at the expense of man's communion with the 'infinite being', then:

> . . . thought took fright in the labyrinth of its freedom, in which everything had become arbitrary, deceptive and bound by appearances. . . . It was necessary to rebel against instinct and to save knowledge for living, at the expense of knowledge of the essence of things. If there was not a more real god to be found outside the natural creative instinct of life . . . then the divinity had to be sought in the normative value of rational consciousness, the capacity for logic had to be deified, and objective moral criteria had to be derived from human self-determination. Morality had to be used to exorcise the chaos of an existence deserted by the gods. It was hunger for real knowledge that made men moralists.[32]

By '. . . save knowledge for living at the expense of knowledge of the essence of things', Ivanov is pointing to the danger inherent in an investigation of the world which provides man with more and more verifiable knowledge at the expense of his sense of non-material values. Man, who for Ivanov is a religious animal, has always reacted to this danger by deifying the mental processes that provide relative scientific knowledge; he has spuriously satisfied his hunger for spiritual values by worshipping his rational consciousness, and has wrung his moral values from the same source. However, in Ivanov's view, man has ultimately never been able to accept a world bounded by the canons of verifiable knowledge:

> If man were a 'positivist' at root, he would never have broken out of the vicious circle of the world of phenomena, and it would never have occurred to him to discount any of his data.[33]

Ivanov advocates, as the way of escape from the dilemma he has described, a form of knowing which restores mankind to an awareness of 'the absolute', conceived in religious terms as the divine principle uniting all creation. The only correct attitude to human

culture is one which seeks to make of it 'a coordinated symbolic system of spiritual values, corresponding to the hierarchies of the divine world, and to justify the relativistic creations of man by their symbolic relation to the absolute'.[34] Ivanov finds in this apprehension of divine unity 'a new degree of rational consciousness';[35] the attempt to claim for intuition the respectability of rational thought is very much in the spirit of Solov'yov (cf. Chapter 1, pp. 36–7).

In the *Correspondence from Two Corners* (1922), Ivanov set awareness of the absolute even more clearly at the opposite pole to the confinement of men within themselves that had resulted from Kantian relativism. Mikhail Gershenzon, his correspondent, had spoken regretfully of the aftermath of Kantianism in European thought. Ivanov, who in this correspondence is arguing from the standpoint of Christian belief, replied that the believer has an immediate bond with the absolute, a bond that is not culturally conditioned, and so he declared:

> Thus, on the fact of our belief in the absolute, which is something other than culture, depends our interior freedom, – and this is life itself, – or our inward bondage to a culture that has long been godless in principle, for it has confined man (as Kant proclaimed once and for all) within himself.[36]

(c) The problem of self-knowledge

There was a suggestion in *Two Elements in Contemporary Symbolism* that the knowledge gained through myth is ultimately knowledge of being (see p. 56, note 21). In the essay *Freedom and the Tragic Life*, written in emigration, Ivanov's preoccupation with the polarity of relative and absolute knowledge finds expression in a slightly different form with more emphasis on the question of knowledge of being.

In *Freedom and the Tragic Life* Ivanov argues that man always tries to think of his values and judgements as absolute; when he is forced to regard them as relative, his natural desire for unconditional knowledge is thwarted, and he is left 'imprisoned in a subjectivist solitude',[37] in which he either despairs, or imagines defiantly but vainly that he is dependent on nothing outside his subjective state. Dostoyevsky, in Ivanov's view, saw this dilemma clearly, and explored it in the vision of the convalescent Raskol'nikov in *Crime and Punishment*. It is the age-old problem of how we are to conceive

of reality and share our experience of it if our conception and our experience are purely subjective and conditional. Dostoyevsky put forward as a solution, says Ivanov, the idea of a 'higher' reality, the object not of theoretical cognition, with its antithesis of subject and object, but of an act of will and belief equivalent to Saint Augustine's *transcende te ipsum* – Dostoyevsky's term being 'проникнове-ние', an intuitive 'penetration' of reality. Ivanov describes the 'lower' reality that must be transcended as 'of lesser ontological value' (see the passage from *Freedom and the Tragic Life* quoted on p. 87, note 97), and knowledge of the 'higher' reality as the key to the riddle of existence. Knowledge of reality of the type he envisages is 'ontological' to the extent that the knower not only knows things outside himself, but is able to affirm his own existence from his 'objective intuition' of other existences. This theory is expounded in detail in *Freedom and the Tragic Life*, and in two essays of the strictly symbolist period, *Thou Art* and *The Religious Work of Vladimir Solov'yov*; it has a vital bearing on Ivanov's aesthetic. The 'act of will and belief' by which, in Ivanov's view, Dostoyevsky transcends the subjective, is akin to the religious experience of love; in terms of knowledge, it is acceptance of the existence of the object to the point of renouncing one's own existence as subject. 'Thou art' ceases to be 'thou art recognized by me as existing' and becomes 'I experience thy existence as my own and in thy existence I again find myself existing'.[38] In other words, Ivanov puts forward a theory of knowledge based on mystical identification of the self with the object known, or, as Mr Norman Cameron's translation of *Freedom and the Tragic Life* runs: 'self-transposition into the other-Ego'. Scriptural support is found for the idea in St John's Gospel (xvii, 21–3), the text to which Tolstoy appeals in support of his characterization of the 'religious consciousness' from which art derives its values (cf. Chapter 1, p. 24, note 78): 'I in them and thou in me, that they may be made perfect in one. . . .' Ivanov coined or adopted Latin formulae for all the pivotal concepts of his philosophy, and the appropriate tag in this case is *Es ergo sum*.

The value of such an ontology, Ivanov insists, is entirely dependent on belief. For the disbeliever, 'thou art, therefore I am' can mean only 'we both float equally pointlessly in the void', and the love of the 'other-Ego' cannot be genuine. It is impossible to underestimate the importance of belief for Vyacheslav Ivanov; belief in

God is inseparable from even the most widely valid parts of his aesthetic, and failure to give this fact due credit, however disturbing it may be to find logical investigation mingled with statements of belief, will only make nonsense of his theories. For, as he concludes for the case of Dostoyevsky, to believe or not to believe is quite simply to be or not to be.[39]

In *The Religious Work of Vladimir Solov'yov*, having observed that the individual is a prisoner of his own relativism and redeemable only by an act of collective will (see p. 59, note 30), Ivanov continues thus:

> In practical life this act [of collective will] is performed whenever my love addresses itself to another with the words: 'thou art', dissolving my own being in the being of this other. The act of love, and love alone, postulates the other person not as an object but as a second subject, is an act of believing and willing, an act of life. . . . Only at this point does there awake in us another, higher consciousness, in comparison with which my former consciousness, confined by my lesser Ego, begins to seem a bad, false dream.[40]

The idea is substantially the same in *Freedom and the Tragic Life*, except that in its earlier form it is linked more closely and significantly with the wider problem of knowledge. The problem is, for Ivanov, that if we lose our link with the absolute, knowledge becomes self-defeating and destroys our very conviction of our own existence. When we 'believe in' an object outside ourselves, however, we know it absolutely, and in so doing reaffirm our own existence.

The essay *Thou Art* [41] opens with a lament for the *cogito ergo sum* of our pre-Kantian ancestors, which comfortable formula, according to Ivanov, has been invalidated for us even down to its separate parts – neither *cogito* nor *sum* will do any longer. With the formula has gone the 'whole individual' whose philosophical mainstay it was. The spiritual scene, however, is not totally desolate: it is rather 'a ploughed field of individual consciousness', waiting to bear a fresh growth of religious creativity. Religious consciousness awakes in us in the moment of perceiving the differentiation of our Ego into an 'I' and a 'thou'. There follows a characterization, in images of Dionysian myth, of the 'frenzy' in which the bounds of individual

consciousness can be broken. Next, the quest of the soul for God is presented in a variety of religious imageries, western and oriental. The soul is always seeking the Absolute, which in Christian mysticism is God the Father in Heaven; but it can only know the Father through the Son, with whom it can enter into a mystic union that enables it to realize itself, a union which is 'ecstatic' in Dionysian terms. The Son of God of the Christian myth is equated with the Eros of the Dionysian myth. The psyche involves a male and a female principle; the female side draws it towards the ecstatic union in which it loses itself in becoming something greater than itself, while the male principle is the conscious self, able to exercise its will and choose between resisting or following the impulse for union with the divine, 'between finite resistance to God and self-realization in the Son of God, between desire to transcend the individual and individual isolation . . .'.

There follows a detailed analysis of the Lord's Prayer in the light of the above, prefaced by this generalization:

> The 'right' prayer which Christ taught, begins with an act of the will, directing our individual consciousness to realms higher than the individual, – with the assertion of the principle of Christ within us: 'Our Father' is – 'Thou art in us' . . .
>
> Heaven resides in man, and is revealed in his consciousness by an inward stirring of the will. . . .

The significance of the Lord's Prayer, Ivanov concludes, is that the future re-growth of religion will spring from within the individual, from the 'microcosm', although history shows the majority of religions to have had their roots outside the individual in the 'macrocosmic' idea. The reason is that the soul will realize the macrocosmic idea within itself:

> When the soul of present-day man finds anew the 'Thou' in its 'I', just as the soul of the ancients found it in the cradle of all religions, then it will understand that the macrocosm and the microcosm are identical, – that the external world is given to man only so that he may learn the name 'Thou' both in his inaccessible neighbour and in his inaccessible God, – that the world is the revelation of his microcosm.

Thou Art is, of course, a Christian philosophy of being, a state-

64

ment of the kind of self-knowledge that only faith can confer. As such, strictly, we have no cause to examine it any further, but as we proceed, its relevance to the aesthetic will become increasingly plain. For *Thou Art* is two things at once. In the first place it is a description of the religious experience, in terms which the most cursory acquaintance with Augustine, Ruysbroeck, Meister Eckhart, or Jakob Böhme will at once render more familiar (Ivanov makes reference to all of these at one point or another in his discussion of 'religious knowledge'). It is also, however, a characterization of the psychology of creativity, not simply because for Ivanov 'true symbolic art approximates to religion' – because religious and aesthetic experience are for him virtually coincidental – but because he is using the elements of religious experience as figures for the aesthetic state of mind, as he discerns it. When later we come to discuss Ivanov's theory of art, as distinct from the philosophy which underlies it, there will be seen to be a striking correspondence between the two; both are illustrated by reference to the fundamental religious experience that is embodied, for Ivanov, in the myth of Dionysus.

It must be emphasized that Ivanov's involvement of religious mysticism and myth in his aesthetic theories is not as occult a practice as it may at first seem to a reader not primarily interested in religious experience, who is looking for generalizations of literary value. It is perfectly possible to see the practice as illustrative in the sense suggested above – as a kind of *Figuraldeutung* (to borrow a term from Mr Auerbach) for the psychology of creativity.

4. Art and communication

The question of communication between individuals is inherent in all the generalizations about knowledge that have so far been reviewed. The individual has been seen as severed from his roots in the absolute, imprisoned by his relativistic view of knowledge and (the implication is) in communication neither with his fellows nor with his maker. The polarity of relative and absolute has been echoed in various ways: as earthly and divine, idealistic and realistic, subjective and objective; as scepticism and belief, as individuation and

community. To this series may be added silence and song, failure and success in communication.

(a) The individual and individualism

The term 'individualism' is often used by Ivanov to describe the force which obstructs communication amongst men; in particular he refers with almost obsessive frequency to 'the pathos of individualism', and we must be clear at the outset as to the meaning of this phrase.

In 1905, Ivanov published an essay devoted entirely to the problem – *The Crisis of Individualism*. This traces the rise of the individual consciousness in Europe through the great individualist heroes of literature from Don Quixote to Zarathustra, who 'for the first time in the history of the world made the spirit of man aware of the demands of the new individualism and the tragic antinomy underlying it'.[42] Individualism appeared to reach its ultimate climax in Zarathustra, at a point where the human Ego had become a god, but now there is an uneasy feeling abroad that the great god is dead. Mankind has never been so vociferous about the claims of the individual, but it is precisely the extreme depth and refinement of our self-assertion that betray the exhaustion of individualism. In the present age there is a 'tragic antinomy' between our appetite for individual self-assertion and our 'collective' yearnings:

> Individualism has 'killed the old god' and deified the Superman. . . . The taste for the superhuman has killed our taste for asserting the power of our own manhood. Religious, social, secular messianists – we all of us alike already live in chorus, hoping collectively. . . . The superhuman is no longer an individual, but of necessity a universal, even a religious concept.[43]

We lack the power to assert ourselves as true individuals, and in banding together in a herd to pay homage to individualism we are asserting its very reverse – 'In truth, we have only differentiated ourselves, and we mistake our differentiation for individualism. . . . We carry the spear in the name of individualism, we preach it, but are not its subjects.'[44]

Ivanov felt very keenly the 'tragic antinomy' between the assertion of artistic personality and the sense of belonging to a 'chorus',

66

a community deriving its values from a universal source. This dichotomy is fundamental to his aesthetic; the point of significance for the artist is that individualism involves a renunciation:

> We are greedy, we want to 'fill ourselves with everything at once': so far are we from the pathos of individualism, – the pathos of scrupulousness, renunciation and one-sidedness.[45]

The 'pathos' of the artist's situation is that he must, paradoxically, in some sense renounce the quest for the absolute, and accept the 'one-sidedness' of relativism, for only if he does so is he able to communicate with his fellow-men.

(b) 'The pathos of individualism'

In *A Correspondence from Two Corners* (written in 1921) Ivanov tries to bridge the gap between his own and Mikhail Gershenzon's view of culture; he wonders whether they will find enough common ground to make communication possible:

> Should we not retreat each into his corner and keep silence, each on his own bed? 'How may the heart find expression? How is another being to understand you? Will he understand what it is you live by? A thought once uttered is a lie.' I do not like to misuse Tyutchev's sad admission; I would like to think that it had the impress not of eternal truth, but of the fundamental falsehood of our dismembered and scattered cultural epoch, which is powerless to create a collective consciousness, an epoch which is realizing the all-but-final conclusions of the original sin of 'individuation', which has poisoned the whole history of man – and his culture.[46]

Man, says Ivanov, cannot conquer his innate tendency to individuation, but is always feebly trying. He has an equally innate tendency to form short-lived cults to preserve the values of the moment. The suggestion here is plainly that the individual should resist such tendencies if he is to enjoy any common ground with his fellow men. The apparent regret for the death of the 'great individual' which alternates in *The Crisis of Individualism* with objections to individualism as a principle, is obviously a more complex feeling than it seems at first. We have already noted in *Thou Art* (see p. 63) a regret for the decline of the 'whole individual' of antiquity; Ivanov

67

clearly distinguishes two levels of individualism – a level on which the individual is able to assert himself without losing his contact with absolute, universal, 'outward' values, and another on which he differentiates himself within the herd without either rising above it, or even achieving a true awareness of community.

In *The Crisis of Individualism* Ivanov similarly distinguishes between an 'exterior' and an 'interior' individualism. Describing the decline of the epic, the art-form in which, he held, individualism had flowered, he writes:

> Exterior individualism has been supplanted in the narrative by the typical; only interior individualism concerns us; but even in accepting this – as a material enriching our common experience – we generalize it as something potentially typical. . . . Whatever our experience might be, we have nothing to say about ourselves as individuals: the too credulous vessel of our age must be swallowed by the Scylla of sociology or the Charybdis of psychology – it must disappear into one or other of two monstrous stomachs, designed to perform the task of digestion in the collective organism of our theoretical and democratic culture. . . .
>
> . . . Individualism is a phenomenon of the subjective consciousness.[47]

In *The Crisis of Humanism* (1919) we read:

> The crisis of humanism is a crisis of the inner form of human self-awareness in and through the individual. As this form has changed, its centre has moved away from the individual, which has as it were become formless in itself. A confused but powerful feeling of universal humanity has gained sway over the souls of men and has caused them to be drawn elementally to union with collective bodies. Humanism is based entirely on the gradual overcoming of individuation, of the separation and particularization of people, of their foreignness to each other, their inaccessibility and impenetrability, – of the self-sufficiency of the whole man.[48]

The 'interior' individualism, then, is a function of man's inability to conceive of his experience in any but subjective terms. The decline of 'exterior' individualism has left man obsessively sorting experience into the typical and the untypical – surely the meanest

possible expression of his desire to order his universe. He feels the need to establish some kind of bond with humanity at large, but in so doing he will end his self-sufficiency as a 'whole man'. This self-sufficient 'whole man' seems to correspond to the 'exterior' individual, the 'whole individual' of *Thou Art*. He is contrasted with the 'interior' individual, as much as to suggest that he has managed to retain some organic link with the universal order.

The contrast between the two types of individual provides a key to the meaning of the 'pathos of individualism'. Only if he is 'whole in spirit' can the individual seek union with the divine world, or commune with his fellows, without losing his individuality. As an artist, in a sense which will become increasingly clear as we proceed, he *must* turn away from complete union and remain an individual, for it is only on the level of the single personality – the level, that is, of the phenomenal world – that he can find expression for his intuitions of the absolute. This is what is meant by 'pathos of renunciation and one-sidedness'. On the other hand, the passage from *A Correspondence from Two Corners*, cited on page 67, makes it quite clear that whatever the particular means of expression found, it must contain an element of the universal for communication to be possible at all. A human being will always assert his separate identity at the expense of his organic link with the created world – and at the expense of his ability to communicate with his fellow-humans, for communication is essentially collective, and so must its instruments be. Ivanov puts this much more concisely elsewhere: 'the word is collective by nature, and consequently – moral', he says in *Manner, Personality and Style* (1912),[49] and in the words of advice to young poets that conclude the essay *The Testament of Symbolism* – 'The new can be bought only at the price of an inward act of heroism on the part of the individual.'[50] It is the task of poetry, according to Ivanov, to say what has not been said before;[51] the 'act of heroism' is the sacrifice of moribund individuality to the task of saying it in a form accessible to the multitude. Moreover, if the word is inherently public, then it must be subject to moral laws, and Ivanov sees the overcoming of the principle of individuation as morally binding on man. He speaks in *Freedom and the Tragic Life* of the 'mystic guilt' incurred by the personality that shuts itself away in solitude, falls away from the comprehensive unity of mankind and so from the sphere of influence of moral law. He describes this situation as

'negative self-determination by the individual';[52] it is evidently the negative aspect of the crisis that was referred to in the passage from *The Crisis of Humanism* quoted on p. 68.

(c) The collective consciousness

'The pathos of individualism' was Ivanov's term for the tension between two opposing human needs – the need for individual self-assertion, and the need for identification with 'the collective'. The 'collective' idea in Ivanov's theories takes two forms, represented by the words 'соборность' and 'народность', both of which notoriously lack a satisfactory equivalent in English. The first can best be illustrated from *Rejection of the World*, an essay written originally as a preface to Georgiy Chulkov's miscellany *Mystical Anarchism* (1906). There Ivanov discusses Ivan Karamazov's rejection of the world, which he sees as a crisis of *individual* conscience, an inability to let his will transcend his own personality and identify itself with the will of God, which is 'inward freedom itself'.[53] To be effective, the anarchical rejection of the world should be rooted in this will of the individual to transcend himself. 'Соборность', he declares, is 'a collective assertion of the ultimate freedom',[54] 'freedom' to be taken in the foregoing sense.

The meaning which Ivanov attaches to the second term is indicated by, for example, the remark in *Freedom and the Tragic Life* that Dostoyevsky sees the whole of mankind in every individual, and the whole people as a single personality.[55] 'Народность', then, is a feeling of popular solidarity by which a whole nation may act as one. 'Соборность' is a form of collectivity in which the fetters of isolation are shaken off, and the personal will of man is identified with the divine will; it also involves some kind of communal assertion or expression of this act. The freedom it implies contrasts with the illusory freedom conferred by relativism. It is with the second form of 'collectivity' that we are most closely concerned in the examination of problems of communication.

The essay *The Gay Craft* argues, in a vein reminiscent of Grigor'ev and the populists, that any artist, however much he may be corrupted by prevailing fashions of individualism, in the final analysis always expresses the 'soul of the people':

A true talent cannot help but express the ultimate depths of the

consciousness of his age. . . . The artist imperceptibly widens our horizons in harmony with the whole elemental striving of the soul of the people.[56]

Ivanov calls for art to enact a popular celebration:

Painting craves frescoes, architecture craves public gathering-places, music calls for the chorus and the drama, the drama for music; the theatre strives to unite in one 'action' the whole crowd gathered for the celebration. . . .

Through the overlying layer of everyday speech, the language of poetry – our language – must send forth shoots, and indeed it is already sprouting from the subterranean roots of popular language. . . .

. . . Through the strata of contemporary knowledge, [poetic] knowledge is destined to surge up in a chill spring from the depths of the subconscious. . . . Overcoming individualism as an abstract principle, overcoming too the 'Euclidian mind', and glimpsing the faces of the divine, [poetry] engraves upon its tripod [57] the words: Chorus, Myth, and Action.

Thus art looks towards the sources of the soul of the people.[58]

The passage cited above indicates that the 'collective' idea partakes of the earlier characterization of art as knowledge of an absolute rather than a relative order; the polarity of relative and absolute in Ivanov's theory of knowledge is restated in terms of the tension between individualism and the popular or 'collective' consciousness. The obvious implication that a true work of art owes its validity to the fact that it expresses the consciousness of the community as a whole, is evidence of a certain continuity with one of the fundamental assumptions of the nineteenth-century Russian aesthetic theories examined in the previous chapter.

The significance for the artist of the tension referred to above is suggested in Ivanov's essay *The Poet and the Crowd*.

(d) 'The poet and the crowd'

The title of the essay, of course, is inspired by Pushkin's *Поэт и толпа*. Pushkin's poem in Ivanov's view first laid bare the tragic gulf between the modern poet and his public. The people look up to the poet as a genius and await his command; but he is not the prophet

they take him for, and, when they demand spiritual bread, he can offer them only the hallowed silence of mystery. Both parties are, tragically, equally right on their own account, and equally unjust to the other. The poet fails to see that the crowd has legitimate business with him, for he no longer knows his own proper business –'. . . he does not know himself, and least of all does he belong to himself – he who says "I" '.[59] In another, happier age the poet might have been able to respond to the call of the crowd – 'In times of popular, "great" art, the poet is a teacher, and music and myth the medium of his instruction.'[60] Socrates, whose relativistic critical cast of mind was close to that which prevails in our day, forfeited the trust of the people by attacking the roots of Greek myth-making, and the modern poet is forced into a similar isolation:

> The Poet will suffer isolation to expiate his pride, but his faithfulness to the spirit will manifest itself in his strength-giving performance of the mystery of the mind.[61]

There is an echo here of the individual's heroic sacrifice in order to make his truth accessible. The poet may be doomed to isolation, but preserves even in his isolation a redeeming link with 'the spirit'.

Both the poet and the people are right, but do each other a wrong, and the consequence is that they forfeit the gift of speech, for both have failed to see that communication depends on neither one of them, but on both:

> Like an electric spark, the word is possible only in a conjunction of the opposite poles of the one creativity: the artist and the people.[62]

This notion is by no means as guilelessly democratic as it appears to be. We have only to consider for a moment Ivanov's own poetic language, which was a more or less conscious illustration of his theories, to see that he does not envisage an approximation of poetic language to current everyday speech, and that he does not take the people as he finds it. His poetry is most decidedly not accessible to 'the people' in any ordinary sense of the word. He believed in the special nature of poetic language, for much the same reasons as those commonly advanced to support the use of archaic forms in liturgy, and the people with whom he would have the artist enter into communion is a yet unrealized ideal people – it is scarcely sur-

prising that Ivanov was occasionally identified as a populist. One of the *Aphorisms* runs thus:

> In the wrangle of Pushkin's Poet with his Crowd, it was a historically important moment when the crowd spoke up – and thereby first declared itself as a force with which any future art would henceforth have to reckon. The consequences of this revolt were significant and took many forms; one of them, predominantly in the sphere of lyric poetry, was a change in our poetic language. This change debased our poetry and was an unnecessary concession to the rebellious 'mob' which masqueraded as the people, but in actual fact was merely a 'third estate' and almost an 'intelligent' mass.
>
> In all ages in which poetry, as an art, has flourished, the poetic language has set itself up in contrast to accepted conversational speech. . . .[63]

The language of true communication, the language that may, to use Ivanov's metaphor, jump gaps like an electric spark, must be a separate language established mutually by the articulate and the inarticulate together, by the poet and the people, and in order to restore such a language, each must make good a lapse from the right frame of mind: turning again to *The Poet and the Crowd*, we read:

> The crowd has discarded its verbal organ – the singer of songs, and he has rejected the word of outward, general import, and sought his own, *inward* word.[64]

The people must regain its self-awareness in order to reinstate the poet as a priest, and the poet must somehow, with the crowd's cooperation, externalize his 'inward word'.

Meanwhile, Ivanov finds that our poets in isolation have a good deal to say about silence:

> Latterly, our poets indulge in a tireless celebration of silence. Tyutchev, too, sang of silence, with greater inspiration than the rest of them. 'Still thy tongue, retire in silence . . .' – this is the new banner they have raised. More than that: Tyutchev's greatest feat was one of poetic silence. That is why his verses are so few, and his sparse words are cryptic and charged with meaning, as it were secret signs of a great and unvoiced music of the soul.

6

The time has come when 'a thought uttered' has become 'a falsehood'.[65]

The 'feat of poetic silence' recalls once more the heroic feat of the individual, and suggests again a sacrifice in order to preserve poetry, rather than a renunciation of poetry, – as if the poet 'in dürftiger Zeit' had a duty to keep the fires of universal art burning in his 'inwardness'. For amplification of the idea we can turn to *The Testament of Symbolism*, in which Tyutchev is invoked as the poet of silence, but also as the precursor of the new symbolism in which lies man's hope of breaking the silence; and a connection is hinted at between symbolism, silence and the hieratic nature of the poetic language: 'In the poetry of Tyutchev Russian symbolism is first . . . determined as a double vision and therefore as a call for a separate poetic language.' The poet is conscious on two levels, he is aware of 'a world of sensuous "phenomena" and a world of extrasensory revelations.' To the latter, he is drawn in his capacity as visionary, dreamer, and freedom-seeker. But he curbs his desire to identify himself with this world, 'in order to preserve his individuality', and, also, in order to find the instruments of expression. The 'mysterious world of spirits' and the 'nameless abyss' cannot be expressed in the 'language of everyday consciousness and outward experience' – but the poet can turn to the 'clear forms of daily life, to the patterns of the "woven cover of gold" that the gods have thrown over the mysterious world of spirits' The suggestion is that the phenomenal world can provide certain 'clear forms' which may serve as figures for the noumenal world (the word 'clear', significantly, echoes 'clairvoyance' – 'ясные формы', 'ясновидение'). *The Testament of Symbolism* continues:

> . . . the most valuable moment of experience and the point where creativity draws nearest to prophecy, is the immersion in that ecstasy of contemplation in which 'there are no bounds' between us and the 'naked abyss', which yawns – in Silence.

For Ivanov, it is in this moment of noumenal revelation that symbolic art becomes possible.[66]

This, then, was Tyutchev's 'feat of poetic silence' – he brought poetry to the point where it might be said that the poet had kept his side of the bargain, and the crowd might (if they were prepared to tune their souls aright) follow him into the world of the spirit. The

few poets who have not debased their speech to the level of the phenomenal world have kept alive for all the possibility of escape from that world, and the means of escape, the instrument of communication, is, of course, symbolic art.

The conclusion of *The Poet and the Crowd* indicates that, for Ivanov, symbolic communication is a process of sharing rather than transference, involving common access to a collective subconscious. 'Symbols', Ivanov writes, 'are the experience of a lost and forgotten heritage of the soul of the people. ... They have been deposited since time immemorial by the people in the souls of its bards as basic forms and categories in which alone any new vision can be framed.' Man's knowledge of the noumenal world takes the form of 'recollection' of something present at all times in the collective subconscious:

> That knowledge is recollection, as Plato taught, is borne out by the poet, inasmuch as he is at once the organ of collective self-awareness and collective recollection. Through him the people recalls its ancient soul. . . .

This view of communication can be amplified from elsewhere; another of the *Aphorisms* runs as follows:

> In lyric poetry we normally look for the personal confessions of a soul musically aroused to emotion. But the lyrical impulse is not enough to make songs of these confessions. The latterday lyric poet, for all that he is emotionally aroused, merely communicates his experiences and imaginings, his sufferings, his inward strifes and his hopes, even his happiness, more often his greatness and the beauty of his raptures: the new lyric has become almost entirely a monologue.

The poet has always been aware of the restraint the monologue imposes, and has sought something wider:

> The poet has been a 'singer of songs' only metaphorically and in virtue of the title he has inherited – and he has not been able to make his personal confession a universal experience through the musical enchantment of communicative rhythm.[67]

Communication does not consist for Ivanov in the monologue, nor even in the dialogue; true communication involves participation

in a common activity, which is variously described as 'recollection of a common past', as 'chorus', 'dithyramb', or simply 'myth'.

(e) The function of myth in Ivanov's theories

Ivanov devoted two full-length works to ancient Greek religion, both of which cover virtually the same ground. The second of them, *Dionysus and the Origins of his Cult*, he wrote in 1922 as professor of Greek at Baku University. It is, as he explains in his preface, a work of strict scholarship, in contrast to his earlier work, *The Hellenic Religion of the Suffering God*, which appeared in 1903 and 1904 and raised wider issues of the philosophy of culture, frequently digressing from the history of myths in order to establish their spiritual value for mankind in any age. The earlier study is of cardinal importance for the study of Ivanov's aesthetic.

It would be as well to begin with some examples to justify the contention that Ivanov's discussion of myth has a figurative value in his aesthetic. *The Hellenic Religion* contains many remarks such as the following which indicate that the Dionysus myths had very much more than a purely historical interest for Ivanov:

> The cult of Dionysus . . . is a dark and complex phenomenon of universal significance, a vast riddle and a problem of equal importance for the understanding of our past (for the Greek past is our common past) and for the new and unknown paths of the spirit that are opening before us.[68]

A clue to the nature of the understanding which the Dionysian myths impart is to be found where Ivanov, discussing the various historical interpretations of a particular myth, asserts that 'what concerns us is not the form in which the phenomenon has survived in history, but its psychological foundation'.[69] The myth is a means of understanding the working of the mind, then, and Ivanov's manner of proceeding is to work back through the historical forms of the myth to the reality it ultimately stands for. Indeed, for Ivanov, the myth *is* in a sense the reality, for 'myth is real'. The study of myth is, in his view, a psychological study (despite the remark about 'the Charybdis of psychology' cited on p. 68, note 47) since: 'The Hellenic cults were not only forms of ritual, they were also inward experiences.'[70]

76

If account is to be taken of remarks such as the above, which betray the connection between Ivanov's study of Greek religion and his 'psychology of art', we must equally bear in mind certain other passages in *The Hellenic Religion* that reveal the attitude informing it. For Ivanov approached Greek civilization in a not very scientific spirit of admiration. This, too, calls for an example; he ends his description of the Dionysian celebrations at Delphi thus:

> On the third day the tragedy commenced. This was the climax of Athenian, indeed of Greek celebrations in general, – days of inestimable importance in the history of the human spirit, – days when the highest of poetry's revelations was communicated through the mouths of tragic masks to a gathering of all the people, a people capable of understanding and appreciating it, – days in which it was possible to realize what we, a later race, can only dream of as 'high art', destined to supplant the lesser, personal, random art, that caters for the understanding and outlook of a few isolated individuals, the only art accessible to us today.[71]

He clearly saw the Greeks as enjoying a wholeness of spirit from which mankind has since lapsed. Nostalgia for an idealized 'golden age' of human civilization pervades Ivanov's analysis of Greek religion, despite his occasional explicit rejection of nostalgia; the 'people' of which he here speaks is, we may be sure, largely equivalent to the ideal people which he contrasts elsewhere with the mere 'third estate', and which is so important a part of the situation in which art arises.

(f) The myth of Dionysus

The terms in which Ivanov presents the Dionysus myth strongly recall his discussion of the tension between individualism and the 'collective' instinct.

The basis of the myth (Ivanov asserts almost at the outset of *The Hellenic Religion*) is the pathos of individuation. He quotes Plutarch on the many forms of Dionysus, his fragmentation into the elements of air, water, earth and fire, and remarks on the suitability in this context of the scholastic term reintroduced by Schopenhauer: *principium individuationis*. He writes of Plutarch's account of the contrast between the worship of Apollo and Dionysus:

77

This testimony is remarkable not for its Platonic cosmology and metaphysics, but for its psychological analysis of two types of emotion that represent, as it were, the two poles of the Greek soul.[72]

The two poles are Apolline order, harmony and stability, and Dionysian formlessness, the 'suffering of being constantly sundered from oneself'.

Ivanov, like Nietzsche, traces the birth of tragedy from a religious need in man. He tells how the tragic muse first blossomed in Dionysian art, and gives a detailed account of the birth of Greek drama from Dionysian rites. He remarks on the many contrary principles that are reconciled in Dionysian religion – solemn weeping and unbridled laughter, sacrifice and dance, the ivy of winter and the rose of spring[73] – and resolves to trace this religion back to its roots, for he can discern in it 'the deep, dark foundations of a genuinely popular religious feeling'.[74]

Ivanov found typically Greek the desire for total non-analytic comprehension of the world, a longing which the modern European mind is, in his view, coming to share. He quotes Nietzsche's observation (in *Wagner als Erzieher*) that we need somebody to simplify rather than to complicate our world for us, and claims that: 'What draws our minds to the pagan pole of our dualistic culture is not the romantic dreamer's *nostalgie du passé*, but the thirst for synthesis.'[75] What Ivanov means by 'our dualistic culture', may be judged from the following:

> The Dionysian religion of suffering and death was . . . a liberating force. It taught the duality of all that exists, it contrasted life and death as two different poles of the mystery of the world . . . it taught two ways – the 'way of descent' and the 'way of ascent'. . . .[76]

A corollary of the 'thirst for synthesis' is an inclination to collective action, equally fundamental, in Ivanov's view, to the spirit of the Greeks. The Dionysian ecstasy is an 'ecstasy of impersonal happiness', springing from – '*Taedium sui*, tiredness of one's particular individuality, freedom from the constraint of individual consciousness, from the prison of the ego. . . .'[77] Even the madness that was so frequent in ancient times and so closely connected with the cult of Dionysus, displayed two forms – one individual and the

78

other collective; it is the collective form that was significant for religion, and perhaps a sign of mental health rather than of illness.[78] The element of 'collective' madness in the Dionysian rites is linked with the question of non-analytic means of knowing:

> This mysticism of orgiastic insanity, like any mysticism, has little to say to our reason; but, as a symbol, it is more immediate than the logic of dogma, and makes accessible to us the mysterious essence of . . . Dionysus, the god of 'passions'.[79]

The 'mysterious essence' of Dionysus is summed up thus:

> From the examination of the mysticism of Dionysus-worship we have established its dual principle: the identification of the god with both the sacrificer and the sacrificed. . . . The religion of the suffering god takes its nature from this primordial mystery of identification. The tearing to pieces by the orgiasts of the god as sacrificial victim, that is, the translation of the victim into his tormentors and hence the transfiguration of the priests into the sacrificial victim – that is the primary symbol of this religion of sundering and separation, of the bursting of all fetters and bonds, of tragic ecstasies of murderous annihilation and longing for a lost unity.[80]

It is, Ivanov adds, an organic religion, not founded by anybody but arisen of its own accord.

Particularly important is the section of *The Hellenic Religion* entitled 'Dionysus and Hellenism: Dionysus and Christianity'. Ivanov's aesthetic rests, as we have seen, on a Christian philosophy of being, and an attempt to link Dionysus with Christ will naturally give more point to his conclusions on Dionysian religion; he does indeed try to indicate such a link, comparing the symbolism of the two religions in considerable detail.[81] Moreover, it is in this section that he has most to say about the exact nature of the confrontation between Apollo and Dionysus – figuratively, therefore, about the psychology of artistic self-expression.

From the historical point of view, Ivanov maintains, Dionysism suffered from the weakness of its priesthood, a circumstance which fostered the growth of art and scientific philosophy (and all, in fact, that Apollo stood for) at the expense of religious philosophy. The growth of Apollonian religion was conditioned by aristocratic opposition to the orgiastic and popular element in Dionysism. Ivanov

goes very thoroughly into the historical and mythological evidence for the confrontation of the two cults. The details do not concern us, but the general picture is this: Apollo, mythologically speaking, only managed to hold his own in the conflict by usurping several Dionysian characteristics – the myths of Apollo and Dionysus became thoroughly intertwined, and eventually both gods were represented in the temple at Delphi. However, Dionysism was enabled to continue its separate historical existence by the Orphic reform of the cult undertaken by Pisistratus, for, Ivanov observes, Orphism gave to Dionysism a much-needed form, and preserved its values by deepening them and placing them on a philosophical basis. Orphism, however esoteric it may have been, had a profound influence on poetry and indeed on the whole of idealist philosophy in ancient Greece.[82]

It is important to establish at this stage what kind of currency the historical intermingling of the Apollonian and Dionysian myths provided for Ivanov's dealings in the theory of art. He had the following to say about the outcome of the confluence:

> Though Apollo may emerge from the struggle transformed, Dionysus too is made lighter and purer. It is the synthesis of the two deities that first sets the seal on the Greek idea. From these two divine potentials is compounded the Hellenic pathos of aesthetic and ethic harmony. Each god completes the other, as the golden vision of Apollo's charms quells the ecstatic turbulence of the musical intoxication, as the preserving measure, the circumscribing form, saves the human 'I' from its centrifugal urge to forsake itself, as the sane objectivization of our inward chaos resolves, with a power that is healing and creatively fruitful, the equally right-minded madness of the soul that has broken its bounds.[83]

Ivanov is here making a perfectly familiar statement, in his figurative manner. He is making it in a somewhat nebulous language that strictly belongs neither to philosophy, nor to the history of myth, nor to poetry; but here is a similar statement in terms that are, though no less colourful, at least more familiar:

> ... jeder Künstler ist ... entweder apollinischer Traumkünstler oder dionysischer Rauschkünstler oder endlich – wie beispielsweise in der griechischen Tragödie – zugleich Rausch- und Traumkünstler: als welchen wir uns etwa zu denken haben, wie

er, in der dionysischen Trunkenheit und mystischen Selbstent-
äusserung, einsam und abseits von den schwärmenden Chören
niedersinkt und wie sich ihm nun, durch apollinische Traumein-
wirkung, sein eigener Zustand, das heisst seine Einheit mit dem
innersten Grunde der Welt *in einem gleichnisartigen Traumbilde*
offenbart.[84]

This (including the highly suggestive underlining of the word
'gleichnisartig') is, of course, Nietzsche speaking of what happens
when a work of art is born. Returning from an excursion into
realms of vision where beasts have speech, the land flows with milk
and honey, and man (or rather, Man) has begged the whole question
of artistic creativity by himself becoming a work of art, he is coming
to terms with the fact that art only arises, so far as the 'real' world
we inhabit is concerned, when the Dionysian vision of ecstatic union
with the created world has been mastered by the Apollonian sense
of form, when it has been consciously assimilated, and symbolic ex-
pression found for it. Ivanov believed as intensely as Nietzsche that
the crucial moment of artistic creativity is when Apollo arrests the
fall of the 'sinking' visionary, and with a power that is musical in
essence (cf. p. 75, note 67) orders his inward experience in terms
of outward reality. Ivanov certainly took his initial inspiration from
Nietzsche, but we are not dealing with a case of borrowing; Ivanov
was more than well enough equipped with knowledge of the sources
to make his own interpretation of Greek religion,[85] which by no
means entirely accorded with that of Nietzsche. However, he
acknowledged his debt to the author of *The Birth of Tragedy* as the
founder of the psychological view of Dionysism,[86] and his detailed
relation of the myth to the aesthetic states of mind is broadly identi-
cal with Nietzsche's. The parallel between the two passages com-
pared above is not exact, but it is close enough to show how Ivanov's
accounts of the myths and cults of Dionysus may be 'read' in terms
of the psychology of creativity, and that the results of such a reading
are comparatively familiar. It is interesting that Andrey Bely, in a
pamphlet published in 1922 in response to Ivanov's third collection
of essays, saw a rough parallel between Ivanov's ideas and the very
passage of *The Birth of Tragedy* quoted above. He had not, it seems,
come across the strikingly similar passage from *The Hellenic Religion*,
but rephrased the paragraph of Nietzsche in the manner of Ivanov
to illustrate the differences he saw between the two.[87]

(g) Dionysian religion and the psychology of perception

Ivanov concludes *The Hellenic Religion* with a summary of the importance of religion for the ancient Greeks, which he considers in terms of the psychology of perception. The passage provides a key to the equation by which the fate of the 'suffering god' is held to be the mythological expression of a psychological state, and is certainly of the utmost importance in understanding Ivanov's aesthetic:

> The claim to be a normative instance of cognition is essentially foreign to religion; but the emotion surrounding religion necessarily conditions the *aspect* of what is known. It seems to me that what we call the aspect of a thing, is compounded of the results of the three-fold psychological conditioning of any perception, firstly, by (apperceptive) associations, inseparable from the perception, – secondly, by the choice of certain features of what is perceived that particularly strike us and obscure the remaining features, – thirdly, by the element of will comprised in our evaluation, our affirmation or rejection of what is perceived. Association, selection and evaluation constitute the psychological medium in which phenomena must be refracted before they enter our consciousness ($\phi\alpha\iota\nu\acute{o}\mu\epsilon\nu\alpha$ for us are still $\delta\iota\alpha\kappa\rho\acute{o}\mu\epsilon\nu\alpha$). The sum of analogous *aspects* of collective perception is crystallized and objectivized in the *style* of a people or an age (style is typical aspect). . . . It seems to me that it is precisely aspect and not dogma, which mediates between religious feeling and the act of knowing.

> And here is the aspect which the world took in the light of Dionysian religion: the world is the suffering god made visible. The sight of the world's suffering is bearable for the spectator of and participant in the universal Act (and all of us are at once spectator and participant, and as participant – both the sacrifice and the priest) only if he has a lively awareness of the absolute solidarity of being, only in the profound ecstasy of mystical oneness. . . .[88]

Ivanov nowhere states more explicitly the aesthetic function of religion – and therefore of myth, since religion was for him the myth-making activity *par excellence*, and he drew no clear distinction between religion and myth. He has also given us here another

indication of what is most significant (in the aesthetic context) in the Dionysian world view. If we can fathom the connection between the two, Ivanov's theoretical utterances will at once seem a good deal less puzzling.

The passage quoted above defines the subjective, or 'affective' element of perception, and suggests that it is determined by religious feeling, whereas we are accustomed to accounts of perception in which the determinants are either more homely emotional needs, or animal instincts. Religion, to judge from this passage, is not knowledge, but is the factor in us that conditions sense-data on their way to becoming knowledge. This conditioning of perceptions involves their interpretation, and also (one may infer from the Greek parenthesis) their synthesis.

Before we accuse Ivanov of vitiating the scientific discussion of perception by introducing questions of belief, let us be sure what he understood by religion in the first place. In *Manner, Personality and Style* (1912) he argues that any poet who repudiates the religious nature of his activity ceases to be a poet at all, but he adds:

> Here ... we understand by religion not a definite content of religious beliefs, but the form of self-determination of the individual in relation to the world and to God.[89]

If religion is 'a form of self-determination of the individual' it is at least recognizably akin to the forces which act on sense-data in an aesthetic theory based on the psychology of perception. The word 'apperceptive' slipped in before 'associations' in line six of the passage from *The Hellenic Religion* points to the same process of self-determination. The feelings which modify the sense-data are, in Ivanov's account of the process, those of an individual torn between the world and God; but this dichotomy can be multiplied, as we have seen, to embrace a number of non-religious contraries – the relative and the absolute, the myriad phenomena and the one noumen, or simply, perhaps, verifiable knowledge as against values. This is a warning not to understand the word 'religion' too narrowly when Ivanov uses it in a psychological context. It may mean very little more than 'apperception'.

The form given to perceptions by the conditioning process, then, is their 'aspect'. To put it another way: 'aspect' is the form of interpreted reality. Ivanov's 'aspect' recalls Ernst Cassirer's concept of

'forms of art' which 'perform a definite task in the construction and organization of human experience',[90] while his 'psychological medium' is reminiscent of the 'mental set' of the pure psychologists. The sum of the forms which the world takes for each individual – the 'typical aspect' – becomes the 'style' of an age, and can be broadly equated with myth. The word 'style' is given a specific plane in Ivanov's vocabulary by its use in *Manner, Personality and Style*. There we read of the artist in his feverish quest for form:

> The power which heals and saves the artistic personality in its quest for the new morphological principle of its creative life – truly the power of Apollo the healer – is *style*.[91]

We have only to recall the passage from *The Hellenic Religion* that was quoted on page 80, note 83, to see that 'style' (or 'collective aspect', or 'myth') is precisely the power that orders the artist's inward experience.

The idea of 'aspect' is echoed in the essay *The Testament of Symbolism*, where it is stated that symbolism embraces two forms of speech, the one analytic and logical, concerned with relationships within the empirical world, the other 'hieratic', 'prophetic', a speech 'whose fundamental form is "myth"', in the sense of a synthetic proposition in which the subject is a symbolic concept and the predicate is a verb: for myth is the dynamic aspect (modus) of the symbol – and the symbol can be contemplated as motion or the cause of motion, as action or as an active force'.[92] The two forms of symbolic speech described here correspond in an obvious way to the 'idealistic' and 'realistic' forms of symbolism distinguished in *Two Elements in Contemporary Symbolism*.

The psychological implications of the Dionysus myth may be summarized, in the light of the foregoing, as follows: the subjective forms which we all give to our experience in an attempt to reconcile the concrete world with the world of values – our collective effort, as it were, to make ourselves 'securely at home in the interpreted world' – become externalized and public ('objectivized') as myth, or in the forms given to them by art, which may amount to the same thing; and symbols, provided they deal in the universal currency of myth, can give knowledge of the world of values, which is 'the divine world', or the *realiora* of *Two Elements*.

(h) The 'dynamic' property of myth

The definition given above of the two forms of symbolic speech contained an adjective often encountered in Ivanov's vocabulary – 'dynamic'. It qualified 'myth', and is thereby associated with the collective interpretation of reality, with true knowledge and communication, and the 'realistic' symbol.

The dynamic attribute of myth is suggested more fully in *Freedom and the Tragic Life*. The epic-tragedy, Ivanov there argues, has a nucleus which contains both the intuition of a transcendental reality and the action taking place within this reality. 'To describe this nucleus of symbolic creation', he adds, 'we use the word "myth".' He repeats the contention that 'myth' is a synthetic proposition in which the subject is a symbol to which is attached a verbal predicate, and gives examples of primitive mythological propositions: 'the sun – is born' and 'God – enters man'. He continues thus:

> Is there not a great similarity to these, even today, in the synthetic propositions that make up the true content of all poetic communication? For in the language of poetry all propositions are synthetic; and it is for this reason alone that they are so delightfully fresh and naïve, so unexpected and full of a spontaneous inner life, whose discovery in the most familiar phenomena fills us with surprise. . . . When the symbol . . . is enriched by the verbal predicate, it receives life and movement; and the unconscious symbolism that is peculiar to all true poetry becomes, in a sense, myth-forming . . .
>
> . . . Truly realistic symbolism, based on the intuition of a higher reality, acquires a principle of life and movement (the verb of the myth) within the intuition itself as a comprehension of the dynamic principle of intelligible substance: as a discernment of its actual form, or, what is the same thing, a discernment of its universal actuality and its activity in the world.[93]

Myth is the element in symbolism that is expressive of 'the dynamic principle of intelligible substance' – a principle which recalls Solov'yov's vision of a natural world which is actively transmuting itself into an ever clearer reflection of the divine principle (cf. Chapter I, p. 40). Ivanov introduces a cognate idea when he speaks of art as an 'energy', as opposed to a static form that arrests the flux of life. In one instance, he accuses the Parnassians of mistaking the

true nature of poetry, which, he says, is not a 'representational' art but a 'motive' art – 'искусство двигательное' – creating not images, but life itself.[94] Elsewhere, the expression of the same idea accords quite closely with the 'mythological' account of perception:

> In the sphere of symbolic art, the symbol is naturally revealed as a potential and an embryo of the myth. . . . But the myth is not arbitrarily invented: true myth is a postulate of collective self-determination, and thus not an invention at all, least of all an allegory or personification, but the hypostasis of a certain essence or energy. . . .
>
> . . . That energy which is called Art appears to us either collected or crystallized in the stable and ready-made forms of its objectivization . . . or in a state of flux and growth before us and only attaining an objective state in our perception.[95]

The significant point in both these uncommonly dense formulations is the suggestion that matter is far from inert, that things can actively assert their true form: nor is this an entirely new suggestion, for we met it at the outset in *Two Elements* (p. 51, note 8) – 'The very clay itself will take on . . . the form which it has been awaiting. . . .' The question of the representation of reality in art, in a decidedly unconventional guise, is revealed as implicit in the theory of myth, for Ivanov is asserting that every real object contains already the only form in which it can properly be represented. The passage from *Freedom and the Tragic Life* cited above (note 93) continues thus:

> The more the writer has the feeling for *realiora in realibus* – that pathos which breaks out in Goethe's 'All that is transient is but an allegory' [sic] – the more naturally, of course, does he meet and conform with the original imaginative patterns of the essential train of thought that lives on in the obscure memory of the ancient myth.[96]

It is around the 'feeling for *realiora in realibus*', the sense of the inherent form of things, that Ivanov elaborates his theory of the artistic process. The quest for form is presented as a complex exchange between the 'real' and the 'more real' worlds, expressed in *Freedom and the Tragic Life* in the following concise form:

> Realistic symbolism in art leads the soul of the spectator *a realibus ad realiora*, which latter reveal themselves in *realibus*;

86

from reality on the lower plane, a reality of lesser ontological value, to the more real reality. Meanwhile, the artist's discovery and development of his theme is moving in the opposite direction; inasmuch as the artist who aims at realistic symbolism descends from an intuitive comprehension of the higher reality to its incarnation in the lower reality – *a realioribus ad realia*.[97]

This is an attempt to say what the artist is doing in representing reality: he leads the spectator from the empirical world to that of pure values, but in order to do so he relinquishes, at least temporarily, his own hold on the 'higher' world, and descends to the lower. Again, there is a parallel figurative expression of the idea in *The Hellenic Religion*: it is the passage quoted on page 78, note 76, where Dionysian religion was claimed to teach the ways of descent and ascent in a dualistic world. Moreover, the ambiguity of the 'pathos of individualism' is suggested even more strongly than before: the poet must overcome his individuality in order to divine the values he has to communicate, but must assume the limitations of individuality again in order to communicate those values.

Once more, in passing from the consideration of communication in general to the specific question of how the artist represents reality, we are passing, in Ivanov's language, from myth in general to the myth of Dionysus, the particular myth which was the ancient Hellene's interpretation of his world (and therefore, as far as Ivanov was concerned, that of the sound in spirit in all ages). We should now, logically, return to the conclusion of *The Hellenic Religion* (p. 82, note 88) and ask what is the significance of the myth of the suffering god for the artist, bound by the real world but in touch with the divine.

In its Dionysian aspect, the world is figured as a god who is both one and many, constantly sacrificed and reincarnated; and man, of whose own suffering this is the figure, can only reconcile himself to his painful world by contemplating the unity of all creation, and experiencing it ecstatically. The two halves of the conclusion of *The Hellenic Religion*, taken together, add up to the proposition that the spiritually whole man interprets the world as a suffering god, in answer to a religious need that has been defined as 'ontological', as a need to determine the nature of his being. The theory of being was expressed in *Thou Art* in parallel images of Christian and Dionysian mythology (cf. p. 63), and the myth which concerns us

here, a myth of sundering and reuniting, stood there for the breaking down of the distinction between subject and object, for knowledge gained by the intuitive identification (or in Christian terms, the loving union) of the subject with the object. This notion, in which perception and apperception are combined in one act, in which the individual becomes aware of his own nature through his perception of an object outside himself, appears often in Ivanov's theories as the foundation of the *artistic* principle of 'realistic symbolism'. The dualism of subject and object runs parallel to the dualism of 'idealism' and 'realism', and the terms of the Dionysus myth may be added to the already long list of terms of the fundamental polarity to which Ivanov appears to reduce practically the whole of existence. To subjective-objective, idealist-realist, and so forth, one may add reincarnation and death, the sacrificial priest and the sacrificial victim, and also (what may still seem a tenuous link will become less so as we continue) the ways of descent and ascent in a dualistic world. This is as much as to say that in Ivanov's aesthetic system the Dionysus myth is an expression of the task of the 'realist' artist in assimilating reality to the world of shared values.

5. Art and reality

Reference has already been made to *Manner, Personality and Style*, an essay which concerns itself more with the creative mental processes than with the general philosophy of culture. We find there the following account of the stages in which the artist bodies forth his inspiration. The inspiration first finds expression in the artist's 'manner': that is to say, the artist's 'originality', the particular savour he imparts to the presentation of his subject matter, is expressive of the underlying inspiration. He next acquires an artistic 'personality' (лицо): 'manner' was a function of 'art for art's sake'; 'personality' involves the realization that for the artist life and art are one, and in his 'personality' the inspiration finds a more 'organic' expression. 'Personality' also involves dissatisfaction with the individual self, the desire for a new kind of freedom and self-determination, for a widening of the horizons. The artist seeks a new form for his inspiration, and finds it (aided, we have seen, by Apollo's healing touch: cf. p. 84, note 91) in 'style'. 'Personality'

is subjective, 'style' is objective, and true art only begins when style is found:

> For the artist who has achieved style, there are two data: the outward perception and the inward reaction to the perception; but he himself, as an artist, dissociates himself from both and disposes freely of them, denying his own subjective identity. This activity becomes normal insofar as he renounces individual arbitrariness and isolating self-sufficiency and freely submits to the objective principle of beauty as a general category of human unity – and at the same time it becomes normative only when what the artist asserts in his work, as a result of its subordination to the general norm, takes on the character of an objective value. But such lofty attainments are bought at the high price of self-limitation. (– 'in der Beschränkung zeigt sich erst der Meister')...[98]

As a description of the creative process, this is recondite indeed, but the correspondence with what has gone before is fairly striking. The individual's escape from the narrow confines of his personality, in Dionysian frenzy, and his preservation by the staying hand of Apollo; the pathos of individualism; the bestowal of an 'aspect' on sense-impressions, and the passage from the subjective to the collective, objective 'aspect': all these ideas find an echo here. However, nothing we have so far considered corresponds to the tentative definition of beauty as 'a general category of human unity'.

The appearance at this point of even an embryonic definition of beauty is important, and provokes reflection on the *kind* of aesthetic we are examining. Definitions of 'the beautiful' are as a rule a feature of metaphysical aesthetics, and are avoided by theories of art that are based, as Ivanov's appears to be, on the psychology of perception. This question will be raised again later; for the present, we are more concerned with the 'heroic feat of the individual', his acceptance of finite limitations in order that he may express for the finite world his intimations of the infinite. What here is only suggested, is propounded in detail in *The Boundaries of Art* and *The Symbolism of Aesthetic Principles*.

The Boundaries of Art opens with a long quotation from the third chapter of Dante's *Vita Nuova* (the account of his second vision of Beatrice) which Ivanov puts forward as an example of ascent into

7

the realm of vision followed by a conscious return to earth in order to communicate the vision to others. This, he maintains, is the situation of every artist, except that many make the ascent but few are successful in descent – in other words, true artists are few. He then traces the stages from the first Dionysian (erotic, musical, mystical) uprising of the spirit, through the ordering dream of Apollo to its successful return, enriched and sobered, to the world of men – or, the stages from the first groping of the mind for something it cannot yet name, to the discovery of the value it seeks and the form in which it may be expressed. The stages are: (1) 'the mighty wave of the Dionysian tempest'; (2) the Dionysian ecstatic vision, not to be confused with the Apolline dream; (3) the cathartic moment when the ecstasy is exhausted; (4) a state, still Dionysian but no longer ecstatic, in which, in Pushkin's words: 'Душа стесняется лирическим волненьем, трепещет и звучит'; (5) the dream-vision of Apollo; (6) a new, 'sober' lyricism; (7) the work of art – 'the dream is incarnate in the word'.[99]

In *The Boundaries of Art* Ivanov had recourse in several places to diagrams; the diagram illustrating the progression just described is reproduced opposite.

The foregoing was an account not of the representation of reality, but of an odyssey of the spirit; the real world only appeared in the progression as the stuff to make dreams tangible. Ivanov goes on to apply the theory of the ascent and descent of the spirit to aesthetic theory as it is more generally understood:

We experience the perception of beauty when we divine a certain fundamental dualism in the circle of the given phenomenon, and at the same time contemplate the final overcoming of this only analytically distinguished duality in a total synthetic unity: here, the essences and the energies that are related to each other as the material substratum to the formative principle, are the elements of the dualism that is broken down. Such a definition presupposes that the formative principle is active, but that the material substratum is not simply passive, but also plastic, in the sense both of a capacity and an inner readiness, by virtue of its very nature, to take on the form that is not imposed upon it from without, but, as it were, penetrates it within. The perception of the beautiful is destroyed if violence is done to the material substratum: the work of art strives to imitate nature, whose forms are

revelations of the inner processes of organic life. . . . Thus, the perception of beauty is the perception of life. . . .[100]

LINE OF ASCENT 1–3. Conception of the work of art: (1) Dionysian excitation; (2) Dionysian epiphany – intuitive contemplation or understanding; (3) cartharsis, conception.

LINE OF DESCENT 4–7. Birth of the work of art: (4) Dionysian excitation; (5) Apolline dream – reflection of the moment of intuition in the memory; (6) Dionysian excitation; (7) embodiment in art – the World Soul agrees to accept the intuited truth through the medium of the artist's creation (synthesis of Apolline and Dionysian principles).

Thus the balance is restored between the spirit and the flesh, for Ivanov makes it quite clear that it is only through the forms of the material world that the higher values can be discerned. He insists that art imitates nature (though he clearly does not mean what that formula normally signifies), and that the values are lost if artistic representation distorts material things beyond the limits of their essential characteristics. However, the material world is 'plastic', and the artist can only shape it into a form that is already latent within in: what he has learnt in his visionary ascent is, precisely, the latent forms of solid things – 'The artist triumphs if he can convince us that the marble craved his chisel . . .', and to illustrate the point Ivanov quotes Michelangelo's lines:

> Non ha l'ottimo artista alcun concetto
> Ch'un marmo solo in se non circoscriva
> Col suo soverchio, e solo a quello arriva
> La man che obbedisce all'intelletto.[101]

The material world is not inert but alive, and dictates to the artist its own underlying form – which is, we already know, its reflection of the principle of divine unity, of the will of the Maker. The suggestion encountered earlier in *Two Elements* – that Ivanov's 'realism' is interpretative, not creative art – becomes much clearer in this light. The 'idealist' artist (that is, the artist swayed by his own, narrowly aesthetic ideal) does violence to reality because he has not discovered the *realiora*, the essential nature of his material. The 'realist' artist, acting by his vision of the higher reality, gives to his material its own incipient form, making manifest what was only a latent principle, and so, strictly speaking, 'creating' nothing.

'The representation of reality' is in Ivanov's case meaningless as a description of the artistic activity without a very radical redefinition of both 'representation' and 'reality'.

When he is not criticizing imperfect or transitional forms of art, then 'reality' is the 'real', essential nature of all that exists; it is made up of the concrete (but by no means inert, indeed 'willing') objects that are the only medium through which earth-bound humans can become aware of spiritual realities.

'Representation', in these conditions, means divination, and obedience and revelation: divination of the form of an object, the stamp of the divine on it; obedience, in making an object the subject-matter of art, to its nature and hence to the will of its creator; and revelation of the unity of all creation, by shaping sounds, colours, or solid materials into their latent form.

In the terms thus defined, Ivanov insists on the principle that art should faithfully imitate reality.

If this is 'art', then what is 'beauty'? In *Manner, Personality and Style*, beauty was described as 'a general category of human unity', as if it were an attribute of individuals who successfully master their individuality and make themselves the instruments of a higher power. In *The Boundaries of Art*, we have just seen a definition not of beauty, but of the perception of beauty. In neither case has Ivanov tried to establish a metaphysical category of 'the beautiful'. In the latter he has suggested that if we can be aware of the duality of spirit and matter, and simultaneously aware of the harmony of creator and creation, then our perception will be 'beautiful'. There appears to be implied here a metaphysical notion of 'the beautiful', even though Ivanov has been careful to define the perception, not

the category. But the remark that the duality is only *analytically* distinguished, is significant; Ivanov is clearly still swayed by the strictly non-metaphysical distinction between analytic, rational thought and the immediate, total, intuitive perception – in other words, he has not entirely lost touch with accepted psychological accounts of the experience of beauty.

The Symbolism of Aesthetic Principles (1905) deals with the same principles as *The Boundaries of Art* (1913) but in a still more obscurely figurative way; it will not, therefore, be very useful to examine it in detail. However, it does shed interesting light on the definition of the beautiful within the framework of an aesthetic poised uneasily between metaphysics and psychology. Ivanov there declares his allegiance to Zarathustra: 'Wenn die Macht gnädig wird und herabkommt ins Sichtbare, Schönheit heisse ich dieses Herabkommen.' The 'descent', he says, is the symbol of a gift – beauty is a gift of God. The 'ascent' is 'glory on high', the 'descent' is 'peace on earth', and:

> We, earthlings, can perceive Beauty only in the categories of earthly beauty. The World Soul is our Beauty. And so, there is for us no beauty if we break the commandment: 'Be true unto this world.'[102]

Ivanov conceives of Beauty not as an attribute, but as a divine light which we can only perceive in so far as it is reflected in material phenomena. We can only frame 'beauty' in *human* terms as a psychological process – the 'descent' from a vision or an intuitive perception to a grasp of how a particular material form may be made to 'stand for' the vision, the non-rational perception of the non-material value.

6. Summary: Ivanov and Cassirer

Ivanov's philosophy of art has been analysed as far as possible in the language in which he presented it. This is because, as was suggested at the outset, this language is both idiosyncratic and figurative and it would obviously be impossible to isolate what it conveys for comparison with other aesthetic systems without a survey made within its own horizons. The least tedious way to summarize Ivanov's

ideas in less idiosyncratic language than that in which they were presented, is to relate them to something more familiar.

Ivanov, despite the psychological bias of his interpretations, was interested primarily in Humanity, rather than psychology. He does not take humanity for granted and concentrate on explaining one quirk of humankind, namely the capacity for experiencing beauty; the goal of his aesthetic is to help man to explain himself and to enjoy a fuller existence – to become, in fact, the 'whole individual' again. The pathos of the human situation is of far greater consequence for Ivanov than the subtleties of the psychology of perception. The choice of a foil for comparison is difficult, but as a succinct modern aesthetic, psychological in its approach but humanist in its bias, and based on the assumption that all thought and knowledge is ultimately symbolic, Ernst Cassirer's *An Essay on Man* (1944) is reasonably apt. It has two particular advantages: one is that Cassirer aims to provide a general philosophy of human culture, as did Ivanov; the other is the accessibility of its language, which makes it particularly suitable as a 'familiarizer'.

First, briefly, the background to Cassirer's philosophy of art, which has in common with Ivanov's a preoccupation with human self-determination. *An Essay on Man* opens with a consideration of 'the crisis in man's knowledge of himself'. The Greeks, says Cassirer, never doubted that man could determine his place in the universe by the exercise of his reason. The medieval philosophers, from Augustine onwards, recognized the weaknesses of human reason, and set ultimate store by the Christian revelation of the truth. The dawn of the scientific age brought a new cosmology in which man was no longer assumed to stand at the head of a hierarchical universe. Giordano Bruno introduced a significant positive attitude towards the idea of the infinite, which ceased to be the frightening reverse of man's finite being, and came to stand for the inexhaustible richness of reality. The human intellect was now aware of its own infinity, but man never lost his teleological cast of mind – even Darwin only substituted the idea of material causes influencing evolution for that of teleological 'final causes'. The new anthropological philosophy begins with the application of Darwinism to the world of culture, with the posing of the question: what is the guiding impulse of human nature that conditions man's cultural development? The 'crisis' arises at this point, from the multiplicity

of plausible guiding impulses: for Freud – sex, for Marx – economic instinct, for Nietzsche – power, and so forth. Metaphysics, theology, mathematics, and biology have succeeded each other in the past as the principal guide for thought on the problem of man; the crisis is felt when there is no such central power, only a bewildering choice. There is, though, a clue to the nature of man in his unique capacity to think in symbols as opposed to signs. Every creature lives in a world of its own, in which 'reality' is the particular answer of its particular organism to the problem of adapting to its surroundings, and there is no 'objective' knowledge of the surroundings in the sense that it would be the same for more than one organism. The capacity for symbolic thought, however, gives the worlds of human beings another dimension, since it gives them a language for other than material things. The *animal symbolicum*, as Cassirer calls man, lives in a symbolic universe, and:

> No longer can man confront reality immediately. . . . He has so enveloped himself in linguistic forms, in artistic images, in mythical symbols or religious rites that he cannot see or know anything except by the interposition of this artificial medium.

'It is symbolic thought which overcomes the natural inertia of man and endows him with a new ability, the ability constantly to reshape his human universe.' – and it is the task of philosophic thought to reveal the unity of a general function by which the bewildering multitude of the shapes given by individuals to the universe is held together.[103]

For Ivanov, too, we can only know things by the interposition of a medium – 'the psychological medium in which phenomena must be refracted before they enter our consciousness' (p. 82, note 88) – though he would not have been happy to call 'artificial' a medium which he saw as ultimately conditioned by the will of God. He likewise held that man must seek a unifying principle behind the shapes of individual worlds, which he called 'aspects'.

Let us now examine Cassirer's discussion of art as an activity of the *animal symbolicum*.[104] The philosophy of art, he points out, has always reflected the tension between the two opposed interpretations of reality, the objective and the subjective. To the objective pole corresponds the mimetic theory of art, and although such theories fall by their inability to give a proper account of the artist's

contribution to the mimetic process, 'imitation of nature' is none the less an undeniable fundamental instinct of man. The subjective pole is represented by the Rousseau-esque view of art as a spontaneous overflow of feelings and emotions. Goethe added another dimension to Rousseau's view – for him: 'Art is indeed expressive, but it cannot be expressive without being formative.' Art acts upon the scattered phenomena to produce an ordered, 'characteristic whole'.

Ivanov recognized a mimetic urge in man, and also an urge to 'celebrate' or transform the natural world in imitating it (pp. 51–2). He acknowledged the validity of Goethe's 'insistent demand to discover and assert the general type in the changing and inconsistent variety of phenomena' (p. 54, note 16), and stressed the power of art to order our knowledge of the world (p. 58, note 29).

Cassirer continues: 'Like all the other symbolic forms art is not the mere reproduction of a ready-made, given reality. It is one of the ways leading to an objective view of things and of human life. It is not an imitation but a discovery of reality.' We classify our sense-perceptions in order to give them an objective meaning, and 'such classification is the result of a persistent effort towards simplification'. Beauty may thus be described as 'a unity in the manifold', and it is difficult to maintain a sharp distinction between subjective and objective, expressive and representative art. The works of the great lyric poets are not mere outbursts of feeling, but reveal 'a deep unity and continuity' by fixing what Goethe called 'the highest moments of phenomena' – and this is achieved 'not by concepts but by intuitions; not through the medium of thought but through that of sensuous forms'.

Ivanov would have agreed whole-heartedly with this, and his reference to Nietzsche's remark about man's need to simplify his world (p. 78) recall's Cassirer's 'persistent effort towards simplification'. Ivanov's characterization of the 'lyric idea' which unites in a single mood the multiplicity of poetic images (p. 58, note 28) tallies closely with Cassirer, both in the rôle assigned to intuition and in the recognition that the intuition is prompted not by rational thought but by the contemplation of forms (cf. p. 90). Moreover, his concept of knowledge, as expressed in *Thou Art*, specifically rests on the overcoming of the distinction between subject and object (cf. p. 88).

Cassirer insists that the artistic interpretation of reality is not

96

confined to artists, but is made by their public, too, as its response to the work of art. 'Like the process of speech the artistic process is a dialogical and dialectic one. . . . We cannot understand a work of art without, to a certain degree, repeating and reconstructing the creative process by which it has come into being. By the nature of this creative process the passions themselves are turned into actions.'

Ivanov, too, insists that true art cannot be a monologue (pp. 73–6). However, he does not see the process as dialogical, either. His system can certainly be called dialectic (thesis: 'I', antithesis: 'thou', synthesis: 'we', to put it very baldly), but his synthesis transcends dialogue; it is something more like 'communal action'. Cassirer is perhaps hinting at the same thing – that artist and audience join together in the business of interpreting reality. There is in any case a striking parallel between Cassirer's 'dialogical and dialectic process' that turns particular passions into 'actions', and the second half of the conclusion of *The Hellenic Religion* (quoted on p. 82). 'Action' is in fact a technical term of Ivanov's aesthetic; we met it on page 71 (Chorus, Myth, and Action) and here is a more sober definition of 'action' from *The Boundaries of Art*:

> We see that the cognitive significance of art is conditioned by the rightful ascent of the artist as discoverer or as one being created, and his descent as creator. Creation in the true sense is . . . descent; and only descent, determining the form of art as an action, determines likewise the activeness of the artist.[105]

The artist's embodiment of his vision in 'sensuous forms' has for Ivanov the character of an action, a joint activity of the artist and his audience, who differ in degree rather than in kind. He is very close to Cassirer on this point, but Cassirer implies that artistic communication involves a two-way transference of the knowledge bestowed by art, whereas for Ivanov this traffic is replaced by the artist's descent in order to show to others 'the way of ascent'.[106]

Cassirer next attempts to say what beauty is:

> That beauty is not an immediate property of things, that it necessarily involves a relation to the human mind, is a point which seems to be admitted by almost all aesthetic theories. . . . Beauty cannot be defined by its mere *percipi*, as 'being perceived'; it must be defined in terms of an activity of the mind, of the function of perceiving and by a characteristic direction of this function. It

does not consist of passive percepts; it is a mode, a process of perceptualization. But this process is not merely subjective in character; on the contrary, it is one of the conditions of our intuition of an objective world. . . . The sense of beauty is the susceptibility to the dynamic life of forms, and this life cannot be apprehended except by a corresponding dynamic process in ourselves.

He is seeking what a little later he calls 'a truly dynamic or energetic philosophy of beauty'.

Ivanov's definition of beauty in *The Symbolism of Aesthetic Principles* (p. 93) indicates that beauty can only be defined in terms of a mental process. This process, to judge from certain other of Ivanov's formulations, especially his conclusion on Dionysian religion (p. 82), is certainly one of conceptualization, if by that is meant the process of transforming sense-perceptions, in accordance with certain felt needs, into a single idea or scheme of ideas by which we can achieve an objective interpretation of reality. But at the same time, *The Symbolism of Aesthetic Principles* points to a category of Beauty, a World Soul which we can intuit, but cannot describe, being able only to give an account of the process leading to the intuition. There is a kindred element in Ivanov's system to the 'dynamic life of forms' which for Cassirer is the goal of the creative process. The term 'dynamic' appears in Ivanov's vocabulary; examples are the 'dynamic aspect' of the realistic symbol (p. 84, note 92); and the 'dynamic principle of intelligible substance' (p. 85, note 93). In *The Boundaries of Art* we saw (p. 91, note 100) that beauty is generated when certain energies, which constitute the 'formative principle', overcome certain other energies corresponding to the material world, to bring about a 'total synthetic unity'. This is certainly the *kind* of philosophy of beauty that Cassirer is seeking, though the correspondence may prove to be no closer than that. Ivanov supposes a formative principle which might be equated with Cassirer's 'dynamic process in ourselves'; but he also supposes a dynamic *nature*, a world in which solid objects actively seek transformation into the forms that are their tokens of belonging to a higher unity. The comparison of Ivanov's 'dynamic nature' with Cassirer's 'dynamic life of forms' will be made more fully at the end of this *résumé*, for it reveals the crucial distinction between the two systems.

Cassirer proceeds to examine 'the logic of the imagination'.

Mankind in general may have replaced the symbolic language of myth and poetry (in which the earliest peoples framed their thoughts and feelings) by rational language and abstract thought; but poets still live in the world of myth, the world of the earlier 'imaginative' language, which is not fantasy, as those who distrust it call it, but is creative in that it gives life to whatever it describes. He adds:

> But with these powers of invention and of universal animation we are only in the ante-room of art. The artist must not only feel the 'inward meaning' of things and their moral life, he must externalize his feelings. The highest and most characteristic power of artistic imagination appears in this latter act. Externalization means visible or tangible embodiment not simply in a particular material medium . . . but in sensuous forms. . . .

The theory of poetic imagination, in Cassirer's view, reached a climax in the thought of the Romantics, for whom poetic imagination came to have universal metaphysical value and to provide the only clue to the nature of reality. The Romantics drew less and less distinction between poetry and philosophy, until Novalis could write: 'Poetry is what is absolutely and genuinely real. That is the kernel of my philosophy. The more poetic, the more true.'

'Fantasy' for Ivanov was imagination misapplied (p. 52, note 13) and throughout his writing on art he frequently contrasted true poetic imagination with the fantasy that distorts. He and Cassirer both give to myth a similar place in the process of passing from the physical experience of life to the intuitive experience of the world of forms (cf., for example, pp. 50, 55). Ivanov in fact rates the value of myth more highly than does Cassirer since he does not draw the latter's distinction between myth and religion,[107] and myth consequently has a more prominent place in his system. For Ivanov, even more than for Cassirer, the highest power, and indeed the task of the artistic imagination lay in the business of 'externalizing' the feelings (cf. p. 73), and this can only be accomplished in the sensuous forms of the 'material substratum' (cf. p. 90, note 100). Furthermore, we have seen him trace the roots of his 'realistic symbolism' back to (amongst others) Novalis. He actually illustrates this point with the same quotation from Novalis as is used by Cassirer above – which, on the face of it, links his theories with Cassirer's definition of Romanticism.[108]

Now Cassirer, in his search for a dynamic philosophy of beauty, rejects both Bergson's and Nietzsche's theories. Bergson's aesthetic intuition, he claims, is a passive, not an active capability, and Bergson likens the progress of aesthetic feeling to a state of hypnosis. Nietzsche's psychological theories, on the other hand, equate artistic inspiration too closely with intoxication, imagination with dream or hallucination. We cannot account, says Cassirer, for the structural unity which characterizes art, by 'reducing it to two different states which, like the dream state and the state of intoxication, are entirely diffused and disorganized'.[109]

We would expect Ivanov to reject Bergson by the same token, since he insisted that order does not descend unbidden, and that the aesthetic experience springs from an act of will; but he never mentioned Bergson although he could hardly have escaped an acquaintance with his work. What he has to say about Nietzsche, however, is interesting. In *The Hellenic Religion* he sums up *The Birth of Tragedy* thus:

> In my opinion this extraordinarily penetrating study is open to objection, above all, for not going sufficiently deeply into the essence of the Dionysian principle as a religious principle – and so for obscuring the religious and cult aspect of tragedy; in broad – for the one-sidedness of its exposition of Dionysian phenomena in purely aesthetic terms.[110]

Cassirer's objection is presumably that, even if Apollo's dream brings order, a dream is a random occurrence, and we must find some other way to describe the purposiveness of artistic imagination. Ivanov – if by 'purely aesthetic' he means 'to do with individual, passive perception' (cf. p. 54, 'an individual aesthetic mode of perception') – is raising much the same objection. When he says that Nietzsche neglected the 'religious and cult aspect of tragedy', he means that he failed to recognize art as something to be *lived*, to be actively and purposefully joined in by priest and worshippers, by artist and spectator alike. This tallies with the idea shared by both Ivanov and Cassirer of the dynamic character of beauty.

A special language presupposes a special purpose. What is it that the special language of art, its 'independent universe of discourse', exists to describe?

According to Cassirer: 'Even art may be described as knowledge,

but art is knowledge of a peculiar and specific kind.' It is knowledge of forms: 'Behind the existence, the nature, the empirical properties of things, we suddenly discover their forms. These forms are not static elements. What they show is a mobile order, which reveals to us a new horizon of nature.' The order is 'mobile' because we are not bound to one interpretation, but may repeatedly have fresh intuitions of a unifying order: 'It is characteristic of the nature of man that he is not limited to one specific and single approach to reality but can choose his point of view and so pass from one aspect of things to another.' Earlier in *An Essay on Man* (chapter II, p. 23) Cassirer adopts the view that –

> . . . it would be a very naïve sort of dogmatism to assume that there exists an absolute reality of things which is the same for all living beings. Reality is not a unique and homogeneous thing; it is immensely diversified, having as many different schemes and patterns as there are different organisms.

The distinctive feature of art in this context is that, instead of following traditional forms and patterns, it creates new ones – as Kant knew, originality is its hallmark.

Ivanov also recognized art as knowledge of a peculiar kind:

> Almost everybody nowadays agrees that art subserves knowledge, and that the kind of knowledge which art represents in a certain sense exceeds scientific knowledge. The object of artistic knowledge is known in a different way from that of scientific knowledge – in some respects in a more limited, less orderly way, and in others in a more essential and live way. The artist's knowledge is subsumed in the concept of intuition, as one of its varieties, not found in the other forms that intuition takes; and the strength of his capacity for intuition is recognized to be one of the distinguishing features of the artistic genius.[111]

He would agree with Cassirer that the forms of which art gives us knowledge are 'no static elements' (cf. pp. 85 ff.). These forms constitute, for Cassirer, the 'dynamic life of forms' of which we have knowledge through the 'dynamic process in ourselves'. The equivalent in Ivanov's terms is the 'dynamic principle of intelligible substance' which his 'formative process' makes manifest. But Cassirer's 'dynamic life of forms' has a 'mobile order'; the world of

which Ivanov's formative process gives us knowledge is most cer-
tainly not mobile in the same sense. It is not variable for each in-
dividual, even less so within the experience of one individual, for it
reflects an absolute, divine order that is the same for all who may be
led to it. In *Two Elements in Contemporary Symbolism* we read that
'a new myth is a new revelation of the same realities', and that this
reality is a universal truth (p. 55). For Ivanov human beings are
linked in 'common mystical contemplation of the one essential, ob-
jective reality which is identical for all'. This is the very opposite of
a mobile order, and indeed, the two concepts of reality differ very
sharply. In Ivanov's view real objects *are themselves symbols* of the
higher reality (p. 54, note 18), and already contain the form the artist
is to give to them. In *The Boundaries of Art* he carries the view a
stage further: the 'material substratum' conceals an inward readi-
ness to take on its appointed form (p. 90) and even dictates this
form to the artist.

What distinguishes Ivanov's single unconditional reality, identical
for all who can intuit it, from Cassirer's 'mobile order', his splendid
host of possible interpretations of reality, some made already and
handed on, others yet to be made? Is Ivanov's universally accessible
unity – God? Up to a point this is certainly so; his whole thought
was coloured by his religious experience, and it is easy enough to find
fairly unambiguous statements of the kind quoted on page 56: 'Thus
the poet believes, thus does he know by intuition. To create myth is
to create belief.' However, Ivanov defines religion as a form of self-
determination rather than clearly defined beliefs (p. 83, note 89)
and he raised the vital issue uncompromisingly in *Lev Tolstoy and
Culture* – 'If there was not a more real god to be found outside the
natural creative instinct of life . . .' (p. 60, note 32). For Cassirer, the
humanist, the 'natural creative instinct of life' is self-sufficient. For
Ivanov, the Christian believer and mystic, there was of course a
'more real god', but this divinity has many faces, including that of
the 'natural creative instinct', and there are many names for the
divine unity to which all forms aspire. Here is another version of
Ivanov's idea of the 'material substratum' that exists in readiness to
receive its form:

> The yearning of the artist and the yearning of the material that
> obeys him are one and the same: both long for live, not symbolic,
> life.[112]

In this case the goal of the ultimate striving is not unity in God, but simply 'live life' – the real thing, as opposed to its interpretation. He is certain, too, that the real thing exists, and is not obliged to find an adequate substitute for it in the 'new horizons of nature' which Cassirer's mobile order opens up.

Nor is the mobile order the last stage in Cassirer's system, for he is not immune from the feeling that there must be a single principle behind the ceaselessly changing, everlastingly new order. Man may be gifted with the power to build up an infinitely variable ideal world of his own, but ... 'Philosophy cannot give up its search for a fundamental unity in this ideal world.'[113] The principle which unifies the mobile order in spite of itself is not an absolute, but a functional principle, a dialectic:

> Such a unity does not presuppose a homogeneity of the various elements of which it consists. Not merely does it admit of, it even requires, a multiplicity and multiformity of its constituent parts. For this is a dialectic unity, a coexistence of contraries.

The function of Cassirer's unifying principle is man's function of becoming aware of his surroundings, and adapting himself to them, – of *constructing* his symbolic universe. The significant word is 'constructing', as opposed to interpreting his universe. To put it differently: ordinary mortals inherit interpretations, whereas the genius – the artist in our case – constructs new interpretations. The genius enjoys a talent for suddenly ceasing to repeat existing patterns of interpretation and creating in their stead new patterns of his own. The dialectic of this process gives ultimate unity to the symbolic construction that is human reality; and herein lies the specific value of art.

For Ivanov, just as for Cassirer, the specific value of art lay in originality, even if it had to be the shared originality of the artist and his material. He declared in *The Poet and the Crowd* that the artist's task is to say only what is new,[114] and in *The Boundaries of Art* he described how the artist and his material together arrive at what has not been expressed before:

> ... [the artist] clearly hears the complaint of his material, to which he is able to give a form, but is powerless to imbue it with real life, and this feeling that the very stuff he is working on has a not yet utilized force and direction prompts the poet fruitfully to the

discovery of new verbal possibilities, the musician to a search for harmonies yet unheard, the painter to a new way of seeing things and colours.[115]

So 'real life' is not a gift for the artist to bestow; the 'live, not symbolic life' remains an unattainable goal, but something new arises out of every attempt to reach it. The difference between the two systems seems slighter than before. Ivanov's symbolic principle, whether expressed in Dionysian or Christian images, is a dialectic, and even he himself refers to it as such from time to time, laying stress on the reconciliation of contrary forces that takes place in Dionysian myth. For both, too, it is the discovery of new forms that ultimately constitutes art, though for Cassirer nature does not play an active rôle in this discovery, whereas for Ivanov nature is always God's nature, and plays a willing part alongside the artist (who is himself only a part of nature) in making manifest the divine will.

Now, to support his theory of the characteristic originality of art, Cassirer quotes from *The Critique of Judgement*, in particular the following remark: 'Genius is the innate mental disposition (ingenium) *through which* Nature gives the rule to art.' He does not follow up the suggestion that nature dictates to art through the talent of the genius, and indeed his quotation is only a part of Kant's observation. It is worth quoting the passage in full, for Kant raised a point which Cassirer passes by in his concern for the human point of view, for 'man's progressive self-liberation' – namely, that the talent of the genius is itself a part of the natural world:

> *Genie* ist das Talent (Naturgabe), welches der Kunst die Regel gibt. Da das Talent, als angebornes produktives Vermögen des Künstlers, selbst zur Natur gehört, so könnte man sich auch so ausdrücken: *Genie* ist die angeborne Gemutsanlage (ingenium), *durch welche* die Natur der Kunst die Regel gibt.[116]

Cassirer seems unwilling to pursue Kant's observation that man's remarkable capacity for interpreting natural phenomena is itself a natural phenomenon; that 'nature' is only asserting itself in yet another way when it provides for genial humans to make fresh symbolic interpretations of itself. Ivanov's position is in this respect closer to Kant's. Cassirer, one suspects, passed the point by because the inkling of it left him slightly uneasy; for it shifts the centre of

gravity just far enough outside man to rock the barque of humanist philosophy.

There is an immense difference in the languages in which the two symbolic systems are expounded. Ivanov to a large extent spoke in symbols about symbols, where Cassirer has found ways to discuss his concepts in more direct terms. But Ivanov's system, made to seem strange by the peculiarities of his language, appears less so after comparison with something broadly akin to it. Perhaps in the last resort the two are separated only by the gulf dividing 'conviction' from 'belief'. As well as several comparatively minor differences along the way – for example, his substitution of communion for communication, and the greater importance he attached to myth in the artistic process – religious belief made for Ivanov one profoundly important difference: where Cassirer, the 'convinced' humanist philosopher, concludes on the triumphant note of mankind's progressive self-liberation, the ever-widening interpretation of reality, Ivanov feels the pathos of man's renunciation of a pure communion of the spirit, in order to make the real world intelligible as a reflection of the 'more real'. It is a reflection of the pathos of Christ come among men.

Moreover, the emphasis in this study on the analysis of Ivanov's thought has obscured the fact that he was not only a religious *philosopher*, but a Christian *poet* too. As a Christian, he believed his system; as a poet, he felt and suffered it, and where Ivanov and Cassirer diverge, a new term of comparison will have to be sought among poets and god-seekers.

The further comparison goes beyond the scope of the present summary, and is a matter for the concluding section of this study. Here it should be remarked that it is paradoxically easier to summarize the teaching of the Russian arch-symbolist by reference to touchstones outside than inside Russia. There is nothing on the contemporary Russian scene that is both close enough in kind and wide enough in its scope to provide a comprehensive term of comparison. Moreover, by whatever way one arrives at the characteristics of Ivanov's aesthetic, one will have said nothing that is necessarily valid for the remainder of the Russian symbolists, for his direct and specific influence was small, important though his rôle undoubtedly was as a catalyst in the literary life of his contemporaries. And yet the outside comparison showed him to derive his

8

most characteristic values in the last resort from that most Russian figure, Vladimir Solov'yov. The influence of Solov'yov is clearly discernible in Ivanov's philosophy of being, examined on pages 62–5. Solov'yov's assertion that man, severed from his relationship to the divine reality, is reduced to a 'disembodied act of self-knowledge', and his proof of the possibility of objective knowledge of entities outside ourselves, are echoed in Ivanov's contention that we owe the conviction that we exist to our belief in a higher, absolute reality. Clearer still is the link between Ivanov's vision of the artist collaborating with nature to realize the divine will (cf. p. 90), and the rôle of the artist in Solov'yov's cosmic order. It is indeed customary to point to Solov'yov as the spiritual father of the symbolist movement in Russia, despite his vigorous denials of paternity.[117] The determining influence of Solov'yov on the tenor of second-generation Russian symbolist *poetry* has been fairly widely acknowledged,[118] and the chief value of the analysis of Ivanov's aesthetic for the broader study, is that it makes it possible to identify the heritage of Solov'yov in the theories, as opposed to the poetry, of the Russian symbolists. The beliefs of, for example, Blok and Bely, in whom that heritage was most openly avowed, never corresponded exactly with Ivanov's, even at the stage in their development when the three had most in common, but each of them in his own way began his literary career under the spell of Solov'yov. What form the influence took, it is difficult to discover from the scattered, polemical and seldom very philosophical writings of the majority of the Russian symbolists. Although to a great extent Ivanov thought in isolation, he was alone in producing a sufficiently coherent aesthetic for it to be possible to distinguish clearly the legacy of the father of Russian symbolism; how widely our findings from the study of Ivanov apply to the theories of other Russian symbolists, will become apparent in the ensuing chapter.

Three

THE SYMBOLIST DEBATE

*La Poésie est ce qu'il y a de plus réel, c'est ce qui n'est com-
plètement vrai que dans* un autre monde.
Ce monde-ci, dictionnaire hiéroglyphique.

<div align="right">

CHARLES BAUDELAIRE

</div>

1. Introduction

(a) *The nature of the problem*

The preceding chapter presented Vyacheslav Ivanov's aesthetic
philosophy, analysed by topics in order to emphasize the fact that
his theory of art is only a part of a single system in which answers
are sought to ontological and epistemological as well as aesthetic
questions. In the present chapter the theoretical writings of other
symbolists are reviewed, as far as possible under the topic-headings
which proved appropriate to Ivanov. There is a great deal to be
gained by examining the ideas of the majority of the symbolists in
this way – by topics rather than by personalities – since we are deal-
ing not with a systematically expressed aesthetic, but with scattered
literary-critical writings and isolated essays on philosophical and
theoretical questions, produced very often in a spirit of polemic or
of self-defence. There was always a certain amount of disagreement
within the Russian symbolist movement, and its ideas were con-
stantly attacked from without, often on sufficiently valid grounds to
disturb the symbolists. For this reason, the review includes a repre-
sentative selection of the other voices that were to be heard in the
controversy surrounding the rise of the symbolist movement in
Russia, particularly after 1904.

The only personality who may seem to suffer by such treatment
is Andrey Bely; however, although Bely left a considerable body of
theoretical and philosophical writings, his method was charac-
teristically unsystematic, involving a constant polemic with him-
self as well as with others, which often generated deliberately

self-contradictory views. Any attempt to review his essays as a systematic body of theory, in isolation from the polemic, runs the risk of giving a false picture.[1] In the ensuing study his contributions to symbolist theory will therefore be treated in the context of the symbolist debate as a whole.

As in the preceding chapter, the point of departure will be an illustration. In this case the illustration will be a representative selection of attempts by Russian symbolist writers to give, directly or indirectly, a brief definition of 'symbolism'. From these will be drawn common features or points of contrast to provide a framework for detailed analysis of a variety of symbolist and anti-symbolist critical writings.

(b) Definitions of 'symbolism'

The following passages all contain either a definition of 'symbolism' (and in one case of 'the symbol'), or a characterization of 'good art' which, in its context, is equivalent to a definition of symbolism. Chronologically, they span the Russian symbolist movement from its comparatively early stages to its aftermath.

The first three statements are by Valeriy Bryusov, and date from the 1890s.

I The symbolist tries to arouse in the reader by the melody of his verse a particular mood which would help him to apprehend the general meaning – and this is all.[2]

II In symbolism poetry has for the first time attained its essential form, and has begun to act upon the soul by means that are proper to it. Symbolism is poetry's realization of itself, the conclusion of all its questing, a radiant crown to the history of literature, whose rays are projected into eternity.[3]

III The creative artist has one aim: to express his own mood, and to express it fully. General comprehensibility or accessibility is impossible to achieve, for the simple reason that people are different from one another.[4]

The fourth definition is from *The Battle for Idealism*, a collection of essays by Volynsky (A. L. Flekser), published in 1900.

IV What is symbolism? Symbolism is the fusion of the phenomenal and the divine worlds in artistic representation. From

this definition there emerge clearly the two principles neces-
sary for symbolist art. Like any art, symbolism is directed
towards the simple and plainly visible events of life, . . . to-
wards natural phenomena and the phenomena of the human
spirit. . . . The very concept of the *phenomenon* – the finest
poetic achievement of contemporary philosophy – has a
logical meaning only in the idealist view of the world, in
which the visible and the invisible, the finite and the infinite,
the sensibly real and the mystical are fused in an indissoluble
unity, as the inalienable signs of two interconnected worlds.
Not for one moment does symbolism exceed the legitimate
bounds of art. In the light of its ideas and concepts, it sees
phenomena and represents only phenomena. This funda-
mental characteristic of symbolist art indicates to us the
proper rôle of the writer's mystic state of mind in the cre-
ation of his poetic scenes and images. But art should never
become either an act of worship or an abstract philosophy.[5]

Bal'mont offered the following definition in a lecture to a Russian
audience in Paris, given in 1900.

V How may we define symbolism more accurately ? It is poetry
in which two contents are mingled, not forcibly but organi-
cally: abstraction masked and beauty made manifest, – they
combine as easily and as naturally as the water of a river
is harmoniously blended with the sunlight on a summer
morning. However, whatever hidden meaning a particular
symbolist work may have, its concrete content is always
complete in its own right; in symbolist poetry it has an in-
dependent life, rich in overtones.[6]

The next four passages are all by Andrey Bely, and were published
between 1906 and 1911, in the period during which the symbolist
movement reached its height in Russia and began to decline.

VI A symbol is the integument of a Platonic idea. Ideas, which
differ in their degree of intensity, enable us to see these suc-
cessive degrees as a progressive circumscription of the single
world idea. The concept of the world idea arises inescapably
if we allow, with Vladimir Solov'yov, the existence of
generic and specific ideas [a footnote here refers the reader
to Solov'yov's *Lectures on Godmanhood*]. . . . The world idea,

109

according to Solov'yov, can be equated with the World Spirit. We may regard the process of liberation and revelation of the World Spirit as an ascent from the original specific idea to the generic. This process – the process of objectivation of the Idea – suggests itself to us as a succession of ascending degrees. A ladder is formed stretching from earth to heaven, from the visible to the essential.[7]

VII The essence of art is an absolute principle which reveals itself through the particular aesthetic form. The meaning of art is a process of revelation whose purpose is dictated by this principle: it is possible to discern a purpose behind the formal relationship in creative art; and further – to link this purposefulness with more general principles. It must be remembered that if the question is formulated in this way, the resulting deepening of the implications of aesthetics means that art is inevitably made subject to more general norms; there is revealed in aesthetics a supra-aesthetic criterion; art at this point becomes not so much art ($\tau\acute{\epsilon}\chi\nu\eta$) as a creative revelation and transformation of the forms of life.[8]

VIII Art is the symbolization of values in images drawn from reality.[9]

IX The symbolist art of the last decades, as far as form is concerned, does not depart essentially from the methods employed by art throughout the ages. . . . Symbolist art, from the point of view of the ideas it contains, is for us in most cases not new . . . the novelty of so-called symbolism lies in its overwhelming abundance of the antique.[10]

'Ellis' (L. L. Kobylinsky) was perhaps the most naïvely dogmatic theorist of the Russian symbolist movement. He contributed regularly to *Vesy*. In 1908 Ellis composed a tirade against the 'symbolist theatre', in which he defined symbolism thus:

X The essence of symbolism is the ability to capture the subtlest overtones of things, without distorting their real appearance, the ability to understand . . . the persistent 're-gards familiers' of any thing in the great temple of Nature.

The essence of symbolism lies in *correspondences* [sic], the innumerable elusive *correspondences*, which can scarcely, and

in any event only partially be embodied, and which never coincide exactly with the world of appearances. The only means of conveying them has always been and will always be the lyrical poet's 'confuses paroles', whose most essential property, it must be acknowledged, is their inaccessibility to the average man, preoccupied with life's anxieties, their aristocratic exclusivity and their absolute unsuitability for any kind of social experiment. It is no accident that the outstanding symbolist poets of our age have been bad dramatists, and the greatest of them have not been dramatists at all.[11]

In 1911 the magazine *Apollon*, which became the vehicle for a campaign to restore order and clarity to symbolist art, published an article by Innokentiy Annensky, originally written in 1903 as a draft introduction to his first volume of poetry. It was entitled *What is Poetry?* and included the following passage:

XI Instead of the tedious hyperbole which in the poetry of the past was used conventionally to convey complex and often invented emotions, the new poetry seeks exact symbols for feelings, i.e. for the real substratum of life, and for moods, i.e. for that form of spiritual life which more than anything else establishes a bond between people, entering with equal justification into the psychology of the crowd and of the individual.[12]

In January 1914 a public discussion was held in St Petersburg on the problems of contemporary literature. The participants included Ivanov, Chulkov, and Anichkov; and Fyodor Sologub, who worked his contribution into an article published the following year in *Russkaya mysl'*. Here are several of the generalizations put forward in this article:

XII Art is more than a mirror held up to the accidents of life. . . . The soul of man always thirsts for live action, and live creativity, it longs to create within itself a world analogous to the outside, objective world, but constructed independently. The vital life of the human mind consists not only in observing objects and bestowing upon them expressive names, but in the constant endeavour to grasp the vital links between them, and to locate the whole of the phenomenal world on a single plan of universal life. Objects appear to our consciousness

not individually, but in their overall relatedness to each other. As our awareness of the relations between things grows in complexity, the whole content of the world around us is reduced to the smallest possible number of general principles, and each object is perceived in relation to the highest generalization that can be thought of. Thus all objects become nothing more than intelligible signs of certain all-embracing relationships. . . . Life itself no longer seems a succession of more or less diverting episodes and appears to the consciousness as part of a world process directed by the Only Will.

[The art of our day] is religious, because it involves tragic acts of willing. Tragedy is always religious, and there is only one will. Also, the art of our day is religious because it is symbolic, and symbolism always gives us a sense of the general interrelatedness of things; it refers all phenomena to a single general principle and like religion, endeavours to penetrate to the meaning of life.

The poet is again becoming a priest and a prophet, and in the temple where he performs his rites art should become a dome, it must become a vast shining dome over life.

. . . The art of our day in covering life with this magnificent dome, even though it is built not for life but for the purposes of art alone, none the less asserts life as a creative process. It asserts only that life which strives to be creative, and rejects that life which stagnates in the fetters of the prosaic.[13]

G. Chulkov's *Vindication of Symbolism* appeared in his book *Our Fellow-Travellers*, published in Moscow in 1922. He sums up his account of symbolism:

XIII Thus, symbolism is one of the means at the disposal of art, whose sense and significance lie in the cognition and celebration of reality, sometimes internal, sometimes external to the creative individual.

. . . On the aesthetic plane, the criterion of symbolism is the moment of correspondence between the thing represented and the general, the whole, the infinite which is revealed behind the thing.[14]

The most obvious feature common to all these statements is,

predictably, a preoccupation with what lies behind the external appearance of things. A concern for the values beneath the surface is present in the self-evident assertions of Bryusov and Annensky that the artist should capture and convey moods and feelings (I, III, XI). Both, however, make it quite plain that they are calling for something altogether more far-reaching than simply 'impressionism'. For Bal'mont, impressionism was to be distinguished from symbolism by its subjectiveness and fragmentariness: '. . . the impressionist is an artist who speaks a language of allusions to subjective experience, and by his fragmentary indications recreates in others an impression of what he is able to view as a whole.'[15] Bryusov in particular states (in passage I) what Bal'mont here implies for the case of the symbolist: that the mood aroused by the symbolist's 'impressionistic' technique is a stepping-stone to the understanding of an objective 'whole', a comprehensive meaning underlying experience.

The majority of the statements we are considering make a more explicit reference to a hidden meaning in the objects represented in a work of art. At its weakest, this is the 'subtlest overtones of things' (X) which according to Ellis (who takes his cue from Baudelaire's *Correspondances*) the symbolist artist should capture. Chulkov's 'the general, the whole, the infinite which is revealed behind the thing' is only slightly less vague (XIII). For Bely, it is the purpose of art to reveal 'an absolute principle' (VII), for Sologub – 'the highest generalization that can be thought of' (XII).

Sologub, however, stresses the relation between the object and the underlying principle: '. . . each object is perceived in relation to the highest generalization . . .'. The whole paragraph, with its insistence that art is a process by which the phenomenal world is related to a single principle, is virtually a paraphrase of Vladimir Solov'yov (cf. Chapter I, pp. 39–41, 47). Bely's process of purposeful revelation (VII) is kindred; indeed, Bely, Volynsky, and Bal'mont, as well as Sologub, all stress that the secret revealed by art is the bridge between the real and the divine or 'supernatural' world, between 'the visible and the invisible, the finite and the infinite' (Volynsky, IV). Bal'mont sees in symbolist poetry 'two contents mingled . . . organically' (V): his 'beauty made manifest', and his image of sunlight blending with water, echo Solov'yov's *Beauty in Nature* (cf. Chapter I, p. 39); Bely (VI) openly expounds Solov'yov's teaching

and describes symbolism as 'a ladder stretching from earth to heaven'.

Amidst the general agreement that art reveals a truth of a higher order behind the phenomenal world, there are several warnings that the representation of reality is still fundamental to art, even if the artist has a higher end in view. Volynsky emphasizes that 'symbolism is directed towards the simple and plainly visible events of life', as well as towards 'the phenomena of the human spirit', and that 'it sees phenomena and represents only phenomena' (IV); Bal'mont issues a reminder that the 'concrete content' of a symbolist work of art is always 'complete'. Bely makes the point in its most essential form: 'Art is the symbolization of values in images of reality' (VIII). These warnings to some extent represent a plea for truth to life, but there are signs that, at least for some symbolists, the object of their attention was not 'real life' in the conventional sense. Bely calls for 'a new attitude to reality' (IX) and speaks of art as 'a *creative* revelation and *transformation* of the forms of life' (VII). This recalls strongly Solov'yov's vision of art as a force transfiguring reality (cf. Chapter 1, p. 44), as does Sologub's view of life as 'part of a world process directed by the Only Will' (XII). When Chulkov discerns the meaning of art in 'cognition and celebration of reality' (XIII), he is employing the terminology coined by Ivanov in the same situation (he uses Ivanov's word 'ознаменование'; cf. Chapter 2, p. 52). But the reality which Chulkov knows and celebrates is 'sometimes internal, sometimes external to the creating individual', suggesting the idea of an autonomous 'reality of the imagination'. Sologub speaks explicitly of 'a world analogous to the outside, objective world, but constructed independently' by the artist within himself (XII), and further declares that art is an edifice 'built not for life but for the purposes of art alone', though it 'asserts life as a creative process'. Even in these brief statements there is evidence of a strong tension between, on the one hand, a principle of objectivity in which the idea of truth to reality is compounded with Solov'yov's notion of the subservience of art to a higher, objective truth residing *outside* man and the phenomenal world, and, on the other hand, recognition of the autonomy of the artistic imagination and the world it 'creates'.

In addition, the question of the function of art, and the value for man of the revelation it can bring of the true order of things, is

raised in the passages under consideration in strongly conflicting terms. For Annensky, art is an activity which 'more than anything else establishes a bond between people' (XI). This is strongly reminiscent of Ivanov's contention that true art is a form of 'communal action' (cf. Chapter 2, p. 97) in which the barriers that isolate the individual are broken down. Ivanov regarded art in this respect as a religious activity, and gave paramount importance to the tragic theatre, both for the common involvement of the spectators implicit in this art form, and for its significance as a development from Dionysian religious rites. Sologub's definition of symbolist art likewise suggests that the task of revealing 'the relations between things' is a common endeavour, and that symbolist art is an activity at least analogous to religion (XII). For Volynsky art is a religious activity to the extent that its aim is 'the fusion of the phenomenal and divine worlds', but he is careful to stress that it should never 'exceed the legitimate bounds of art' or 'become either an act of worship or an abstract philosophy' (IV). Bryusov, on the other hand, dissents from the common assumption that art unites people; one would assume from passage III that he saw creative art as accessible only to those who in some respect resemble the artist. The issue here is that of 'the poet and the crowd' which so vexed Ivanov (cf. Chapter 2, pp. 71 ff); and what in Bryusov was probably only a preoccupied aloofness may be seen carried to its logical conclusion in 'Ellis' for whom the 'most essential property' of (symbolist) poetic speech is its 'aristocratic exclusivity and . . . absolute unsuitability for any kind of social experiment', to the extent that the notion of symbolist theatre is abhorrent to him.

There are signs, then, of difference of opinion among the symbolists as to the scope of art as a human activity, and of a particular tension between the desirability of sharing the secrets revealed by art, and the difficulty of making them comprehensible to a wide public. This is plainly akin to the tension between individualism and the collective ideal which lies at the root of Ivanov's aesthetic (cf. Chapter 2, pp. 66 ff.).

A cursory analysis of thirteen fragmentary definitions has suggested a number of heads under which the treatment of 'the problem of art and reality' by the symbolists at large may usefully be examined. It has also (it is hoped) suggested enough points of affinity with the aesthetic system of Ivanov to justify the plan of

elucidating their scattered and unsystematic theorizing by reference to that system, which for all its difficulties, enables us to see the broadest implications of the ideas that were common in some form or another to almost all the Russian symbolists. In particular, it should by now be plain that, as in the case of Ivanov, the narrow question of the relation of art to reality in the symbolist aesthetic can only be examined in the light of the form which the symbolists *wished* this relationship to take, and of the not necessarily artistic expectations which they called upon art to fulfil. From the foregoing sample alone, we must assume that these expectations were high and often had only a tenuous connection with strictly aesthetic questions – if, indeed, they did not precede all aesthetic questions. Sologub looked to art for a revelation of nothing less than 'the meaning of life' (XII). Bely, it will be remembered, concluded that art is 'subject to more general norms' (VII), and indeed, in Vladimir Solov'yov's aesthetic, which was Bely's inspiration at this point, art subserves the higher spiritual and social organization of mankind. Chulkov was speaking for the majority of symbolists when he declared that 'the question of the aims of art is indissolubly linked with that of the meaning of life'.[16]

2. Art and life

(a) Literature and life

One of the criticisms most commonly levelled against the symbolists by their detractors was that they were out of touch with life. Even the more objective contemporary historians of Russian literature frequently took this view. L'vov-Rogachevsky in 1910 attributed the crisis in the ranks of the Russian symbolists to belated remorse at this failing, and declared that symbolist poetry had always been prompted by its literary antecedents rather than by 'life'.[17] In 1914, Ivanov-Razumnik voiced in the journal *Zavety* the opinion that symbolism was foreign to the Russian 'psychological type', whose characteristics were a hunger for down-to-earth reality and a devotion to the 'human, all too human'.[18] I. Gofshtetter, who as early as 1902 analysed 'decadence' as a psychiatric disorder, found that the decadents showed signs of a profound love of life, but reproached

them for 'the fictitious nature of their contact with life'.[19] In a very interesting and broadly-based analysis of symbolism published in *Russkaya mysl'* in 1905, S. Vipper recognized that symbolism was a widespread characteristic of human thinking, and a part of man's effort to order his vision of the world he inhabits, but declared that the contemporary symbolist movement had weakened itself by becoming abstract and despising 'concrete' reality.[20] There were some signs of the remorse to which L'vov-Rogachevsky referred, though few symbolists were as candidly self-reproachful as Bryusov in his review for *Vesy* of Sologub's *A Book of Tales* (1904):

> We 'decadents', practitioners of the 'new art', are all somehow divorced from everyday reality, from what people like to call the real truth of life. We go through life cut off from our surroundings (and this, of course, is one of our weakest sides) as if we were walking under water in a diving-bell, preserving a telephone link only with those outside our surroundings, at the surface, where the sun shines.[21]

However, it would be misleading to take Bryusov's remorse at its face value, since his standards were not those of the protagonists of traditional realism. The review quoted above extolled Sologub's closeness to life – a quality which the critics of symbolism most emphatically did not discern in the author of *Melkiy bes*.[22] Far from showing remorse, the majority of symbolists replied to their critics with the assertion that their art was, on the contrary, closely concerned with life. Even such a comparatively early 'decadent' as Ivan Konevskoy (I. I. Oreus) identified himself with the 'seething thirst for life' which he diagnosed as being responsible, along with an access of Christian conscience, for the disturbed state of the Russian mind in the last two decades of the nineteenth century,[23] and Zinaida Gippius saw art as belonging not only on the canvas, but in life.[24] Two émigré accounts of the Russian symbolist movement stress that for the symbolists, life was in some sense coextensive with art: Fyodor Stepun has made this point with particular reference to Blok and Bely,[25] and V. Khodasevich has observed that the symbolists' writings were as 'real' to them as anything in life.[26] Indeed, most of the symbolists writing in the mature phase of the movement went beyond the bare assertion that their art had implications for life in general. Amongst their critical writings there

may occasionally be found a reminder that poetry springs from life, not life from poetry,[27] or the wish for a form of art that would bring us nearer to life,[28] but more often we find not vague protestations of this kind, but attempts to formulate a theory of the social function of symbolist art, sometimes unmistakably in response to the traditionally Russian demand that art should further the highest aims of society. A very clear summary of the symbolist standpoint on this question is to be found in Modest Gofman's long introductory article to the *Book about Russian Poets of the Last Decade* which appeared under his editorship in 1909:

> Throughout practically the whole of the nineteenth century there has been a constant debate as to whether art should be for art's sake, or for life. This dispute, which in the 1880s was naïve, arises in our own time, but in a more serious and complex form, and gives a very important indication of the state of contemporary art and its future development. In the 1880s 'life' was understood in a material, or naturalistic sense, and the artist was able to preach 'art for art's sake' without any qualms. In our time, 'life' is taken to mean the whole of the spiritual as well as the material world, everything which *really* exists. And the symbolist answer to the question, without any doubt, is that art must be for life, or better – that life and art are one. The decadent tendency – the religion of aestheticism – gives a different answer to this question: for the decadent, art is divorced from life. . . .
>
> And just as the distinguishing feature of symbolism is its realism, (not on any account naturalism), so decadence is distinguished by its lack of realism, its illusionism, idealism, and complete loss of the reality of the religious and mystical experience.[29]

Gofman is here relating the symbolists' concern for life to the problems which exercised the radical critics of the latter part of the nineteenth century. More important still: in distinguishing between decadence and symbolism, he is dissociating symbolism from the aesthetic gospel of 'art for art's sake', with the crucial proviso that the 'life' with which art concerns itself shall be understood in a sense wide enough to embrace 'religious and mystical experience'.

Some specific support can be found for Gofman's dissociation of symbolism from 'art for art's sake'. Historians of Russian literature writing in the early years of the twentieth century periodically

expressed the view that the principle of 'art for art's sake' was intrinsically foreign to Russian letters, and that its brief appearance on the Russian literary scene in the 1880s was a necessary but transitory reaction against the attitudes engendered by 'naturalism' or 'positivism', and over-insistence on the social function of art. P. S. Kogan, for example, writing in Ovsyaniko-Kulikovsky's monumental *History of Nineteenth-Century Russian Literature* (published in 1911), maintained that even the 'monstrous extremes of aestheticism' which sprang up in the Pobedonostsev era did not fundamentally alter Russian literature's 'traditional rôle as a great social factor', but rather helped, by insisting on the freedom of artistic creativity, to counteract the publicistic excesses of the 1860s and 1870s.[30] According to Ivanov-Razumnik, the 1860s and 1870s were characterized by failure to recognize the autonomy of art, and the 1880s by a renaissance of the ideal of 'art for art's sake' attributable to the reactionary political climate of the period which favoured such an ideal; but the twentieth-century generation of writers, he held, steered a course between these two extremes and came closer to the ideal of a pure art which none the less serves the cause of humanity.[31]

S. A. Vengerov, in a revised version of a lecture on *Basic Features of the History of Contemporary Russian Literature* originally delivered in 1897, contended that 'our literature has never confined itself to the sphere of purely artistic interests', and that the most fruitful phase of Russian modernism was 'the synthetic period in which the old truth-seeking combined with new forms and a deeper attitude to the eternal problems of life'. In particular, he distinguished the second generation of 'decadents' (that is, those whom Gofman called 'symbolists') by their concern for social change.[32] Occasionally the symbolists themselves explicitly repudiated 'art for art's sake'. Blok in particular is repeatedly shown to have done so – by émigré as well as by Soviet critics.[33] Valeriy Bryusov, in his reply to Tolstoy's *What is Art?*, suggested that the formula had no meaning.[34] In his programmatic article which appeared in 1904 in the first number of *Vesy*, he declared that 'art for art's sake' was dead art, withdrawn from its sources in life, and its practitioners, in order to overcome the discrepancy between their theory and the facts of creativity, had to do violence to the meaning of the word 'beauty'.[35] In an article entitled *The Bread of Life* (1901) Zinaida Gippius described 'art for art's sake' as 'a snake biting its own tail, a confining vault without a

door'.[36] Georgiy Chulkov evidently discerned the same pattern as Kogan, Vengerov, and (in particular) Ivanov-Razumnik:

> The principle of 'art for art's sake' is just as naïve as that of the *usefulness* of art. We have already graduated from aestheticism. *The World of Art* and the pioneers of Russian symbolism have performed their important and significant cultural task. The epigones of decadence may continue to repeat the elementary stages, and the 'critics' of the gutter press may debase the ideas of extreme individualism, but Russian society will continue to look for a link between art and life.[37]

The attitude to 'art for art's sake' that is indicated here has important implications for the controversy over symbolist 'realism' which will be examined in this chapter, for it amounts to a (quite unoriginal) assertion that the symbolist artist should continue to uphold the autonomy of creative activity, and still remain involved in life. This assertion was by no means confined to the writers mentioned above; M. Nevedomsky in 1903 called for an art that should be neither 'civic' nor 'pure' but 'free',[38] and Sologub twelve years later wrote that . . .

> . . . 'Art for life' and 'art for art's sake' are equally incomplete forms of art.
> The art of our times is once again taking the broad road of free creativity. . . .[39]

E. A. Lyatsky found that it was precisely the Solov'yovian principle of the 'transformation of life' which rendered the distinction between 'art for life' and 'art for art's sake' meaningless.[40]

The attitude of Gofman, Kogan, Ivanov-Razumnik and Vengerov to this question was informed by the view, generally accepted in their day, that Russian literature had a 'traditional rôle as a great social factor', as Kogan expressed it.

Vengerov, in the lecture cited above, suggested that the Russians had always channelled into literature the energies which in other political circumstances would have found expression in organized public social and political activities.[41] M. Nevedomsky, writing in 1903, expressed the same view, adding that 'outside literature, Russians did not live, one might say. Literature served as a surrogate for civic life, literary facts were the only social facts.'[42] Prince Pyotr Alekseyevich Kropotkin, expounding the Russian situation to the

English-speaking world in 1901, took an identical line,[43] and somewhat later in a very 'solid' work published in the official *Journal of Education* in 1917, V. N. Rossikov observed that the history of Russian literary criticism was to all intents and purposes 'a history of the development of social awareness in Russia'.[44] S. Makovsky, who was important in the symbolist movement as editor of the periodical *Apollon*, described this characteristic of Russian letters in similar terms, though he did so in order to decry it.[45]

It should be borne in mind that the often contradictory attitudes of the various symbolist factions to the social function of art were formed in constant awareness of this widely held view, and also that the symbolists were in most cases loath to dissociate themselves from the Russian literary past. There are signs, indeed, that their anxiousness to show that they 'belonged' in the Russian literary tradition was an important factor conditioning their concepts of the rôle of art in society, and their theorists were acutely sensitive to the criticism that the symbolist movement neglected the burning social and political issues of the day.

The symbolist position on this question became the subject of lively controversy. P. S. Kogan pointed out that the poetry of the modernist movement which flowered in the 1880s and 1890s had to come to terms sooner or later with the social tradition in Russian literature and the 'stern civic demands made upon poetry by progressive journalism',[46] whilst E. A. Lyatsky (aroused partly by the work of Makovsky referred to above) declared that as soon as the modernist movement threw up a few genuine talents, the 'lost link with the broad traditions of Russian literature' would be restored.[47] Most objectors to the symbolists saw less hope of their returning to the fold.

(b) *Individualism and the tradition of social commitment*

The controversy was focused at a comparatively early stage by the publication of two miscellanies, the one a counter-manifesto to the other. *Problems of Idealism* [48] was published in 1903; its link with modernism in literature and the symbolist movement was indirect, its contributors being idealist philosophers, only one of whom (N. A. Berdyayev) was at all closely connected with literary symbolism. It contained articles investigating the application of idealist

philosophy to questions of ethics, history, progress, and freedom of thought. It provoked an almost immediate rejoinder from the 'realist' critics [49] in the form of a collection of essays entitled *Outlines of a Realist World View*,[50] whose contributors perhaps overestimated the connection between *Problems of Idealism* and the 'modernist' movement in literature. Two contributions on specifically literary topics raised objections to the view that art is independent of social issues. B. Friche claimed that no work of art was independent of the 'social and psychological medium' in which it originated [51] and V. Shulyatikov inveighed against what he saw as attempts to legalize the retreat from reality by insistence on the autonomy of art. He found particularly blameworthy Nevedomsky's article in *Bozhiy Mir* of April 1903 (cited above) and Skabichevsky's *New Currents in Contemporary Literature* (examined in Chapter I).[52] Most critics connected with the symbolist movement, on the other hand, found *Problems of Idealism* remarkable for its relevance to practical questions; D. Filosofov declared that 'the most characteristic articles in the book are nothing if not slashing feuilletons on burning topics of honest-to-goodness Russian reality'.[53]

The reactions of the theorists of symbolism to the constant reproach that they had abandoned the social values of the Russian literary tradition were frequently ambiguous and occasionally contradictory, as might be expected in view of the tension they felt between the individual and communal ideals. Faced with the ambiguity inherent in the desire to serve society with a 'free' art, their opinions covered a spectrum from the aloofness of the aesthete to an ideal of the union of mankind in a new form of religious society, and the quasi-political commitment of the movement known as 'mystical anarchism'. However, we may be certain that in the climate of educated Russian public opinion in which they worked, very few of them felt they could afford in their theorizing about art to adopt the standpoint of the thoroughgoing aesthete and ignore the wider social issue. As early as 1893, N. K. Mikhaylovsky, criticizing Merezhkovsky for escaping in the wake of the French symbolists from contemporary social realities, took the view that Russian society was too 'young' to become so disillusioned with and afraid of life.[54] Symbolism in Russia did indeed exhibit a concern, however utopian, with social realities; it is as well to heed the reminder of V. Asmus that 'Russian symbolism arose as a movement which

undertook to find a solution not simply to formal problems of art, but in the first place to practical problems – philosophical and historical, ethical, social and political'.[55] Some critics of the movement discerned an intensification of its concern for social and political issues after the 1905 revolution,[56] although the editors of *Vesy*, when the periodical ceased publication in 1909, expressed their satisfaction that it had survived the 'grave social crisis of 1905' without modifying its position.[57]

The ambiguity of the symbolist standpoint on this issue is betrayed most often by a particular kind of reservation about the link between art and the real world, exemplified by Bely in *The Meaning of Art* when he asserts that 'any aesthetic is inevitably linked with fundamental concepts of reality', but adds that aesthetics should be independent of 'the prevailing world-views'.[58] At one extreme the assertion of the independence of art was taken to its logical conclusion by Ellis, who took issue with Vengerov's words (quoted at note 32), and declared the miscegenation of aesthetics and politics to be a distasteful manifestation of primitive backwardness.[59] Elsewhere Ellis argued that, if the essence of artistic creativity lies in contemplation, which is a gift of the few, art cannot be 'collective' or have a social meaning.[60] Those of the symbolists who took the opposing view that literature should serve society, were all, significantly in some degree influenced by the teaching of Solov'yov, and their concept of the service their work should render to society was in two important respects fundamentally at variance with the traditional Russian view of the social usefulness of art. In the first place, they were insistent that the rôle of literature in society was not utilitarian but 'prophetic'; the symbolist writer's prophetic words might represent 'a higher form of didactic art'[61] but were not concerned with the conventional preaching of social and political ideas. Secondly, for those symbolists whose thinking was influenced by Solov'yov's cosmogony, 'society', far from being the sacrosanct goal of human activity, was only a stage in human striving towards a higher ideal: union not among men, but of mankind with god. Bely, for example, reviewing in 1904 a book by the German Neo-Kantian Windelband, wrote:

> Society cannot be the last link in a teleological process. It must itself have a universal aim. Otherwise the meaning of the normative principles, for which we were of necessity bound to abandon

123

hedonism and eudaemonism, is weakened. In this Windelband adopts a position identical to that of V. Solov'yov.[62]

However, once these reservations have been made, it must be recognized that the 'religious' wing of Russian symbolism, a group which included Merezhkovsky, Ivanov, Bely, Chulkov, Sologub, and (for part of his career) Blok, were in their own way sincerely concerned with the social realities of their day and felt that their art was, or at least could be, a positive social activity, even though their opponents sometimes considered their renunciation of individualism to be purely nominal and based on a misunderstanding of the true nature of social commitment.[63] A relatively impartial critic of the symbolists, writing in 1906, recognized that, despite their endemic vice of self-conscious isolation, they had begun to display 'a tendency to come out into the open', and even signs of a dawning concern for civic and social matters.[64] Georgiy Chulkov, in his *Vindication of Symbolism*, protested that he could not understand why the symbolists had been reproached with indifference to society. The poet, he claimed, served society, but not in the conventional sense, and there was no need to saddle him with everyday concerns. More important still, Chulkov called for a form of social content in art 'which, whilst uniting man with man, would not, however, lessen the stature of the individual as such'.[65] Just as Bely asserted the independence of artistic creativity despite its ultimate commitment to serve a higher end (see note 58), Chulkov here asserts the independence of the individual despite his necessary participation in social activity. The contradiction in both instances between independence and commitment is surely something one might expect to have permeated the Russian symbolist theories. For though Asmus may be perfectly right in pointing out that the Russian symbolists accepted by and large the ideal of service to the community through literature, the movement from which they drew their early inspiration was a movement for the liberation of art from tendentious appeal, and the assertion of the values of individualism. Indeed, those Russian symbolists who were closest to the movement's original French models, and furthest from Solov'yov's community ideal, often asserted their 'individualism' at the expense of the social ideal. Ellis had no doubts whatsoever that art was matter for exceptional individuals only: 'Art is essentially a concern of the few and for the

few.'[66] Bryusov expressed strong reservations about the idea that art is useful as a communal force uniting individuals,[67] and though he began his *About Art* by saying that he shared with Tolstoy the basic assumption that art is a 'means of communion', he concluded, in language drawn directly from Schopenhauer, that:

> Man, as an individual, is separated from others as it were by insuperable barriers. The 'Ego' is self-sufficient, a creative force which derives its whole future from within itself. The world is as it appears to me.[68]

Others were quick to notice the vein of anti-social feeling in decadence and symbolism. In 1905, F. Makovsky (not to be confused with S. Makovsky) observed that 'decadence' had so far renounced the Russian heritage as to have abandoned any pretence of social commitment and gone over to the preaching of extreme egoism.[69] Chulkov, who abhorred the egoistic and solipsistic extremes of the symbolist movement, guessed at the reasons for their occurrence:

> Frightened by mechanistic social commitment, people are renouncing any kind of social commitment; disenchanted with the affairs of the world, they pipe in solitude, not without a certain half-witted self-satisfaction.[70]

The writer of an editorial in *Pereval* in 1906 felt that the individualists had been driven to extremes by the howls of uncomprehending criticism with which the utilitarian majority had greeted their first assertions of the freedom of the creative individual, but he claimed that the balance had been restored.[71] Sologub put the same interpretation on the treatment by Russian critics of the movement for artistic individualism. Individualist poetry, he wrote, had horrified Russian critics because it seemed anti-social, which it was not, for 'social commitment itself has a value only when it is based on a clearly expressed recognition of separate individualities'. He saw the movement for individualism as an early, freedom-seeking stage on the path towards 'democratic symbolism, which thirsts for collectivity'[72]

In Russian symbolist theory, the question of the social function of art was more often than not contingent upon certain other issues, slightly different in their emphasis, such as that of 'individualism'

in the examples given above. These are, in fact, the very issues which preoccupied Ivanov in the elaboration of his aesthetic.

Ivanov's aesthetic was devised in order to remedy the condition of man as he saw it: man imprisoned in the vicious circle of relativistic knowledge, isolated, thirsting both for communion with his fellows and for the fullest realization of his individuality. His quest was for a form of activity that would satisfy both needs, and this was to be found in a revitalized religious art which restored to mankind faith in the bond between the mortal world and eternal spiritual values. The preoccupations which underlie Ivanov's system were common in one form or another to all the Russian symbolists; though none was able to produce a comparably ordered doctrine, the discussions in the symbolist forum, and the dialogue with the enemies of the movement, revolved round the same characteristic themes – isolation, individualism, 'collectivity', the link between art and religion, the special rôle of the theatre in uniting people in a common action, and the short-lived theory of mystical anarchism. All the symbolists were acutely aware of the barriers separating 'the poet' from 'the crowd'.

An extraordinary passage of almost incomprehensible density from a collection of Chulkov's articles published in 1912 relates the issue of social commitment to all the most important topics in Ivanov's cluttered aesthetic philosophy:

> Scientific socialism, asserting economic interest as the stimulus to struggle and progress, divines only one facet of religious evolution. If we raise the curtain of formal scientific method, we see life in its entirety, we see the magic that suffuses the whole universe. The social struggle takes on a theurgic meaning: the very earth itself strives for liberation.
>
> But the theme of social commitment is a trap for the unwary. Not every social act can be included in the chain of historical phenomena which forms a living bridge from multiplicity to unity, from the transitory to the absolute. The social struggle takes on a theurgic meaning only if it is Dionysiac.[73]

This passage is significant not for any sense that might be wrung from it, but as a particularly good illustration of the way in which, in the writings of the symbolists, the argument about the social commitment of literature transposes into arguments which may

appear to have little direct connection with either aesthetic or social theory. Asmus is probably describing the same process when he writes that the ambiguity of Ivanov's theory of 'collective' art is partly due to his replacement of the concept of social commitment by its 'aesthetic phantom'.[74] It is this 'aesthetic phantom' that we must now examine in the case of the symbolists at large.

(c) *The retreat from individualism*

In Ivanov's view, man was condemned to isolation by his adherence to a relativistic theory of knowledge; other symbolists also spoke of isolation, but not as a rule in such a philosophical context. The reading public who received the poetry of the earlier generation of Russian symbolists was made amply aware of a romantic attitude of withdrawal into solitude, particularly in the case of Bal'mont and Bryusov.[75] A fairly typical expression of this attitude can be seen in Zinaida Gippius' complaint that men had ceased to communicate with each other, despite their thirst for communion, as a result of their preoccupation with their own inward state.[76] In her foreword to the 1904 collection of her verse, she voiced feelings of diffidence at launching into the world yet another volume of verse that few would understand since '. . . the modern poet has refined and particularized himself, and cut himself off as a man (and, of course, as a poet) from his neighbour, has retreated not even into individualism, but into a narrow subjectivism'. However, she nursed the paradoxical hope that the modern poet's lonely path would bring him eventually to a new kind of community with his fellows.[77] G. Chulkov spoke of a tradition of life-weary isolation in Russian poetry which had originated with Lermontov and come down by way of Tyutchev to the poets of his day.[78]

When the symbolists raised the issue of individualism, they were concerned less with withdrawal than with the breaking of isolation, though they were, it is true, asserting the value of every individual's private world, and in a certain sense (which critics of the movement were quick to seize upon) its self-sufficiency.[79] Their detractors associated their stand on this point with the resurgence of idealist philosophy at the turn of the century, particularly with its manifestation in *Problems of Idealism*. Shulyatikov in *Outlines of a Realist World View* held 'the sadness and longing of solitary souls'

responsible for the anachronistic league of idealists of which he was an amazed witness.[80] P. Novgorodtsev, one of the idealist philosophers in question, claimed that contemporary idealist philosophy underlined the importance of individuality and the dignity and rights of the individual, and that it had, by virtue of this, common ground with all 'live and progressive' trends of thought of the day.[81] On the other hand, at least one marxist critic denied any but the most superficial common ground between the marxist and the modernist (to him, therefore, idealist) championship of the individual – P. S. Kogan found that:

> . . both share a common ideal of the free individual. But marxism arrives at free individualism through society, modernism – by setting it against society.[82]

Sologub, who traced in the Russian symbolist movement a progression from an individualistic to a democratic phase, complained that the individualistic trend of Russian modernism had been interpreted mistakenly as antisocial by those who had failed to grasp that 'society itself has a value only when it is founded in the clearly expressed awareness of separate individuals'.[83] On the other hand, left-wing opinion was generally that the brand of idealism represented by *Problems of Idealism* and associated with symbolism was not simply antisocial, but even politically reactionary.[84] The question of an evolution within the symbolist movement towards a greater degree of social involvement became the subject of a dispute which laid bare the ambiguity of the symbolist concept of individualism. Commentators of various hues associated in particular the early 'decadent' phase of symbolism with the expression of extreme individualism, and recognized that among the later symbolists there was some attempt to modify the exaggerated position adopted by their predecessors. An example of this position is Konevskoy's pronouncement *On the Question of the Poet and People*:

> There can, of course, be no question of any common soul of the people. Only individuals have living souls. . . .
> The 'universally human' is a purely negative, not a positive value. The 'universally human' is only a reflection and an echo of the individual personality.[85]

Ivanov-Razumnik, writing in 1915 about Andrey Bely, remarked that the older generation of decadents had passed through a 'heroic

period' of extreme individualism and resistance to the demands of society, which had brought the movement to a dead end from which the younger generation were forced to seek a way of escape.[86] In 1910 L'vov-Rogachevsky took issue with Ivanov's assertion in *By the Stars* that decadence was yielding place to a school of thought which called for a greater involvement in the world at large; he retorted that the symbolists would never shed the 'ultra-individualism' which was fundamental to their way of thinking.[87] In an article in *Russkoye bogatstvo* in 1913, A. Red'ko attempted to explain the significance of 'decadent' individualism: he maintained that the decadents had become disillusioned by the search for truth in the late-nineteenth-century climate of positivism, and had sought refuge in the apparent certainty of the unlimited right of the individual to free self-expression.[88] Within the symbolist camp itself, a contributor to *The Golden Fleece* in 1908 observed that the rival periodical *Vesy* now disowned 'decadence', which was characterized by a mood of extreme individualism, and preached in its place 'pure symbolism'.[89] More characteristic of the second generation of Russian symbolists is, indeed, the idea that symbolism became in Russia a means of overcoming narrow individualism. According to Sergey Gorodetsky, the extreme individualism of the 'decadent movement' had been necessary for the advancement of poetry, but it had prevailed longer than was necessary.[90] G. Chulkov associated the striving of the symbolists to overcome individualism with the heritage of Tyutchev and Solov'yov, and maintained that all the symbolist poets except Sologub[91] subscribed in some form to 'a principle which excludes decadence, and asserts a universal principle, the principle of a new social contract based on love, the cult of the Eternal Feminine and "mythmaking" – everything which, in my view, can be classed as "mystical realism"'.[92] He saw in this tendency the vindication of individualism:

> The vindication of individualism lies in the chosen way of symbolist poetry. Tyutchev is one of the elect. Though he proceeded from individual, isolated experiences, Tyutchev was nonetheless able to build a secure bridge to universality and objectivity: he was the first Russian symbolist.[93]

The paradox which Chulkov describes here is strongly reminiscent of Ivanov's 'pathos of individualism' (cf. Chapter 2, pp. 67–9),

and elsewhere Chulkov takes up explicitly Ivanov's teaching on the 'crisis of individualism' and the value of mythmaking; in *The Veil of Isis* he equates Ivanov's 'idealistic symbolism' with 'decadence' and 'extreme individualism', and points to the way in which such a weakness can be overcome:

> But the true lyricist escapes from the circle of isolated individual experience.
> ... False decadent individualism supposes that the assertion of individualism lies essentially in the affirmation of separate, isolated random moments. ...
> But true individualism cannot be satisfied with desires that lead astray and the transitory play of shadows: essentially the affirmation of individuality lies in the discovery of its link with the world. The individuum only becomes an individual when he masters himself, remembering Nietzsche's words: man is a bridge, not an end in himself.[94]

Ivanov's theory of the 'tragic antinomy' between the particularity of the individual and his allegiance to the higher order of things (which allegiance Chulkov here refers to as a 'link with the *world*', meaning 'the macrocosm', not the world of everyday reality – cf. the passage cited on page 133) did not make many such disciples, but signs of a similar unease and confusion surround the discussion by the symbolists of the issue of individualism. In an article in *Vesy* entitled *Nietzsche and the Contemporary Crisis*, G. Tasteven declared that Nietzsche's 'martyrdom on the cross' bound the writers of his day to overcome individualism, which could never bring about the longed-for union between the 'ego' and the 'cosmos', and so to hasten the coming of a 'new organic age'.[95] Such attitudes may have had their origins in Solov'yov's criticisms of 'decadence'. For example, in 1890, in a review of Minsky's *In the Light of Conscience*, Solov'yov diagnosed in Minsky the spiritual sickness of his age, whose symptom was 'the assertion of his *ego* as an absolute, in total disregard of the real and moral link which makes his *ego* an inseparable part of the great whole'.[96]

The intimation that individualism was an ambiguous value, that the individual needs to preserve a link with the universal cosmic order, spread beyond the circle of those influenced primarily by Solov'yov. I. F. Annensky perceived two levels of interaction between the individual and 'life' –

Apart from his inescapable participation in life, every one of us has his own, purely contemplative communion with life. . . .

. . . Here every one of us . . . feels himself not only the Lord of Life, but its very sun. . . .[97]

Benois in 1906 contributed to *The Golden Fleece* an article on 'artistic heresies', to which category he assigned individualism, for reasons which summarize the symbolist attitude to the question:

Individualism, taken to its logical conclusion, is a heresy because it deflects creativity from freedom and light. By 'freedom' I mean the mystical principle of inspiration, i.e. 'free submission' to a supreme, super-human principle.

. . . Individualism is a heresy primarily because it denies communication.[98]

Even Bal'mont, who epitomized the tendency to stand at the centre of a personal solar system, and who could write in 1904 –

The heights of awareness and creativity follow the same great principle of individuality, isolation, solitude, separation from the universal. . . .[99]

– was by 1908 praising Walt Whitman for his individualism in the following terms:

He is a poet of individuality, of the boundlessness of Life, and of the harmonious link of all separate individualities with the World Whole.[100]

It is clear that the symbolists of Ivanov's generation, as opposed to the earlier generation of 'decadents', felt the need to temper the doctrine of individualism with a summons to some form of collectivity. This need (and it was to art, it must be remembered, that the symbolists looked for its fulfilment) appears in at least three guises: as an attempt to find a force that would bind each individual to a common, absolute world order; as a longing for a universal means of communication among men; and as a desire for a common bond between the artist and the 'people'. Although these are all, in effect, reflections of one and the same wish (for art to 'belong' in the community of man), expressed with three different emphases, it seems best for the sake of exposition to treat each as a separate issue.

3. Art and communication

(a) The call to collective action: 'mystical anarchism'

In its first form, the need for collective activity found its fullest expression in the shortlived movement known as 'mystical anarchism', which attempted to provide a programme that would eliminate or rise above the contradiction inherent in the symbolist attitude towards individualism.

According to Ivanov-Razumnik, mystical anarchism sprang from the idealist philosophy represented by Berdyayev, in particular from his 'metaphysical ultra-individualism', his assertion that individualism would triumph in a utopian 'union of mankind, based on inner freedom and love, and not on outward organization'.[101] Bely described mystical anarchism as 'a sign of the ultimate degree of disappointment with the positivist solution to problems of the meaning of life',[102] whilst P. Yushkevich (a marxist critic) attributed its rise to a tendency among Russian mystics after the 1905 revolution to toy with extreme left-wing opinions.[103]

The adherents of the movement were for their part never so precise about its origins. The programme which prefaced the first volume of *Fakely*, the organ of the mystical anarchists, concludes thus:

> We raise our torch in the cause of the assertion of individuality and of the free union of men, founded in love of the future transfigured world.[104]

The theorist of the movement was G. Chulkov,[105] who published in 1906 a collection of essays on mystical anarchism with a preface by Ivanov to which reference has already been made (cf. Chapter 2, p. 70). His definition of mystical anarchism can be briefly paraphrased as follows.

'Anarchism' is the doctrine of the freedom of the individual from 'external binding norms'. By 'Mysticism' is understood irrational experiences belonging to the sphere of music, which 'does not reproduce phenomena, but is an immediate representation of the "Ding an sich"'. It is through 'mystical' experiences that the individual realizes his oneness with the world (i.e. the *Weltall*, not the everyday world). Mystical anarchism is 'the doctrine of the means of ultimate liberation, which embraces the *ultimate assertion of*

individuality in the principle of the absolute'. Nineteenth-century anarchists failed to discover this 'musical' principle, and to realize that 'plainly we must turn to the Earth, to the "new realism", renouncing depersonalized love, as well as the false, artificial egoism of Stirner'.[106] To Solov'yov we owe the discovery that life is 'a process of continuous mystical celebration, constant joyful communion with the truly real fundamental principle', but Solov'yov unfortunately was unable to grasp the musical 'immediacy' and totality of understanding by which alone the principle of love can be comprehended.[107] The mystical anarchists reject the chaotic world of the here and now; they accept (and pledge themselves to 'love', in a religious sense) the vision vouchsafed them by art, of the world of the future, transformed in the light of the divine principle.[108]

Mystical anarchism gathered little support, and was attacked above all from within the ranks of the symbolists. In a scathing review of *Fakely*, Bryusov dismissed the mystical anarchists' programme as self-defeating:

> The formula 'I reject the world' throws overboard the whole of the raw material of artistic creativity – the whole world.[109]

Zinaida Gippius described the movement as a spicy blend of mysticism and decadence with Solov'yov's cult of Sophia and Ivanov's 'orgiasm', seasoned with socialism.[110] In the view of Ellis, the mystical anarchists distorted symbolism and forgot about socialism,[111] two elements which he saw in any case as incompatible (see note 59). It is interesting that Ellis's concept of the goal of art, which the mystical anarchists seemed to him to thwart, was ultimately very similar to theirs – the artist's task, he declared, is to gradually discover 'the One, as yet Unknown God'.[112]

There are signs, however, that outsiders identified the symbolists with the mystical anarchists more widely than the former would have wished. In a piece written in 1914 for the newspaper *Tovarishch*, D. Filosofov declared that all symbolists and decadents were sufficiently alike to be classed together as mystical anarchists, and that their attempts to differentiate amongst themselves were a purely domestic affair. He claimed that Blok as well as Ivanov was in at the birth of mystical anarchism, and that both were 'in complete solidarity with G. Chulkov'.[113]

Though ultimately based in Solov'yov's religious philosophy,

mystical anarchism laid more emphasis on the individual's participation in the 'spiritualization' of the world, and on the special forms of understanding this necessitated, than on the nature of the ultimate religious goal.[114] Those who looked to religion as the force that could engender a new sense of community, for the most part felt the mystical anarchists incapable of the 'true religious feeling' which alone could inspire a community.[115] The characteristic view of the group of religious thinkers led by Merezhkovsky, to which Filosofov belonged, was expressed by Zinaida Gippius:

> . . . we want a religion which would vindicate, sanctify and accept life. A religion not of solitude, but of communion, of the union of the many in the name of the one.[116]

(b) The religious ideal of community

There was less unanimity, however, as to where symbolist art stood in relation to the common religious endeavour. When Sologub defined the art of his day as religious (in the passage quoted on p. 112), he clearly meant that art is a parallel to religious activity, pursuing the same end by analogous means. Volynsky's view (cf. passage IV) bore even more unmistakably the stamp of Solov'yov, but also carried an explicit warning against confusing art with worship. He summed up his position thus:

> When it has restored its link with religious consciousness, poetical consciousness will one day become as it was in ancient Greece, man's finest activity.[117]

Modest Gofman was apparently following a widespread fashion when he dwelt on the significance of the etymological connection between symbolism and religion (the Greek '$\sigma\upsilon\mu\beta\acute{\alpha}\lambda\lambda\epsilon\iota\nu$' being equivalent to the Latin 'religare', whose meaning – 'to join together' – answered to what the symbolists most wished to stress in the idea of religion),[118] though Ivanov had pointed out three years earlier that 'religio is so often interpreted in the sense of "joining" only by virtue of a false etymology, which was, it is true, already general at the time of the Christian apologists, who sought in this word the symbolic significance of "community"'. However, Ivanov was careful to add that he welcomed the implied association between the principles of religion and community.[119] Chulkov

adduced a different classical derivation to link symbolism with religious endeavour: '... we must now understand this term [symbol] partly in the sense which the ancients gave to it. The worshippers of Demeter meant by "$\Sigma\acute{v}\mu\beta\alpha\lambda ov$" a sacred sign for the mystery of the divinity.'[120] Zinaida Gippius, in an introduction to her verse, suggested that the most important human need is for prayer, of whatever form and to whatever deity, and that poetry is one of the possible forms of prayer,[121] whilst Ellis referred to symbolism as 'this new religion of humanity'.[122] It seemed to some contemporary critics that symbolism would naturally become for its adherents a creed in the religious sense; M. Nevedomsky, writing in 1908, observed that French 'decadence' grew from a search for a synthetic 'religion of life', and that it was now Russia's turn to take up the search.[123] But Zinaida Gippius had spoken out against the danger of idolizing art and making it an end in itself, associating this vice with the decadents and the theory of 'art for art's sake'.[124] Clearly the religious movement among the Russian symbolists had no intention of turning art into a new form of religion, and its representatives were prepared to protest against signs of such an attitude among the earlier 'decadents' and 'aesthetes'; Berdyayev, too, spoke of a 'decadent religion of aestheticism', and both he and Nevedomsky described the phenomenon as a first, extreme reaction against positivism.[125] Ellis's remark cited above sets him apart by this token as an epigone of 'decadence' in the later period of religious symbolism, but Bryusov took strong exception to Ivanov's thesis (as he interpreted it) that 'art should serve religion', and named Ellis and Bely as supporters of Ivanov on this issue.[126] Bely's view, at least in 1907, was not altogether consistent. He wrote in *The Meaning of Art* that art 'has no meaning other than a religious meaning', but that it is not subject to religious dogma, except when it is moribund.[127] At the same time, he recognized that when art is 'religious' in the sense that it is pledged to the revelation of an absolute principle, it is 'inevitably made subject to more general norms' (cf. the passage from *The Meaning of Art* quoted on p. 110, VII). For Ivanov, art stood in a deeper and more organic relationship to religion than simply that of its handmaiden (cf. Chapter 2, pp. 82 ff.), but, as the champion of the autonomy of art, he would have been justifiably alarmed by remarks such as those quoted above. It is interesting, too, that Bely's attempt to link art with religion, while preserving it from

135

subordination to dogma, incensed Filosofov, who pointed out that true religion, if it is the quest for 'eternal absolute values' (and the symbolist search for the meaning of life was just such), *necessarily* involves dogma.[128]

Broadly speaking, the question of the subordination of art to religious aims took second place to considerations of the 'collective' function of both art and religion, and on this issue the outside critics of symbolism had much to say; in many cases, they commented sympathetically on the closeness of the symbolists in this respect to a long-standing tradition of religious feeling in Russian literature. S. A. Vengerov wrote that the most appealing aspect of 'our Hellenic-Bacchic decadence' was its religious questing. He defined religious feeling as a particular 'exalted state of mental organization', which the symbolists shared with Belinsky, Dobrolyubov, and Chernyshevsky.[129] Yushkevich in *The Decay of Literature* likewise described the radicals of the 1860s as being religious in the sense that religion is a feeling of belonging to a higher collective entity, and criticized the religious thought which informed the symbolist movement, not for its religiosity, but for attempting to replace genuine social contact by illusory links with the people through such abstract notions as God, Christ, and the Absolute.[130] Ivanov-Razumnik, too, assigned the symbolists to a place in the nineteenth-century Russian tradition by their part in a process of change in the Russian religious consciousness, a fluctuation between the 'religion of life and man' and the 'religion of God'.[131]

In symbolist discussions of 'collectivity' the emphasis was always apt to shift from social organization to communication amongst men, and the idea of 'communion' in religion was similarly treated: Zinaida Gippius provides a good example of this:

> Until all of us, writers and readers alike, find our common God, or at least grasp that we are striving towards Him, – the One God – until then, our prayers – the songs of our poets – which are alive for each one of them – will be incomprehensible and of no use to anybody.[132]

It is therefore surprising to find that myth (which in Ivanov's philosophy was religion in its essentially communicative form, cf. Chapter 2, pp. 82–3, 85 ff.) received relatively little attention from other symbolist writers. Sologub in 1915 restated, in terms

reminiscent of the opening of Ivanov's *Two Elements* (cf. Chapter 2, pp. 50–1) the conditions under which symbols may generate myth.[133] Sergey Gorodetsky, who between 1906 and 1909 was strongly influenced by both Ivanov and G. Chulkov, wrote in 1909 of a myth-making movement in Russian literature, consisting of (apart from its instigator, Ivanov) Aleksey Remizov and himself. He denied Chulkov a place in the 'movement' on the grounds that he did not accept all the 'principles of mythmaking'; Gorodetsky's observation is correct, for in *The Veil of Isis* Chulkov took over from Ivanov the idea of mythmaking, but reversed its emphasis: he was far more concerned with the part myth might play in the formation of a community of individuals, than in its implications for poetic communication.[134] But Gorodetsky's point in writing about the myth-making movement was to declare it still-born; when in 1909 Ivanov's *By the Stars* appeared – the work in which were given the 'fundamental principles of mythmaking' – it produced, said Gorodetsky, no effect whatsoever, even on his fellow-mythmakers.[135]

(c) *'The poet and the crowd'*

Ivanov held that in the generation of myths there could be found a solution to the problems of poetic communication – the inadequacy of the poet's means of expression, the gulf between his understanding and that of the majority, and the special rôle which the theatre must assume in this context as a form of communication through common action. Without looking to myth as the ultimate solution, the symbolists by and large were preoccupied with the same problems.

For Ivanov, the characteristic state of the modern poet was Tyutchev's 'feat of poetic silence': the poet endures silence in order to find an inward language for the expression of the spiritual truths revealed to him, and he lives in the hope that, in conditions of a renewed community of man, his inward language will become common currency (cf. Chapter 2, pp. 73–4). Myth was important to Ivanov as the means by which this could be brought about. Of the other symbolists, generally speaking, those who were closest to the spirit of decadence and individualism, and furthest from the religious vein of symbolist theory, were least able to find a way beyond the dilemma of 'poetic silence'. For Bal'mont, the poet's creations

were illuminated by an 'inward light' which shone for him in the depths of a 'vast silence', and Tyutchev's virtue was to have recognized the inevitability of this situation.[136] Bal'mont illustrated his point, inevitably, by quoting Tyutchev's celebrated poem *Silentium*. Bryusov had set a fashion among the symbolists by placing one line from this poem – 'A thought uttered is a falsehood' – at the head of his preface to *Chefs d'œuvre* in 1895.[137] In 1904 he quoted the line in question when making a very self-evident point about the impossibility of expressing the artist's intentions exhaustively in any medium whatsoever,[138] though a few years previously he appeared to place the emphasis on preparation in solitude for the eventual breaking of the silence.[139] Ivanov, it will be remembered, although he felt that the 'language of everyday consciousness and outward experience' was unable to convey the highest spiritual truths, was well aware that the prophet would ultimately find the instrument of expression only in the 'clear forms' of the phenomenal world (cf. Chapter 2, p. 74). Others besides Ivanov dwelt on the discrepancy between the poet's vision and the medium in which he was forced to express it, and most of them showed themselves to be aware of the fallacy in Tyutchev's dictum, which Vengerov pointed out in the 1909 version of his lecture on Russian modernism: that words are always ultimately engendered by reality, and therefore in a sense always 'true'.[140] Bryusov, again in *About Art*, found Lermontov's *Sea Princess* a most fitting image for the poet's feelings dragged into an alien world of words, sounds or colours,[141] and Ellis in his *Russian Symbolists* warned of the danger that poets immersed in contemplation might forget that art depends on forms drawn from the world of the senses and so lose the power to communicate.[142] Merezhkovsky, who derived both his interest in Tyutchev and his religious notions from Solov'yov, wrote in an early symbolist manifesto that symbols should spring naturally from reality: he qualified this statement with the inevitable quotation from Tyutchev, but claimed that in symbolist poetry the force of what is *not* expressed in words, but 'shines through the beauty of the symbol', acts more strongly than what *is* expressed.[143]

Despair at the fallibility of the medium, just as much as excessive individualism, was considered by second generation symbolists to be a vice of the earlier 'decadent' movement. Modest Gofman held that Tyutchev's dictum was the hall-mark of decadence rather than

of symbolism – the symbolist artist was confident that 'the divine can be embodied in the earthly'.[144] Ivanov had this confidence; indeed, his whole system hinged on his faith in the inter-penetration of the noumenal and phenomenal worlds. Bely, in whom the influence of Potebnya is discernible, declared that a thought uttered, far from being a falsehood, is a man's attempt to 'master his surroundings' by endowing them with meaning in his own terms.[145]

The realization that they lacked any common ground with the public at large did not as a rule disturb the symbolists' sense of belonging to a select band whose exceptional gifts justified their recondite activity. However regretful they might sound about the failure to find a common speech intelligible to the majority of people, they were for the most part firmly enough convinced of their own superiority to feel that the 'crowd' must learn their language, rather than they the crowd's. Such convictions were so widely expressed among the symbolists that Izmaylov in 1908 complained with some justification that the modernists seemed not to want to be understood.[146] Aristocratism of this kind was certainly more widespread among the earlier generation of symbolists, but was not confined to them: even those who shared Ivanov's neo-populist concern for the crowd, and nostalgia for the artist's secure reception among the people in the ancient world, thought in terms of remoulding the consciousness of the public rather than of stooping to their level. Konevskoy defined the 'mystical feeling in Russian lyric poetry' as 'a peculiar sense of all that is concealed from ordinary human causal understanding and the average individual's instincts and receptivity',[147] and he held that the public is capable of understanding only the shallowest commonplaces.[148] Ellis proved in later years to be the carrier of the aristocratic virus (cf. the passage quoted on p. 111, X). He showed his acute distaste for mediocrity in the concluding words of his study *On Contemporary Symbolism, 'the Devil' and 'Action'*:

> Besides, is not Satan better than a good part of the human race whom we save from him. . . .[149]

He regarded the creative gift as a sacred fire handed down from generation to generation among the initiated.[150] It was for this reason that he abhorred the notion of art as a communal activity[151] and he openly attacked Ivanov's ideal of a 'collective' art:

> The crisis of symbolism . . . is that it has forgotten the chastity

of solitude, the duty of withdrawal and Nietzsche's heritage, the 'pathos of separation', and has sunk to the disgraceful notion of a bond between the priest of Dionysus and the first spectator who should chance to be sitting nearest to the stage![152]

His aristocratism was blatant; he spoke of 'our cult of aristocratic symbolism (not in the class sense), individualistic symbolism standing above life . . .'.[153]

Ellis was alone in appearing to deny even that the artist-prophet had a duty to go out amongst the people. Bryusov placed the emphasis on the artist's mission as 'one sent by God'.[154] Bal'mont in 1900 declared that the symbolist poet avoided generally accessible poetic devices,[155] but in 1908 he assumed that the poet sought to gain a hold over people's minds, and should employ the most effectively 'hypnotic' devices to this end.[156] Bely in *The Meaning of Art* warned that without the 'enticing haze' which surrounds the summits of creative achievement, art would become 'too accessible'.[157] Even Chulkov, whose ideas on the 'democratization' of art were closest to Ivanov's, could not abandon the idea that the gift of either writing or understanding poetry is something exceptional; in calling for general participation in the healing act of art, he invited all men to become exceptional. In the 1914 public debate on symbolism, he likened the poet to the initiate in the ancient Egyptian mysteries, but claimed that all could and should attain wisdom by 'becoming a poet'.[158] A very few voices were raised within the symbolist movement against the general refusal to supply the people with the 'spiritual bread' (cf. Chapter 2, p. 72) for which they clamour. One such voice was that of Gorodetsky, whose criticism echoed the terms used by Ivanov in *The Poet and the Crowd*, and was probably directed more against Ivanov than any other possible target.[159] It must however be emphasized that, except in the case of Ellis, the symbolists' belief that art is a privilege which may only be extended to those ready for it, did not automatically mean that they held reactionary political views; they were for the most part conventionally liberal in their political views, and, as will be seen, many of them had a broadly populist outlook. On the other hand, it is easy to understand how their fear of mediocrity became interpreted by their critics as political reaction. L. Voytolovsky, who was another contributor to *The Decay of Literature*, pointed out that the only common

people to appear in 'decadent' poetry, other than in a nostalgically feudal context, were whores, never peasants or workers, and he maintained that the decadents' hatred of greyness was but a masked hatred of the masses.[160]

(d) Symbolism and the theatre

Ivanov's concern for the restoration of contact between 'the poet' and 'the crowd' led him to the theatre. His ideal of religious communion necessarily involved the theatre (cf. Chapter 2, p. 77); he saw in Greek tragedy the natural expression of the religious consciousness of an ancient people. In his introduction to a play by Lydia Zinov'yova-Annibal (his second wife) he proposed a new form of drama, restored to something approaching the religious function of Greek tragedy, whose task should be to 'forge a link between "the Poet" and "the Crowd"', to unite the crowd with the artist, whom inward necessity had separated from it, in a single combined celebration and act of worship'.[161] This task was in its conception 'aristocratic' in the sense defined above: Ivanov made it clear that its fulfilment involved a transformation of the people, not an assimilation of the poet to the people.

Many of the Russian symbolists turned to the theatre with similar expectations. Chulkov, for example, emphasized the appropriateness of the theatre as an activity in which the religious consciousness of man could be revived; in his contribution to a miscellany in which several symbolist writers expressed their hopes for the future development of dramatic art, he referred to the theatre as 'a religious act' by way of which the community of man can approach the unity of the absolute.[162] Sologub, in the same miscellany, urged that the theatre should become a 'liturgical act' and a 'mysterious rite'.[163] The experimental theatre linked with the symbolist ideas of this period certainly appeared to these whose sympathy with it was limited to be religious in intent; A. E. Red'ko, reviewing the period in question in 1926, found that:

> V. Kommissarzhevskaya's theatre turned itself into a kind of church, in which the producer and the actors celebrated exactly like priests in the traditional church, in the name of the infinite power guiding the world.[164]

Red'ko was in fact exaggerating a characteristic of the experimental

theatre that was never so clearly defined; Meyerhold, it is true, pointed to the ritual which surrounded the highly emotional Dionysian religious ceremonies as an indication that spontaneous improvisation had but little expressive value in the theatre,[165] but he was at the same time particularly concerned to trace the progressive secularization of the 'mystery' theatre, its gradual transference from the church to the market-place.[166]

Amongst the symbolists, the emphasis was more frequently laid on the possibilities provided by the theatre of escape from the narrow individualism of the lyrical impulse. In Chulkov's words:

> The lyric poet, by his choice of the theatre as the medium for his work, shows that the individualism behind which he concealed his longing in the past cannot any longer save him, and he steps out on to the stage with his longing and his summons to the people, to share with them his grief.[167]

Blok provides a hardly disputable example of an essentially lyric genius who turned to the theatre at this time (his first dramatic work dates from 1906) in an attempt to break out of his isolation.[168] In his long article *On the Theatre* (1908) he wrote (in terms strongly reminiscent of Ivanov's *The Poet and the Crowd*, which clearly impressed him deeply[169]) of the writer's position in relation to the people, who have amassed in him their vitality and now appear before him, 'spiritually hungry', demanding gratification of their longings.[170] There is another echo of Ivanov in the hope expressed by Blok that through the theatre the 'wholeness of life' might be restored.[171] Sergey Gorodetsky in 1907 looked to drama as the form of expression most appropriate to the 'active, life-creating, life-affirming principle' of the new literature which was destined to overcome 'the old vice of Russian life: the separation of the intelligentsia from the people'.[172] Sologub, for whom art existed to make men aware that the whole of life is subordinate to 'the Only Will' (cf. Chapter 3, p. 112) saw the isolation of the individual as a state of aimless independence of the divine will; and it was in the tragic theatre, he held, that the individual could be brought to assert his own will in harmony with that of his maker.[173]

The call to the poet to make his vision accessible through the theatre naturally involved a summons to the crowd to follow the poet into the realm of the spirit – 'through the theatre', wrote Chulkov,

'we should rise to heights which we are not capable of attaining in everyday life',[174] and Zinaida Gippius envisaged an ideal 'theatre of the future' which would be 'prophetic' in the sense that it would make the future a reality for the spectator – it would, in other words, indicate to the spectator the form of life towards which he should aspire.[175] It was such attempts to make the spectator aware of a higher level of reality that led to the 'stylized' acting characteristic of the symbolist theatre; A. E. Red'ko, basing himself on Blok's article in commemoration of Kommissarzhevskaya,[176] linked the prevalence of such acting techniques in the theatre of Kommissarzhevskaya and Meyerhold with Ivanov's call to make art the bridge between *realia* and *realiora*.[177] In point of fact, 'stylization' was superseded in Meyerhold's dramatic theory by 'the grotesque', whose essence lay in 'the constant striving of the artist to lead the spectator from the level which he has just attained to another, which he was not expecting'.[178] The interest of the symbolists in the puppet theatre was probably prompted by similar considerations; the issue of the periodical *Apollon* for March 1916 was entirely devoted to a detailed study of the marionette theatre by Yu. Slonimskaya, who concluded that the marionette, whose movements might be modelled on human gestures but had infinite possibilities of divergence from the human likeness, was able to create its own world, independent of everyday realities, and involve the spectator in this world.[179]

(e) The element of populism

Behind such projects for an ideal theatre of the future, there clearly lay the desire to make art into a force for the preservation of the spiritual health of the community, as well as the search for a solution to an aesthetic problem, namely, that art without an audience (it can be argued) is incomplete, and can scarcely be called art at all. The 'decadents' had little doubt that art practised in isolation is still viable, but the symbolists – any who subscribed to the view that art should transform the society of man, and indeed the whole world – needed a theory of art in which mankind at large is organically involved. Despite Voytolovsky's pessimistic appraisal of the symbolists' attitude to the people, there crept into symbolist thinking what appeared to many outsiders to be a note of populism.

Filosofov, writing of the literary controversies of the period 1901–8, suggested that the educated classes in Russia had always felt they had an unpayable debt to the people, and that the idea expressed in such 'decadent' lines as

> В хороводы, в хороводы,
> О, собируйтесь, народы, . . .

was but an oversimplified form of the same feeling, experienced by hooligans.[180] The lines he quotes are in fact from a poem by Gorodetsky – *To Vyacheslav Ivanov, Priest of Dionysus* – published in *Fakely*, the organ of the mystical anarchists. Filosofov singled out Ivanov and Blok as purveyors of 'a naïve inverted populism',[181] whose characteristics were not only the ideal of union with the people, but the rejection of Western culture.[182]

It seems at first sight inappropriate to connect Ivanov with a revival of Russian populism, in view of both the deliberate inaccessibility of his verse, and his unusually thorough and profound assimilation of Western culture. However, Ivanov's closest associates were not troubled by the discrepancy between the narrowness of appeal of his poetry and his ideal of a 'popular art'. Chulkov wrote that 'wide accessibility . . . has nothing to do with the universally popular quality . . .', and that it was an irony of history that the poetry of Vyacheslav Ivanov, which was inaccessible even to a large proportion of the intelligentsia, should none the less voice 'popular' feelings.[183] Chulkov considered Ivanov to be in this respect a complete contrast to Bryusov. Ellis, as is to be expected, saw no such irony, and spoke scornfully of 'dissimulated and purely verbal summons to "popular allegiance", composed in the isolation of the study'.[184] On the question of the rejection of Western culture, it should be borne in mind that Ivanov's classical learning did not make him automatically an heir to the classical tradition in Western European civilization: he concentrated on certain aspects of Greek mythology and religion which seemed to him to answer to mankind's universal religious need, and their revival in modern times was in his view more likely to take place in Russia than in the West. Filosofov's contention is also borne out by the zeal with which the majority of the 'second-generation' Russian symbolists set about demonstrating the native origins of their movement.[185] The sources of such marginally 'populist' attitudes in Ivanov and a number of other

symbolists are not clear. It is possible that Ivanov derived them from his study of Greek religion, but it is equally possible that he discovered in Greek religion a mould into which he could pour certain conceptions which he already held, such as the Solov'yovian idea of the union of all mankind in a 'free theocracy'. In Blok's case, it has been suggested that his ideal of 'popular art' derived from Apollon Grigor'ev,[186] but Blok, too, was influenced early in his creative life by Solov'yov. In any case, one ingredient of the climate in which the symbolists formed their ideas was a revived form of 'neo-populism' which sprang up around the turn of the century.[187]

We have so far been describing not an avowed populist allegiance, but a politically ill-defined concept of 'drawing closer to the soul of the people', or 'a dream of once more submerging oneself in the soul of the people'.[188] However, those who did not share in this tendency labelled it outright as 'populism' or 'neo-populism'. Bely, reviewing Gor'ky's *Confession* in 1908, declared that he found Gor'ky's writing more acceptable than the 'quasi-populist exclamations to the effect that the sun shines more brightly in our sad country than in the tropics', which he associated with the theoreticians of 'collective creativity' – a clear reference to Ivanov and Chulkov and their allies.[189] But in a review of Bely's *Lug zelyonyy* in the journal *Vestnik Yevropy* (1910) we read:

> Sometimes in Mr Bely's verbal outpourings there can be heard a note of anarchic protest, in the vein of Morris, against technical progress, in favour of a summons to 'meadows green'. Sometimes there is an echo of something like populism. . . .[190]

Dismay at technical progress, always a feature of slavophilism and populism, was certainly widespread among the Russian symbolists.[191] Though this is scant evidence on which to classify them as populists, the symbolist viewpoint clearly seemed to many outsiders to be uniformly populist, despite Bely's wish to confine the 'populist' label to the group advocating 'collective' art. Voznesensky in 1910 complained that the successive symbolist groupings – the 'erotic group', the 'urban poets', and now the 'populists' – were labelled on the strength of purely superficial evidence, and that symbolist thinking was, beneath these labels, monotonously uniform; he made particular mention of Bely's 'childishly arty-crafty populism'.[192] L'vov-Rogachevsky in the same year declared that, with

Blok lecturing to literary society on neo-populism, and Bely introducing the émigrés in Paris to 'a combination of religion and social democrat teachings', the symbolists as a group seemed to want to 'go to the people'.[193] Kranikhfel'd accused Merezhkovsky of using his critical appraisals of Gogol' and Lermontov as a platform for the announcement that a new age of 'religious populism' was setting in.[194] The journal *Zavety*, in which a good deal of symbolist writing was published, was openly populist in character.[195]

4. Art and reality

(a) Objectivity and subjectivity

The ideas so far examined amount to an ideology rather than an aesthetic; they have all been concerned with the part that art should or should not play in the general amelioration of the human condition, and not with the relationship in which the work of art stands to man's physical surroundings and to his needs. We have reviewed the symbolist discussion of 'art and life' rather than 'art and reality', and have seen that symbolist attitudes were formed at least partly in response to the reproach that the symbolists had deserted the Russian tradition of social commitment in art. The more narrowly aesthetic theories associated with the movement were developed in the course of another controversy, centred in this case on the issues of 'realism' and 'idealism' (to adopt the terms employed by those engaged in the dispute). In the intellectual climate of Russia at the turn of the century, it was inevitable that the literature born of a movement to free the individual and assert the autonomy of art, even if it allowed that art should play a part in the social organization of man, would invite the criticism that it 'lacked objectivity'. Literature in this climate was expected to be a recognizable reflection of the surroundings of the public which received it, and the fact alone that the subject-matter of symbolist writing was frequently exotic, or fantastic, or set in distant places and remote historical ages, ensured that the symbolists would be accused by many of eschewing the reality of their time and escaping into a private 'aesthetic' world.

The symbolists' reactions to the accusation of 'subjectivism' (for

this is what their critics usually meant by 'idealism') were ambivalent. They wished to assert that the experiences represented in their works were represented 'objectively'; at the same time, since they claimed for their experiences a greater depth, scope and significance than was to be found in those which had hitherto provided art with its subject-matter, they frequently took the attitude that the term 'objective representation', in the sense in which it was generally understood, was irrelevant to their own artistic methods. Bely in 1906 tried to establish a double standard of objectivity: in the pursuit of truth, he suggested, symbolism is a valid alternative to scientific method:

> There are some who fear 'the mysticism of symbolism and indeed any indeterminacy'. This fear is understandable, since it is normally supposed that in our experiences, if we are freed from the elements of logic, we will endlessly shift from one random experience to another. . . . Science in its development strives to determine the causal links between phenomena, and through this causality to introduce objectivity into the relationships between phenomena. . . . Symbolism, arranging experiences into a definite system [Bely is referring to the 'succession of ascending degrees' by which the 'objectivation of the World Idea' is achieved – see passage VI on page 110 of this chapter] aims to achieve, by the objectivation of these experiences, a psychological objectivity.
>
> Thus both methods (the logical and the psychological) have, as their ultimate aim, exactness and precision.[196]

For Bely, art aimed to represent phenomena in the light of an ideal world-order. Sologub expressed virtually the same notion, but with a slight shift of emphasis away from the representational aspect of art:

> Symbolist art is not tendentious, and has not the slightest interest in representing life in any particular way – it is concerned only to express its truth about the world. Such art has no motive to make inaccurate use of its models, which in its case are all the objects of the objective [sic] world.[197]

Both Bely and Sologub were here asserting that 'objectivity' was independent of what was commonly understood by 'realism' in art; Bely remarked in 1907 that 'realism is a nonsense, or else a sly

trick'.[198] Both were answering the criticism, often enough levelled at them, that symbolist art distorted reality.

Criticism of this kind was probably originally aroused by the views expressed by certain of the 'first-generation' symbolists, the 'decadents'; for example, by Annensky's contention that 'poetic creations are in themselves incommensurate not only with the so-called real world, but even with the logical, moral, and aesthetic aspects of the ideal world'.[199] More characteristic of 'second-generation' symbolists was an attempt to claim for symbolism some degree of realism, or to set it up as a (preferable) alternative to realist methods. Berdyayev, in his article *Decadence and Mystical Realism* (1907), associated anti-realism with 'decadence', and spoke in terms not unlike Bely's of the 'realism' that should supplant this tendency.[200] Fyodor Stepun, writing in *Severnyye Zapiski* in 1913, suggested that Russian literature had passed through phases of both 'false and artistically dead objectivism' and 'false, arbitrary subjectivism' and should now aspire to a synthesis of these two principles.[201] Anichkov, discerning a move towards 'realism' in a literary movement generally associated with 'idealism', found that the 'idealists' repeated in a new form the demand for objectivity which had prevailed in the world of art since Schiller; their claim that the artist had 'so profound and prophetic a knowledge of life that he can represent it in a form more truthful than life itself', had become axiomatic in certain circles.[202]

The question at issue, in fact, was not whether the symbolists reflected or avoided reality in their art, but what they understood by 'reality'. Ellis (who was, as has been seen, in several respects a 'late decadent') wrote, in answer to Berdyayev's contention that decadence was anti-realistic:

> But does not any art, renouncing given reality, impart an awareness of another reality, rising above everyday reality. . . .[203]

In supposing the 'other reality' to be separate and distinct from the world of everyday experience, Ellis was as naïve as the realist critics who failed to see that whatever the symbolists represented in their art, it was, for them at least, 'real'. Even the most radical critics of the symbolist movement held that art does not aim at exact representation, but at the portrayal of a refracted vision of the world; it has been suggested in Chapter One that in one form or another such

a view prevailed against all odds in nineteenth-century Russian aesthetic theory. Ultimately, the controversy we are considering was not over accuracy of representation, but over rival notions of the ideology which should inform the artist's vision. This becomes strikingly apparent if we compare the following passage with passage XII on page 111:

> Art is the expression of life, and the content of life is always revealed in movement. Wherever this is life, there flows the wonderful live stream of indomitable energy. . . .
> Art is a particular, brilliant means of classifying these forces and activities of real life: it is reality itself, purged of all trivia.
> . . . In this sense art is a form of spiritual energy. It arouses new and unknown feelings. It is a magic, as Guyau says, which may, in a single moment and with a single word, conjure forth a whole world. Here beauty comes to the aid of art.
> Beauty transforms reality . . . the beauty of art leavens reality with the intoxication of dreams and ecstasy. . . .
> [Art] is a spirit which rises above the formless chaos of everyday life and, in the creative images of the artist, imbues it with the element of reason and emotion.
> The spell of beauty consists in infecting the beholder with the artist's moods and feelings. . . . In addition, beauty in art helps to make reality more comprehensible; it aims to make the products of the creative imagination not a simple representation, but works of art, i.e. profoundly realized events of life.[204]

The above was written by L. Voytolovsky for the marxist collection *The Decay of Literature*; it prefaced an attack on the symbolist movement, but, closely parallels Sologub's view of art as a force that orders our experience of the phenomenal world, and his affirmation of 'life as a creative process' raised above the level of 'the prosaic'. For both Voytolovsky and Sologub, this process takes place through the medium of a world 'conjured forth' by the artist. In particular, the idea that beauty transforms reality echoes Ivanov's concept of 'transfiguration' (which, as will be seen, was common to all the symbolists who claimed to be 'realists'). The answer to the strictly aesthetic question of the sense in which art can be said to represent reality is in both cases broadly the same; even when they seem to be

disagreeing about aesthetics, the symbolist and the outraged 'realist' are more often than not disagreeing about something else – not even, in fact, about the social function of art, but about the ideal world towards which the function is directed.

It is for this reason that so much space has been devoted to the ideology of the symbolists, to their ideas of the relation between art and an ideal world order in which the spiritual ills of the human race would be cured. The examination which follows of their claims to 'objectivity', and even to 'realism', would scarcely make sense without foreknowledge of these ideas, or without some understanding of the accusations to which such claims were a sometimes oversensitive response.

(b) The 'inward' reality

The majority of Russian critics nurtured on the nineteenth-century realist tradition were unprepared for the degree of attention paid by the symbolists to the imaginative life of the individual artist, and their complaint was often that the symbolists, through some flaw in their psychological make-up, were inclined to investigate their inward selves rather than their surroundings. Thus P. S. Kogan in his *Essays on the History of Contemporary Russian Literature* wrote that the children of an age of social crisis tended naturally to have 'a hostile attitude to realism and the objective investigation of reality', and to delve into their own souls in search of both the causes and the remedies for their ills. Faced with a world of human suffering, the kind of artist who created the world anew from within himself would generate (Kogan maintained) not the desire to fight for the betterment of the human condition, but a mood of pessimism.[205] M. Nevedomsky observed that, in the difficult social conditions of his day, it had become harder for the individual to establish his relationship to a more complex and rapidly changing society,[206] whilst according to L'vov-Rogachevsky, in the age of political reaction in which symbolism had grown up, 'the intelligentsia fled from politics like the devil from incense', and, creating an ideal world in their poetic dreams, lost touch with the real world.[207] Andrey Polyanin, in the course of an attack on acmeism in the journal *Severnyye Zapiski*, recalled that the symbolists had been driven into the inner world of their own souls by a feeling that the

'mysterious "means of poetic effect"' were to be found there rather than in 'unreflecting conscientious representation of the external world'.[208]

In 1906 S. Makovsky, himself the editor of a symbolist periodical, gave a regretful account of the process by which each succeeding generation destroys the past and re-creates it in accordance with its own desires. 'Thus', he concluded, 'live reality is turned into a dream. And, at the end, there remains only the reflection in art of what once was life.' He found this impoverishment of life by art as dangerous as its reverse, the negation of art in favour of life.[209] He was adopting, in effect, the same attitude as Nevedomsky and L'vov-Rogachevsky. His remark was quoted with approval by another critic of symbolism, E. A. Lyatsky, who held that the symbolists' subordination of art to 'a supreme super-human principle' betrayed a lack of the intense feeling for life which was a prerequisite of creativity.[210]

The symbolists' answer to the criticism that they were too inward-looking to be objective, was generally that reality (or life) was immeasurably enriched and extended by their 'colonization of inwardness', which did not exclude, but heightened the exploration of the phenomenal world. They replied, in effect, by reference to the transformed world of their vision. Though they proclaimed the value of the independent world of the artist's imagination, they stressed that it was rooted in real phenomena which the artist had no call to misrepresent. Hence they could occasionally claim that it was they who were exact in their representation of reality – always, of course, the 'extended' reality – and their critics who were guilty of distortion. Thus Volynsky objected to the theories of art of Chernyshevsky and Pisarev not because of the functional rôle they assigned to art, but because their materialist views were 'false', and he equated symbolism with idealism as a means of 'uniting heaven with earth' (in other words, of bringing about the world order which he advocated in opposition to that proposed by Chernyshevsky or Pisarev). He then attempted, in the wake of this decidedly tendentious argument, to turn the tables on the materialists by objecting to any tendentiousness in art – 'for a pure and strict perception of the world', he wrote, 'is always more poetic and nearer to the truth than tendentious artistry in whatever spirit'.[211] Volynsky's championship of objectivity is here at least

annulled by his demand that the artist's vision shall be the 'right' one. The call for truth to the inward rather than the outward reality was a commonplace among the symbolists. Bryusov's statement in *Vesy* in 1905 that 'creative art is purely a reflection of life, nothing more'[212] gives a misleading impression, unless it is borne in mind that by 'life' he could mean something as intangible as 'the soul of the writer'. In his reply to Tolstoy's *What is Art?* Bryusov argued that it is the artist's conception that is important in a work of art, not the beauty of the objects represented in it, for they are more beautiful in reality.[213] The accusation that the symbolists retreated into themselves was probably provoked by statements of this kind, where the new-found inwardness is emphasized at the expense of the representational aspect of art, and even more by remarks such as the following:

> Like the realists we acknowledge life to be the only fitting subject-matter for art, but whereas they sought it outside themselves, we direct our gaze inwards.[214]

Many instances can be found of a desire on the part of the symbolists to find a point of balance between the inward and the outward realities. Zinaida Gippius envisaged art as 'a striving of the human ego to create ... a synthesis of the given ego with life, always, therefore, *similar* to life – never *identical* with it ...'. Such a synthesis, she held, 'is always superior to life, a reinforcement of life, an extension of life'[215] Those who complained of the absence of 'life' in modern literature were confusing two different things: 'everyday life' (быт) and 'life' (жизнь).[216] Chulkov took the view that the critic's task was to reveal the 'link between art and life'; the kind of relationship he had in mind is indicated by his statement that 'the artist's dream ... is like a light on the difficult paths of life'.[217] Sologub, in the passage cited on page 111 (XII), found that the desire to create an independent world of the imagination was natural to man, and was the consequence of his desire to realize the divine will on earth. In an earlier article, dating from 1907, he affirmed the autonomy of the poet's imagination (and disparaged Belinsky for denying it) but declared that the poet's task was to reconcile the creation of his own world with his duty to 'approach humbly the phenomena of life ... to accept and affirm to the last everything in the phenomenal world' He was prepared, he said,

to accept Aldonsa as she was, reeking of onions, and not make a Dulcinea of her.[218]

In all these examples, the idea that art reflects a world created by the artist, in his imagination, from the formless elements of reality, is compounded with the idea that art reveals in the real world a hidden order, a harmony which is latent in it and can be realized only in art. These two ideas were the fixed points between which the theorists of Russian symbolism moved, when they chose to confine their discussion to the aesthetic question. They seldom strayed far from the view that the artist orders life, or extends it, or realizes its highest potential, but neither retreats from life nor distorts it. At least in theory, the symbolists' aim was exactly what their detractors claimed it was not: to establish a harmonious relationship between the individual psyche and the real world. I. Gofshtetter, in an article on 'the philosophical and psychological motives of decadence', described what seemed to him to be the principal failing of the symbolists; he described quite accurately the situation from which, in the view of the symbolists, their theories provided a way of escape:

> Above all, once the soul of man loses its ideal, it loses all logical connection between itself and the outside world, the social life of its surroundings. To the decadent, therefore, everything which goes on around him must appear as an infinite succession of disparate, isolated phenomena, meaningless and unconnected. . . .
>
> He has . . . no criterion that might help him to find his way in the disorder and confusion of phenomena and facts. . . .[219]

The theories of the symbolists were designed to provide just such a 'criterion' by which to order random phenomena. In the passage cited at note 196, for example, Bely puts forward symbolism as one way by which we may escape from a situation in which we 'endlessly shift from one random experience to another'.

(c) The interpretation of 'realism'

In the pronouncements of the symbolists on the vexed question of objectivity, there is surprisingly little appeal to the psychology of perception. The opponents of symbolism, if they held the views which the symbolists attributed to them, left themselves open to the retort that the human animal does not in any case perceive the

world as it really is, and can at best 'reproduce' only his own impression of it, inevitably coloured by his own experience and ideals. However, the symbolists, as a rule, came no nearer to such a retort than Bely's formula in *The Meaning of Art*, which assumes the subjective 'inward' element of human's experience of reality to be an extension of the objective reality itself:

> From the point of view of contemporary psychology, *reality is the sum total of all possible experience* (inward and outward) . . . the visible world is but a small part of reality.[220]

The reason for this is certainly not that the symbolists were unaware of such objections on strictly aesthetic grounds to the call for exact reproduction of reality in art. It is more likely to have been that they took such objections for granted, since both they and the majority of their realist opponents had progressed beyond what both factions referred to as the 'positivist' or 'naturalist' concept of truth to life. Whenever the symbolists accused their realist critics of taking too simplified a view of the process of 'reproduction' in art, the realists invariably replied that they had long since outgrown such a naïve approach to realism. In 1899 (comparatively early, that is, in the growth of the Russian symbolist movement), there appeared in *The World of Art* an article by V. Gureyev entitled *Idealists and Realists*, which goes to the heart of the controversy, uniting the various strands we have been following. Gureyev summarized the objections of the realists to the idea of 'pure art', and pointed out their 'methodological error' (as he called it), their disregard of the fact that objective reality is inaccessible to the human mind. He continued:

> It is clear that the task of art is only to reproduce our concepts of reality. . . Hence it is clear that realism in the strictly scientific sense of the word is fundamentally quite unthinkable in art.
> . . . The truth of art is of an altogether different kind: without contradicting reality, it elevates and extends our conception of the real world. For the ordinary observer, artistic truth is merely concealed in the truth of life. . . .
> This is what we expect of the artist. To reveal the spirit and the meaning of facts, to guide the way through them, to dispose them so as to make visible their relation one to another, the relation of

the particular to the general, of what is random to what is constant, of the transitory to the eternal, to throw into relief and illuminate what is most important and typical – this should be the aim of any artistic representation of real life.

And as history shows, in all ages and all places creative artists have, by the force of their talent, transformed discordant reality into a harmonious work of art, raised particulars into generalizations, and through beauty drawn nearer to the ideal.[221]

Gureyev here assumes realism to be the most naïve form of naturalism, as did Skabichevsky in 1901 (cf. Chapter 1, p. 33). In succeeding years, the symbolists appear to have felt unaccountably threatened by the positivist idea of objectivity. They were faced with opposition in terms approximating at times very closely to their own; the difference between Gureyev and Gofshtetter (note 219) or even Voytolovsky (note 204) is in fact 'methodologically' speaking, not very great, and yet the 'realism' which Gureyev and his successors contrasted with symbolism, or the 'old realism' which they set against their 'new realism', was always the 'realism in the strictly scientific sense of the word' which *both* factions agreed was 'unthinkable in art'. Bryusov, for example, in his well-known criticism of the 'realism' of the Moscow Arts Theatre, understood the expression 'the imitation of nature' to signify purely mechanistic copying, and made the absurd claim that such is the activity of realist novelists.[222] This anomaly pervades the controversy between the symbolists and the realists, which was prolonged and vociferous, and ostensibly concerned the aesthetic question, both sides claiming that their art was 'realist'.

The whole controversy is a web of contradictions which it is difficult to unravel. Realist critics for whom 'symbolism', or 'decadence', was synonymous with artistic worthlessness, sometimes claimed as realists the most successful symbolist writers, whose artistic merit was thought beyond question. Thus P. S. Kogan saw in Sologub signs of a 'new realism' which had 'passed through the school of Nietzscheism and decadence',[223] and Ivanov-Razumnik described Bryusov as 'a strict, incisive, "rational" artist of a characteristically realist type'.[224] At the same time, some of the symbolists assimilated outstanding realists to their own category of 'realistic symbolism' – for Bely, 'the realism of our literature began with

Chekhov, and is reaching its climax in Sologub'.[225] Annensky wrote that, after Dostoyevsky, Gor'ky was to his mind the most clear-cut Russian symbolist.[226] Nevedomsky (who was not a symbolist, but was to some extent in sympathy with the movement) held that Chekhov in *The Cherry Orchard* displayed a tendency to symbolism, and he discerned the same tendency in the volumes of the *Znaniye* group.[227] Bely, as will be seen in due course, used *The Cherry Orchard* as the basis for his exposition of realist symbolism.

The continuity of symbolism with the nineteenth-century realist tradition was asserted and denied by turns. Anichkov described this tradition as the demand 'that art should be truthful, that its reproduction of reality should be inspired by that genuine striving for truth which makes life itself an artistic ideal', and he suggested that the difference between this and the symbolist position was slight.[228] Bryusov suggested at least twice that his views and Tolstoy's coincided.[229] Kogan, on the other hand, took the view that 'modernism . . . runs completely counter to the heritage of Russian realism',[230] only to decide later that the 'new realism' was 'a combination of the old realism with modernism'.[231]

Such wrangling over the allegiance of particular writers sheds little light on what either the realists or the symbolists meant by 'realism'. It will be necessary to turn for elucidation to the statements of both factions on the connection between symbolism (or modernism, or decadence) and realism.

Blok wrote in 1907:

> The realists are inclining towards symbolism, because they have grown weary of the flat expanse of Russian reality and thirst for mystery and beauty.
>
> . . . The symbolists are moving towards realism, because the stifling air of their 'cells' has grown hateful to them, they wish for a breath of freedom, wide activity, and health-giving work. In this there is something akin to the 'going to the people' of the Russian intelligentsia.[232]

Blok here links the symbolists' inclination to realism with the characteristic desire to end their isolation, and even with the populist element in symbolist thinking. N. Apostolov, too, saw the connection between modernism and realism as a confusion of individualist and socially committed realist allegiance:

The symbolists serve both the individualist and the realist ideals.

Bryusov is dubbed both a Nietzschean and a realist. Merezhkovsky is almost universally acknowledged to be a Nietzschean of an extreme individualist cast of mind. But in his approach to social questions Merezhkovsky is an incorrigible idealist in the democratic cause. . . .[233]

Sologub held that the symbolic poetic image should have a 'two-fold accuracy': it should be an exact representation, and at the same time it should occupy its own place in the universal scheme of things – 'only then', he wrote, 'will it facilitate the expression of the most general world-concept of the given age'. From this he concluded that 'the most legitimate form of symbolist art is realism', and gave folk-tales as an example of such symbolist realism.[234] Sologub is here defining symbolism as an enlargement of realism, or as realism on two planes simultaneously – the earthly and the 'cosmic'. This idea partakes to a great extent of Ivanov's 'higher' realism which stems in turn from Solov'yov's concept of a universal world order. Sologub, however, is clearly more concerned with the 'popular' than with the universal; for him too, the problem of realism was closely linked to the problem of social communication.

Chulkov was closely concerned with the idea of realist symbolism. His mystical anarchism specifically involved the adoption of a 'new realism'.[235] In his *Vindication of Symbolism* he described Dostoyevsky as both a realist and a symbolist; he dwelt upon Dostoyevsky's well-known claim to be 'a realist in a higher sense', and identified this 'higher sense' with Goethe's: 'Everything transitory is but a symbol' and Baudelaire's 'correspondances'.[236] In *Yesterday and Today*, he described Ivanov as a realist in the sense that his 'lyrical microcosm' was linked with the 'objectively given macrocosm'.[237] Such a concept of 'symbolist realism' is founded in the Solov'yovian notion of a link between the inner world of the individual and the objective, divine cosmic order. Modest Gofman wrote in his introduction to his anthology of symbolist verse that 'the most essential feature of symbolism is realism, a belief in the reality of the content, coupled with a perception of it such as Tyutchev had' – Tyutchev's perception being, in his view, the poetic equivalent of Solov'yov's philosophical perception. Symbolism was to steer a path between

'the nebulous indeterminacy of mysticism and crude, naturalistic copying'.[238] By 'belief in the reality of the content' of art, Gofman is clearly echoing Solov'yov's teaching that art should reveal the relationship in which the phenomenal world stands to the ultimate reality (cf. Chapter 1, pp. 39–40) and that the metaphysical knowledge of the artist is real (cf. Chapter 1, pp. 41–2).

From some quarters of the symbolist camp a very different, and less coherent, reaction was heard to the realist-symbolist controversy: it generally took the form of an argument against the existence of a distinction between symbolism and realism. Chulkov, in his *Principles of the Theatre of the Future*, spoke of a widespread inclination to believe that all art – or at least all 'good' art – is symbolic.[239] He ascribed this view to Rémy de Gourmont, and also to A. G. Gornfel'd, who had indeed declared, in a polemic with Chulkov in the pages of *Tovarishch*, that there is no such thing as non-symbolist poetry.[240] Bely, too, advanced this argument in an essay on Chekhov,[241] but as Ivanov-Razumnik pointed out, he contradicted himself by continuing to speak of the mingling in Chekhov of the two *opposed* tendencies of realism and symbolism.[242] The loudest advocate of this view was Ellis, who maintained that symbolism can be said to replace both the 'abstract-speculative', and the empirical or scientific means of knowing phenomena, by 'the contemplation of living ideas in phenomena'; and since artistic creativity can be defined as the ability to discern the noumenal in the phenomenal, all art can be said to be symbolist. Symbolism is distinguished from realism only as a more perfect form of art.[243] Again, the underlying concept of art is that of Solov'yov, but the emphasis has been shifted to the rôle of art as a superior means of knowing reality. Ellis was not altogether consistent in his use of terms, and could write that:

> The blending of *realism and symbolism* is the weak point of prose-writing in our day.
>
> None of our prose-writers has solved this difficult problem, in none of them do we see symbolism springing organically from reality, or an object gradually transformed into a symbol, as happens in Ch. Baudelaire's *Petites [sic] poèmes en prose* or in Huysmans' boldest passages.[244]

However, he never departed essentially from his thesis that realism,

even if it was current in his day as an artistic method, was an imperfect form of the artistic activity, the goal of which was knowledge of reality.

Outside observers frequently associated the symbolists with the idealist movement in contemporary Russian philosophy, and in many cases there was, at least outwardly, a good deal of justification for this view. Even the comparatively unphilosophical Bal'mont held that the realists, always 'simple observers', were in thrall to material reality, while the symbolists, who were by contrast 'thinkers', were able to enter 'the sphere of the ideal'.[245] Chulkov wrote in 1908 that the contemporary theatre was essentially idealist; it lacked as yet, he claimed, the kind of realism which reaches out to the absolute, but at least refuted completely the false realism of the empiricist view.[246] On the other hand, Ivanov, we have seen, maintained that true religious symbolism was 'realist', not 'idealist'. Anichkov, in an article which clearly owes much to Ivanov, declared that the 'new trend' of religious symbolism was fundamentally incompatible with an idealist aesthetic.[246a]

Perhaps the clearest indication of the devaluation of the terms 'realism' and 'idealism' in the philosophical debate involving the symbolists and their opponents is to be found in Sergey Bulgakov's reply to *Outlines of a Realist World View*, in which he set out to explain what constitutes 'genuine realism'. Bulgakov acknowledged the variety of meanings which the word 'realism' had acquired, and pointed out that 'in the theory of knowledge many metaphysical idealists (including the author) stand on realist ground, while many positivists adopt the point of view of subjective idealism'. The idealists, Bulgakov claimed, were in fact the only true 'realists' (using the term in the sense that they possessed a genuinely scientific attitude of mind and attempted to clear the ground of illusions and deceptions) because they acknowledged that spiritual phenomena are as real as physical phenomena. There is here an obvious link with the idea of an 'extended reality' proposed by the theorists of literary symbolism. Bulgakov continued:

Thus the idealists consciously extend the sphere of the real . . . beyond the bounds of the sensibly knowable, and they do this not in contradiction to philosophical realism, but precisely in accordance with its demands.

He denied that the idealists stood aloof from empirical reality, and he defined 'ideal' thus:

> An ideal is a general guiding aim, which is embodied in life in a multitude of particular concrete aims and practical tasks, springing from particular historical conditions. And these conditions must be carefully studied and taken account of in order to more successfully transform reality in the direction of the ideal.

As a programme which might be applied to art, this is perfectly compatible with the Russian realist tradition, but the process described is still unmistakably the world process of Solov'yov – Bulgakov elsewhere in the article describes this as 'the process of bringing about the Kingdom of God'.[247] His specific comment on *Outlines of a Realist World View* – that it was a collection of defensive apologetics which fell far short of the 'realism' it claimed for itself – further weakens the conventional distinction between realists and idealists. It is interesting that L. Slonimsky, who reviewed both *Problems of Idealism* and *Outlines of a Realist World View* for *Vestnik Yevropy*, made a similar comment, although he was by no means sympathetic to the idealists.[248] Bulgakov chose to emphasize the idealist-realist's concern with empirical reality, since he was replying to accusations of withdrawal and 'otherworldliness'. Berdyayev, the other idealist philosopher associated with the symbolist movement, emphasized in his *Decadence and Mystical Realism* that 'realism' is dependent on the objectivity of the ideal world. Realism – or, as Berdyayev termed it, 'mystical realism' – 'comes only when the subjective experience is referred to the objective centres, to the essential monads'[249] Echoes of this idea are frequently to be found amongst the religious group of symbolists – an example is Chulkov's remark on Ivanov's realism at note 237. Berdyayev maintained that the failure of the decadents to grasp this truth led to their 'loss of the sense of, and awareness of, realities' (cf. note 200).

Even among the opponents of symbolism, it was widely held that the gap between idealism (or its literary counterpart, symbolism), and realism was narrowing. Thus Shulyatikov, writing in *Outlines of a Realist World View*, maintained that from its very inception in the 1870s, 'idealist art had to come to terms with many of the demands of realism', and that the theories which underlay such art represented an attempt to adapt to existing realities for purposes of

survival.[250] A. Izmaylov attacked symbolism in general, and Ivanov in particular, in his book *At the Turning Point* (1908), accusing them primarily of a lack of originality. He thought that modernism and idealism were in the process of abandoning their extremes and seeking common ground.[251] L'vov-Rogachevsky wrote in *The Contemporary* (in 1914) that 'the fathers of Russian symbolism' – Merezhkovsky, Sologub, Bryusov, and Bal'mont – were belatedly coming round to arguments which the realists had long ago put forward, but that the symbolists for their part had 'exerted a profound influence on the realists'.[252] A. Red'ko in *Russkoye bogatstvo* put forward in 1913 the odd view that the 'decadents' had latterly come to seem more realistic in an age in which reality itself was turned topsy-turvy by revolution and reaction.[253] V. N. Rossikov, in his *Literary Criticism at the Beginning of the Twentieth Century*, simply classed symbolism and decadence as one of the forms of contemporary realism, the others being 'aesthetic' realism, naturalism, and impressionism.[254] The view that symbolism after 1905 had to 're-arm' itself with some of the characteristics of realism, lasted on into the early Soviet period.[255] Comparatively few voices protested the irreconcilability of the 'idealist' and 'realist' mental types: Ivanov-Razumnik declared that romanticism and symbolism (which in his view were synonymous) were foreign to the fundamentally realist Russian cast of mind, but he called for resistance to this alien element, in favour of an alternative which is strikingly reminiscent of Bulgakov's 'ideal':

> ... we must sanctify and accept life by a striving towards the transformation of life. . . .[256]

He saw the crisis in the literature of his day as stemming largely from a collision between realism and symbolism, at the level not of literary schools, but of fundamental *Weltanschauung*.[257]

The inconclusive debate about the relation of symbolism to realism provoked in 1914 a long article by D. Tal'nikov (the pseudonym of D. Shpital'nikov) entitled '*Symbolism' or Realism?*[258] which provides a reasonable summary of the arguments. In Tal'nikov's view, the conflict between symbolism and realism in literature sprang from that between idealism and materialism in philosophy. He complained that the symbolists, in claiming to be the true realists, assumed their opponents to be adherents of naturalism and 'mechanistic

realism', and were therefore combating a spectre of their own creation, whilst, for example, Sologub's definition of symbolist realism was 'almost in the spirit of the old "realistic art" in which we see the solution to all problems of artistic creativity'. Present-day materialists, Tal'nikov continued, understand very well that the creative process in art transcends reality through intuition, but do not regard this process as a manifestation of the divine. He saw all great art as being in a sense symbolic, and suggested that the symbolists, being uneasily aware of this, had had to cast around for some justification of their separate existence as a literary school. This view bears out the point made earlier (on page 155) about the artificiality of the symbolists' dissociation of themselves from the realists. The true distinction between realism and symbolism, according to Tal'nikov, lies largely in rival conceptions of the function of the symbol and of art in general. Realism 'refracts the objects of the real world through the prism of art', and is naturally superior to the unrefracted naturalistic representation; but the realist's principal concern is with reality, not, as in the case of the symbolist, with the 'eternal and invisible' world supposedly lying beyond reality. The danger besetting the symbolists is that their search for noumena may lead them not *through* empirical reality, but *past* it. Their symbolic images are liable to become abstractions, whereas for the realist artist a 'symbol' is always a concrete image, with an emotional context, leading to a generalization. Those of the symbolists who were genuine poets, in Tal'nikov's view, inevitably progressed beyond symbolism to realism.

Tal'nikov concluded with a plea for more art and less theorizing:

> Dogma and art are two different things, but is not barren art sometimes a splendid illustration of arrogant dogma ?

His main point was that good art has its own way of reflecting realities, which remains the same whatever theories are put forward to explain the phenomenon of creativity.

(d) Art and the theory of knowledge

The assertions of the symbolists so far reviewed have for the most part been not so much statements of an aesthetic, as protestations (in the face of suggestions to the contrary) that symbolist art is objective, that symbolism is realism, or that all good art is both

symbolic and realistic. They suggest certain characteristic symbolist attitudes to the representation of reality in art, by way of which the aesthetic question may be more closely approached. These may be summarized as follows:

1. Art creates its own reality.
2. Art reveals a 'higher reality', or gives knowledge of aspects of the real world which are inaccessible to rational cognition.
3. Art reveals the relatedness of phenomena to a higher entity.
4. Art orders human experience of the real world.
5. Art contributes to a process of transformation of the real world in the direction of an ideal.

The symbolist approach to the cognitive aspect of art emerges clearly from Gureyev's *Idealists and Realists*. The symbolists had, of course, inherited the concern of the modernist movement as a whole to raise the status of art and assert it as an independent realm of discourse. Gureyev observed that the realists, in denying the independence of art, assigned to it a subordinate rôle as a means of popularizing social knowledge.[259] He was in other words insisting that art is not a *vehicle* of knowledge, but an independent *form* of knowledge. This idea appears repeatedly, though with a certain variation of emphasis, in the theories of the Russian symbolists.

Volynsky in his essay *Philosophy and Poetry* acknowledged that art attains truth by a process of immediate realization or intuition, but disagreed with Nechayev's contention that art and philosophy belong in different spheres; in the highest forms of creativity, he maintained, both meet.[260] Bryusov wrote of Konevskoy that he sought knowledge 'not of the truth that is to be found by reasoning, by logical thought, but some kind of revelation which [he] hoped to find in art, in beauty'.[261] Bryusov declared in 1904 that the only satisfactory theory of art rests on Schopenhauer's explanation that art is intuitive as opposed to rational knowledge of the world.[262] He also criticized René Ghil's 'scientific' method in a way which reveals his own concept of artistic intuition:

Scientific intuition only generalizes disparate facts, the connection between which is beyond the powers of normal logical thought to establish, but Ghil, as a true poet, creatively divines what is hidden behind the facts, and for which earthly phenomena are but a transparent clothing.[263]

163

He distinguishes between the 'scientific intuition' which gives more complete knowledge of the phenomenal world, and artistic intuition, whose *goal* is different.

For Ellis, the essence of creativity was 'cognition through contemplation', and he went so far in the association of symbolism with intuitive cognition as to assert that symbolism and intuition are essentially the same. He maintained, however, that the object of artistic knowledge cannot properly be determined 'because reality itself, refracted through the prism of creativity, is transformed within itself, yielding to the mysterious action of the creative dream'.[264] This is, surely, no more than an assertion that the object of artistic knowledge is the artist's vision of reality, rather than the real world.

Russian symbolists of the 'second generation' characteristically stressed both the goal and the function of the intuitive knowledge attained through art. The lowest common denominator of their attitude to the question is the fevered call to the exploration of the unknown which prefaced the first issue of the almanac *Grif* in 1903.[265] Chulkov, for whom the true artist was 'primarily an investigator of the world in its innermost mystery, a seer and a priest', and 'pure lyricism without gnosis is a dangerous intoxication',[266] found that the meaning of art 'can be defined as cognition and celebration of reality' (cf. passage XIII on p. 112) and that the goal of this cognition is 'the infinite which is revealed behind the thing'. He described Boris Zaytsev as 'truly a realist, not in the sense of shallow naturalism and positivism, but in the sense of knowledge of hidden meanings'.[267]

Bely devoted a good deal of space in his critical and philosophical essays to the question of the theory of knowledge, and he was generally understood to advocate symbolism as an advance on logical means of knowing.[268] Indeed, in Bely's view symbolism 'is the culmination of knowledge', since it is a premise of the teleological principle underlying the (Kantian) theory of knowledge.[269] His 'teleology' was founded in the Solov'yovian world process, the relation of individual phenomena to a single principle that is realized through symbolism.[270] Blok showed a similar sense of the place of artistic knowledge in a universal process when he spoke of 'art which, together with science, leads to a knowledge of the ultimate aims of life on earth'.[271]

The idea that art gives man knowledge of the goal of his existence

transposed frequently into the idea that the knowledge bestowed by art imposes its form on what is known, and redeems experience from chaos. Bely found that a genuine theory of knowledge could only arise through the attempt to 'discover the unifying principle in the categories of knowledge', which condition was in his view pre-eminently satisfied by the Neo-Kantian philosopher Rickert;[272] in *Symbolism* he stated more explicitly that the act of cognition confers order on the chaos of reality, and that it is therefore more proper to speak of 'creation' than of 'cognition'.[273] Bely here appears to invoke the idea that art recreates reality in its own way and for its own purposes, but he himself warned against the danger that the artist's refraction of reality could become an object of contemplation in its own right: a metaphysic based on such a situation, he claimed, is nothing more than the gratification of a human appetite for contemplation, and is based on a 'purely nihilistic attitude to surrounding reality'.[274] He tried to show his concern not with subjective knowledge, but with knowledge of the external world, or of a 'reality' embracing both the subjective and the external worlds (cf. note 220).

For Blok, too, art was always a force that orders the chaos of life: he expressed this view most clearly after the revolution,[275] but it holds good for his earlier symbolist period. Blok, in his long article *On the Theatre*, expressed uneasiness at the pernicious influence of a theory of knowledge which weakens man's hold on the simplest concrete phenomena of his surroundings. His objection recalls Ivanov's resistance to 'a relativistic theory of knowledge' (cf. Chapter 2, p. 59, note 30). 'Why' asked Blok, 'do we speak of everything in such a limp and pale way?' and he answered his own question thus:

Because at the root of all the problems that have unfolded before us lies one vast premise whose name is – *doubt*. We are invited to justify our judgements on epistemological grounds. I do not think that this is bread for us. The theory of knowledge can be a heavy stone indeed for one whose heart and blood and will are infected by the sad exultations of contemporary life.[276]

The same notion lay at the root of mystical anarchism; Chulkov called for the mystical anarchist to reject the world 'in so far as it is chaotic, multiple and mortal',[277] which is surely an inverted

injunction to order the world and discover its eternal unifying principle.

It is interesting that the theory of knowledge of the realist opponents of symbolism, as it is expressed in the preface to *Outlines of a Realist World View*, shows at least superficially a similar insistence that the cognitive act is part of man's struggle to master the chaos of his surroundings:

> Realism is not a complete cognitive *system*, but a certain means for the systematic cognition of the *données* of experience. It is primarily a *working* solution: for realism, cognition is a live and immediate battle to wrest from nature her secrets, a battle in which man's actual mastery of the world is at issue.[278]

Here, however, it is a question of man's struggle with his *material* surroundings, whereas the symbolists moved freely between (and often combined) the two ideas that artistic cognition orders man's *experience* of his surroundings, and that it imposes its form on the external realities themselves. Most often, the symbolists seemed to believe the second to be possible in terms of the first, to imagine that art can order external reality with the same freedom and power with which it gives form to the subjectively created world of the artist. Some contemporary critics of the symbolist aesthetic showed an awareness of this ready confusion between the inward and the real worlds. Mokiyevsky, in an article with the suggestive title *The Theory of Knowledge and the Symbolists' Infernal Amalgam* (it was a direct response to the publication of Ivanov's *The Heritage of Symbolism* in 1910) framed his objection in the following terms: man's world is confined to what impinges on his consciousness; its quality varies with the capacity of different individuals for knowing it, and those who know it most deeply and truly are poets, whose business is predominantly with feelings and subjective reactions to the external world. As soon as the poet tries to judge the external world by laws which apply to his interior world, he is liable to be asked by philosophers on what theory of knowledge he bases such a transition from feeling to knowing. All our 'theurgizing poets and poetizing theurgists' are put to rout at this juncture, Mokiyevsky maintained, by the theory of knowledge; even Ivanov, for all his philosophical culture, succumbs to a negative theory of knowledge, characteristic of mystics, which discredits rational cognition and overvalues the

irrational.[279] Asmus, in his very illuminating study of the symbolist aesthetic, hints at something similar when he says that the question of the 'transformation of reality' by art is reducible to a question of cognition, since the 'transformation', in Ivanov's words, consists in passive contemplation of values rather than in a transforming *activity*.[280] Bely, for example, is adopting the position described here by Asmus when he asserts that creation has primacy over knowledge. The position surely derives from the certainty of the 'religious group' among the symbolists that the material world is constantly undergoing a transformation, which will ultimately bring it into harmony with the divine spiritual values, and that simply to reveal this process is to participate in it. All who in any degree shared this certainty felt that to know by contemplation the objects of the real world is already to contribute to their transformation. It is the theory of knowledge appropriate to a world in which every object is itself a symbol of a higher universal order, and to the 'life' envisaged in Solov'yov's philosophy, whose definition Chulkov gave as:

> ... A process of constant mysterious celebration, a constant joyous union with the truly real ultimate principle.[281]

Chulkov, like Bely, expressed the idea that the (symbolist) cognitive act is also a creative act, and he expressed it in a way which reflects the position under discussion. 'Baudelaire was right,' he wrote, 'in asserting that the world is a symbol. Realistic symbolism reveals the symbolic structure of the world, but art entails not only the cognitive, but the creative moment.'[282] Art, according to this view, demonstrates that the objects of the external world are themselves symbols of the universal order; through this process it confers knowledge of the universal order; but the process is creative in that it helps to bring about the universal order in this world.

Goethe's 'all that is transitory is but a symbol' made a particularly appropriate slogan for the Russian symbolists of the 'second generation'.[283] The attitude it represents is to be found for instance in the editorial preface to the first issue of *The Golden Fleece* in 1906 – 'art is symbolic, for it embodies the symbol – the reflection of the eternal in the transitory'.[284] This attitude was derived not only from literary antecedents – principally Baudelaire's *Correspondances*, of which Ellis, Chulkov and Ivanov made so much – but also from philosophical antecedents in the idealism of Berdyayev and his

associates, and ultimately perhaps from Solov'yov.[285] S. Vipper noted in 1905 how widespread had become the view that reality consists of symbols, and art is its key.[286] As an assertion of realism, this attitude of the symbolists was frequently misunderstood by their contemporaries: L'vov-Rogachevsky wrote in his *The Symbolists and their Successors*:

> In this ideal world, where 'words are chameleons, where everything is but a symbol', they retreated from reality and gradually lost the capacity to understand its language, its movement, its struggle.[287]

The attitude that all objects of the real world are symbols may be traced in one form or another even in symbolists of the first generation, notably those whose views had a religious bias. It is implicit in Volynsky's idea that art represents phenomena in the light of an understanding of the unity of the sensibly real and the mystical worlds (cf. passage IV, p. 109), and in Zinaida Gippius' characterization of the task of art – 'to give people the comfort of believing in the invisible as if it were the visible'.[288] P. P. Pertsov, in his *Literary Memoirs*, associated the characteristic 'dual world view' with Merezhkovsky.[288a] In 1906 there appeared in *The Golden Fleece* Bryusov's *Carl V: A Dialogue about Realism and Art* in which a 'young author' (supposedly Bryusov) discusses his new play with an editor, a poet and 'a mystic' (this last apparently caricaturing the position adopted by Bely and Ivanov[289]). The mystic puts forward the idea that phenomena – any phenomena – are symbols by which we can know the eternal idea, and he quotes Goethe's formula. The young author finally concludes that his realism is no different from the symbolism of the mystic.[290] Reviewing Sologub's *A Book of Tales* in 1904, Bryusov praised him for transforming the objects of his everyday surroundings into 'symbols of the eternal relation of man to the universe'.[291]

Amongst the second-generation symbolists this attitude was fundamental to the views of Bely and Ivanov. We have already seen how it underlay Ivanov's 'dynamic principle of intelligible substance' (cf. Chapter 2, p. 85). In *The Problem of Culture* Bely declared that Goethe's formula found its ultimate vindication in symbolism.[292] In one of his essays on Chekhov, he suggested that the realist artist, contemplating the moment of real life which he is

bent on depicting, penetrates to the *au delà* without even suspecting it; he is not necessarily aware that any moment of reality, seen in depth, becomes a 'door into eternity'.[293] Ellis, who stood on the divide between decadence and second-generation symbolism, described the inevitable quotation from Goethe as a classical formula for the creative process, since it asserts the truth that only by penetration into the world of phenomena can one attain to the 'idea', and that 'phenomena have meaning not in themselves, but only as a *Gleichnis*, as the reflection of another, mysterious and hidden, perfect world'.[294] In *The Russian Symbolists* he referred to such an aesthetic as a development and perfection of Schopenhauer's view of art, owing in particular to Schopenhauer the idea that contemplation is not simply cognition of real objects, but creative transformation of the object by the imagination.[295] Chulkov interpreted Dostoyevsky's 'realism in a higher sense' by reference to Goethe's formula (see note 236), and in praising Ivanov's concept of the link between poetry and life he wrote:

> The whole world . . . appears before us as a system of real symbols, and the poet, like an astrologer, reads the prophetic book.[296]

This strongly recalls Schopenhauer's: 'Das Leben und die Träume sind Blätter eines und des nämlichen Buches. Das Lesen im Zusammenhang heisst wirkliches Leben.'[297] The same idea is to be found in Sologub's *The Art of Our Day*, quoted on page 112 (passage XII) ('thus all objects become no more than intelligible signs of certain all-embracing relationships . . .'). Moreover, the assumption that 'all that is transitory is but a symbol' underlay the symbolists' claim to be scientifically 'objective' in their investigation of the mysterious 'higher' reality, for it enabled them to treat the 'lower' physical reality as a middle term between the questing mortal mind and the higher mysteries. This attitude is made strikingly clear by Sergey Solov'yov in an article in *Vesy*:

> Symbolist poetry is the science of The Eternal, just as physics and chemistry constitute the science of nature. Like any science, symbolist poetry is exact and determinate. Its obscurity is the complexity of an algebraic formula, and has nothing in common with mysticism and fantasy.[298]

(e) 'The ways of ascent and descent'

At this point the symbolist aesthetic as a whole can be seen to co-incide very closely with Ivanov's contention that the symbolist poet should have a feeling for *realiora in realibus* (Chapter 2, pp. 86–7). For Ivanov, the aesthetic process involved movement in two directions: the artist perceives the 'more real' behind the objects of reality, and 'ascends' in search of it; he 'descends' from his vision of the higher reality, in order to express it in terms of the lower reality, the material world. His art in turn leads the spectator from the material reality of his surroundings to the reality of the eternal values – *a realibus ad realiora*. It must be emphasized that in one form or another this view was very widely distributed in the Russian symbolist movement. It is to be found, naturally enough, in those directly influenced by Ivanov, such as Chulkov: it is implicit in the second of the two short passages cited on page 112 (XIII). It was adopted by Ellis, who, despite his hostility to many of the religious group of symbolists, wrote:

> Only immersion in the world of phenomena makes the idea attainable; consequently, contemplation must be directed not only from the real, but *through* the real. . . .[299]

Outside the religious group, it is implicit in Bal'mont's assertion that in symbolist poetry 'alongside the concrete content there is in addition a hidden content',[300] and in Sergey Makovsky's: 'on the other hand, we are shades of eternity, dimly becoming aware of ourselves as aesthetic beings and securing this being in beautiful images'.[301] It was also expressed as late as 1923 by M. Kuzmin, who in 1910 broke away from symbolism in the name of 'clarism'. Kuzmin praised Ivanov and Gershenzon's *Correspondence from Two Corners* as a valuable gift 'to all those who are able to distinguish behind reality the universal scheme of things'.[302] Likewise, Filosofov, who opposed Ivanov, none the less saw the urge to 'find the eternal in the transitory' as characteristic of the culture of the modern age as a whole.[303]

The idea of the artist's 'descent' ('нисхождение' was Ivanov's term for it) in order to embody the non-material values in images of the material world, is equally widespread. Bely's: 'Art is the symbolization of values in images drawn from reality' (passage VIII, p. 110) betrays the same desire to emphasize that the higher values

can only be expressed in the language of concrete reality; so too does Sologub's:

> In order for the symbol to become a perpetually opening window on to infinity, the image must have a double accuracy. It must itself be an exact representation in order not to become a random and idly invented image – there is no depth to be discovered in idle inventions.[304]

Bal'mont, in his *Elementary Words about Symbolism* (a lecture first given in Paris in 1900) described the process of creativity in terms which strongly recall Ivanov's lines of descent and ascent:

> ... the poet, in creating his symbolic work, proceeds from the abstract to the concrete, from the idea to the image, – he who acquaints himself with the poet's works ascends from the work of art to its spirit. . . .[305]

K. Chukovsky, writing about Przybyszewski in *Vesy* in 1904, warned that there are times when an artist's creativity dries up because the 'eternal and immutable' has occurred to him, but he has not been able to find the 'random and transitory' with which to externalize it.[306]

The insistence of the symbolists that they expressed their eternal values in the language of the here and now is, of course, entirely consonant with their efforts to refute the accusation that they escaped into the aesthetic world, and with their desire to show that they were a force in human affairs. This was, perhaps, the only form in which they could oppose their dualist world view to the monism of their more numerous antagonists (in the introduction to *Outlines of a Realist World View* we read that '[contemporary realism] is fighting for a monist concept of knowledge'[307]), but this is not to say that their insistence on the need for art to preserve its links with reality was entirely conditioned by their determination to oppose the realists on their own ground – it was to some extent inherited from the symbolists' literary forebears. Gudziy has shown that Ivanov's idea of 'descent' can be illustrated from Tyutchev,[308] and it is in any case present in the nineteenth-century heritage (cf. Chapter 1, p. 45). Red'ko, writing in fact about the acmeists, pointed out that the use of symbolic images, drawn from everyday life, in order to 'speak of the general in terms of the particular', was fundamental to the realist tradition.[309]

Some contemporary critics seem to have entirely missed the concern of the symbolists for the particular and finite. Ivanov-Razumnik, for example, maintained that symbolism eventually came to imply 'a certain world view involving the repudiation of the finite world in the name of the infinite'[310] This was, at least in theory, simply not true of the symbolists. Others, as for example Tal'nikov, acknowledged the symbolists' concern for the particular, and saw their departure from realism only as a failure to follow properly their own precepts.

(f) The transformation of reality

To Ivanov is due the credit not for the first formulation, but for the systematization of the process which the majority of Russian symbolists – and many realists – regarded as fundamental to the representation of reality in art. Ivanov differs from the main stream of second-generation symbolism (only slightly) in his view of the transformation of reality which all agreed could be brought about by the process of 'descent' and 'ascent'.

For Solov'yov, the aesthetic process consisted in the 'transfiguration of material through the embodiment in it of some other, higher-than-material principle', or in 'the transformation of physical life into its spiritual counterpart' (see Chapter 1, pp. 39, 40). Ivanov built his system around this concept, but described the action of art upon reality as a 'transfiguration' (преображение) rather than as a 'transformation' (преобразование) (cf. Chapter 2, p. 57). The distinction implied by the separate translation of the two Russian words does not always hold good; for many symbolists, and others, the two terms seem to have been virtually synonymous, and to have meant 'transformation' rather than 'transfiguration'. Ivanov had, with Solov'yov, an unshakable faith in the *reality* of the spiritual order, and consequently believed that art must lead to 'a real betterment of reality' (cf. Chapter 1, p. 39, note 131). Using the tentative distinction drawn above, we may say that the symbolists by and large, in discussing this aspect of the theory of symbolism, used the word 'transformation' at least as often as 'transfiguration', and even when they used the latter, they probably meant by it something nearer to the former. It is therefore dangerous to assume that all the symbolists envisaged quite the same effect of art on

reality as did Solov'yov and Ivanov. It is worth examining the ways in which the concept occurs amongst the symbolists.

Among the earlier generation, the concept was occasionally introduced in passing, as by Konevskoy, who praised Boecklin for his sense of 'Goethe's pure pantheism', expressed in the lines:

> Und umzuschaffen das Geschaff'ne,
> Damit sich's nicht zum Starren waffne,
> Wirkt ewiges lebendiges Thun.
> Und was nicht war, nun soll es werden.[311]

The artist is here seen to participate, as it were, in nature's constant self-perfection. Later, Konevskoy spoke of the poet as 'an Emperor, lord and master of the dead material of the external world'.[312] Bal'mont in 1900 distinguished the symbolists from the realists by their power to transform:

> Whilst the realist poets view the world naïvely, as simple observers, submitting to its material basis, the symbolist poets, creatively transforming substance by their complex sensibility, gain mastery over the world and penetrate its mysteries.[313]

Bal'mont suggests in one word (пересоздавать) both re-creation and transformation.

Bryusov likewise described the artistic process as the creation of life. In *About Art*, protesting against the tendency to see the work of art as a reflection of the historical moment which gave rise to it, he suggested that 'the contrary opinion, that life and nature are created by art, is somewhat nearer to the truth. . . . Man is a creative force.'[314] The echo of Oscar Wilde was probably not accidental. In 1904 Bryusov suggested that art departs from mere imitation in the sense in which Grillparzer held that 'art is to reality what wine is to the grape',[315] and pursued further the idea that an artist creates his own reality:

> We ourselves create our world – in the sense that forms having an extent in time and space, and subject to the law of cause and effect, are conditioned by the properties of our faculty of perception. We merely divine confusedly, by means of some still obscure spiritual powers, another conception of the world, another, a second level of the universe, and acknowledge that the whole of 'reality' surrounding us is but a projection of it.[316]

Bryusov inverts the commonplace that our knowledge of the world is conditioned by the limitations of our capacity to perceive it, and suggests that our interpretation of what we perceive actually imposes itself upon reality.

The 'transformation' concept is to be found more often still among the religious group of symbolists, and in the idealist philosophy of the contributors to *Problems of Idealism*. Berdyayev, for example, was reproached by Yushkevich for his assertion in his *The New Religious Consciousness and Society* that '. . . in a theocracy . . . there begins the final liberation from matter, from the law of inevitability, there begins the transfiguration of nature in the image of divine beauty'.[317] This is simply a restatement of Solov'yov, and the term employed is 'transfiguration'. Bulgakov, in his reply to *Outlines of a Realist World View* described the aim of the idealists as 'the transformation of reality in the direction of the ideal' (see note 247). Filosofov levelled against *Problems of Idealism* much the same criticism as was used by Tal'nikov, on the level of literary criticism rather than of philosophy, against the symbolist theorists – he accused its contributors of losing touch with the empirical world, as well as the world of the spirit, and hence losing the possibility of changing it:

> But in our idealists one senses a lack of this live connection with either mystical perception or sensory experience. The cold, rationalist principles of their philosophy are too formal and abstract, too sequestered, to be the vital force which could overcome our intellectual disharmony, assuage the torment of our souls and transfigure empirical reality that surrounds us.[318]

Both Bulgakov and Filosofov were religious philosophers whose thinking betrays the influence of Solov'yov. Bulgakov used the word 'transform'; Filosofov used 'transfigure', but its context suggests a change more physical than a 'transfiguration'.

The editorial prefaces which launched the periodicals of the second 'wave' of symbolism often contained the idea of transformation in some form. The editors of *The Golden Fleece* declared in its first issue: 'we sympathize with all who are working for the renewal of life'[319] *Pereval* announced that it stood for (amongst other things) 'unremitting labour on the renewal of the content of life'.[320] The editors of *Fakely* raised their torch in the cause of a 'free union

of mankind, founded in love of the future transfigured world' (see note 104). Chulkov (who was possibly responsible for the editorial quoted above) based his theory of mystical anarchism on the need to transfigure the world:

And the battle for the anarchic ideal leads not to undifferentiated chaos, but to a *transfigured* world. . . .[321]

He wrote of Tyutchev:

Admittedly in Tyutchev's work the hidden world is revealed not in its harmonious structure, but in its chaos, but the very chaos sings and sounds as it were in anticipation of its transfiguration.[322]

In 1914, speaking of the importance of symbolism for a democratic society, Chulkov declared that '. . . the progress of symbolism as an aesthetic phenomenon means absolutely nothing if life is not to change'.[323] This suggests that, although like Ivanov he consistently used the word 'transfiguration', he used it, or came to use it, to refer more to social change in the here-and-now than to the spiritual rebirth of man envisaged by Ivanov.

Sologub in *The Art of Our Day* (1915) used the word 'transfiguration': he spoke of the lyrical urge 'creating another world, longed for and indeed inevitable, but also impossible without the eventual transfiguration of the world'. However a few pages later we read:

Thus the new art calls us to great labour, the task of transfiguring our life, the feat of restoring the free spirit of mankind. . . . Contemporary art becomes increasingly suffused with a yearning for heroic action, for a life of optimism and activity. . . . This corresponds to the resolute, impetuous spirit of contemporary democratic society. . . .[324]

By 'transfiguration' Sologub appears in this case to refer to tangible social change. In his speech at the celebrated debate of 1914, he used the word 'transformation' – 'life demands to be transformed in the creative will. In this thirst for transformation, art must show the way to life. . . .'[325] Sologub, like Bryusov (cf. note 314), enthusiastically adopted Oscar Wilde's paradox that life endeavours to imitate art,[326] and at times he adopted an attitude of extreme solipsism[327] but in his more serious moments he clearly envisaged art as a force working for social change.

Bely, too, suggested occasionally that the aesthetic process brings about an actual change in the conditions of human life. In 1910, for example, in answer to the specific question: 'Does the artist have a responsibility to society?', he replied that art has a higher purpose and that works of art must be regarded as 'means for the creative transformation of life'.[328] (He used the same word as did Bal'mont at note 313.) However, Bely's approach was primarily epistemological; he returned again and again to the idea that to know reality is to create one's own world, and that the world so created is 'objective'. To paraphrase his argument as best one may: if the creative individual's self-created world is rooted in an intuitive awareness of the absolute reality of the divine order, then it is an objectively real world.[329] Thus in a great many of his (by no means consistent) statements of the effect wrought by art upon reality, the emphasis is on the 'creation' or 're-creation' of reality. A typically dogmatic statement of this point of view runs as follows:

> Art (*Kunst*) is the art of living. To live means to be capable, to know, to be able (*Können*). Knowledge of life is the capacity to preserve any life (my own, another's, that of the race). But the preservation of life lies in continuing it; the continuation of anything is creation; art is the creation of life.[330]

This seems to be an attempt to prove by mock-algebraic logic the quite unoriginal proposition that the word 'art' must be extended to designate all of life, provided it is lived at the highest level of awareness. In an essay of the same period as the above, dealing with the importance of the theatre, Bely restated his position, putting more stress on the value for man as a social animal of the 'life created by his own imagination':

> The fiction of the dramatic poetry . . . steals into your soul and, on leaving the theatre, you take this fiction out with you into life. And further: by this fiction you put life to the test. Life is colonized by the images of the fiction. . . . The dramatic fiction infects people like a fever, with the creation of an exalted and important life. . . . The creative idea becomes for everybody a life more valuable than that which is given to them . . . perhaps the ultimate aim of drama is to assist the transfiguration of man in such a way that he begins to create his own life. . . .[331]

Bely is in effect asserting that man can live by his artistic imagination, and that the conscious aim of art should be to adapt human life to the artist's vision. The confidence that this is possible derives from the certainty that the world of the symbolist artist's vision is 'real'. Elsewhere Bely wrote that 'the symbolic reality is the reality towards which the reality accessible to our observation should strive'.[332] It is never quite clear whether Bely intended this protest to apply to human *life* (when we can see it as, for example, a reorganization and 'respiritualization' of man's consciousness), or to empirical reality. In Bely's *The Crisis of Consciousness and Henrik Ibsen* we read:

> . . . the will to contemplation is the source of all *creativity*; and the active role of creativity in changing the conditions of being stands out clearly in the history of mankind.

It is not entirely clear whether 'conditions of being' refers to man's material surroundings, or to what we might call 'the human condition'. However, Bely continues:

> It is the point of application of the will that changes, the will itself is certainly not suspended, as Schopenhauer supposed. Previously, this point of application was the conditions of my given being (empirical reality), now the point of application of the will has become the capacity for recreating reality in images of artistic and intellectual creativity. . . .[333]

The distinction which Bely makes between Schopenhauer's view and his own appears to be this: where in Schopenhauer's philosophy, when the idea is attained the will 'suspends itself', Bely posits a transference of the activity of the will to the task of making the intuitively perceived idea 'real'. His position is essentially an attempt to advance beyond Schopenhauer in the light of Solov'yov's concept of the constant drawing together of matter and spirit, the constant realization of the ideal world.

It seems certain that even those symbolist thinkers who stood closest to Solov'yov believed that art will change the world in an active sense; this belief underlay their rejection of 'art for art's sake'. They all departed from the notion of 'transfiguration' as defined by Solov'yov in his analogy of diamonds and coal (cf. Chapter I, p. 39): they envisaged not the transfiguration of the *appearance* of the world in the light of their knowledge of the relationship in which

the material world stands to the ideal, but a transformation of the human world in the here-and-now. Even Ivanov, whose use of the word 'transfiguration' was closest to Solov'yov's concept, made 'Action' one of the terms of the aesthetic process (cf. Chapter 2, p. 71), and he was for a short time drawn to mystical anarchism by its promise of collective 'action'. Ellis, always the aloof, 'aristocratic' symbolist, attacked the attempt of his fellow symbolists to find an 'action-programme' and transform society. Merezhkovsky's tragedy, Ellis wrote, lay in his 'transition from artistic *contemplation* to a thirst for *'action'*, to the desire to create life and regenerate contemporary man', and he maintained that the efforts of his fellows to turn Solov'yov's 'fantastic day-dreams' into a practical programme showed that the time was not yet come for the secret of symbolism to be made the basis for collective action.[334] Reviewing *By the Stars* in *Vesy*, he found that Ivanov's worst fault was his lack of a sense of perspective in time – he was grossly unrealistic about the prospects of realization of his mystical beliefs.[335] Ellis was virtually alone in his rejection of the idea that symbolism could be a social force; he had no desire to go beyond the view that art, in depicting the objects of the real world, turned them into symbols of 'the great unknown'.[336]

The symbolists' faith in the transforming power of the word rests ultimately on the epistemological peculiarity which characterized their thinking – namely, the idea that to know the empirical world in the higher sense, to know it in the light of an intuitive apprehension of the only 'real' order, is to 'create' or 'recreate' empirical reality in a *more real* form than that in which it is given to us. In its weakest form this faith is manifested in Blok's assurance that 'our dreams are close to reality. Our words are about to become flesh.'[337] Its most extreme and uncompromising statement is to be found in Bely's *The Magic of Words* where he claims that, if there were no words, the world would not exist:

> Every word is a sound; spatial and causal relationships pertaining outside myself become comprehensible to me through the word. If words did not exist, then the world would not exist either. My 'I', divorced from its surroundings, has no existence whatsoever; the world, divorced from me, likewise does not exist; 'I' and 'the world' arise only in the process of their coming together in sounds.[338]

178

The reaction of the contemporary critics of the symbolist movement to this notion was understandably always sceptical, and often scornful. The central idea of the symbolist aesthetic was something they could naturally not entertain. The attitude of the majority of them might be summed up by Shulyatikov's words, extolling the position of the traditional realist in terms which echo the claim of the symbolist artist to be a 'prophetic' leader, but resolutely exclude the symbolists from this position:

> Formerly . . . the man of letters was, in the eyes of the public, a teacher of life, a preacher and a prophet. Today's man of letters, who is coming more and more to create 'from within himself', who is going over more and more to the position of builder of a 'new world', existing independently of 'real life', is naturally losing the authority of a leader of public opinion.[339]

In the terms in which the 'realists' conceived of art as a force in the world, the symbolist claim could only appear ridiculous, a retreat from the only obvious connection between art and reality, and above all a retreat from any kind of social ideal into a self-sufficient individualism; thus Kogan classified the non-realist artist, who transforms reality according to his desires and creates the world anew, as typically individualist.[340] Kogan blamed Oscar Wilde (whose *Intentions* was indeed often referred to by the Russian symbolists) for the prevalence of the idea that the work of art creates the only true reality.[341] To N. I. Nikolayev, the symbolists' 'thirst for transformation' betrayed the fundamental contradiction in their aesthetic – in their art they repudiated everyday reality (he wrote), and yet Ivanov's aesthetic theory, with all its concern for collectivity, was grounded ultimately in the everyday life which it denied.[342] Lev Shestov found Ivanov's position equally unacceptable; he remarked scornfully that a philosopher who creates his own reality is simply licensing an investigation without reference to the world around him.[343]

The realists themselves, however, obviously believed that art should in a certain sense 'transform reality'. Voytolovsky's article in *The Decay of Literature*, in which he maintained that 'beauty transforms reality', has already been cited (see note 204). Lunacharsky in 1904, in *Outlines of a Realist World View*, described the realists' expectations of art, their hopes for its preservation from the

stunting effects of individualism, and their certainty that through art man perfects his world:

It is a question not simply of engendering life at one's own level, but of creating it higher than oneself. If the essence of all life is self-preservation, then beautiful, good, true life is self-perfection. Neither, of course, can be confined in the narrow frame of individual life, but must be set in its relation to life in general. The only good, the only beauty, is the most perfect form of life.[344]

Both the realists and the symbolists were engaged (in the Russian social context, perhaps inevitably) upon a transformation of reality. The aspirations which guided them were ultimately not dissimilar: both factions strove for a harmonious community of man, and a fuller self-realization of the individual. The fundamental difference between their programmes is, in the final analysis, the difference between a monist and a dualist ideology. The symbolists wished to transform the world in the light of a transcendental order whose existence the realists denied; the realists wished to transform the world on the basis of a philosophy which seemed to the symbolists to deny one whole aspect of reality, and so to restrict unnecessarily the human perception of the world.

Conclusion

POETRY AND THE ABSOLUTE

*J'ai tant rêvé de toi
que tu perds ta réalité.*

ROBERT DESNOS

1. The philosophy of Solov'yov in the symbolist aesthetic

Examination of the aesthetic theories of the six nineteenth-century figures discussed in Chapter One showed that their preoccupation with the social utility of art gave rise to a disturbing inconsistency in their accounts of the relation between art and reality. This may be described as an attempt to reconcile, or to assert simultaneously, two suppositions, the one socio-ethical, the other aesthetic. On the one hand, it was expected that the artist's representation of reality should reflect a generally shared moral dissatisfaction with an imperfect world. On the other, it was recognized that in representing what he sees, the artist is 'recreating' reality, not necessarily in the light of a rational analysis, but in terms of a personal, imaginative vision or intuition of the essential nature of things. The tendency of the nineteenth-century theorists was to try to make the second supposition dependent upon the first, to show the artist's personal vision to derive from the striving of the community to improve its condition. The first supposition itself gave rise to a specifically aesthetic assumption, namely, that artistic representation involves a process of generalization; this was expressed most characteristically as the artist's search for the 'typical' amidst the random particulars of a world progressing towards a more harmonious social order. This assumption is in fact the reverse of the second supposition, which involved recognition of the power of the artist to present not an abstracted picture of reality, but what Belinsky, for example, called a 'clear and living representation', a recreation of reality at the level of the particular, the fruit not of reasoned abstraction but

of the imaginative vision. The nineteenth-century theorists, in attempting to say what the artist does in representing reality, were consequently always prey to a greater or lesser degree of ambiguity and uncertainty.

Vladimir Solov'yov presents in this respect a paradoxical exception, for he was able to resolve to his own satisfaction the tension between the pursuit of the general and the particularity of the means of expression. In his case, concern for the particular takes the form of an assertion that art brings about 'the immortalization of . . . individual phenomena' (Chapter 1, p. 40, note 141); art, in other words, concerns itself with 'the minutest material details' precisely *because* the material world is subject to a process of constant assimilation to the highest possible generalization, the 'objective idea'.

Russian symbolism had its origins in the widespread European movement to assert the individuality of the artist, and recognize the independence and the peculiar powers of the artistic imagination; it sprang, that is, from another situation in which a socio-ethical assumption is linked with its supposed aesthetic counterpart. The symbolists, quite apart from their ideological opposition to the realist tradition, consequently placed an often exaggerated emphasis on the aspect of the artistic process which their nineteenth-century forbears could only reservedly admit into their theories. However, although many of the earlier representatives of the symbolist movement went so far in their assertion of the values of the individual as to adopt a demonstratively solipsistic attitude, the mature phase of Russian symbolism was characterized by a retreat from extreme individualism, and an attempt to discredit the subjective element in creativity and show art to be an instrument for the reconstruction of communal values. This change of standpoint had several causes.

In the first place, there are signs in the theoretical writings of the symbolists of an ultimate allegiance to the nineteenth-century tradition of social commitment in literature, fostered at least to some extent in response to the provocation of constant accusations, from the acknowledged heirs to that tradition, that the symbolists betrayed the struggle for a new social order in Russia. The vein of neo-populism that is also discernible in Russian symbolist thinking is probably only partly the result of this factor, for it seems also to have been conditioned by nostalgia for an age in which the artist held a more secure position in society, as a mouthpiece, a prophet, even a leader

or a priest. Indeed, a second cause of the symbolists' retreat from individualism was disillusionment with the values of the isolated individual, dissatisfaction with an essentially Romantic situation (also represented in the Russian tradition, notably by Tyutchev and Fet) in which the poet, for want of a common language with the people, brooded in melancholy silence or sang to himself alone.

In the second place, the individualism of the Russian symbolists was tempered by the pervasive influence of the philosophy of Vladimir Solov'yov, who himself, in however idiosyncratic a way, shared in the prevailing assumption of the social utility of art. Solov'yov provided an altogether different answer to the problem of the artist's isolation, by way of his contention that the individual is able to transcend his subjective state and have 'positive', though extremely general knowledge of the metaphysical essence of the cosmos' (cf. Chapter 1, p. 42, note 147). This opened the way for an ideal of a community of man in which individuals would be united by their common awareness of the invisible, essential world.

Furthermore, the acceptance of Solov'yov's views of the interaction of art and the world of physical realities brought to a head the tension in the symbolist aesthetic between the idea that the artist distils from reality what is most generally valid for the community to which he belongs, and the idea that he transmutes reality in the light of an imaginative vision or intuition. For in the light of this view it seemed clear that the artist, possessed of his intuition of a universal, supremely real order lying beyond the visible world, can only express that intuition at the level of visible, particular phenomena. The symbolist aesthetic consequently embodied a demand for an extended realism (in Sologub's words, a 'dual accuracy'), faithfulness both to the invisible world and to its material incarnation. This was expressed schematically by Ivanov as a process of 'ascent' and 'descent' between 'higher' and 'lower' orders of reality. Thus the symbolists were wont to claim, when accused of being 'unrealistic', that their art reproduced faithfully enough a 'reality' understood to include the invisible as well as the visible world.

However, leaving aside the question of the content of 'reality', the symbolist theorists, when speaking of representation in art, went beyond the assumption that art is an interpretation of the world we inhabit, presented not by the methods of rational analysis,

but by a recreation of the immediate elements of reality in the light of the artist's deeper understanding of them. The theories of art of the nineteenth-century 'realist' tradition had always called for art to be more than an interpretation, to be a part of the process by which man changes his surroundings for the better. Solov'yov's teaching that art helps to bring about a transformation that is already latent in all matter – its progressive 'spiritualization', or approximation to the invisible order – provided in the symbolist aesthetic for a more immediate gratification of the desire that art should change reality, for it implied that, for the artist to contribute to the transformation of the world, it is enough for him simply to represent the finite, the imperfect, in the light of his vision of the infinite, the perfect and desirable order.

At its source, in Solov'yov's writings, this teaching belongs to the sphere of mystical religious philosophy, and gives only very qualified support for a crude expectation of immediate change to be wrought by art in the human condition. Optimistic though Solov'yov was about the possibility of realization of the ideal order on earth, he hoped in terms which proved too vague to answer to the expectations of the symbolists who followed his lead. Indeed, one of the thinkers associated with Russian symbolism, the renegade marxist Sergey Bulgakov, complained that Solov'yov's teaching was 'defective in the sense that it lacks a clearly-defined socio-economic and political programme'.[1] In the form in which it was retailed by the second generation Russian symbolists, Solov'yov's teaching of the 'spiritualization of matter' was overcharged with expectations as a result of its assimilation to two other tendencies in symbolist thinking.

In the first place, the symbolists were under constant pressure, particularly after 1905, to show that their art was concerned with social change, and to redeem themselves from the taint of alliance with the forces of reaction. Consequently, they were tempted to exaggerate the claim that symbolist art had by its very nature a transforming power.

In the second place, the solipsistic tendencies deriving from their relativistic philosophy, their inclination to believe that the individual's vision of a higher order is uniquely 'real', led the symbolists to take an unwarrantedly optimistic view of the immediacy with which the artist's vision might be realized in the visible world.

Amongst all the theorists of Russian symbolism, Vyacheslav Ivanov stands closest to Vladimir Solov'yov, and is in the least degree responsible for the debasing of Solov'yov's philosophy. Ivanov was himself, unlike the remainder of the symbolists, a primarily religious thinker, and Solov'yov's theories were meaningful to him as religious philosophy. Though he was, none the less, tempted into undue optimism in his hopes for the realization of a divine order, at least at the stage of his dalliance with 'mystical anarchism', Ivanov remained principally concerned with the implications *for the artist* of a religiously based aesthetic, of the belief that the higher order he intuited was real, and that his task lay in making his intuition widely intelligible and in leading others to share in it.

It was by its insistence on such belief that Ivanov's system proved, in the comparison drawn in the summary to Chapter Two, to be ultimately at variance with the otherwise strikingly similar system of Cassirer. Cassirer regarded art as the instrument of man's interpretation of the phenomenal world, as the medium in which he constructs for himself a symbolic universe. For Ivanov, art was interpretative only in so far as it revealed the reflection of an absolute, not a symbolic, order in the phenomenal world. The concluding aim of the present study is to suggest the aesthetic implications of Ivanov's position, and for this a fresh term of comparison is required.

2. 'The disinherited religious mind'

A new term of comparison is offered by Erich Heller's well-known essay on Rilke and Nietzsche,[2] the value of which for this study lies in its sober treatment of the question, vexed almost beyond the asking, of thought and belief in poetry, and in its highlighting of the outward signs which appear to associate Vyacheslav Ivanov with the world of Rilke and Nietzsche.

The similarity is one of kind, not of stature: Ivanov shared with Rilke the same poetic endeavour, identified by Erich Heller as that of 'the religiously disinherited religious mind'. The outward signs of kindredness are to be seen in Rilke's deity, the Orpheus compounded of both Apollo and Dionysus, and in the similar pathos of

Rilke's poetic task: 'We need *eternity*; for only eternity can provide space for our gestures. Yet we know that we live in narrow finiteness. Thus it is our task to create infinity *within* these boundaries, for we no longer believe in the unbounded.'[3] The signs are plainer still in Rilke's live, reproachful things: 'I feel that more and more I am becoming the disciple of things ... who adds, through comprehending questions, intensity to their answers and confessions ...',[4] and in his hints of a higher power at work behind things:

> Und welcher Geiger hat uns in der Hand?
> O süsses Lied.[5]

Perhaps the clearest evidence of the link is their identity of emphasis. For Rilke, as for Ivanov, it is not enough that things help us to feel our *'real "relatedness"* to what really *is'*: he insists that we *live* by this process. Erich Heller quotes the twelfth of the first group of *Sonnets to Orpheus*:

> Heil dem Geist der uns verbinden mag;
> denn wir leben wahrhaft in Figuren.
> Und mit kleinen Schritten gehn die Uhren
> neben unserm eigentlichen Tag.
>
> Ohne unsern wahren Platz zu kennen,
> handeln wir aus wirklichen Bezug.

We saw an equally insistent emphasis on 'life' in Ivanov's description of the common yearning of the artist and his material. Thus far Ivanov can be assimilated to Rilke's world.

However, it is precisely on this last point that the assimilation proves imperfect. Rilke felt that we truly live our lives *in symbols* – 'wir leben wahrhaft in Figuren'. Ivanov found that all nature, man and things alike, longs for live, *not symbolic* life. Rilke, in Erich Heller's view, found the peace of 'pure relatedness', which is so pure because no real 'otherness' enters into it, and in which life and death are one. Ivanov's symbolism also unites life and death, and light and darkness, and a host of other no less distressing contraries. But the reconciliation of these opposing forces is for him not a triumph of pure inwardness, but a victory for outwardness, for the real 'other' that lies beyond the symbols. Erich Heller discerns the 'excruciating problem' of Rilke, Nietzsche and the spiritually disinherited European mind in the awareness that 'the "real order" has to be "created" where there is no intuitive conviction that it

exists'. Rilke and Nietzsche laboured and suffered to create their 'real order' (and so too does Cassirer's ideal artist labour, but with little mention of suffering). Ivanov, we know, had the intuitive conviction that the 'real order' exists. He insisted at every turn that artistic creation is, after all, only revelation of the 'real order'. He inherited the intuition from Vladimir Solov'yov, who was in so many respects the spiritual father of Russian symbolism. When defining the value of a work of art in *Two Elements in Contemporary Symbolism*, he observed that in order to realize Solov'yov's ideal of 'theurgic art' – in order to 'consciously direct the earthly embodiments of the religious idea' – we must believe in the reality of what is being embodied (cf. p. 52, note 10). Ivanov shared this ideal,[6] and the mystical faith that inspired it. He had an unshakeable belief, or 'intuitive conviction', that the divine order is real (or in his language, 'more real').

3. Poetry and belief

Belief in the real order did not automatically elevate Ivanov to a sanctuary of the spirit from which he might show the way to less fortunate fellow-seekers. Even if he could know some part of the 'real order', he could say it only at the price of half-relinquishing it, and then trying to praise it in the doubt-ridden language of the world below. Faith, after all, is by no means an effortless certainty. If it were so, we would expect Ivanov's poetry to have an unusually consistent serenity and self-assurance, which in fact it does not have. It has its serene moments, and his earliest collection, *Pilot Stars* (1903) is in particular pervaded by a very self-assured sense that poetry is spiritual guidance for the spiritually needy. However, a self-assured position *poetically* occupied does not mean that all doubts have been driven beyond the palisade, and the tone of Ivanov's poetry became gradually less assured. Its subject-matter was in any case, significantly, not so often the things of eternal beauty themselves, as the difficulty of finding poetic expression for them; even his contemporaries had realized this by the end of the period we are considering.[7] Here is an example of a poem written in 1915, when Ivanov was less sure of the value of 'descent', of the rewards of renunciation:

> Людская молва и житейская ложь,
> Подоблачной стаи моей не тревожь.
>
> Все знаю, в воздушный шалаш восходя
> И взгляд равнодушный по стогнам водя:
>
> С родной голубятней расстался бы я, —
> Была бы понятней вам песня моя.
>
> Эфирному краю скажи я 'прости'
> И белую стаю свою распусти, —
>
> Я стал бы вам нужен, и сроден, и мил,
> С недужным недужен, с унылым уныл.[8]

The falsehood and prattle of the world must not disturb the poet's serene existence as a flock of snow-white doves in the celestial dovecote that is their home. He knows that, were he to flutter down from the sky, his song would become more intelligible on earth – but by then he would have become loved and needed, kindred, sick and sad along with other mortals. The implication is that he refuses to descend.

Very probably the same uncertainty is reflected in Ivanov's awkward definitions of beauty which fail to resolve the tension between 'Beauty' and the aesthetic experience, between the metaphysical absolute and the material forms of beauty. But it is the material forms that are called into question, not Beauty itself; the uncertainty is at the level of the incarnation, and does not beset the fount of the godhead, so that Ivanov's hope for this world was bought at an ultimately less agonizing price than the desperate hopes of Rilke or Nietzsche. With so secure a belief in the reality of the other world, he did not even feel obliged to prove this world real: for him, the reality of the lower order of things was founded in that of the higher order it reflected.

This feeling of *ultimate* certainty is well expressed in an early poem, two lines of which were quoted earlier in this study:

> Природа — знаменье и тень предвечных дел:
> Твой замысел — ей символ равный.
> Он есть: он — истина. Прах Фидиев истлел:
> Но жив отец громодержавный!
>
> Сомкнуть творения предгорнее звено,
> Ждет Человек своей свободы.

Дерзай, Промефиад: тебе свершить дано
Обетование Природы!
Творящей Матери наследник, воззови
Преображение Вселенной,
И на лице земном напечатлей в любви
Свой идеал богоявленный![9]

The poet's conception really *is*, it is the truth, the Father is still alive, and the world shall take on a new light. . . . Rilke was all that he was precisely because he could not make an assertion in this vein.

Ivanov's optimism is rooted in the belief that man and his material surroundings are but the phenomena of a higher, and purposeful entity. He conceived the situation in religious terms, since his was a not-yet-disinherited religious mind, but these are by no means the only possible terms. The situation remains basically the same as that of which Kant was aware when he reminded us that the gift of creating new forms of the natural world is itself a gift of nature. Neither optimism nor pessimism is inherent in this situation: the recognition that through man nature made gillyflowers too, simply closes the vicious circle of human striving for objective knowledge. However, the striving can be glorious or miserable in its own right; it can give rise to optimism, pessimism or total cynicism, and we may turn to a more recent poet for a beautifully concise definition of the optimistic striving that was Ivanov's:

De la pensée discursive ou de l'ellipse poétique, qui va plus loin, et de plus loin? . . . La réponse n'importe. . . . Car si la poésie n'est pas, comme on l'a dit, 'le réel absolu', elle en est bien la plus proche convoitise et la plus proche appréhension, à cette limite extrême de complicité où le réel dans le poème semble s'informer lui-même.

Par la pensée analogique et symbolique, par l'illumination lointaine de l'image médiatrice, . . . par la grâce enfin d'un langage où se transmet le mouvement même de l'Être, le poète s'investit d'une surréalité qui ne peut être celle de la science. . . .

Mais plus que mode de connaissance, la poésie est d'abord mode de vie – et de vie intégrale. . . .

Ainsi, par son adhésion totale à ce qui est, le poète tient pour nous liaison avec la permanence et l'unité de l'Être. Et sa leçon est d'optimisme. . . . L'inertie seule est menaçante. Poète est celui-là qui rompt pour nous l'accoutumance.[10]

Saint-John Perse, too, saw the vicious circle close, putting absolute reality and objective knowledge, tantalizingly, just outside the power of man to frame. But he would not be outwitted by the paradox of man's natural creative gift; he saw this paradox as an 'extreme limit of complicity', a situation in which the reality created and perpetually renewed by poetic endeavour conspires to vindicate itself entirely from its own resources. For Saint-John Perse the universal Being (or the power of Nature, or God) is manifest in the endeavour alone; its movement is reflected in the striving of humans for its attainment, and it is something that can be 'lived out' on earth by right-minded men. True poetry, Ivanov said, is not representational, but 'motive'; it creates not images, but life itself. 'People who are bound by fact', wrote Solov'yov, referring to the conventional realists of his day, 'live vicariously and it is not they who create life. It is the believers who *create life*.'[11]

Notes

Chapter One

1. All three labels were applied at various times and by various factions to the same group of writers. The editors of the symbolist periodical *Vesy*, reviewing their activities when its publication ceased in 1909, claimed to have provided a vehicle for 'the whole world-view known by the relative terms "symbolism", "modernism", "the new art", and even "decadence" . . .' ('К читателям', ВЕСЫ, 1909 № 12, стр. 186). There is a good deal of evidence to suggest that these terms were broadly equivalent. Aleksey Remizov thought that the term 'decadence' was introduced into Russia with a somewhat indiscriminate application by Max Nordau, and given wider currency by Mikhaylovsky and Solov'yov (А. Ремизов: *Подстриженными глазами*, Париж, 1951, стр. 294). Bryusov in 1899 spoke of 'the new school (decadence, symbolism) . . .' (В. Я. Брюсов: *О искусстве*, М., 1899, стр. 23) and Bal'mont in 1904 remarked that 'strictly speaking, symbolism, impressionism and decadence are only *psychological lyricism,* differently compounded, but always essentially the same' (*Горные вершины*, М., 1904, стр. 77). A. Voznesensky wrote in 1910 that 'by the new poetry is generally meant the poetry which is called in the drawing-room "symbolism" and on the street "decadence"' (А. Вознесенский: *Поэты, влюбленные в прозу*, Киев, 1910, стр. 5).

 On the other hand, there were from time to time attempts to treat 'symbolism' as a more mature movement which had outgrown 'decadent' attitudes. Volynsky (A. L. Flekser) concluded his essay 'Decadence and symbolism' with the suggestion that the symbolists had 'overcome decadence, with its naïve banal fantasies and vacuous demonism', and were to be distinguished by their thirst for a religious truth (А. Л. Волынский: 'Декадентство и символизм', в кн. *Борьба за идеализм*, СПб., 1900). For Modest Gofman, symbolism was distinguished from decadence by its inclination to realism (М. Гофман: 'Романтизм, символизм и декадентство', в

Книге о русских поэтах последнего десятилетия, М., 1909, стр. 25); however, Fyodor Sologub thought that the tendency to realism was precisely what linked 'decadence', 'modernism' and 'symbolism' (Ф. Сологуб: *Символисты о символизме*, ЗАВЕТЫ, 1914 № 2, стр. 75).

2. В. Г. Белинский: *Взгляд на русскую литературу* 1846 г. *Взгляд на русскую литературу* 1847 г. М., 1960, стр. 7.

3. Ibid., pp. 73–4.

4. Ibid., p. 14.

5. Ibid., p. 83.

6. Ibid., p. 33.

7. Ibid., pp. 87–8.

8. Ibid.. p. 74.

9. Ibid., p. 68.

10. Ibid., p. 28.

11. Ibid., p. 29.

12. Loc. cit.

13. René Wellek: *Concepts of Criticism*, Yale, 1963, pp. 252–3.

14. *История русской критики*, т. I, Ак. Наук, М/Л., 1958, стр. 16.

15. René Wellek: 'Social and aesthetic values in Russian XIX-century literary criticism', in *Continuity and Change in Russian and Soviet Thought*, ed. Simmons, Harvard, 1955, pp. 382 ff.

16. Ibid., p. 388.

17. Belinsky: op. cit., pp. 83–4.

18. Ibid., p. 26.

19. For example, in his article '"Hamlet", the play by Shakespeare, and Mochalov in the role of Hamlet', in which Belinsky defends the actor Mochalov from the charge of 'subjectivism' on the grounds that: 'If Mochalov's acting were not suffused with this aesthetic creative life, which softens and transforms reality, freeing it from the bounds of the finite, then . . . not many willing spectators would be found. . . .' Белинский: *Полное собр. соч.* т. 2, М., 1953, стр. 340–1.

20. For example, Б. Бурсов: *Вопросы реализма в эстетике революционных демократов*, М., 1953, стр. 103–4.

21. Cf. René Wellek: 'Social and aesthetic values in Russian XIX-century literary criticism' (see note 15), p. 388.

22. Н. Г. Чернышевский: *Эстетические отношения искусства к действительности*, СПб., 1865, стр. 1–2.

23. Ibid., pp. 4–5.

24. Ibid., pp. 6–7.

25. The expression 'the beholder's share' is borrowed from E. H. Gombrich's *Art and Illusion* (1960; second edition London, 1962) as a succinct way of referring to the part played by the far from innocent eye of both the artist and his spectator, in interpreting reality to make a work of art, and in 'reading' the finished work.

26. Chernyshevsky: op. cit., pp. 6–7.

27. Chernyshevsky refers his quotation to 'Фишер: *Ästhetik*, II Teil, p. 299 ff.'. Friedrich Theodor Vischer, an influential Hegelian, completed his six-volume *Ästhetik oder Wissenschaft des Schönen* between 1846 and 1858.

28. There is possibly a more than simply historical significance in the fact that Chernyshevsky (and indeed all the 'radical' critics, as well as Belinsky) used the word 'фантазия' rather than 'воображение' when speaking of the imagination. 'Фантазия' has disparaging overtones that were in keeping with their attitude to the activities of the imagination. Even in one of his rare uses of the word 'воображение', Chernyshevsky couples it with 'мечта' – 'dreams of the imagination' (op. cit., p. 53) – which seems to indicate that for him the imagination is not quite respectable as a conscious mental process.

29. For the whole of the foregoing paragraph, see Chernyshevsky: op. cit., pp. 44–54.

30. Ibid., p. 59.

31. Ibid., p. 66.

32. Ibid., p. 101.

33. Ibid., p. 102.

34. Ibid., p. 103.

35. Ibid., p. 118.

36. Ibid., pp. 125–6.

37. Ibid., pp. 127–9.

38. Ibid., p. 131.

39. Ibid., p. 141.

40. Ibid., p. 143.

41. Ibid., p. i.

42. Ibid., pp. 144–7.

43. Ye. Ya. Kolbasin described this atmosphere as one of 'elegantly aristocratic liberalism'. See История русской критики, т. I, М/Л., 1958, стр. 452.

44. Blok wrote a long introductory article to the edition of Grigor'ev's poetry which appeared under his editorship in 1916 (*Collected Works*, vol. 5, M/L., 1962, pp. 487 ff.). His enthusiasm for Grigor'ev is documented by frequent references in his notebooks, but, significantly, it did not outlast the heyday of the symbolist movement, to judge by his apology in 1918 for his inability to lecture on the writer who had once interested him so strongly (*Coll. Works*, vol. 6, p. 26).

45. А. Л. Волынский: *Русские критики*, СПб., 1896, стр. 684.

46. See, for example, У. А. Гуральник: *Аполлон Григорьев – критик*, в кн. *История русской критики*, т. I, стр. 479, and Blok's suggestion that Grigor'ev declined to 'haughtily judge great Russian artists either by the aesthetic canons of the German professors, or from the standpoint of a "progressive political and social theory"' (А. Блок: *Собр. соч.*, т. 5, М/Л., 1962, стр. 513).

47. А. Григорьев: *Сочинения*, т. I, СПб., 1867, стр. 189–90.

48. Ibid., p. 137.

49. Ibid., p. 140.

50. Ibid., pp. 138–9.

51. Ibid., p. 193.

52. Ibid., pp. 194–5.

53. Ibid., pp. 142, 201.

54. Ibid., p. 202.

55. Ibid., p. 141.

56. Ibid., pp. 184–9.

57. Ibid., p. 145.

58. Ibid., p. 187.

59. Ibid., p. 203.

60. Cf., for example, I. A. Richards: *Principles of Literary Criticism*, London, 1961, pp. 111–12, 139–40, 234–5, etc.

61. Apollon Grigor'ev: op. cit., p. 184.

62. Ibid., pp. 226–7.

63. Ibid., p. 226.

64. Ibid., p. 212.

65. Л. Н. Толстой: *Что такое искусство?* Собр. соч, т. 15, М., 1964, стр. 80.

66. Ibid., pp. 77–8.

67. Ibid., p. 84.

68. Ibid., p. 81.

69. Ibid., p. 221.

70. Ibid., pp. 85–7, 172.

71. Ibid., p. 179.

72. Ibid., p. 136.

73. Л. Н. Толстой: *Об искусстве, Собр. соч.*, т. 15, М., 1964, стр. 43.

74. Л. Н. Толстой: *Что такое искусство?*, Собр. соч. т. 15, стр. 213.

75. Ibid., pp. 89–90.

76. Ibid., p. 183.

77. Ibid., p. 185.

78. Ibid., p. 189.

79. Ibid., p. 200.

80. Ibid., pp. 109–10, also p. 152: 'Искусство всенародное имеет определенный и несомненный внутренний критерий – религиозное сознание. . . .'

81. Ibid., pp. 96 ff.

82. Ibid., pp. 199–200.

83. Ibid., pp. 219–20.

84. Indeed, Tolstoy saw the more highly educated as being at a disadvantage, since truly aesthetic emotions are experienced only by the 'simple soul' – in the case of contemporary man, only in childhood. See Tolstoy, op. cit., pp. 178–9.

85. Ibid., pp. 135–6.

86. Вячеслав Иванов: 'Лев Толстой и культура', в кн. *Борозды и межи*, М., 1916, стр. 77.

87. Such a wish was characteristic of Tolstoy's mental disposition, as was well appreciated by symbolist critics. Anichkov pointed out that Tolstoy was a westernizer at heart; Vyacheslav Ivanov, commenting on Anichkov's remark, suggested that Tolstoy was drawn to America rather than to Europe, attracted not by Western ideas, but by the settler-spirit of starting life on fresh ground. See Ivanov: op. cit., p. 83.

88. Толстой: *Об искусстве, Собр. соч.* т. 15, стр. 41–2.

89. Толстой: *Что такое искусство?, Собр. соч.* т. 15, стр. 144.

90. А. М. Скабичевский: *История новейшей русской литературы,* изд. 3-е, СПб., 1897, стр. 66.

91. А. М. Скабичевский: 'Беседы о русской словесности' (1876), *Сочинения,* изд. 3-е. т. I, СПб., 1903, стр. 858.

92. Ibid., p. 861.

93. А. М. Скабичевский: 'Живая струя' (1869), *Сочинения,* т. I, СПб., 1903, стр. 117.

94. Ibid., p. 116.

95. Ibid., p. 142.

96. А. М. Скабичевский: 'Задачи литературной критики', РУССКОЕ БОГАТСТВО, 1890 № 12, стр. 135–6.

97. А. М. Скабичевский: 'Жизнь в литературе и литература в жизни' (1882), *Сочинения,* т. 2, СПб., 1903, стр. 62.

98. Ibid., p. 76.

99. Ibid., p. 78.

100. Ibid., p. 74.

101. Ibid., p. 115.

102. А. М. Скабичевский: 'Заметки о текущей литературе' (1893), *Сочинения*, т. 2, СПб., 1903, стр. 389.

103. Ibid., pp. 391–2.

104. Кн. С. Волконский: 'Искусство и нравственность', ВЕСТНИК ЕВРОПЫ, 1893 № 4.

105. Skabichevsky: op. cit., pp. 397, 398, 403.

106. Сборник: *Философские течения русской поэзии*. Сост. П. Перцов, СПб., 1896.

107. А. М. Скабичевский: 'Курьезы и абсурды молодой критики', *Сочинения*, т. 2, СПб., 1903, стр. 541, 543.

108. А. М. Скабичевский: 'Новые течения в современной литературе', РУССКАЯ МЫСЛЬ, 1901, ноябрь.

109. А. М. Скабичевский: *Сочинения*, т. 2, СПб., 1903, стр. 923.

110. Ibid., p. 924.

111. Ibid., p. 929.

112. Ibid., pp. 930–3.

113. Ibid., p. 931.

114. Skabichevsky's account of the 'spiritual exaltation' in which all our capacities are extended bears comparison, for example, with Baudelaire's observation in *Fusées*:

> Il y a des moments de l'existence où le temps et l'étendue sont plus profonds, et le sentiment de l'existence immensément augmenté.

A. G. Lehmann sees this utterance as the hall-mark of the whole of modern European aesthetics since Baudelaire. See A. G. Lehmann, *The Symbolist Aesthetic in France*, Oxford, 1950, p. 32.

115. А. М. Скабичевский: *Сочинения*, т. 2, СПб., 1903, стр. 936.

116. *Очерки реалистического мировоззрения*, СПб., 1904, стр. 587.

117. In Solov'yov's view, socialism is an attempt to fill the void left by the decline of religion. Until there is a revival of the religious spirit in man, Solov'yov argued, socialism provides a good (and in any case inevitable) substitute, but it can never be a moral value in its own right. The frequently-made claim

that socialism is a practical realization of Christian morality is false, since 'Christianity demands that one should give of oneself, whereas socialism demands that one should take from others'. It did not, apparently, occur to Solov'yov, that socialism might demand that one should take back what was originally one's own by rights. He saw the value of socialism in the fact that its inevitable failure would teach man the limits of his self-assertion, and so prepare the way for the return to God, and the organization of society into a 'free theocracy'.

See Вл. Соловьев: 'Первое чтение о богочеловечестве', *Собр. соч.*, т. 3, СПб., 1901–7, стр. 3–11.

118. Е. Аничков: 'Очерк развития эстетических теорий', *Вопросы теории и психологии творчества*, т. 4, Харьков, 1915, стр. 198–215.

119. К. Мочульский: *Владимир Соловьев: жизнь и учение*, изд. 2-ое, Париж, 1951, стр. 241.

120. Ibid., p. 21.

121. Ibid., p. 33.

122. Ibid., p. 237.

123. Л. Шестов: *Умозрение и откровение*, Париж, 1964, стр. 38.

124. Вл. Соловьев: *Собр. соч.*, т. 3, СПб., 1901–7, стр. 20.

125. Вл. Соловьев: *Собр. соч.*, т. 6, стр. 426.

126. Вл. Соловьев: 'Первый шаг к положительной эстетике', *Собр. соч.*, т. 6, СПб., 1901–7, стр. 425 (Quotation: p. 429).

127. Ibid., pp. 429–30.

128. Ibid., pp. 430–1.

129. Anichkov: op. cit., pp. 208–9.

130. Cf. Mochul'sky: op. cit., p. 240.

131. Вл. Соловьев: 'Красота в природе', *Собр. соч.*, т. 6, СПб., 1901–7, стр. 30.

132. Ibid., pp. 31–7.

133. Вл. Соловьев: *Собр. соч.*, т. 3, стр. 35–7.

134. Ibid., pp. 52–3.

135. Ibid., p. 2.

136. Ibid., p. 114.

137. Ibid., pp. 111–12.

138. Ibid., p. 23.

139. Ibid., pp. 60–2.

140. Вл. Соловьев: '*Общий смысл искусства*', *Собр. соч.*, т. 6, стр. 69.

141. Ibid., p. 77.

142. Ibid., p. 78.

143. Ibid., p. 77.

144. Вл. Соловьев: 'О действительности внешнего мира и основании метафизического познания', *Собр. соч.*, т. 1, стр. 208.

145. Ibid., p. 210.

146. Ibid., p. 207.

147. Ibid., p. 213.

148. Вл. Соловьев: 'Первая речь о Достоевском', *Собр. соч.*, т. 3, стр. 182.

149. Ibid., p. 174.

150. E. H. Gombrich: *Art and Illusion*, second ed., London. 1962. In particular pp. 23 ff. and Chapter III ('Pygmalion's Power').

151. Вл. Соловьев: *Собр. соч.*, т. 3, стр. 173.

Chapter Two

In references to the two principal collections of Vyacheslav Ivanov's essays, their titles will be abbreviated thus:

ПЗ. = *По звездам*. Статьи и афоризмы. СПб., 1909.
БМ. = *Борозды и межи*. Опыты эстетические и критические. М., 1916.

1. Berdyayev, writing of the regular Wednesday-evening symposia held at Vyacheslav Ivanov's apartment in St Petersburg, between 1903 and 1906, recalls that the Ivanovs exerted a spell

over these very mixed gatherings, and showed a particular talent for drawing people out of themselves (Н. Бердяев: 'Ивановские среды', в кн. *Русская литература XX века*, ред. С. А. Венгеров, М., 1916, стр. 97). Sergey Makovsky brought away a similar impression of Ivanov's willingness to listen and his comparative silence on his own account (С. Маковский: *Портреты современников*. New York, 1955, p. 275), as did Fyodor Stepun (Ф. Степун: *Встречи*, Munich, 1962, p. 143). Georgiy Ivanov, in an obituary article, regretted that Vyacheslav Ivanov's personal attractiveness could not survive him in print like his works, since it was for his personal qualities that he most deserved to be remembered (Г. Иванов: 'Памяти Вяч. Иванова', ВОЗРОЖДЕНИЕ, Париж, 1949, тетрадь 5).

Ivanov's thought does not appear to have affected people in the same way as his personality. Many of his contemporaries, both poets like Blok and critics such as N. I. Nikolayev, were quick to notice the absence of everyday life from Ivanov's *poetry*, and accused him of gross neglect of reality without paying much attention to his theoretical realism (А. Блок: 'Творчество Вячеслава Иванова', *Собр. соч.*, т. 5, М/Л., 1962. Н. И. Николаев: 'Новые принципы литературной критики: "По звездам"', в кн. *Эфемериды*, Киев, 1912, стр. 374–81). Ivanov's critical essays rarely met with such enthusiastic appraisal as that of A. Zakrzhevsky (А. Закржевский: *Религия. Психологические параллели*, Киев, 1913). In an article prompted by the appearance of *Борозды и межи*, Lev Shestov characterized Ivanov as a solitary figure, standing aside from the Russian literary tradition, in which (Shestov suggested) a writer's reputation depended on the wide acceptability of his 'world view' (Лев Шестов: 'Вячеслав Великолепный', РУССКАЯ МЫСЛЬ, 1916 № 10, стр. 80–110).

However, the reason for the comparatively slight influence of Ivanov's ideas may have been the obscurity of their formulation rather than simple failure to convince; A. Izmaylov certainly thought as much (А. Измайлов: 'Звенящий кимвал', в кн. *Пестрые знамена*, М., 1913, стр. 44–5, 54).

Georgiy Ivanov at least acknowledged Vyacheslav Ivanov to

be the theorist *par excellence* of the Russian symbolist move-
ment, despite the oblivion into which even his more contro-
versial ideas had fallen since the period when the movement
flourished (G. Ivanov, op. cit.). Vladimir Pyast felt that
Ivanov's influence was only beginning in 1907 (Вл. Пяст:
'Вяч. Иванов', в *Книге о русских поэтах последнего десяти-
летия*, ред. М. Гофман, М., 1909, стр. 268). Only Fyodor
Stepun has claimed for Vyacheslav Ivanov a specific positive
influence – on Berdyayev's theory of knowledge, and, sur-
prisingly, on the 'philosophical constructs of Jung's theory of
psychoanalysis' (Ф. Степун: 'Памяти Вячеслава Иванова',
ВОЗРОЖДЕНИЕ, Париж, 1949, тетрадь 5).

2. This is O. Deschartes, pseudonym of Ol'ga Aleksandrovna
Shor, of whom Ivanov is reputed to have said in his later years:
'Only O.D. can write about me . . .' (S. Makovsky, op. cit.,
pp. 292–3). Mme Deschartes has published two studies of
Ivanov: 'Être et mémoire selon Vyacheslav Ivanov', *Oxford
Slavonic Papers*, vol. 7, 1957, and 'Vyacheslav Ivanov', *Oxford
Slavonic Papers*, vol. 5, 1954; according to Stepun, she is
working on a detailed biography (see F. Stepun: *Mystische
Weltschau*, München, 1964, p. 276).

3. 'Две стихии в современном символизме', ПЗ., стр. 247. In
the initial exposition of *Two Elements in Contemporary Symbol-
ism*, only actual quotations are referred to the pages on which
they occur.

4. ПЗ., стр. 248.

5. Loc. cit.

6. Ivanov refers in a footnote to: 'Владимир Соловьев: 'Первая
речь о Достоевском', *Собр. соч.*, т. III, стр. 175'.

7. The poem is *Creation*, from *Pilot Stars*; see Conclusion, note 9.
 'Heir of the Creating Mother, call for
 The transfiguration of the universe.'

8. ПЗ., стр. 250.

9. Loc. cit.

10. ПЗ., стр. 251.

11. The word Ivanov uses is 'ознаменование', and he uses it
 frequently enough to establish it as a technical term in his

aesthetic vocabulary. W. H. Auden has established an almost exactly equivalent term in his lecture *Making, Knowing and Judging* (Oxford, 1956), in which he ascribed the impulse to create works of art to a transformation of man's passive awe of certain elements in his surroundings, into an active desire to express this awe in 'a rite of worship or homage'. 'In poetry', said Auden, 'the rite is verbal; it pays homage by naming', and Ivanov's word, implying both 'signification' and 'celebration', is very close to Auden's homage paid by naming.

12. ПЗ., стр. 255.

13. ПЗ., стр. 253.

14. Cf. Н. Г. Чернышевский: *Эстетические отношения искусства к действительности*, СПб., 1865, стр. iii, 101, 144–7.

15. ПЗ., стр. 266.

16. ПЗ., стр. 270.

17. 'Realism' is here surely a misprint for 'symbolism'? If not, it fogs the issue in a most unhelpful way.

18. ПЗ., стр. 274–5.

19. ПЗ., стр. 279–80.

20. ПЗ., стр. 282–3.

21. ПЗ., стр. 285.

22. ПЗ., стр. 286.

23. ПЗ., стр. 288.

24. ПЗ., стр. 290.

25. The two terms translated here are 'преобразование' and 'преображение' respectively.

26. 'Спорады', ПЗ., стр. 350.

27. 'Заветы символизма', БМ., стр. 131–2.

28. 'Спорады', ПЗ., стр. 350.

29. Loc. cit.

30. 'Религиозное дело Владимира Соловьева', БМ., стр. 109–110. The Russian of the concluding phrase is: '. . . гносеологический релативизм, перенесенный в жизнь, обращается в мэонизм онтологический.' For 'мэон', a term which probably found its way into Ivanov's vocabulary from Plotinus by

way of Solov'yov, see: 'Копье Афины', ПЗ., стр. 52; Вяч. Иванов: 'Эллинская религия страдающего бога', НО-. ВЫЙ ПУТЬ, 1904, № 2, стр. 72; 'Ницше и Дионис', ПЗ., стр. 6.

31. 'Лев Толстой и культура', БМ., стр. 85.

32. Ibid., p. 86.

33. 'О неприятии мира', ПЗ., стр. 110.

34. БМ., стр. 92.

35. 'Религиозное дело Владимира Соловьева', БМ., стр. 103.

36. М. О. Гершензон и В. И. Иванов: *Переписка из двух углов*, Москва-Берлин, 1922, стр. 23.

37. Vyacheslav Ivanov: *Freedom and the Tragic Life*, trans. N. Cameron (from text provided by Ivanov), London, 1952, p. 24.

38. Ibid., p. 27.

39. Ibid., pp. 29–32.

40. 'Религиозное дело Владимира Соловьева', БМ., стр. 110.

41. 'Ты еси', ПЗ., стр. 425–34. The quotations from *Thou art* are not referred separately to page-numbers, since the essay is extremely short, and its ideas are presented here consecutively.

42. 'Кризис индивидуализма', ПЗ, стр. 87.

43. Ibid., pp. 95–6.

44. Ibid., p. 97.

45. Loc. cit.

46. Гершензон и Иванов: *Переписка из двух углов*, стр. 61–2.

47. 'Кризис индивидуализма', ПЗ., стр. 99.

48. Вяч. Иванов: 'Кручи: кризис гуманизма', ЗАПИСКИ МЕЧТАТЕЛЕЙ, 1919 № 1, стр. 113. 'Автаркия' is one of Ivanov's hellenisms; αὐτάρκεια = self-sufficiency.

49. 'Манера, лицо и стиль', БМ., стр. 174.

50. 'Заветы символизма', БМ., стр. 144: 'Новое не может быть куплено никакой другою ценой, кроме внутреннего подвига личности.'

51. See 'Поэт и чернь', ПЗ., стр. 36.

52. Vyacheslav Ivanov: *Freedom and the Tragic Life*, p. 78.

53. 'О неприятии мира', ПЗ., стр. 109.

54. Ibid., p. 120.

55. Vyacheslav Ivanov: *Freedom and the Tragic Life*, p. 57.

56. 'О веселом ремесле', ПЗ., стр. 226.

57. This is the τρίπους from which the Delphic priestess delivered her oracles. It had a particular significance for Ivanov in the interpretation of the myths of Apollo and Dionysus, symbolizing the union of two deities. See 'Религия Диониса', ВОПРОСЫ ЖИЗНИ, 1905 № 7, стр. 129.

58. 'О веслом ремесле', ПЗ., стр. 244.

59. 'Поэт и чернь', ПЗ., стр. 34.

60. Ibid., p. 34.

61. Ibid., p. 37.

62. Ibid., p. 37.

63. 'Спорады', ПЗ., стр. 354–5.

64. 'Поэт и чернь', ПЗ., стр. 37.

65. Ibid., p. 38.

66. 'Заветы символизма', БМ., стр. 123–5.

67. 'Спорады', ПЗ., стр. 353.

68. Вяч. Иванов: 'Эллинская религия страдающего бога', (Referred to hereafter as ЭР.), НОВЫЙ ПУТЬ, 1904 № 1, стр. 115.

69. ЭР., НОВЫЙ ПУТЬ, 1904 № 3, стр. 54.

70. Ibid., p. 38.

71. ЭР., НОВЫЙ ПУТЬ, 1904 № 1, стр. 133.

72. Ibid., p. 123. Cf. Nietzsche: *Die Geburt der Tragödie*, chapter 10. Ivanov quotes from Plutarch where Nietzsche was content simply to use him; the touch of pedantry is typical. See also note 85.

73. ЭР., НОВЫЙ ПУТЬ, 1904 № 1, стр. 129–34.

74. ЭР., НОВЫЙ ПУТЬ, 1904 № 2, стр. 48.

75. Ibid., p. 59.

76. Ibid., pp. 73–4.
77. ЭР., НОВЫЙ ПУТЬ, 1904 № 3, стр. 60.
78. Ibid., pp. 46–50.
79. ЭР., НОВЫЙ ПУТЬ, 1904 № 8, стр. 23.
80. ЭР., НОВЫЙ ПУТЬ, 1904 № 9, стр. 59.
81. Вяч. Иванов: 'Религия Диониса', ВОПРОСЫ ЖИЗНИ, 1905 № 7, стр. 134. Ivanov concludes in the summary of his *Дионис и прадионисийство* (Баку, 1923) that Christianity has its roots in Dionysian religion.

 'Эллинская религия страдающего бога' and 'Религия Диониса' are in fact the same work, the title having been changed when the serialization was transferred from НОВЫЙ ПУТЬ to ВОПРОСЫ ЖИЗНИ. The abbreviation ЭР. will therefore be used for both.
82. ЭР., ВОПРОСЫ ЖИЗНИ, 1905 № 7, стр. 126–32.
83. Ibid., p. 130.
84. Nietzsche: *Die Geburt der Tragödie*, § 2.

 '. . . every artist is . . . either an Apollonian artist in dreams or a Dionysian artist in ecstasy, or finally – as for example in Greek tragedy – an artist in dreams and in ecstasy at one and the same time. Thus we may imagine him sinking in his Dionysian intoxication and mystical renunciation of self, alone, and apart from the chorus in its exaltation, and we may imagine how now, through Apollonian dream-inspiration, his own state, that is, his oneness with the innermost foundation of the universe, is revealed to him *in a symbolic dream-image*.'
85. It was, in fact, Ivanov's intention to outdo Nietzsche in knowledge of the sources; see, for example, his 'Автобиографическое письмо С. А. Венгерову', в кн. *Русская литература XX века*, ред. Венгоров, т. 3, М., 1916, стр. 95.
86. ЭР., НОВЫИ ПУТЬ, 1904 № 2, стр. 64. The preface to Ivanov's *Дионис и прадионисийство* opens with the words: 'The powerful impulse of Friedrich Nietzsche prompted me to study the religion of Dionysus. In "The Birth of Tragedy" its genial author showed to the contemporary world a spiritual principle that is outside time . . .'

87. А. Белый: *Сирин ученого варварства*, Берлин, 1922, стр. 11.

88. ЭР., ВОПРОСЫ ЖИЗНИ, 1905 № 7, стр. 147. διακρό-
μενα = 'separate parts'.

89. 'Манера, лицо и стиль', БМ., стр. 175.

90. Ernst Cassirer: *An Essay on Man*, Yale, 1962, pp. 142, 167.

91. 'Манера, лицо и стиль', БМ., стр. 169.

92. 'Заветы символизма', БМ., стр. 129–30.

93. Vyacheslav Ivanov: *Freedom and the Tragic Life*, pp. 50–2.

94. 'Заветы символизма', БМ., стр. 139.

95. 'Предчувствия и предвестия', ПЗ., стр. 196, 199.

96. Vyacheslav Ivanov: *Freedom and the Tragic Life*, p. 52.

97. Ibid., pp. 49–50.

98. 'Манера, лицо и стиль', БМ., стр. 170.

99. 'Границы искусства', БМ., 189–93.

100. 'Границы искусства', БМ., стр. 199.

101. Ibid., p. 200. 'Even the greatest artist can conceive nothing that does not lie confined within the bulk of one marble block, and this is reached only by the hand that obeys the intellect'.

102. 'Символика эстетических начал', ПЗ., стр. 26–7.

103. Cassirer: *Essay on Man*, chapters 1, 2, 5, 6. Quotations: pp. 25, 62.

104. Ibid., chapter 9.

105. 'Границы искусства', БМ., стр. 219.

106. Ibid., p. 197.

107. See Cassirer: *Essay on Man*, chapter 7.

108. 'Две стихии в современном символизме', ПЗ., стр. 269.

109. Both Cassirer and Ivanov appear to overlook that Nietzsche enjoined 'purposeful dreaming'.

110. ЭР., НОВЫЙ ПУТЬ, 1904 № 2, стр. 63–4.

111. 'Границы искусства', БМ., стр. 212.

112. Ibid., p. 221.

113. Cassirer: *Essay on Man*, chapter 12. Quotation: p. 228.

114. 'Поэт и чернь', ПЗ., стр. 36.

115. 'Границы искусства', БМ., стр. 224.

116. Kant: *Kritik der Urteilskraft*, 1-er Teil, 1-er Abschnitt, § 46.
'Genius is the talent (or natural gift) which gives the rule to art. Since talent, as the innate productive faculty of the artist, belongs itself to nature, we may express the matter thus: Genius is the innate mental disposition (*ingenium*) *through which* nature gives the rule to art.' (Kant: *Critique of Judgment*, trans. J. H. Bernard, Hafner Publishing Company Inc., New York, 1951.)

117. See, for example, К. Мочульский: *Владимир Соловьев: жизнь и учение*, 2-ое изд., Париж, 1951, стр. 242.

118. As, for example, by Bely, who wrote of the climate of Russian symbolist circles immediately after the death of Solov'yov: 'Можно сказать: в 1901 году мы жили атмосферой его поэзии, как теургическим завершением его учения о Софии – Премудрости.' (А. Белый: *Воспоминания об А. Блоке*. Reprinted by Bradda Books, Letchworth, 1964, p. 19).

Chapter Three

1. Cf. F. Stepun: *Mystische Weltschau: fünf Gestalten des russischen Symbolismus*, München, 1964, p. 292.

2. В. Брюсов: *Русские символисты*, выпуск второй, М., 1894, вступительная статья, стр. 9.

3. В. Брюсов: *Письма к П. П. Перцову*, М., 1927, № 19, 18/11/1895.

4. В. Брюсов: *О искусстве*, М., 1899, стр. 18.

5. А. Волынский: 'Декадентство и символизм', в кн. *Борьба за идеализм*, СПб., 1900, стр. 318–19.

6. К. Д. Бальмонт: 'Элементарные слова о символической поэзии', в кн. *Горные вершины*, М., 1904, стр. 77.

7. А. Белый: 'О субъективном и объективном', в сборнике *Свободная совесть*, книга 2, М., 1906, стр. 269.

8. А. Белый: 'Смысл искусства', в кн. *Символизм*, М., 1910, стр. 199.

9. А. Белый: 'Теория или старая баба', в кн. *Арабески*, М., 1911, стр. 268.

10. А. Белый: 'Эмблематика смысла', в кн. *Символизм*, М., 1910, стр. 49, 50.

11. Эллис: 'Что такое театр?', ВЕСЫ, 1908, № 4, стр. 89–90.

12. И. Ф. Анненский: 'Что такое поэзия?', АПОЛЛОН, 1911, № 6, стр. 56.

13. Ф. Сологуб: 'Искусство наших дней', РУССКАЯ МЫСЛЬ, 1915, № 12, отдел 2, стр. 36–7, 61–2.

14. Г. Чулков: 'Оправдание символизма', в кн. *Наши спутники*, М., 1922, стр. 108, 109.

15. К. Д. Бальмонт: *Горные вершины*, М., 1904, стр. 77–8.

16. Г. Чулков: *Наши спутники*, М., 1922, стр. 103.

17. В. Львов-Рогачевский: 'Быть или не быть русскому символизму?', СОВРЕМЕННЫЙ МИР, 1910 № 10, отдел 2, стр. 83. Он же: 'Из жизни литературы. В лагере символистов', СОВРЕМЕННИК, 1914 № 2, стр. 102.

18. Р. Иванов-Разумник: 'Литература и общественность', ЗАВЕТЫ, № 3, март 1914, отдел 2, стр. 109–10.

19. И. Гофштеттер: *Поэзия вырождения*, СПб., 1902, стр. 10, 22.

20. С. Виппер: 'Символизм в человеческой мысли и творчестве', РУССКАЯ МЫСЛЬ, 1905 № 2, отдел 2, стр. 103–4.

21. В. Брюсов: Заметка о книге Ф. Сологуба: *Книга сказок*, М., 1904. ВЕСЫ, 1904 № 11, стр. 50.

22. V. P. Kranikhfel'd, in an article dating from 1909, wrote: 'It goes without saying that morbid Sologub to a great extent despises life.' В. П. Кранихфельд: 'Федор Сологуб', в кн. *В мире идей и образов*, т. 2, Пг., 1917, стр. 9.

23. И. Коневской: 'На рассвете', в кн. *Посмертное собрание сочинений*, М., 1904, стр. 125.

24. З. Гиппиус: 'Современное искусство' (1903), в кн. *Литературный дневник*, СПб., 1908, стр. 67–8.

25. F. Stepun: *Mystische Weltschau*, pp. 324, 375.

26. В. Ходасевич: 'О символизме', в кн. *Литературные статьи и воспоминания*, New York, 1954, p. 156.

27. For example, Boris Sadovskoy's light-hearted dialogue 'Жизнь и поэзия', ТРУДЫ И ДНИ, 1912 № 2.

28. Г. Чулков: 'Оправдание земли', в кн. *Сочинения*, т. 5: *Статьи 1905–11*, СПб., 1912, стр. 55: '. . . но ведь мы хотим не только эстетического волнения, оторванного от жизни, – ведь мы хотим таких переживаний, которые привели бы нас от искусства к жизни.'

29. М. Гофман: 'Романтизм, символизм и декадентство', в кн. *Книга о русских поэтах последнего 10-летия*, М., 1909, стр. 24–5.

30. П. С. Коган: 'Литературные направления и критика 80-х и 90-х годов', в кн. *История русской литературы XIX века*, ред. Овсянико-Куликовский, т. 5, М., 1911, стр. 61–2.

31. Р. Иванов-Разумник: *История русской общественной мысли*, Пг., 1918, т. 2, стр. 328–31.

32. С. А. Венгеров: *Основные черты истории новейшей русской литературы*, СПб., 1909, стр. 12, 62, 82. Originally given as a lecture in St Petersburg University on 24.ix.1897, and published the following year in ВЕСТНИК ЕВРОПЫ.

33. For example, Д. Е. Максимов: 'Критическая проза А. Блока', в кн. *Блоковский сборник*, Тарту, 1964, стр. 60, and F. Stepun: *Mystische Weltschau*, p. 393.

34. В. Брюсов: *О искусстве*, М., 1899, стр. 14.

35. В. Брюсов: 'Ключи тайн', ВЕСЫ, 1904 № 1, стр. 11.

36. З. Гиппиус: 'Хлеб жизни', в кн. *Литературный дневник*, СПб., 1908, стр. 13.

37. Г. Чулков: 'Казни', в кн. *Собр. соч.*, т. 5, СПб., 1912, стр. 78.

38. М. Неведомский: 'О современном художестве (Л. Андреев)', МИР БОЖИЙ, 1903 № 4, стр. 39.

39. Ф. Сологуб: 'Искусство наших дней', РУССКАЯ МЫСЛЬ, 1915 № 12, отдел 2, стр. 35–6.

40. Е. А. Ляцкий: 'Вопросы искусства в современных его отражениях', ВЕСТНИК ЕВРОПЫ, 1907 № 4, стр. 659.

41. С. А. Венгеров: *Основные черты истории новейшей русской литературы*, СПб., 1909, стр. 12.

42. М. Неведомский: 'О современном художестве (Л. Андреев)', МИР БОЖИЙ, 1903 № 4, стр. 40.

43. P. Kropotkin: *Russian Literature* ('Ideals and Realism in Russian Literature'), London, 1905, pp. v–vi, 287 (originally a series of lectures given at the Lowell Institute in Boston in March 1901).

44. В. Н. Россиков: 'Литературная критика в начале XX века', ВЕСТНИК ВОСПИТАНИЯ, 1917 № 1, стр. 76.

45. С. Маковский: *Страницы художественной критики*, книга первая, СПб., 1906, стр. 13–15.

46. П. С. Коган: 'Литературные направления и критика 80-х и 90-х годов', стр. 73.

47. Е. А. Ляцкий: 'Вопросы искусства в современных его отражениях', ВЕСТНИК ЕВРОПЫ, 1907 № 4, стр. 687.

48. *Проблемы идеализма*, ред. П. И. Новгородцев, М., 1903. Contributors included S. Bulgakov, N. A. Berdyayev, S. L. Frank, E. N. and S. N. Trubetskoy, and P. I. Novgorodtsev, amongst others.

49. It must be remembered that Berdyayev and Bulgakov were renegade marxists, and their new standpoint was therefore particularly provocative to critics from the realist camp, many of whom were themselves marxists.

50. *Очерки реалистического мировоззрения*, изд. С. Дороватовский и А. Чарушников, СПб., 1904.

51. Б. Фриче: 'Социально-психологические основы натуралистического импрессионизма', в кн. *Очерки реалистического мировоззрения*, стр. 655–6.

52. В. Шулятиков: 'Восстановление разрушенной эстетики', в кн. *Очерки реалистического мировоззрения*, стр. 586, 612.

53. Д. Философов: 'Проповедь идеализма', в кн. *Слова и жизнь*, СПб., 1909, стр. 165.

54. Н. К. Михайловский: 'Русское отражение французского символизма' (1893), в кн. *Литературные воспоминания и современная смута*, т. 2, СПб., 1900, стр. 60.

55. В. Асмус: 'Философия и эстетика русского символизма', в. кн. *Литературное наследство*, №№ 27–8, 1937, стр. 3.

56. See, for example, В. Львов-Рогачевский: 'Символисты и наследники их', СОВРЕМЕННИК, 1913 № 6, стр. 265. Также: Д. Тальников: 'Символизм или реализм?', СОВРЕМЕННЫЙ МИР, 1964 № 4, отдел 2, стр. 146.

57. 'К читателям', ВЕСЫ, 1909 № 12, стр. 190.

58. А. Белый: 'Смысл искусства', в кн. *Символизм*, М., 1910, стр. 196.

59. Эллис: 'Что такое литература?', ВЕСЫ, 1907 № 10, стр. 55–6.

60. Эллис: *Русские символисты*, М., 1910, стр. 29.

61. See J. Holthusen: *Studien zur Ästhetik und Poetik des russischen Symbolismus*, Göttingen, 1957, p. 45: '. . . eine höhere Spielart des Didaktismus in der Kunst . . .'.

62. Б. Бугаев: 'Две замечательные книги', ВЕСЫ, 1904 № 12, стр. 37.

63. Cf. Б. Эйхенбаум, Ю. Никольский: 'Д. С. Мережковский – критик', СЕВЕРНЫЕ ЗАПИСКИ, 1915 № 4, стр. 130–2.

64. Волжский (Алексей Сергеевич Глинка): 'Об уединении в поэзии и философии современного модернизма', в кн. *Из мира литературных исканий*, СПб., 1906, стр. 294–6.

65. Г. Чулков: 'Оправдание символизма', в кн. *Наши спутники*, М., 1922, стр. 123.

66. Эллис: *Русские символисты*, М., 1910, стр. 29.

67. В. Брюсов: 'Ключи тайн', ВЕСЫ, 1904 № 1, стр. 7–8.

68. В. Брюсов: *О искусстве*, М., 1899, стр. 8, 27.

69. Ф. Маковский: 'Что такое русское декадентство?', ОБРАЗОВАНИЕ, 1905 № 9, отдел 1, стр. 125.

70. Г. Чулков: 'Балаганчик', ПЕРЕВАЛ, 1907 № 4, стр. 51.

71. 'От редакции', ПЕРЕВАЛ, 1906 № 1, стр. 3.

72. 'Ф. Сологуб о символизме', БЮЛЛЕТЕНИ ЛИТЕРА-
 ТУРЫ И ЖИЗНИ, № 14, март 1914, литературный отдел,
 стр. 835–6.

73. Г. Чулков: 'Покрывало Изиды', *Сочинения*, т. 5, СПб.,
 1912, стр. 128.

74. В. Асмус: 'Философия и эстетика русского символизма',
 Литературное наследство, №№ 27–8, 1937, стр. 44.

75. 'Bryusov's soul', wrote Vladimir Pyast, introducing the selec-
 tion from Bryusov in Modest Gofman's anthology, 'is a soul
 that is by nature confined within itself', and he quoted Bryu-
 sov's lines:

 > Мы беспощадно одиноки
 > На дне своей души-тюрьмы!

 М. Гофман (ред.): *Книга о русских поэтах последнего 10-
 летия*, М., 1909, стр. 70.

76. З. Гиппиус: 'Критика любви', в кн. *Литературный днев-
 ник*, СПб., 1908, стр. 45–7.

77. З. Гиппиус: 'Необходимое в стихах'. Предисловие к *Со-
 бранию стихов 1889–1903*, М., 1904, стр. i–ii.

78. Г. Чулков: *Сочинения*, т. 5, СПб., 1912, стр. 31–4.

79. According to Ivanov-Razumnik, decadence was a heightening
 of individualist thinking, resulting from the historical and
 social conditions of the end of the nineteenth century. In his
 view, the decadent of the 1890s 'reckoned himself infinitely
 powerful and rich in the narrow, vicious circle of his "ego"',
 and, despite later assurances to the contrary, was imprisoned
 in his personal world – particularly Blok and Sologub.

 See: Иванов-Разумник: 'Литература и общественность.
 Вечные пути (романтизм и реализм)', ЗАВЕТЫ, 1914 № 3,
 отдел 2, стр. 102–3.

80. В. Шулятиков: 'Востановление разрушенной эстетики', в
 кн. *Очерки реалистического мировоззрения*, СПб., 1904, стр.
 629–30. Under the heading 'idealists' Shulyatikov lumped to-
 gether: neo-romanticism, decadence, Nietzscheanism, the
 literature of 'moods', philosophical and metaphysical ideal-
 ism, and mysticism.

81. П. Новгородцев: 'О философском движении наших дней', НОВЫЙ ПУТЬ, 1904 № 10, стр. 66. Novgorodtsev was careful to exclude aesthetes, decadents, Nietzscheans, and marxists from the category of 'idealists'.

82. П. С. Коган: 'Литературные направления и критика 80-х и 90-х годов', в кн. *История русской литературы XIX века*, ред. Овсянико-Куликовский, т. 5, М., 1911, стр. 91.

83. Ф. Сологуб: 'Искусство наших дней', РУССКАЯ МЫСЛЬ, 1915 № 12, отдел 2, стр. 43–4.

84. Л. Мартов: 'Общественные движения и умственные течения в период 1884–1905 гг.', в кн. *История русской литературы XIX века*, ред. Овсянико-Куликовский, т. 5, М., 1911, стр. 31.

85. И. Коневской: 'К делу о поэте и народе', в кн. *Посмертное собрание сочинений*, М., 1904, стр. 224–5.

86. Иванов-Разумник: 'Пылающий (Андрей Белый)' (1915), в кн. *Александр Блок. А. Белый*, СПб., 1919, стр. 28.

87. В. Львов-Рогачевский: 'Лирика современной души', СОВРЕМЕННЫЙ МИР, 1910 № 9, стр. 131.

88. А. Редько: 'У подножья африканского идола', РУССКОЕ БОГАТСТВО, 1913 № 6, отдел 2, стр. 324–5.

89. 'Эмпирик': 'О "чистом символизме", теургизме и нигилизме', ЗОЛОТОЕ РУНО, 1908 № 5, стр. 77.

90. С. Городецкий: 'Ближайшая задача русской литературы', ЗОЛОТОЕ РУНО, 1909 № 4, стр. 70.

91. Chulkov would have in mind Sologub's thesis that only the artist who dares to assert his ego to the full, and set his personality at the centre of his universe, can produce truly 'life-creating' art (see *The Art of Our Day*, p. 56). In works such as *A Book of Complete Self-Assertion* and *A Liturgy to Myself*, Sologub put his principles into practice.

92. Г. Чулков: 'Дымный ладан', *Сочинения*, т. 5, СПб., 1912, стр. 24–5.

93. Г. Чулков: 'Исход', там же, стр. 33.

94. Г. Чулков: 'Покрывало Изиды', там же, стр. 124–5.

95. Г. Тастевен: 'Ницше и современный кризис', ЗОЛОТОЕ РУНО, 1907 №№ 7–9, стр. 114–15.

96. Владимир Соловьев: 'По поводу сочинения Н. М. Минского "При свете совести"', ВЕСТНИК ЕВРОПЫ, 1890 № 3, стр. 437, 441.

97. И. Ф. Анненский: *Вторая книга отражений*, СПб., 1909, стр. 3.

98. А. Бенуа: 'Художественные ереси', ЗОЛОТОЕ РУНО, 1906 № 2, стр. 81.

99. К. Д. Бальмонт: *Горные вершины*, М., 1904, стр. iii.

100. К. Д. Бальмонт: 'Певец личности и жизни', в кн. *Белые зарницы*, СПб., 1908, стр. 83.

101. Иванов-Разумник: *История русской общественной мысли*, Пг., 1918, т. 2, стр. 481. The words quoted are Berdyayev's. However, in an article entitled 'Decadence and Mystical Realism', having given a definition of 'mystical realism', which makes it sound very like the programme of the mystical anarchists, Berdyayev described mystical anarchism as an abortive attempt to achieve 'mystical realism' without overcoming the decadent tendency to subjectivism. See Н. А. Бердяев: 'Декадентство и мистический реализм', РУССКАЯ МЫСЛЬ, 1907 № 6, стр. 117, 119.

102. А. Белый: 'Второй том', в кн. *Арабески*, М., 1911, стр. 488–489.

103. П. Юшкевич: 'О современных философско-религиозных исканиях', в сборнике *Литературный распад*, книга первая, СПб., 1908, стр. 95–6.

104. ФАКЕЛЫ, книга 1. Предисловие. СПб., 1906.

105. D. Filosofov described Ivanov as 'the ideologist of mystical anarchism' (Д. Философов: 'Весенний ветер', в кн. *Слова и жизнь*, СПб., 1909, стр. 13), and many shared this view. However, Modest Gofman's estimate of Ivanov's complicity in mystical anarchism is probably nearer the truth. See *Книга о русских поэтах последнего 10-летия*, ред. М. Гофман, М., 1909, стр. 19:

'Вячеслав Иванов, поэт по преимуществу здоровый и

озаренный нежным венком мудрости, оказался причастным "мистическому анархизму"....'

106. Г. Чулков: *О мистическом анархизме*, СПб., 1906, стр. 27–30.

107. Ibid., pp. 57–60.

108. Ibid., p. 67.

109. В. Брюсов: 'Вехи IV: Факелы', ВЕСЫ, 1906 № 5, стр. 56.

110. З. Гиппиус: 'Все против всех', в кн. *Литературный дневник*, СПб., 1908, стр. 322–3.

111. Эллис: 'Кризис современного театра', ВЕСЫ, 1908 № 9, стр. 64.

112. Эллис: 'О современном символизме, о "чорте" и о "действе"', ВЕСЫ, 1909 № 1, стр. 77.

113. Д. Философов: 'Дела домашние', ТОВАРИЩ, 23/9/1907.

114. Ivanov in his introduction to Chulkov's *Mystical Anarchism* showed that he felt this limitation. He described mystical anarchism as a doctrine 'of the means (not the end) of freedom', and as a 'formal category of contemporary consciousness'.

See: Вяч. Иванов: 'О неприятии мира', в кн: *По звездам*, СПб., 1909, стр. 119–20.

115. Д. Философов: 'Мистический анархизм', ЗОЛОТОЕ РУНО, 1906 № 10, стр. 65.

116. З. Гиппиус: *Литературный дневник*, Спб., 1908, стр. 58.

117. А. Волынский: 'Декадентство и символизм', в кн. *Борьба за идеализм*, СПб., 1900, стр. 320.

118. М. Гофман: 'Романтизм, символизм и декадентство', в кн. *Книга о русских поэтах последнего 10-летия*, М., 1909, стр. 20.

119. Вяч. Иванов: 'О неприятии мира', в кн. *По звездам*, СПб., 1909, стр. 120–1.

120. Г. Чулков: 'Покрывало Изиды', *Сочинения*, т. 5, СПб., 1912, стр. 119.

121. З. Гиппиус: 'Необходимое в стихах'. Предисловие к *Собранию стихов 1889–1903*, М., 1904, стр. ii.

122. Эллис: 'Кризис современного театра', ВЕСЫ, 1908 № 9, стр. 63–4.

123. М. Неведомский: 'В защиту художества', СОВРЕМЕН-НЫЙ МИР, 1908 № 3, стр. 216–17, 227.

124. З. Гиппиус: *Литературный дневник*, СПб., 1908, стр. 12–13.

125. Н. А. Бердяев: 'Декадентство и мистический реализм', РУССКАЯ МЫСЛЬ, 1907 № 6, стр. 120.

126. В. Брюсов: *Дневники 1891–1910*, М., 1927, стр. 142.

127. А. Белый: 'Смысл искусства', в кн. *Символизм*, М., 1910, стр. 223.

128. Д. Философов: 'Весенний ветер', в кн. *Слова и жизнь*, СПб., 1909, стр. 19.

129. С. А. Венгеров: Послесловие: 'Победители или побеж-денные? в кн. *Основные черты истории новейшей русской литературы*, СПб., 1909, стр. 51–3.

130. П. Юшкевич: 'О современных философско-религиозных исканиях', в сборнике *Литературный распад*, книга 1, СПб., 1908, стр. 99–103.

131. Иванов-Разумник: 'Литература и общественность', ЗА-ВЕТЫ, № 3, март 1914, отдел 2, стр. 107.

132. З. Гиппиус: *Литературный дневник*, СПб., 1908, стр. 169.

133. Ф. Сологуб: 'Искусство наших дней', РУССКАЯ МЫСЛЬ, 1915 № 12, отдел 2, стр. 40.

134. Г. Чулков: 'Покрывало Изиды', *Сочинения*, т. 5, СПб., 1912, стр. 126–7.

135. С. Городецкий: 'Формотворчество', ЗОЛОТОЕ РУНО, 1909 № 10, стр. 53–4.

136. К. Д. Бальмонт: *Горные вершины*, М., 1904, стр. 88.

137. В. Брюсов: Предисловие к *Chefs-d'œuvre*, М., 1895. He also quoted Fet's lines:

О если б без слова
Сказаться душой было можно.

138. В. Брюсов: 'Ненужная правда', МИР ИСКУССТВА, 1904 №№ 1–6, отдел 111, стр. 68.

139. В. Брюсов: *О искусстве*, М., 1899, стр. 12–13. Bryusov wrote: 'Let the artist prepare himself like a prophet for life's great deed. Let him first become wise. For the chosen few, there are years of silence. Only solitary meditation can give him the right to show his commandments to the people.'

140. С. А. Венгеров: Послесловие: 'Победители или побежденные?', в кн. *Основные черты истории новейшей русской литературы*, СПб., 1909, стр. 88.

141. В. Брюсов: *О искусстве*, М., 1899, стр. 21–2.

142. Эллис: *Русские символисты*, М., 1910, стр. 28.

143. Д. С. Мережковский: *О причинах упадка и о новых течениях современной русской литературы*, СПб., 1893, стр. 42.

144. М. Гофман: 'Романтизм, символизм и декадентство', в кн. *Книга о русских поэтах последнего 10-легия*, М., 1909, стр. 26.

145. А. Белый: 'Магия слов', в кн. *Символизм*, М., 1910, стр. 429.

146. А. Измайлов: *На переломе*, СПб., 1908, стр. 53–4.

147. И. Коневской: 'Мистическое чувство в русской лирике', *Посмертное собрание сочинений*, М., 1904, стр. 199.

148. И. Коневской: 'К делу о поэте и народе', *Посмертное собр. соч.*, стр. 223–4.

149. Эллис: 'О современном символизме, о "чорте" и о "действе"', ВЕСЫ, 1909 № 1, стр. 82.

150. Эллис: 'Что такое литература?', ВЕСЫ, 1907 № 10, стр. 57.

151. See, for example: Эллис: *Русские символисты*, М., 1910, стр. 29–30. Он же: 'Итоги символизма', ВЕСЫ, 1909 № 7, стр. 73.

152. Эллис: Заметка о сборнике *Кризис театра* (М., 1908), ВЕСЫ, 1908 № 9, стр. 66.

153. Loc. cit.

154. В. Брюсов: 'Ключи тайн', ВЕСЫ, 1904 № 1, стр. 16.

155. К. Д. Бальмонт: *Горные вершины*, М., 1904, стр. 83.

156. К. Д. Бальмонт: *Белые зарницы*, СПб., 1908, стр. 63.

157. А. Белый: 'Смысл искусства', в кн. *Символизм*, М., 1910, стр. 206.

158. Г. Чулков: 'О символизме', ЗАВЕТЫ, 1914 № 2, стр. 79–80.

159. С. Городецкий: 'Аминь', ЗОЛОТОЕ РУНО, 1908 № 7, стр. 106.

160. Л. Войтоловский: 'Итоги русского модернизма', в сборнике *Литературный распад*, книга 1, СПб., 1908, стр. 45–6.

161. Вяч. Иванов: 'Новые маски', ВЕСЫ, 1904 № 7, стр. 1–2.

162. Г. Чулков: 'Принципы театра будущего', в сборнике *Театр. Книга о новом театре*, СПб., 1908, стр. 214.

163. Ф. Сологуб: 'Театр одной воли', в сборнике *Театр. Книга о новом театре*, стр. 180, 182.

164. А. Е. Редько: *Театр и эволюция театральных форм*, Л., 1926, стр. 36.

165. В. Э. Мейерхольд: 'Балаган', в кн. *О театре*, СПб., 1913, стр. 157.

166. Ibid., p. 147.

167. Г. Чулков: 'Принципы театра будущего', в сборнике *Театр. Книга о новом театре*, стр. 203.

168. Cf. А. Б. Рубцов: *Драматургия А. Блока*, ред. Кулешов, Минск, 1968, стр. 26.

169. Cf. the first section of Blok's article: 'Творчество Вячеслава Иванова'. А. Блок: *Собр. соч*, т. 5, М/Л., 1962, стр. 7–11.

170. А. Блок: 'О театре', *Собр. соч.*, т. 5, М/Л., 1962, стр. 246.

171. Ibid., p. 261.

172. С. Городецкий: 'Ближайшая задача русской литературы', ЗОЛОТОЕ РУНО, 1909 № 4, стр. 80–1.

173. Ф. Сологуб: 'Театр одной воли', в сборнике *Театр. Книга о новом театре*, стр. 191.

174. Г. Чулков: 'Покрывало Изиды', *Сочинения*, СПб., 1912, т. 5, стр. 131.

175. З. Гиппиус: *Литературный дневник*, СПб., 1908, стр. 239–252.

176. А. Блок: 'Памяти В. Ф. Коммиссаржевской', *Собр. соч.*, т. 5, М/Л., 1962, стр. 418. Kommissarzhevskaya, said Blok, was a true artist, able to see 'not only the *first* level of the world, but also what is concealed behind it, the unfathomable distance which to the ordinary gaze is obscured by naïve reality'.

177. А. Е. Редько: *Театр и эволюция театральных форм*, Л., 1926, стр. 25–9.

178. В. Э. Мейерхольд: 'Балаган', в кн. *О театре*, СПб., 1913, стр. 169.

179. Ю. Слонимская: 'Марионетка', АПОЛЛОН, 1916 № 3, стр. 40–1.

180. Д. Философов: *Слова и жизнь*, СПб., 1909, стр. 9.

181. Ibid., p. 14, . . . 'Наивное народничество наизнанку'.

182. Both here and above, Filosofov bases himself on Ivanov's 'О веселом ремесле и умном веселии', в кн. *По звездам*, СПб., 1909.

183. Г. Чулков: *Сочинения*, т. 5, СПб., 1912, стр. 40.

184. Эллис: 'О современном символизме, о "чорте" и о "действе"', ВЕСЫ, 1909 № 1, стр. 79.

185. The most categorical claim as to the native origins of Russian symbolism was made by Chulkov, who wrote:

> 'With us, the Russians, symbolist poetry arose completely independently, apart from Western influences, and in all conscience it must be acknowledged that the first Russian symbolists were Tyutchev and Vladimir Solov'yov. . . .' (Г. Чулков: *Сочинения*, т. 5, СПб., 1912, стр. 24.)

Similar claims were made or implied even by some writers associated with the earlier phase of the Russian symbolist movement. Bal'mont claimed that Fet and Sluchevsky, as well as Tyutchev, were Russian symbolists who had developed independently of Western influences (К. Д. Бальмонт: *Горные вершины*, М., 1904, стр. 83), and Zinaida Gippius voiced the feeling that foreign culture would not take root in Russia, which awaited its own, possibly 'barbaric' developments (З. Гиппиус: *Литературный дневник*, СПб., 1908, стр. 99).

186. Д. Е. Максимов: 'Критическая проза Блока', в сборнике *Блоковский сборник*, Тарту, 1964, стр. 55.

187. Cf. Л. Мартов: 'Общественные движения и умственные течения в период 1184–1905 гг.', в кн. *История русской литературы XIX века*, ред. Овсянико-Куликовский, т. 5, М., 1911, стр. 40–4.

Сергей Соловьев: 'Символизм и декадентство', ВЕСЫ, 1909 № 5, стр. 56.

188. Both these expressions belong to Blok. The first is from his notebook for 22nd July 1908 (А. Блок: *Записные книжки*, М., 1965, стр. 114: 'Написать доклад о единственном возможном преодолении одиночества – приобщение к народной душе и занятие общественной деятельностью'). The second applied to Vyacheslav Ivanov (А. Блок: *Собр. соч.*, М/Л., 1962, т. 5, стр. 18).

189. А. Белый: 'На перевале. XII: Слово правды', ВЕСЫ, 1908 № 9, стр. 61–2.

190. Заметка о книге А. Белого *Луг зеленый*, ВЕСТНИК ЕВРО-ПЫ, 1910 № 11, стр. 416.

191. S. Vipper remarked that the early nineteenth-century Romantics had felt that science had impoverished man by restricting his imagination, and he discerned a similar feeling amongst the Russian symbolist writers of his day (С. Виппер: 'Символизм в человеческой мысли и творчестве', РУССКАЯ МЫСЛЬ, 1905 № 2, отдел 2, стр. 113). There are many more specific examples to be found: Bely expressed regret at modern man's dependence on the mechanical side of civilization (А. Белый: *Арабески*, М., 1911, стр. 401); his particular complaint was that 'the mechanical progress of culture cannot completely satisfy our spirit' (А. Белый: 'О субъективном и объективном', в сборнике *Свободная совесть*, кн. 2, М., 1906, стр. 273–4). In those of a more 'decadent' cast of mind, such attitudes were naturally taken further, sometimes to ridiculous extremes: 'Ellis' decried the vulgarization that ensued when 'the symbolic candle of the life of "Man" pits its light against the electric lighting of the most real drawing-room . . .' (Эллис: 'Наши эпигоны', ВЕСЫ, 1908 № 2, стр. 64).

192. А. Вознесенский: *Поэты, влюбленные в прозу*, Киев, 1910, стр. 30, 40.

193. В. Львов-Рогачевский: 'Лирика современной души', СО-
ВРЕМЕННЫЙ МИР, 1910 № 9, стр. 126.

194. В. П. Кранихфельд: 'Новые наследники "Переписки"
Гоголя', в кн. *В мире идей и образов*, Пг. 1917, т. 3, стр. 259.

195. Cf. Д. Тальников: '"Символизм" или реализм?', СОВРЕ-
МЕННЫЙ МИР, 1914 № 4, отдел 2, стр. 124.
 В. Саянов: *Очерки по истории русской поэзии XX века*,
Л., 1929, стр. 75.

196. А. Белый: 'О субъективном и объективном', в сборнике
Свободная совесть, кн. 2, М., 1906, стр. 270–1.

197. 'Ф. Сологуб о символизме', БЮЛЛЕТЕНИ ЛИТЕРАТУ-
РЫ И ЖИЗНИ, № 14, март 1914, литературный отдел, стр.
835.

198. А. Белый: 'Смерть или возрождение', в кн. *Арабески*, М.,
1911, стр. 497.

199. И. Ф. Анненский: 'Что такое поэзия?', АПОЛЛОН, 1911
№ 6, стр. 52–3.

200. Н. А. Бердяев: 'Декадентство и мистический реализм',
РУССКАЯ МЫСЛЬ, 1907 № 6, стр. 114.

201. Ф. Степун: 'О некоторых отрицательных сторонах со-
временной литературы', СЕВЕРНЫЕ ЗАПИСКИ, 1913
№ 10, стр. 132.

202. Е. Аничков: *Реализм и новые веяния*, СПб., 1909, стр. 60.

203. Эллис: 'В защиту декадентства', ВЕСЫ, 1907 № 8, стр. 70.

204. Л. Войтоловский: 'Итоги русского модернизма', в сбор-
нике *Литературный распад*, кн. 1, СПб., 1908, стр. 39–40.

205. П. Коган: *Очерки по истории новейшей русской литерату-
ры*, т. 3: 'Современники', выпуск 1, изд. 2-ое, М., 1911,
стр. 8–12.

206. М. Неведомский: 'В защиту художества', СОВРЕМЕН-
НЫЙ МИР, 1908 № 3, стр. 228.

207. В. Львов-Рогачевский: 'Символисты и наследники их',
СОВРЕМЕННИК, 1913 № 6, стр. 267–8.

208. А. Полянин: 'В поисках пути искусства', СЕВЕРНЫЕ
ЗАПИСКИ, 1913 №№ 5–6, стр. 230.

209. С. Маковский: *Страницы художественной критики*, книга I, СПб., 1906, стр. 15, 23.

210. Е. А. Ляцкий: 'Вопросы искусства в современных его отражениях', ВЕСТНИК ЕВРОПЫ, 1907 № 4, стр. 678.

211. А. Волынский: 'О символизме и символистах', СЕВЕРНЫЙ ВЕСТНИК, 1899 №№ 10–12, стр. 216–23.

212. В. Брюсов: 'Священная жертва', ВЕСЫ, 1905 № 1, стр. 27.

213. В. Брюсов: *О искусстве*, М., 1899, стр. 14.

214. V. Bryusov, cited by В. Саянов: *Очерки по истории русской поэзии XX века*, Л., 1929, стр. 41.

215. З. Гиппиус: *Литературный дневник*, СПб., 1908, стр. 139.

216. Ibid., pp. 285–7.

217. Г. Чулков: *Сочинения*, т. 5, СПб., 1912, стр. 55–6.

218. Ф. Сологуб: 'Демоны поэтов', ПЕРЕВАЛ, 1907 № 7, стр. 48–51, 1907 № 12, стр. 46–8.

219. И. Гофштеттер: *Поэзия вырождения*, СПб., 1902, стр. 7.

220. А. Белый: 'Смысл искусства', в кн. *Символизм*, М., 1910, стр. 204–5.

221. В. Гуреев: 'Идеалисты и реалисты', МИР ИСКУССТВА, т. 2, №№ 13–24, СПб., 1899, лит. часть, отдел 1, стр. 83–91.

222. В. Брюсов: 'Ненужная правда', МИР ИСКУССТВА, 1902 №№ 1–6, отдел 3, стр. 68–9.

223. П. Коган: *Очерки по истории новейшей русской литературы*, т. 3, выпуск 1, изд. 2-ое, М., 1911, стр. 106.

224. Иванов-Разумник: 'Литература и общественность', ЗАВЕТЫ, 1914 № 3, стр. 106.

225. А. Белый: 'Далай-лама из Сапожка', ВЕСЫ, 1908 № 3, стр. 64.

226. И. Ф. Анненский: *Книга отражений*, СПб., 1906, стр. 128–9.

227. М. Неведомский: 'О современном художестве', МИР БОЖИЙ, 1904 № 8, стр. 18, 29.

228. Е. Аничков: *Литературные образы и мнения 1903 года*, СПб., 1904, стр. 12.

229. В. Брюсов: *Дневники 1891–1910*, 18/1/1898. Он же: *О искусстве*, М., 1899, стр. 8.

230. П. Коган: 'Литературные направления и критика 80-х и 90-х годов', в кн. *История русской литературы XIX века*, ред. Овсянико-Куликовский, т. 5, М., 1911, стр. 100.

231. П. Коган: *Очерки по истории новейшей русской литературы*, т. 3, выпуск 1, изд. 2-ое, М., 1911, стр. 126.

232. А. Блок: *Собр. соч.*, т. 5, М/Л., 1962, стр. 206.

233. Н. Апостолов: *Импрессионизм и модернизм*, Киев, 1908, стр. 36.

234. Ф. Сологуб: 'Искусство наших дней', РУССКАЯ МЫСЛЬ, 1915 № 12, отдел 2, стр. 42.

235. Г. Чулков: *О мистическом анархизме*, СПб., 1906, стр. 30.

236. Г. Чулков: 'Оправдание символизма', в кн. *Наши спутники*, М., 1922, стр. 102.

237. Г. Чулков: 'Поэт', в кн. *Вчера и сегодня*, М., 1916, стр. 69.

238. М. Гофман: 'Романтизм, символизм и декадентство', в кн. *Книга о русских поэтах последнего 10-летия*, М., 1909, стр. 22–3.

239. Г. Чулков: 'Принципы театра будущего', в кн. Театр. *Книга о новом театре*, СПб., 1908, стр. 206.

240. А. Г. Горнфельд: 'Торжество победителей', ТОВАРИЩ, 23/8/1907.

241. А. Белый: 'А. П. Чехов' (1907), в кн. *Арабески*, М., 1911, стр. 395 ff.

242. Иванов-Разумник: 'Пылающий (Андрей Белый)', в кн. *Александр Блок. Андрей Белый*, СПб., 1919, стр. 89–90.

243. Эллис: 'Итоги символизма', ВЕСЫ, 1909 № 7, стр. 57–9. Он же: *Русские символисты*, М., 1910, стр. 5.

244. Эллис: 'Наши эпигоны', ВЕСЫ, 1908 № 2, стр. 64.

245. К. Д. Бальмонт: *Горные вершины*, М., 1904, стр. 76.

246. Г. Чулков: 'Принципы театра будущего', в кн. *Театр. Книга о новом театре*, СПб., 1908, стр. 215.

246а. Е. Аничков: *Реализм и новые веяния*, СПб., 1909, стр. 73–4.

247. С. Булгаков: 'О реалистическом мировоззрении', ВОПРОСЫ ФИЛОСОФИИ И ПСИХОЛОГИИ, 1904, кн. 3, стр. 384–94.

248. Л. З. Слонимский: 'Новейшие идеалисты', ВЕСТНИК ЕВРОПЫ, 1903 № 9, стр. 313–25. Он же: 'Мнимые реалисты', ВЕСТНИК ЕВРОПЫ, 1904 № 10, стр. 727–8.

249. Н. А. Бердяев: 'Декадентство и мистический реализм', РУССКАЯ МЫСЛЬ, 1907 № 6, стр. 117.

250. В. Шулятиков: 'Восстановление разрушенной эстетики', в сборнике *Очерки реалистического мировоззрения*, СПб., 1904, стр. 603, 654.

251. А. Измайлов: *На переломе*, СПб., 1908, стр. 29–30.

252. В. Львов-Рогачевский: 'Из жизни литературы', СОВРЕМЕННИК, 1914 № 2, стр. 104. Он же: 'Быть или не быть русскому символизму?', СОВРЕМЕННЫЙ МИР, 1910 № 10, отдел 2, стр. 85.

253. А. Редько: 'У подножья африканского идола', РУССКОЕ БОГАТСТВО, 1913 № 6, стр. 318–19.

254. В. Н. Россиков: 'Литературная критика в начале XX века', ВЕСТНИК ВОСПИТАНИЯ, 1917 № 1, стр. 90.

255. For example: В. Саянов: *Очерки по истории русской поэзии XX века*, Л., 1929, стр. 66.

256. Иванов-Разумник: 'Литература и общественность', ЗАВЕТЫ, 1914 № 3, стр. 110.

257. Ibid., p. 109.

258. Д. Тальников: '"Символизм" или реализм?', СОВРЕМЕННЫЙ МИР, 1914 № 4, отдел 2, стр. 124–48.

259. В. Гуреев: 'Идеалисты и реалисты', МИР ИСКУССТВА, т. 2 №№ 13–24, СПб., 1899, лит. часть, отдел 1, стр. 84.

260. А. Волынский: 'Философия и поэзия', в кн. *Борьба за идеализм*, СПб., 1900, стр. 217–22.

261. В. Брюсов: 'Иван Коневской', в кн. *Книга о русских поэтах последнего 10-летия*, М., 1909, стр. 106.

262. В. Брюсов: 'Ключи тайн', ВЕСЫ, 1904 № 1, стр. 19.

263. В. Брюсов: 'Ренэ Гиль', ВЕСЫ, 1904 № 12, стр. 30–1.

264. Эллис: *Русские символисты*, М., 1910, стр. 7–8, 32.

265. Альманах ГРИФ, М., 1903, стр. 5: '. . . жажда неизведанного томит нас, и нам нет иной дороги, как итти вперед с

верой или без веры в будущее, навстречу неведомому. Привет тебе, неизвестность. . . .'

266. Г. Чулков: *Сочинения*, т. 5, Спб., 1912, стр. 136.

267. Ibid., p. 60.

268. Заметка о книге А. Белого *Луг зеленый*, ВЕСТНИК ЕВРОПЫ, 1910 № 11, стр. 414-15.

269. Б. Бугаев: 'Две замечательные книги', ВЕСЫ, 1904 № 12, стр. 36.

270. А. Белый: 'О целесообразности', НОВЫЙ ПУТЬ, 1904 № 9, стр. 150-3.

271. А. Блок: 'Дон Карлос', *Собр. соч.*, т. 6, М/Л., 1962, стр. 372.

272. А. Белый: 'Эмблематика смысла', в кн. *Символизм*, М., 1910, стр. 59-60.

273. А. Белый: 'Эмблематика смысла', в кн. *Символизм*, М., 1910, стр. 129-30.

274. А. Белый: 'Кризис сознания и Генрик Ибсен', в кн. *Арабески*, М., 1911, стр. 165.

275. Blok expressed this view most clearly in his speech 'On the destiny of the poet', first published in 1921:

> 'The poet is a child of harmony; and he is accorded a certain role in human culture. His task is threefold: firstly – to free the sounds from the formless element in which they are born and exist; secondly – to impose a harmony on these sounds, to give them a form; thirdly – to bring this harmony into the external world.'

А. Блок: 'О назначении поэта', *Собр. соч.*, т. 6, М/Л., 1962, стр. 162.

276. А. Блок: 'О театре', *Собр. соч.*, т. 5, стр. 261.

277. Г. Чулков: *О мистическом анархизме*, СПб., 1906, стр. 31.

278. Сборник *Очерки реалистического мировоззрения*, ред. С. Дороватовский, А. Чарушников, СПб., 1904, предисловие, стр. v.

279. П. Мокиевский: 'Теория познания философов и дьявольский сплав символистов', РУССКОЕ БОГАТСТВО, 1910 No. 11, отдел 2, стр. 116-18.

280. В. Асмус: 'Философия и эстетика русского символизма', в кн. *Литературное наследство*, №№ 27–8, 1937, стр. 24–6.

281. Г. Чулков: *О мистическом анархизме*, СПб., 1906, стр. 57.

282. Г. Чулков: 'Покрывало Изиды', *Сочинения*, т. 5, СПб., 1912, стр. 133.

283. Cf. В. Жирмунский: 'Преодолевшие символизм', РУССКАЯ МЫСЛЬ, 1918 № 12, стр. 279. Zhirmunsky wrote of the second 'wave' of Russian symbolists, whose principal representatives were, in his view, Ivanov, Bely and Blok:

> 'The wealth and fullness of life towards which their forerunners strove, were revealed for them as a manifestation of the infinite . . . in everything finite is felt a breath of the infinite.'

284. 'От редакции', ЗОЛОТОЕ РУНО, 1906 № 1.

285. Fyodor Stepun has described Berdyayev's symbolist theory of knowledge in terms which reflect fairly closely the teaching of Solov'yov on the place of man in the divine world-process. See: F. Stepun: *Mystische Weltschau*, München, 1964, pp. 118–19.

286. С. Виппер: 'Символизм в человеческой мысли и творчестве', РУССКАЯ МЫСЛЬ, 1905 № 2, отдел 2, стр. 298.

287. В. Львов-Рогачевский: 'Символисты и наследники их', СОВРЕМЕННИК, 1913 № 6, стр. 268.

288. З. Гиппиус: *Литературный дневник*, СПб., 1908, стр. 252.

288a. П. П. Перцов: *Литературные воспоминания 1890–1902*, М/Л., 1933, стр. 220.

289. Cf. J. Holthusen: *Studien zur Ästhetik und Poetik des russischen Symbolismus*, Göttingen, 1957, p. 48.

290. В. Брюсов: 'Карл V: диалог о реализме в искусстве', ЗОЛОТОЕ РУНО, 1906 № 4, стр. 65–6.

291. В. Брюсов: Заметка о книге Сологуба *Книга сказок*, М., 1904. ВЕСЫ, 1904 № 11, стр. 51.

292. А. Белый: 'Проблема культуры', в кн. *Символизм*, М., 1910, стр. 9.

293. А. Белый: 'Вишневый сад', ВЕСЫ, 1904 № 2, стр. 45–8.

294. Эллис: 'Итоги символизма', ВЕСЫ, 1909 № 7, стр. 65.

295. Эллис: *Русские символисты*, М., 1910, стр. 9–15.

296. Г. Чулков: *Сочинения*, т. 5, СПб., 1912, стр. 41.

297. Schopenhauer: *Die Welt als Wille und Vorstellung*, vol. 1, § 5 (Sämtliche Werke, München, 1911, vol. 1, p. 21).
'Life and dreams are pages of one and the same book. Real life consists in reading the two together. . . .'

298. Сергей Соловьев: 'Символизм и декадентство', ВЕСЫ, 1909 № 5, стр. 54.

299. Эллис: *Русские символисты*, М., 1910, стр. 16.

300. Quoted by П. П. Перцов: *Литературные воспоминания 1890–1902*, М/Л., 1933, стр. 220.

301. С. Маковский: *Страницы художественной критики*, книга I, СПб., 1906, стр. 21.

302. М. Кузмин: *Условности: статьи об искусстве*, Пг., 1923, стр. 156.

303. Д. Философов: 'Весенний ветер', в кн. *Слова и жизнь*, СПб., 1909, стр. 35.

304. 'Ф. Сологуб о символизме', БЮЛЛЕТЕНИ ЛИТЕРАТУРЫ И ЖИЗНИ, № 14, март 1914, стр. 835.

305. К. Д. Бальмонт: *Горные вершины*, М., 1904, стр. 94.

306. К. Чуковский: 'Пшибышевский о символе', ВЕСЫ, 1904 № 11, стр. 35.

307. Сборник *Очерки реалистического мировоззрения*, СПб., 1904, предисловие, стр. vii.

308. Н. Гудзий: 'Тютчев в поэтической культуре русского символизма', Ак. Наук: *Известия по русской изящной словесности*, 1930, т. 3, кн. 2. Л., 1930, стр. 505.

309. А. Редько: 'У подножья африканского идола', РУССКОЕ БОГАТСТВО, 1913 № 7, стр. 183.

310. Иванов-Разумник: 'Литература и общественность', ЗАВЕТЫ, № 3, март 1914, отдел 2, стр. 104.

311. И. Коневской: 'Живопись Бёклина', *Посмертное собр. соч.*, М., 1904, стр. 168.
The lines of Goethe quoted by Konevskoy:
'An eternal, living active force is at work to create the

world anew, lest it fortify itself against change, and what was not, shall now come into being.'

312. И. Коневской: 'Наука и поэзия', *Посмертное собр. соч.*, М., 1904, стр. 231–2.

313. К. Д. Бальмонт: *Горные вершины*, М., 1904, стр. 94.

314. В. Брюсов: *О искусстве*, М., 1899, стр. 20. Cf. Oscar Wilde's *The Decay of Lying*.

315. В. Брюсов: 'Ключи тайн', ВЕСЫ, 1904 № 1, стр. 7.

316. В. Брюсов: 'А. Белый: Возврат. Третья симфония', ВЕСЫ, 1904 № 12, стр. 59.

317. Quoted by P. Yushkevich in the marxist miscellany. *Литературный распад*, кн. 1, СПб., 1908, стр. 98.

318. Д. Философов: 'Проповедь идеализма', в кн. *Слова и жизнь*, СПб., 1909, стр. 171–2.

319. 'От редакции', ЗОЛОТОЕ РУНО, 1906 № 1.

320. 'От редакции', ПЕРЕВАЛ, 1906 № 1, стр. 4.

321. Г. Чулков: *О мистическом анархизме*, СПб., 1906, стр. 67.

322. Г. Чулков: *Сочинения*, т. 5, СПб., 1912, стр. 34.

323. Г. Чулков: 'О символизме', ЗАВЕТЫ, 1914 № 2, стр. 79.

324. Ф. Сологуб: 'Искусство наших дней', РУССКАЯ МЫСЛЬ, 1915 № 12, отдел 2, стр. 48, 57.

325. 'Ф. Сологуб о символизме', БЮЛЛЕТЕНИ ЛИТЕРАТУРЫ И ЖИЗНИ, № 14, март 1914, стр. 836.

326. Ф. Сологуб: 'Искусство наших дней', РУССКАЯ МЫСЛЬ, 1915 № 12, отдел 2, стр. 39.

327. Ф. Сологуб: 'Я: книга совершенного самоутверждения', ЗОЛОТОЕ РУНО, 1906, № 2, стр. 76: – 'Я создал и создаю времена и пространства. . . .'

328. А. Белый: 'Ответ на вопрос, поставленный одним журналом некоторым писателям и авторам', БЮЛЛЕТЕНИ КНИЖНЫХ И ЛИТЕРАТУРНЫХ НОВОСТЕЙ, Второй год, № 4, 10/11/1910, стр. 103.

329. See, for example, А. Белый: 'О субъективном и объективном', в сборнике *Свободная совесть*, кн. 2, М., 1906, in

which Bely put forward the paradox that 'subjectivism' is in itself valueless, but that it is only through a form of subjectivism that human knowledge can attain a degree of objectivity far surpassing that which can be achieved by scientific reasoning.

330. А. Белый: 'Песнь жизни', в кн. *Арабески*, М., 1911, стр. 43.

331. А. Белый: 'Театр и современная драма', в кн. *Арабески*, М., 1911, стр. 17–18.

332. Quoted by С. Медынский: *Религиозные влияния в русской литературе*, М., 1933, стр. 96.

333. А. Белый: 'Кризис сознания и Генрик Ибсен', в кн. *Арабески*, М., 1911, стр. 166–7.

334. Эллис: 'О современном символизме, о "чорте" и о "действе"', ВЕСЫ, 1909 № 1, стр. 80–1.

335. Эллис: Заметка о книге Вяч. Иванова *По звездам*, СПб., 1909. ВЕСЫ, 1909 № 8, стр. 60–1.

336. Эллис: 'Итоги символизма', ВЕСЫ, 1909 № 7, стр. 65.

337. А. Блок: 'О театре', *Собр. соч.*, т. 5, М/Л., 1962, стр. 276.

338. А. Белый: 'Магия слов', в кн. *Символизм*, М., 1910, стр. 429–30.

339. В. Шулятиков: 'Восстановление разрушенной эстетики', в сборнике *Очерки реалистического мировоззрения*, СПб., 1904, стр. 612.

340. П. С. Коган: *Очерки по истории новейшей русской литературы*, т. 3, выпуск 1, изд. 2-ое, М., 1911, стр. 12.

341. П. С. Коган: 'Литературные направления и критика 80-х и 90-х годов', в кн. *История русской литературы XIX века*, ред. Овсянико-Куликовский, т. 5, М., 1911, стр. 98.

342. Н. И. Николаев: 'Новые принципы литературной критики', в кн. *Эфемериды*, Киев, 1912, особенно стр. 381.

343. Л. Шестов: 'Вячеслав Великолепный: к характеристике русского упадничества', РУССКАЯ МЫСЛЬ, 1916 № 10, отд. 2, стр. 86.

344. А. В. Луначарский: 'Основы позитивной эстетики', в сборнике *Очерки реалистического мировоззрения*, СПб., 1904, стр. 182.

Conclusion

1. С. Булгаков: *От марксизма к идеализму*, СПб., 1903, стр. xx.

2. Erich Heller: 'Rilke and Nietzsche, with a discourse on thought, belief, and poetry', in *The Disinherited Mind*, Cambridge, 1952. Second edition, Harmondsworth, 1961.

3. Rilke: *Tuscan Diary*, quoted by Erich Heller, *The Disinherited Mind*, Second edition, p. 142.

4. Ibid., p. 125.

5. Ibid., p. 128.

6. Cf. Вяч. Иванов: 'Религиозное дело Владимира Соловьева', в кн. *Борозды и Межи*, М., 1916. This essay was originally a memorial lecture on the tenth anniversary of Solov'yov's death; it reads in places more like a panegyric for a prophet than a critical appraisal of Solov'yov's writings on religion. In an autobiographical note for Modest Gofman, Ivanov mentioned only Nietzsche and Solov'yov as formative influences on his own work. See: *Книга о русских поэтах последнего 10-летия*, ред. М. Гофман, М., 1909, стр. 263.

7. See: А. Белый: *Сирин ученого варварства*, Берлин, 1922, стр. 8:

> 'Процветание пейзажа – из слов поэта о нем, а процветание слова поэта из . . . мысли поэта о слове; с тем же белым мелком перед черной доской возникает перед нами опять Вячеслав Иванов. . . .'

8. Вячеслав Иванов: 'Голубятня', в кн. *Свет вечерний*, Oxford, 1962, pp. 11–12.

9. Вячеслав Иванов: 'Творчество', в кн. *Кормчие звезды*, СПб., 1903, стр. 40.

10. Saint-John Perse: *Poésie*. Allocution au Banquet Nobel du 10 décembre 1960, Paris, 1961.

11. Владимир Соловьев: 'Вторая речь о Достоевском', *Собр. соч.*, СПб., 1901–7, т. 3, стр. 185.

Bibliography

The number of works consulted in the preparation of this study of the Russian symbolist aesthetic in its setting has necessarily been very large, and no useful purpose would be served by listing them all. What follows is a list of works actually cited, together with a small number of others which have proved of value, and an indication of the sources drawn upon in the Russian periodical literature of the turn of the century.

This bibliography confines itself to works which shed some light on the theories and ideology of the Russian symbolists, rather than simply on the general history of the movement. The material is arranged alphabetically, with titles in Roman script following those in Cyrillic, within the following classification:

1. THE SYMBOLIST DEBATE
 (a) Bibliographies
 (b) Periodicals
 (c) Symbolist writing
 (d) Reactions to the symbolists in contemporary literary critic-ism
 (e) Reactions to the symbolists in contemporary works on philosophy and aesthetics
 (f) Post-symbolist works on the symbolist aesthetic
2. VYACHESLAV IVANOV
 (a) Ivanov's philosophy of art
 (b) Works on Ivanov
3. THE NINETEENTH-CENTURY HERITAGE
4. GENERAL

1. The symbolist debate

(a) Bibliographies

The most useful bibliographies for orientation in the symbolist period are:

Владиславлев: *Русские писатели*, М/Л., 1924.

Голубева, О. Д.: *Литературно-художественные альманахи и сборники 1900–1911*, М., 1957.

Б. П. Козьмин: *Писатели современной эпохи*. Био-библиографический словарь русских писателей XX века. 1928.

К. Д. Муратова (ред.): *История русской литературы конца XIX – начала XX века*. Библиографический указатель. М., 1963.

Н. П. Рогожин: *Литературно-художественные альманахи и сборники 1912–1917*, М., 1958.

(b) *Periodicals*

The present study is based upon an extensive exploration of the literary-critical journals, and the literary-critical sections of more broadly-based journals, in which the symbolists and their opponents regularly published their work. The most important of these are:

АПОЛЛОН. СПб., 1909–17.

БЮЛЛЕТЕНИ ЛИТЕРАТУРЫ И ЖИЗНИ. М., 1909–18. (The title of this periodical varied during its earlier years.)

ВЕСТНИК ВОСПИТАНИЯ. М., 1890–1917.

ВЕСТНИК ЕВРОПЫ. СПб., 1866–1917.

ВЕСЫ. М., 1904–9.

ВОПРОСЫ ЖИЗНИ. СПб., 1905–6.

ВОПРОСЫ ФИЛОСОФИИ И ПСИХОЛОГИИ. М., 1889–1917.

ЗАВЕТЫ. СПб., 1912–14.

ЗАПИСКИ МЕЧТАТЕЛЕЙ. Петербург, 1919–22.

ЗОЛОТОЕ РУНО. М., 1906–9.

ЛОГОС. Международный ежегодник по философии культуры. М., 1910–25.

МИР БОЖИЙ. СПб., 1892–1906.

МИР ИСКУССТВА. СПб., 1899–1904.

НОВЫЙ ПУТЬ. СПб., 1903–4.

ОБРАЗОВАНИЕ. СПб., 1892–1909.

ПЕРЕВАЛ. М., 1906–7.

РУССКАЯ МЫСЛЬ. М., 1880–1918.

РУССКОЕ БОГАТСТВО. СПб., 1876–1917. (The title changed several times after 1905.)

РУССКОЕ СЛОВО. М., 1895–1918.

СЕВЕРНЫЙ ВЕСТНИК. СПб., 1882–98.

СЕВЕРНЫЕ ЗАПИСКИ. СПб., 1913–16.

СОВРЕМЕННИК. СПб., 1911–15.

СОВРЕМЕННЫЙ МИР. СПб., 1909–14.

ТРУДЫ И ДНИ. М., 1912–14.

Reference is made to editorial comment in the following two literary almanacs, the first closely connected with the symbolist movement, the second with 'mystical anarchism':

ГРИФ. Альманах книгоиздательства 'Гриф', М., 1903.

ФАКЕЛЫ. 3 тт., СПб., 1906–8.

(c) *Symbolist writing*

This includes the work of a number of sympathetic contributors to the symbolist periodicals who were not strictly speaking symbolists, and the relevant works of such figures as Meyerhold.

Анненский, И. Ф.: Книга отражений, СПб., 1906.
Вторая книга отражений, СПб., 1909.
'О современном лиризме', АПОЛЛОН, 1909 №№ 1, 2, 3.
'Что такое поэзия?', АПОЛЛОН, 1911 № 6.

Бальмонт, К. Д.: Белые зарницы. Мысли и впечатления. СПб., 1908.
Горные вершины. Критические статьи. М., 1904.
'Наше литературное сегодня', ЗОЛОТОЕ РУНО, 1907 № 12.
Поэзия как волшебство. М., 1915.

Белый, А: Арабески, М., 1911.
'Две замечательные книги', ВЕСЫ, 1904 № 12. (Under Bely's real name, Борис Бугаев.)
'Идеалисты и "Новый путь"', ВЕСЫ, 1904 № 11.
Луг зеленый, М., 1910.
'На перевале. XII: Слово правды', ВЕСЫ, 1908 № 9.
'О проповедниках, гастрономах, мистических анархистах и т.п.', ЗОЛОТОЕ РУНО, 1907 № 1.

16+

'О субъективном и объективном', в сборнике *Свободная совесть*, кн. 2, М., 1906.

Поэзия слова, М., 1922.

Символизм, М., 1910.

'Химеры', ВЕСЫ, 1905 № 6.

Бенуа, А.: 'Художественные ереси', ЗОЛОТОЕ РУНО, 1906 № 2.

Бердяев, Н. А.: 'Декадентство и мистический реализм', РУССКАЯ МЫСЛЬ, 1907 № 6.

Духовный кризис интеллигенции. Статьи по общественной и религиозной психологии. СПб., 1910.

Блок, А.: Собрание сочинений в 8 тт., М/Л., 1960–3.

Записные книжки, М., 1965.

Брюсов, В. Я.: Предисловие к *Chefs d'œuvre*, М., 1895.

'А. Белый. Возврат. Третья симфония.' ВЕСЫ, 1904 № 12.

'Вехи IV: Факелы', ВЕСЫ, 1906 № 5.

Дневник 1891–1910, М., 1927.

Заметка о *Книге сказок* Ф. Сологуба, М., 1904. ВЕСЫ, 1904 № 11.

'Карл V: диалог о реализме в искусстве', ЗОЛОТОЕ РУНО, 1906 № 4.

'Ключи тайн', ВЕСЫ, 1904 № 1.

'Ненужная правда', МИР ИСКУССТВА, т. 7, 1902 №№ 1–6, отдел 3.

О искусстве, М., 1899.

Письма Брюсова к П. Перцову 1894–6, М., 1927.

'Ренэ Гиль', ВЕСЫ, 1904 № 12.

Русские символисты. Выпуск 2-ой, М., 1894.

'Священная жертва', ВЕСЫ, 1905 № 1.

Волынский, А. Л. (А. Л. Флексер): Борьба за пдеализм. Критические статьи, СПб., 1900.

'О символизме и символистах. Полемическая заметка.', СЕВЕРНЫЙ ВЕСТНИК, 1899 №№ 10–12.

Русские критики, СПб., 1896.

Гиппиус, З.: Литературный дневник 1899–1907, СПб., 1908.

'Необходимое в стихах'. Предисловие к Собранию стихов 1889–1903, М., 1904.

234

Гофман, М.: 'Романтизм, символизм и декадентство', в кн. Книга о русских поэтах последнего 10-летия, ред. М. Гофман, М., 1909.

Городецкий, С. М.: 'Аминь', ЗОЛОТОЕ РУНО, 1908 №№ 7–9.
'Ближайшая задача русской поэзии', ЗОЛОТОЕ РУНО, 1909 № 4.
'Глухое время', ЗОЛОТОЕ РУНО, 1908 № 6.
'Идолотворчество', ЗОЛОТОЕ РУНО, 1909 № 1.
'На светлом пути: поэзия Федора Сологуба с точки зрения мистического анархизма', Факелы, кн. 2, СПб., 1907.
'Некоторые течения в современной русской поэзии', АПОЛЛОН, 1913 № 1.
'Огонь за решеткой', ЗОЛОТОЕ РУНО, 1908 №№ 3–4.
'Три поэта: Брюсов, Иванов, Бальмонт', ПЕРЕВАЛ, №№ 8–9, 1907.
'Формотворчество', ЗОЛОТОЕ РУНО, 1909 № 10.

Гуреев, В.: 'Идеалисты и реалисты', МИР ИСКУССТВА, т. 2, 1899 №№ 13–24, лит. отд. 2.

Коневской, Иван (И. И. Ореус): Посмертное собрание сочинений, под ред. В. Брюсова. М., 1904.

Маковский, С.: Страницы художественной критики, кн. 1, СПб., 1906.

Мейерхольд, В. Э.: О театре, СПб., 1913.

Мережковский, Д. С.: 'Балаган и трагедия', РУССКОЕ СЛОВО, 14/9/1910.
О причинах упадка и о новых течениях современной русской литературы. СПб., 1893.

Садовской, Б.: 'Жизнь и поэзия', ТРУДЫ И ДНИ, 1912 № 2.

Слонимская, Ю.: 'Марионетка', АПОЛЛОН, 1916 № 3.

Соловьев, Сергей: 'Символизм и декадентство', ВЕСЫ, 1909 № 5.

Сологуб, Федор (Ф. К. Тетерников): 'Демоны поэтов', ПЕРЕВАЛ, 1907 № 7.
'Искусство наших дней', РУССКАЯ МЫСЛЬ, 1915 № 12.
'О символизме', ЗАВЕТЫ, 1914 № 2.
'Театр одной воли', в сборнике Театр. Книга о новом театре, СПб., 1908.

'Ф. Сологуб о символизме', БЮЛЛЕТЕНИ ЛИТЕРАТУРЫ И ЖИЗНИ, № 14, март 1914.

Тастевен, Г.: 'Ницше и современный кризис', ЗОЛОТОЕ РУНО, 1907 №№ 7–9.

Чуковский, К.: 'Пшибышевский о символе', ВЕСЫ, 1904 № 11.

Чулков, Г.: Сочинения, т. 5, СПб., 1912 Статьи 1905–11.
'Балаганчик', ПЕРЕВАЛ, 1906 № 1.
Вчера и сегодня, М., 1916.
Наши спутники, М., 1922.
О мистическом анархизме, СПб., 1906.
'О символизме', ЗАВЕТЫ, 1914 № 2.
'Принципы театра будущего', в сборнике Театр. Книга о новом театре, СПб., 1908.
'Светлеют дали', ВЕСЫ, 1904 № 3.

Эллис (Л. Л. Кобылинский): 'В защиту декадентства', ВЕСЫ, 1907 № 8.
Заметка о книге Вяч. Иванова По звездам, СПб., 1909. ВЕСЫ, 1909 № 8.
Заметка о сборнике Кризис театра, М., 1908. ВЕСЫ, 1908 № 9.
'Итоги символизма', ВЕСЫ, 1909 № 7.
'Кризис современного театра', ВЕСЫ, 1908 № 9.
'Наши эпигоны', ВЕСЫ, 1908 № 2.
'О современном символизме, о "Чорте", и о "Действе"' ВЕСЫ, 1909 № 1.
Русские символисты, М., 1910.
'Что такое литература?', ВЕСЫ, 1907 № 10.
'Что такое театр?', ВЕСЫ, 1908 № 4.

(d) *Reactions to the symbolists in contemporary literary criticism*

Anon.: Заметка о книге А. Белого Луг зеленый, ВЕСТНИК ЕВРОПЫ, 1910 № 4.

Александрович, Ю.: После Чехова: 1898–1908, М., 1908.

Абрамович, Н. Я.: Литературно-критические очерки, СПб., 1909.

Адрианов, С.: 'Критические наброски о модернизме', ВЕСТ-НИК ЕВРОПЫ, 1910 № 10.

Аничков, Е.: 'Последние побеги русской поэзии', ЗОЛОТОЕ РУНО, 1908 №№ 2–4.
Литературные образы и мнения 1903 года, СПб., 1904.
Реализм и новые веяния, СПб., 1909.

Апостолов, Н.: Импрессмонизм и модернизм, Киев, 1908.

Баженов, Н. Н.: Психиатрические беседы на литературные и общественные темы, М., 1903.

Венгеров, С.: Основные черты истории новейшей русской литературы, СПб., 1909.
(ред.) Русская литература XX века, М., 1916.

Войтоловский, Л.: 'Итоги русского модернизма', в сборнике *Литературный распад*, кн. 1, СПб., 1908.

Волжский (А. С. Глинка): Из мира литературных исканий, СПб., 1906.

Вознесенский, А.: Поэты, влюбленные в прозу, Киев, 1910.

Гофштеттер, И.: Поэзия вырождения (Философские и психологические мотивы декадентства), СПб., 1903.

Горнфельд, А.: 'Заметка о реализме', РУССКОЕ БОГАТСТВО, 1910 № 12.
'Торжество победителей', ТОВАРИЩ, 23/8/1907.

Гуревич, Л. Я.: Литература и эстетика, М., 1912.

Жирмунский, В.: Немецкий романтизм и современная мистика, СПб., 1914.
'Преодолевшие символизм', РУССКАЯ МЫСЛЬ, 1918 № 12.

Жураковский, Е.: Симптомы литературной эволюции, 2 тт., М., 1903.

Иванов-Разумник, Р. В.: 'Литература и общественность', ЗАВЕТЫ, № 3, март 1914.

Измайлов, А.: Литературный олимп, М., 1911.
На переломе, СПб., 1908.

Коган, П. С.: 'Литературные направления и критика 80-х и 90-х гг.', в кн. История русской литературы XIX века, ред. Овсянико-Куликовский, М., 1911.

Очерки по истории новейшей русской литературы, 3 тт., М., 1908–12.

Кранихфельд, В. П.: В мире идей и образов, Пг., 1917, 3 тт.
'Литературные отклики. Новые наследники "Переписки" Гоголя', СОВРЕМЕННЫЙ МИР, 1909 № 8.

Kropotkin, Prince P. A.: Russian Literature, London, 1905.

Луначарский, А.: 'Заметки философа', ОБРАЗОВАНИЕ, 1906 № 8.

Львов-Рогачевский, В.: 'Быть или не быть русскому символизму?, СОВРЕМЕННЫЙ МИР, 1910 № 10.
'Из жизни литературы', СОВРЕМЕННИК, 1914 № 2.
'Лирика современной души (Русская литература и группа символистов)', СОВРЕМЕННЫЙ МИР, 1910 № 9.
'Символисты и наследники их', СОВРЕМЕННИК, 1913 №№ 6–7.

Ляцкий, Е. Я.: 'Вопросы искусства в современных его отражениях', ВЕСТНИК ЕВРОПЫ, 1907 № 4.

Маковский, Ф.: 'Что такое русское декадентство?', ОБРАЗОВАНИЕ, 1905 № 9.

Михайловский, Н. К.: Литературные воспоминания и современная смута, 2 тт., СПб., 1900.

Молоствов, Н. Г.: Волынский и новейшие идеалисты, СПб., 1905.

Неведомский, М. (Миклашевский, М. П.):
'В защиту художества О наших "модернистах", "мистиках", "мифотворцах" и т.д.', СОВРЕМЕННЫЙ МИР, 1908, №№ 3–4.
'О современном художестве. Леонид Андреев', МИР БОЖИЙ, 1903 № 4.
'О современном художестве', МИР БОЖИЙ, 1904 № 8.

Николаев, Н. И.: 'Новые принципы литературной критики', в кн. Эфемериды, Киев, 1912.

Полянин, А.: 'В поисках пути искусства', СЕВЕРНЫЕ ЗАПИСКИ, 1913 №№ 5–6.

Редько, А.: 'У подножья африканского идола', РУССКОЕ БОГАТСТВО, 1913 №№ 6–7.

Россиков, В. Н.: 'Литературная критика в начале XX века', ВЕСТНИК ВОСПИТАНИЯ, 1917 №№ 1–2.

Слонимский, Л. З.: 'Новейшие идеалисты', ВЕСТНИК ЕВРОПЫ, 1903 № 9.
'Мнимые реалисты', ВЕСТНИК ЕВРОПЫ, 1904 № 10.

Соловьев, Вл.: 'По поводу сочинения Н. М. Минского "При свете совести"', ВЕСТНИК ЕВРОПЫ, 1890 № 3.

Степун, Ф.: 'О некоторых отрицательных сторонах современной литературы', СЕВЕРНЫЕ ЗАПИСКИ, 1913 № 10.

Тальников, Д. (Д. Шпитальников): '"Символизм" или реализм?', СОВРЕМЕННЫЙ МИР, 1914 № 4.

Философов, Д.: 'Дела домашние', ТОВАРИЩ, 23/9/1907.
'Мистический анархизм', ЗОЛОТОЕ РУНО, 1906 № 10.
Слова и жизнь, СПб., 1909.

Фриче, Б.: 'Социально-психологические основы натуралистического импрессионизма', в сборнике *Очерки реалистического мировоззрения*, СПб., 1904.

Эйхенбаум, Б., Никольский, Ю.: 'Д. С. Мережковский – критик', СЕВЕРНЫЕ ЗАПИСКИ, 1915 № 4.

Эмпирик: 'О "чистом символизме", теургизме и нигилизме', ЗОЛОТОЕ РУНО, 1908 № 5.

(*e*) *Reactions to the symbolists in contemporary works on philosophy and aesthetics*

Аничков, Е.: 'Очерк развития эстетических теорий', в кн. Вопросы теории и психологии творчества, т. 4, Харьков, 1915.

Булгаков, С.: 'О реалистическом мировоззрении', ВОПРОСЫ ФИЛОСОФИИ И ПСИХОЛОГИИ, 1904, часть 3.
От марксизма к идеализму, СПб., 1903.

Виппер, С.: 'Символизм в человеческой мысли и творчестве', РУССКАЯ МЫСЛЬ, 1905 № 2.

Гуревич, А.: 'Критицизм', ЖИЗНЬ, СПб., 1901, т. 1.

Иванов-Разумник, Р.: История русской общественной мысли, Пг., 1918, 2 тт.

Луначарский, А.: 'Основы позитивной эстетики', в сборнике *Очерки реалистического мировоззрения*, СПб., 1904.

Мартов, Л.: 'Общественные движения и умственные течения в период 1884–1905 гг.,' в кн. История русской литературы XIX века, ред. Овсянико-Куликовский, М., 1911.

Мокиевский, П.: 'Теория познания философов и дьявольский сплав символистов', РУССКОЕ БОГАТСТВО, 1910 № 11.

Новгородцев, П.: 'О философском движении наших дней', НОВЫЙ ПУТЬ, 1904 № 10.

Очерки реалистического мировоззрения, изд. С. Дороватовского, А. Чарушникова, СПб., 1904.

Проблемы идеализма, ред. П. И. Новгородцев, М., 1903.

Радлов, Е.: 'О главных направлениях современной эстетики', СЕВЕРНЫЙ ВЕСТНИК, 1896 № 1.

Челпанов, Г.: 'Основные направления в современной теории познания', МИР БОЖИЙ, 1904 № 8.

Шулятиков, В.: 'Восстановление разрушенной эстетики', в кн. *Очерки реалистического мировоззрения*, СПб., 1904.

Юшкевич, П.: 'О современных философско-религиозных исканиях,' в сборнике *Литературныи распад*, СПб., 1908.

(f) *Post-symbolist works on the symbolist aesthetic*

Асмус, В.: 'Философия и эстетика русского символизма', ЛИТЕРАТУРНОЕ НАСЛЕДСТВО, тт. 27–8, М., 1937.

Гудзий, Н. К.: 'Тютчев в поэтической культуре русского символизма', АН СССР, Известия по русскому языкознанию и словесности, Л., 1930.

Иванов-Разумник, Р.: Александр Блок. Андрей Белый, СПб., 1919.

Коган, П. С.: Литература этих лет 1917–23, Иваново-Вознесенск, 1924.

Литературные манифесты от символизма к октябрю: сборник материалов. Ред. Н. Л. Бродский, М., 1929.

Максимов, Д. Е.: 'Критическая проза А. Блока', в кн. Блоковский сборник, Тарту, 1964.

Медынский, Г. А.: 'В поисках утерянных реальностей (Богоискательство и символизм), в кн. Религиозные влияния в русской литературе, М., 1933.

Мочульский, К. В.: Александр Блок, Париж, 1948.

Андрей Белый, Париж, 1955.

Перцов, В.: 'Реализм и модернистские течения в русской литературе начала XX века', ВОПРОСЫ ЛИТЕРАТУРЫ, 1957 № 2.

Редько, А. Е.: Театр и эволюция театральных форм, Л., 1926.

Рубцов, А. Б.: Драматургия А. Блока, ред. Кулешов, Минск, 1968.

Саянов, В.: Очерки по истории русской поэзии XX века, Л., 1929.

Donchin, G.: The Influence of French Symbolism on Russian Poetry, 's Gravenhage, 1958, chapter 3.

Holthusen, J.: Studien zur Ästhetik und Poetik des russischen Symbolismus, Göttingen, 1957.

Lo Gatto, E.: L'estetica e la poetica in Russia, Firenze, 1947.

Maslenikov, O.: The Frenzied Poets, Berkeley, 1952.

Stepun, F. A.: Mystische Weltschau: fünf Gestalten des russischen Symbolismus, München, 1964.

2. Vyacheslav Ivanov

(a) Ivanov's philosophy of art

The majority of Ivanov's philosophical and critical essays were re-published in the collections which are given first:

Борозды и межи. Опыты эстетические и критические, М., 1916.

По звездам. Статьи и афоризмы. СПб., 1909.

Родное и вселенское, М., 1917.

Автобиография, в Книге о русских поэтах последнего 10-летия, под ред. М. Гофмана, М., 1909.

Автобиографическое письмо С. А. Венгерову, в кн. Русская литература XX века, под ред. С. А. Венгерова, т. 3, М., 1916.

'Б. Н. Бугаев и Realiora', ВЕСЫ, 1908 № 7.

'Гёте на рубеже двух столетий', в кн. История западной литературы, под ред. Ф. Д. Батюшкова, т. 1, кн. 1, М., 1912.

Дионис и прадионисийство, Баку, 1923.

'Из области современных настроений', ВЕСЫ, 1905 № 6.

'Кручи: кризис гуманизма', ЗАПИСКИ МЕЧТАТЕЛЕЙ, 1919 № 1.

'О символизме', ЗАВЕТЫ, 1914 № 2.

'О "красном смехе" и "правом безумии"', ВЕСЫ, 1905 № 3.

'О любви дерзающей', ФАКЕЛЫ, т. 2, 1907.

Переписка из двух углов (с М. О. Гершензоном), Москва/Берлин, 1922.

'Рассказы тайновидца', ВЕСЫ, 1904 № 8.

'Религия Диониса', ВОПРОСЫ ЖИЗНИ, 1905 №№ 6-7.

'Эллинская религия страдающего бога', НОВЫЙ ПУТЬ, 1904 №№ 1-3, 5, 8-9.

'Эстетическая норма театра', НОВАЯ ЖИЗНЬ, Альманах 3, М., 1916.

Correspondance d'un coin à l'autre (avec M. O. Herrschensohn), Paris, 1931. (Suivie d'une lettre de V. Ivanov à Ch. DuBos).

Freedom and the Tragic Life. A Study in Dostoyevsky. English Translation by N. Cameron, London, 1952. (N.B. The text for this work was provided by Ivanov from previously unpublished sources; I have been unable to discover from the publisher of the English translation its exact whereabouts.)

'Simbolisma', ENCICLOPEDIA ITALIANA, xxxi, 1937.

(b) Works on Ivanov

The following have some bearing on his philosophy of art.

Абрамович, Н. Я.: 'Стихийность в молодой поэзии', в кн. Литературно-критические очерки, кн. 1, СПб., 1909.

Адамович, Г.: 'Вяч. Иванов и Лев Шестов', в кн. Одиночество и свобода, Нью-Йорк, 1955.

Адрианов, С.: 'Критические наброски: По звездам', ВЕСТНИК ЕВРОПЫ, 1909 № 10.

Anon.: 'Лекция-концерт В. Иванова и А. Б. Гольденвейзера', АПОЛЛОН, 1916 № 1.

Белый, А.: 'Вяч. Иванов. Силуэт', в кн. Арабески, М., 1911.
'Иванов', в кн. Поэзия слова, М., 1922.
Сирин ученого варварства. По поводу книги В. Иванова 'Родное и вселенское', Берлин, 1922.

Бердяев, Н.: 'Ивановские среды', в кн. Русская литература XX века, под ред. С. А. Венгерова, т. 3, М., 1916.

Блок, А.: 'Творчество Вяч. Иванова', Собр. соч., т. 5, М/Л., 1962.

Булгаков, С.: 'Сны Геи ("Борозды и межи")', в кн. Тихие думы: из статей 1911–15 гг., М., 1918.

В – ский, Ч. (В. Е. Чешихин), 'Вяч. Иванов: "Борозды и межи"', ВЕСТНИК ЕВРОПЫ, 1916 № 8.

Г.Т.: 'По звездам', ЗОЛОТОЕ РУНО, 1909 № 6.

Закржевский, А.: Религия. Психологические параллели, Киев, 1913.

Зелинский, Ф.: 'Вяч. Иванов', в кн. Русская литература XX века, под ред. С. А. Венгерова, т. 3, М., 1916.

Измайлов, А. А.: 'Вяч. Иванов', в кн. Помрачение божков и новые кумиры, М., 1910.
'Звенящий кимвал', в кн. Пестрые знамена, М., 1913.

Коган, П. С.: Литература этих лет, 1917–23, Иваново-Вознесенск, 1924, глава 3.
'Переписка из двух углов', ПЕЧАТЬ И РЕВОЛЮЦИЯ, 1921 № 3.

Кузмин, М.: Условности. Статьи об искусстве, Пг., 1923.

Маковский, С.: Портреты современников, Нью-Йорк, 1955.

Николаев, Н. И.: 'Новые принципы литературной критики. По звездам', в кн. Эфемериды, Киев, 1912.

Пяст, В.: 'Вячеслав Иванов', в Книге о русских поэтах последнего 10-летия, под ред. М. Гофмана, М., 1909.

Степун, Ф.: Встречи, Мюнхен, 1962.
'Памяти Вяч. Иванова', ВОЗРОЖДЕНИЕ, Париж, 1949, тетрадь 5.

Философов, Д.: 'Весенний ветер', в кн. Слова и жизнь, СПб., 1909.

Ф.С.: 'По звездам', ЛОГОС, 1910 кн. 1.

Шестов, Л. (Л. И. Шварцманн): 'Вячеслав Великолепный: к характеристике русского упадничества', РУССКАЯ МЫСЛЬ, 1916 № 10.

Эллис: 'По звездам', ВЕСЫ, 1909 № 8.

Эрберг, К.: 'О воздушных мостах критики. По звездам', АПОЛЛОН, 1909 № 2.

Deschartes, O.: 'Vyacheslav Ivanov', OXFORD SLAVONIC PAPERS, V, 1954.

'Être et mémoire selon Vyacheslav Ivanov', OXFORD SLAVONIC PAPERS, VII, 1957.

Tschöpl, Carin: Vjačeslav Ivanov. Dichtung und Dichtungstheorie. (University of Göttingen doctoral dissertation, 1966.)

3. The nineteenth-century heritage

For the six nineteenth-century writers discussed in Chapter One, the editions drawn upon for illustration are:

Белинский: Взгляд на русскую литературу за 1846 год.

Взгляд на русскую литературу за 1847 год. С Послесловием Е. Мельникова, М., 1960.

Полное собр. соч., 13 тт., М., 1953–9.

Григорьев: Собр. соч., т. 1, СПб., 1876.

Скабичевский: 'Задачи литературной критики', РУССКОЕ БОГАТСТВО, 1890 № 12.

История новейшей русской литературы, Изд. 3-ье, СПб., 1897.

'Новые течения в современной литературе', РУССКАЯ МЫСЛЬ, 1901, ноябрь.

Сочинения, 2 тт., СПб., 1903.

Соловьев: Собр. соч., 6 тт., СПб., 1901–7.

Толстой: Собр. соч., 20 тт., М., 1960–5.

Чернышевский: Эстетические отношения искусства к действительности, СПб., 1865.

Reference is also made to the following secondary works:

Бурсов, Б.: Вопросы реализма в эстетике революционных демократов, М., 1953.

История русской критики, т. 1, М/Л., 1958.

Мочульский, К.: Владимир Соловьев: жизнь и учение, Изд. 2-ое, Париж, 1957.

Шестов, Л.: Умозрение и апокалипсис. Религиозная философия Вл. Соловьева, в кн. Умозрение и откровение, Париж, 1964.

Wellek, René: Social and aesthetic values in Russian nineteenth-century literary criticism, in *Continuity and Change in Russian and Soviet Thought*, ed. E. J. Simmons, Harvard, 1955.

4. General

Reference is made for purposes of illustration or comparison to the following works:

Auden, W. H.: *Making, Knowing and Judging*, Oxford, 1956.

Auerbach, Erich: *Mimesis, Dargestellte Wirklichkeit in der abendländischen Literatur*, Bern, 1946.

Cassirer, Ernst: *An Essay on Man* (*An Introduction to a Philosophy of Human Culture*), Yale, 1944 and 1962.

Gombrich, E. H.: *Art and Illusion*, 1960; 2nd ed., London, 1962.

Heller, Erich: *The Disinherited Mind*, Cambridge, 1952, 2nd ed., Harmondsworth, 1961.

Nietzsche: *Die Geburt der Tragödie aus dem Geiste der Musik* (1872).

Richards, I. A.: *Principles of Literary Criticism*, London, 1961.

Saint-John Perse: *Poésie*. Allocution au Banquet Nobel du 10 décembre 1960, Paris, 1961.

Wellek, René: Concepts of Criticism, Yale, 1963.

Index